D0396809

HOLLYWOOD
DRIVE

What It Takes to
Break In, Hang In & Make It
in the Entertainment Industry

HOLLYWOOD DRIVE

What It Takes to
Break In, Hang In & Make It
in the Entertainment Industry

Eve Light Honthaner

ELSEVIER

AMSTERDAM • BOSTON • HEIDELBERG • LONDON
NEW YORK • OXFORD • PARIS • SAN DIEGO
SAN FRANCISCO • SINGAPORE • SYDNEY • TOKYO
Focal Press is an imprint of Elsevier

Focal
Press

Acquisition Editor: Elinor Actipis
Project Manager: Kristin Macek
Assistant Editor: Cara Anderson
Marketing Manager: Mark Hughes
Cover Design: William Harrold

Focal Press is an imprint of Elsevier
30 Corporate Drive, Suite 400, Burlington, MA 01803, USA
Linacre House, Jordan Hill, Oxford OX2 8DP, UK

Recognizing the importance of preserving what has been written, Elsevier prints its books on acid-free paper whenever possible.

Library of Congress Cataloging-in-Publication Data
Honthaner, Eve Light
 Hollywood drive : what it takes to break in, hang in & make it in the entertainment industry / Eve Light Honthaner.
 p. cm.
 ISBN 0-240-80668-9 (alk. paper)
 1. Motion pictures–Vocational guidance I. Title.
PN1995.9.P75H66 2005
791.4302′93–dc22

 2004060833

British Library Cataloguing-in-Publication Data
A catalogue record for this book is available from the British Library.

For information on all Focal Press publications
visit our website at www.books.elsevier.com

05 06 07 08 09 10 10 9 8 7 6 5 4 3 2 1

Printed in the United States of America

Working together to grow
libraries in developing countries

www.elsevier.com | www.bookaid.org | www.sabre.org

ELSEVIER BOOK AID
 International Sabre Foundation

Through all the joys, challenges, accomplishments and bumps along the way, my life has been enriched and my career choices always made easier with the unwavering support of my husband, Ron.

He's always here for me—helping me with everything and anything, cheering me on, keeping me humble and constantly reminding me of how much I'm loved.

He's the best . . . and this book is dedicated to him.

And in loving memory of two very dear and very talented friends who are both deeply missed:

Ray Storey (Production Designer and Writer)

&

Keith Wester (Production Sound Mixer)

Contents

7 Starting Out 121

8 Job Search Strategies 141

9 The Resume and Cover Letter 159

Introduction

> "Life is not a having and a getting, but a being and a becoming."
> —Myrna Loy

Do you have any idea how difficult it is to come up with a good book title? Let's just say in the case of this book, it was much more difficult than I ever imagined it would be. The title I'd always wanted to use, but someone beat me to, is *What They Don't Teach You In Film School*. My second choice was *Fade In On Reality*, but I was told it sounded too much like a book on pop psychology or an exposé on reality TV. And besides, it didn't contain any of the right buzz words needed to attract target online searchers and buyers, so it's now a chapter title instead. Stuck at a creative impasse, I asked friends for help. I told them the book is for those thinking of getting into the industry, film students, those about to start their careers and those already in the industry who aren't quite sure how to move their careers forward. I said the gist of it is this: if this is really what you want to do, then you've got to thoroughly understand how the business works (the competition; the politics; your career options; how to get your foot in doors; how to survive the tough times; the importance of attitude, networking; etc.) and have the tools you need to give yourself at least a good fighting chance of making it. And you've got to walk in with your eyes wide open, knowing exactly what to expect. I wanted something catchy that would convey the message that within these pages one could learn how this industry really works and what it takes to succeed. Well, many months, e-mails, calls and committee meetings later, the title was

finally agreed upon. What a process this was! Here are some of the other interesting suggestions I received.

The Industry: Glitz, Glamour or BS?
The Facts About Fantasy Land
An Insiders Guide to Becoming a Hollywood Big Shot
Breaking Into the Business of Show Business
Filmmaking: It's Not a 9 to 5 Job
Total Hollywood
The Show Business Navigator
Hollywood Simplified
Hollywood Means Business
Work'n Hollywood
Insider Secrets: How to Create and Build a Career in the Film
 Industry
Working It in Hollywood: How to Snag and Keep Your Dream Job
How Hollywood Really Works: The Inside Scoop on Breaking In
Film School and Beyond: What You Really Need to Know
Produce Your Own Career in Film
Keep Your Clothes on and Still Have a Career
No One Ever Said It Would Be Easy
It's Who You Know. Plain and Simple
The You-Can't-Learn-That-In-A-Film-Book Film Book

Of all the suggested titles, one of the most fun was *From Lambada to Titanic and Back Underwater—My Adventures in Hollywood*. Although my latest creation doesn't contain stories of adventurous exploits (sorry!), it definitely contains the perspective of my 25+ years in the industry. And while not what you'd consider "juicy" by any stretch of the imagination, I have interwoven some relevant stories throughout, recounting various experiences I've had to back up the advice, viewpoints and realities I'm presenting.

I've definitely had my share of *Lambada*-type projects, working for raging screamers, sleazeballs and gropers, long stretches of unemployment and rapidly diminishing checkbook balances, not knowing if I'd ever get another show, not knowing how I was ever going to survive a few of the productions I worked on, not knowing if I'd

be able to go on yet one more interview, not knowing how to stand up for myself and not having the confidence to think I could ever move beyond a certain level in my career. I wasted a lot of years not having a clear goal, not thoroughly understanding how the business works and not fully realizing what I was capable of achieving.

Although no book or class can totally prepare you for a career in the entertainment industry, this book is my way of passing on some insights, direction and a sense of confidence no one gave me when I started in the business and of offering you the benefit of my many years of practical experience, all learned the hard way and yours for the taking. It's not merely a book about how the industry works and how to get your foot in the right door. It goes beyond that and includes an attitude and philosophy that should make your journey a bit smoother and help you through some rough spots along the way.

As with my first book, *The Complete Film Production Handbook* (Focal Press), I didn't just jump out of bed one morning and announce to the world that I'd decided to write another book. It just evolved. And like the first, it all started to come together when someone said to me, "They don't teach us this stuff in film school."

The evolution actually started in 1998, when my friend Phil Wylly recommended me to The International Film & TV Workshops in Rockport, Maine. They had asked him to teach their 1-week AD/UPM/Line Producer class, which he had done a few months earlier. But he was working on a show at the time and gave them my name instead. I had been thinking of teaching for a while but wasn't sure I could overcome the sheer terror I had of public speaking. I told Phil I couldn't. He said of course I could—after all, hadn't I had written an entire book on production? After quite a bit of coaxing, I decided my desire to teach was stronger than my fear of standing up and talking to a *small* group of students. So off to Maine to I went, and after a slightly nervous first hour with my students, I was fine. I was so fine, the school asked me to come back a few months later.

That same summer, I happened to be at ShowBiz Expo at the Los Angeles Convention Center. Walking by USC's Summer Production Workshop booth, I suddenly had the courage to introduce myself

to the Director, Duke Underwood. I had, after all, just survived the Maine experience incredibly intact and with a desire to do more teaching. We talked for a few moments, and I showed Duke my book and took his card. At that moment, I was just one of the many industry professionals in this town who think they'd like to teach. But I had a connection at USC: Woody Omens, from the university's Cinematography Department, with whom I had previously worked. A good word from Woody and I had my meeting with Duke a couple weeks later. Not only that, but after we talked for a while, Duke offered to give me a class the following summer. I had been thinking about this a great deal, so after gratefully accepting his offer, I told him I didn't want to teach the same type of class I did at the Maine Workshops. I said I'd like to propose an idea for a new course. Always looking for something different, he was all ears.

As an industry professional for many years, my various production offices have been heavily populated by recent film school graduates and interns, as well as young men and women who had never attended film school but had passed "go" to follow their dreams and were able to land entry-level industry jobs. Many had connections, others didn't; but they all started off as production assistants who had just gotten their foot into Door #1. It always surprised me how many of them were unprepared for what they were about to encounter. Learning a craft (or two or three) and making student films is one thing, but a real production office and a real set on a real movie is quite another. Many industry neophytes expect to "make it" within the first 6 months, and few are prepared for how truly tough and how fiercely competitive it is, the freelance lifestyle, the necessity of networking and the fact that they must constantly sell (and prove) themselves over and over and over again. Not everyone understands the concept of "paying dues," who does what in the reel world or what type of attitude will increase their chances of success. As a result, I've witnessed my share of disappointed and disillusioned young people. Reality starts setting in quickly, often when they show up for their first day of work expecting to make movies, and instead, we ask them to make the coffee.

Not only are many industry newcomers uninformed and uneducated as to how this industry really works, but most start out with dreams of becoming producers, directors, actors and/or writers. Occasionally, a few will have other goals, such as becoming a cinematographer, production designer, editor or studio mogul. But most are unaware of the hundreds of other job possibilities within the industry—positions that are often easier to attain than those highest on the ladder—and which could be stepping stones to an ultimate goal or satisfying careers in their own right. There isn't a lot of room at the top, and the competition to get there is brutal. What few of these bright-eyed rookies understand is that considering how many are on the ladder, few make it to the top. Even fewer stay there.

I wanted to teach a class that would properly prepare students for a career in the entertainment industry and give them the upper hand over their competition. I wanted to teach them exactly what to expect: the good, the bad and the ugly. Duke listened intently to everything I had to say and then told me to go home and write a course description. He'd put it in the new catalog, and if people signed up, I was on. I'd have my class the following summer.

My first class consisted of 20 students, and it was a great six weeks for them and for me. By the time it was over, it was clear I was on to something. I have now completed my sixth summer at USC. From the beginning, the resounding response from my students has been, "This is great! No one's ever taught us this stuff before!"

The experience of teaching this class never ceases to amaze and excite me, because what I have to offer is significant, helpful and so very much appreciated. Chris Kachel, a former student, sent me the following to read to last year's class: "Eve's advice is all the more valuable, because it's based on information not many people have. Her class arms you with rare information and a road map that actually does lead you to where you want to go." My students truly do leave the course with an upper hand and a sense of confidence, because they're walking away with industry "secrets" most of their competitors don't have.

Before my first summer at USC was over, I knew what I was teaching was incredibly valuable, and that the material would make

a terrific book. Although the book could never quite provide the personal impact the class has to offer, I knew it was needed. And at the time (in 1998), there were few such books on the market.

I never lost the desire to write the book, but there was always something else to fill up my already busy life. I finally got tired of talking about it, thinking about it, breaking numerous promises to turn in a completed proposal and avoiding a firm commitment. But as you can see, I finally got started. Only now, having taken so long, there are numerous other books competing for the same market. Fortunately, there's always room for one more, if it's good. And like any other topic, you'll find the material overlaps from book to book. It's up to you, though, to find parts of each book that resonate with you, or to find one in particular that will be everything you're looking for. I hope this book will be that for you, and that its essence will stay with you throughout your career, whether you decide to get into this crazy business or choose another.

This business is tough. It's not always fair and I've seen my share of creative, talented individuals who do all the right things and still don't make it. And while I can't promise that you'll reach all your goals, I can offer you the information, the tools, the attitude and the philosophy you'll need to give yourself a good fighting chance at success, in spite of the odds. The rest will depend on your level of passion, your ability to venture outside of your comfort zone, your willingness to play the game, the time and effort you're willing to devote to building your career, and last but not least, a certain amount of pure and simple luck. There are no guarantees in this business, but if you want it badly enough, it's worth the journey.

I've spent a considerable amount of time e-mailing, talking to and corresponding with friends, colleagues and people I respect in this industry to get their opinions on many of the key issues covered within these pages. So in many instances, you're getting the benefit of their advice as well as mine; and collectively, we represent eons of experience. This is a business in which you can never stop learning, and you certainly can never learn enough from the many men and women who have walked before you.

My list of thank yous starts with much appreciation to Gordon Thomas for his suggestion of the *Hollywood Drive* title (I love it!), to

my clever brother Elliot Light for his suggestion of a Hollywood Drive street sign for the book cover, to my multitalented friend Bill Harrold for the fabulous cover design and to pal Wayne Williams for all his help in making it happen. What a team!

Secondly, I'd like to thank my former students for their recognition, passion and, most of all, their successes—proving time and again how significant my class has come to be.

My sincerest thanks to Duke Underwood for giving me the chance to develop my own course, for inspiring me with his love of teaching and dedication to his students, for his guidance, encouragement and friendship—and for thinking that I make great guacamole.

To my friends, co-workers, support system and "network" of contacts; for all I've learned from them, for all the questions answered, the proofreading so willingly done and the suggestions and advice so graciously offered, for letting me tap into their areas of expertise, sharing their opinions and helping me explore the realities of the industry: I'd like to extend my heartfelt gratitude for their inspiration and generous contributions to this book. In alphabetical order, they are: Nick Abdo, Barry Adelman, Stephanie Austin, Jean-Pierre Avice, Robert Bahar, Aubbie Beal, Dustin Bernard, Thea Bernstein, Kristen Brennan, Michael Brooks, Jim Byrnes, Carol Byron, Vicky Cervantes, Harriet Cheng, Michael Coscia, Mary Dalton, Danielle Daly, Bill Dance, Lindsay Devlin, Terry Edinger, Sharon Espinosa, Christine Evey, Bill Ewing, Louis G. Friedman, Peggy Geary, Steve Getzoff, Luisa Gomez de Silva, Janet Graham-Borba, Luke Greenfield, Allen Grossman, Heather Hale, Jenny Hedley, Susan Hirshberg, Anne Hopkins, Brian Seth Hurst, Mark Indig, Mike Jacobs, Jr., Susan James, Jackie Jaye-Brandt, Joseph R. Jennings, Susan Johnston, Jack Kindberg, Wayne Lamkay, Alison Laslett, Shawn Levy, Ron Lynch, Suzanne Lyons, Guy Magar, Travis Mann, Stephen Marinaccio, Andrew Mary, Karon May, Vivian McAteer, Cory McCrum-Abdo, Mark McNair, Doug Menville, Carolyn Miller, Eric Mofford, Missy Moyer, Lloyd Nelson, Phil Nemy, Carole Nix, Jerrold Ofgang, Woody Omens, Mike Papadaki, Jackie Pardue, Victoria Paul, John Pisani, John Poer, Donald Pollok, Cindy Quan, Gig Rackauskas, Morgana Rae, Keith Raskin, Michael Rizzo, Helen Rodger, Jay Roewe, Kate

Robbins, Vail Romeyn, Jonathan Sanger, Barbara Schwartz, Ned Shapiro, Ira Shuman, Jonathan Singer, Phil Smoot, Susan Spohr, Darren Sugar, Susan Sullivan, Jerram Swartz, Patience Thoreson, Steve Tramz, Jonathan Tzachor, Tom Udell, Warren Vanders, Danielle VanLier, Heidi Wall, Richard Wells, Michael J. Werner, Joni Wester, Mark Wolfe, Chris Zambros, Don Zepfel and Matt Zettell.

Extra special thanks to John Dahl, Graham Ludlow, Jeffrey Gund, Mark Hansson, Todd Howard, Dan Gordon, Marc Hernandez, Vivian VanLier, Matt Kutcher, Phil Wylly, Chris Moore and Steve Molen.

To Elinor Actipis, Christine Tridente and the gang at Focal Press, thanks for all your help and patience.

1

Fade In On Reality

> *"I don't take the movies seriously, and anyone who does is in for a headache."*—Bette Davis

There's a Los Angeles radio station I occasionally listen to, and a bumper message they sporadically play says, "Welcome to Hollywood! What's your dream?" It's no secret that scores of people move to this town every day, as they do New York and other entertainment and film centers, to try to break into the "biz," to be discovered, to attend film school, to get an agent, to perform, to sell a script, to be seen, to be the one who discovers talent, to network, to land a great job, to find the right portal that's going to transport them to the fantasy world they've been dreaming of. Some make it; many more don't. Some have dream-come-true experiences and others leave terribly deflated and disappointed. And once in the biz, some will encounter more good experiences than not, and others will find that surviving in this industry is a struggle throughout their entire career.

But whether you're someone who's thinking of getting into the business, a film student or someone who has recently started working in the industry, no matter what you assume it's going to be like, want it to be like, or expect, it's going to be different than anything you've ever imagined—and most likely, much, much tougher! Being in this business, you will no doubt encounter some or all of what

many of us have faced: the challenges, the joy, the politics, the excitement, the rejection, the camaraderie, the struggles, the fun, the frustration, the gratification, the disappointment, the adventure—the entire roller coaster ride of emotions wrapped up into one profession. And yet no one can adequately prepare you for what it's like. No amount of reading or attending classes or seminars will teach you absolutely everything you need to know. Some of it can only be learned through practical experience and by sheer osmosis. More importantly, I can't tell you exactly what it's going to be like for you, because the experience isn't quite the same for any two people. Having stated that, I can provide you with a thoroughly realistic understanding as to how the industry works and what it generally takes to become a contributing member of this realm. Because only when you fully comprehend what it's truly like will you be equipped to make the best decisions and choose the career path that's right for you—whether it's in this business or not.

Having What It Takes

To succeed in this business, being smart, talented, creative and/or skilled in a particular craft (or two, or three) is not enough. You have to be special, to stand out, to be willing to sell yourself over and over again, to have the right attitude, temperament and personality; to be willing to play the game and relentlessly do what it takes—not only to succeed, but to simply hang in there and survive.

Wanting "it" badly enough, truly believing it's going to happen, imagining yourself in the job of your dreams and counting on the power of positive thinking will help, but it's not nearly enough to get you there. You'll need to develop a thick skin, some major chutzpah and be ready to kick major butt. Only the most motivated, determined, assertive, ambitious, ballsy and tenacious need apply. You'll want to develop strong industry relationships, know how the business works, know how to get your foot in doors and how to get your name out there. You can't be lazy or complacent and you must daringly venture far from the security of your comfort zone. You have to possess an abundance of passion, drive, enthusiasm, perseverance, patience, energy and confidence. You

have to want it so badly, you can taste it. You have to love this business soooooo much, you can't for one nanosecond imagine yourself doing anything else.

Reality Stings

Yes, many do become successful, famous and wealthy, but it's crowded at the top of that ladder. There's no guarantee you'll reach the top of that much sought-after pinnacle, and if you do, that you'll be able to stay there. And lest you think once you're working in this industry, you'll have a clear shot to easy street— think again. It's not always so easy!

Yes, you can make some good money in this business, but for the majority of freelancers who don't work all the time, that good money will sometimes have to last for quite some time. I bet this will surprise you: of the 118,000 members of the Screen Actors Guild, only 2% earn $200,000 or more per year; at any one time, 80% are not working (under a SAG contract); and 80–85% don't earn enough to qualify for the Guild's health and pension benefits, which require earnings of at least $11,000 per year.

The competition is brutal, and the demand for jobs has never been greater. For every opening, the line of people vying for that position is out the door and down the block (and sometimes, around the corner). Having recently spoken to representatives of two temporary employment agencies, each associated with a different major studio, both report on average that, of the approximately 45 to 50 resumes they receive each week, only one individual is placed into the studio's temp pool.

More colleges and universities throughout the country are offering industry-related studies than ever before, and 30,000–40,000 individuals are graduating each year with associate, bachelor, master and doctorate degrees in Broadcast Journalism; Radio and Television Broadcasting; Radio and Television Technology; Dramatic/Theatre Arts and Stagecraft; Film, Video and Photographic Arts; Communications, Communications Technologies and Visual and Performing Arts. Legions of these newly trained and educated, as well as individuals who have never been to film school but have always

dreamed of getting into the industry, flood into film centers (primarily Los Angeles) every day. Linda Buzzell, author of *How To Make It in Hollywood* (HarperPerennial) confers by stating: "The entertainment industry is now more ruthlessly competitive than ever. The world's best and brightest in every job category—performers, directors, executives, technicians—are flooding into Hollywood in ever-increasing numbers."

At the same time, we're losing U.S.-based film jobs to other countries in alarming numbers; funding from the major motion picture studios is not as fluid as it once was; with the current popularity of Reality TV, the networks are producing less-expensive television shows with smaller crews; and there are fewer jobs to go around than ever before. What hurts the most is that even well-established, talented individuals who have been in the industry for years are having trouble staying employed.

The past several years, the issue of runaway production has been of major concern to our industry. This phenomena is defined as U.S.-developed feature films, movies for television, TV shows or series that are filmed in other countries for economic reasons. In addition to favorable exchange rates (which obviously tend to vary), several other countries offer attractive tax incentives and labor rebates, seducing U.S. productions by the budget reductions they offer. For several years, our country's shows were primarily running away to Canada, but currently, Prague, Australia, Romania and Mexico have also become prime shooting locations, creating a noticeable decline in Canadian production levels as well as our own.

In the June 10, 2004 issue of *Production Weekly* (a subscription-based listing of all upcoming film and television projects), of the 52 feature films listed, almost 50% were slated to be shot in foreign countries. And of the 110 movies for all forms of television and miniseries filmed under a Directors Guild contract in 2003, 55 were reported to have been shot in Canada, five in Australia or New Zealand, four in Europe, one in Mexico and four in South Africa. That's approximately 62% being shot outside the U.S.

A few years ago, the Screen Actors Guild and the Directors Guild of America jointly issued a report showing that the total economic

impact as a result of U.S. economic runaway film and television production was $10.3 billion in 1998, up more than fivefold since the beginning of the decade. The report also estimated that runaway production cost U.S. entertainment industry workers more than 60,000 full-time equivalent positions from 1996 to 1999. The U.S. Bureau of Labor Statistics claims that, in 2001, between 22,500 and 36,000 jobs were lost. Jack Kyser, chief economist for The Los Angeles Economic Development Corporation, found a loss of 32,400 show business jobs in the L.A. area alone between 1999's peak employment figure of 146,000 and the final 2003 figure of 113,600.

In addition to runaway production, every few years we collectively hold our breath waiting to see if the Writers Guild of America, Directors Guild of America and the Screen Actors Guild will be going out on strike. Should the membership of any one of these guilds vote to strike, thousands are thrown out of work for months on end and untold numbers of auxiliary businesses are adversely affected.

Suffice to say, the demand for entertainment jobs far outweighs the supply.

It sounds scary, doesn't it? Well, you should be scared. Knowing what you're in for is the only way you're going to be able to decide if you have what it takes to even give it a good try. And if this is to become your chosen field, you'll want to walk into it with your eyes wide open, armed with the tools you'll need to give yourself a good, fighting chance.

Attend Film School or Jump Right In?

This is a question I'm often asked, and there is no right or wrong answer. I never attended film school but can see the advantages gained by those who have. Can you make it big without film school? Absolutely. Can you go to film school and then not succeed in the biz? Absolutely. This is a very personal choice.

Film school can be quite costly, but it provides a broad, well-rounded understanding of the industry, as it focuses on film history and theory as well as the teaching of many different skills and

evolving technologies. Students generally walk away from school having learned at least a modicum of writing, producing, directing, acting, editing, cinematography, set design and so forth. It's where you learn the ropes, learn about the equipment and make your own film. And making your own films while in school is great training. Many a student project has won acclaim at international film festivals or other competitions, some managing to attract the attention of studio bigwigs and agents. In addition to or instead of a film, students also often walk away from school with a terrific script (or two)—another formidable calling card with which to start their careers.

Networking is another advantage to film school, because after graduation, individuals in a position to do so may help, recommend or hire their former classmates whenever possible. Many colleges and universities also offer outstanding internship programs and job placement services. And on-going support frequently comes in the form of extremely active and helpful alumni associations.

Today, in addition to entertainment attorneys, many top industry professionals hold law degrees, as opportunities do increase for those film/tv/communications majors who opt for even further education.

On the other hand, while a film school education generally proves beneficial to those who want to write, produce and direct, it may not be as practical for someone whose career goal is to become a transportation coordinator, a special effects coordinator or a location manager. An advanced education may not be as necessary for someone wanting to be a casting director, script supervisor, production coordinator, stunt coordinator or key grip as it is to someone wishing to be an editor, cinematographer or production designer.

If you're still in the "contemplating" stage, consider going to one of the fine schools in Los Angeles or New York—at least for a semester or two. I have nothing against the wonderful schools everywhere, but if you're serious about wanting to be in this business, you'll get so much more bang for your buck learning your trade in a city that has a large show biz community. You can take

advantage of the many networking organizations, seminars, trade shows and other industry-related events L.A. and New York have to offer. Through your school, you'll have access to internships with major studios and production companies, which will be advantageous to have on your resume when entering the job market. You'll be exposed to the business and meeting people who work in the business, so you can start building a solid network for yourself before you ever graduate. It's definitely something to consider.

A film degree will provide you with a tremendous learning experience, and while it may enable you to make better connections, understand more or move up faster, it's no guarantee. You may be oozing with talent, proficient in any number of skills and the creator of a number of brilliant student films, but without the free equipment, free help and built-in support system, the reel world might just as well be located on another planet. And as much as you think you know, there's still a level of expertise that can only be attained by way of practical experience. So unless your first job is that of making your own movie, you've landed a great first position by way of nepotism or a law degree has earned you a junior executive slot—plan to start at the bottom and pay your dues. Check your ego in at the door and expect to be treated as any other entry-level employee—whether you're a film school graduate or not.

As advantageous as a film school education can be, I've seen individuals graduate with such a keen sense of entitlement, or such unrealistic expectations or ego-driven attitudes, they often crash and burn without ever reaching their destination. I've witnessed other film school grads who are incredibly talented but fail to establish themselves because of their deficiency in networking and/or political skills.

Then there are those who, like me, never attended film school. I landed in the business by accident, and once there, never wanted to leave. Some don't attend because they can't afford to and still others are too anxious to wait a moment longer than necessary to jump right in and learn as they go. While a part of me has always missed not having had the more well-rounded education and in-depth exposure to aspects of the industry beyond my area of

expertise, there have always been opportunities to continue learning. Extension and short-term evening courses, seminars and books are plentiful to anyone wishing to take advantage of them. For those of us in production especially, vendors such as Panavision and Technicolor offer seminars and tours of their facilities, while smaller vendors, upon request, are generally quite amenable to educating both customers and potential customers about their equipment and services on a more one-on-one basis. I've also learned a lot just by asking co-workers to explain how they've achieved or are planning to achieve a certain shot, a design, a mood, a sequence, an effect, a look or a scene.

My best education has always been in the doing. Having worked on *Titanic* and *In Dreams*, I learned many of the ins and outs of shooting in Baja, Mexico, and had a crash course in international shipping. Working on *Titanic, In Dreams* and *The Thirteenth Year*, I learned much about filming in water. On *Florida Straits*, my knowledge of post production increased. On *Hot Dog, The Movie*, I perfected the skill of thinking on my feet, and my job at Orion was a good lesson in politics. Whether it's been working on a show that involves a railroad line, a circus, a racetrack, an athletic team or daredevil stunts—each job, each show is an opportunity to continue learning.

Making Coffee Instead of Movies

One of the biggest misconceptions people have upon graduating film school or just deciding to get into the entertainment field is that because they are bright, talented and creative and may know how to stage a scene, load a camera or edit a montage, they should be able to land a job as a producer, director, cinematographer, editor, production designer or some other notable position, and that it shouldn't take longer than six months to a year to achieve this worthy goal. It happens that way occasionally, but rarely. No matter how incredibly talented you are and how many student films you've made, you'll most likely have to start at an entry-level position and work your way up—a process that may take longer than you anticipate. Your entry-level position will most likely be that of

someone's assistant or apprentice, a receptionist, a production assistant (PA) or a mailroom clerk. And as menial as the job may appear or feel or be, think of it as the first step toward where you want to go–a means to an end. It's fairly obvious that most entry-level employees are way, way, overqualified for washing coffee cups, pushing mail carts, making deliveries and photocopying scripts; and while you might find this work ego-deflating, remember that many of the most successful people in this business have started this way, having learned from the bottom up.

I've seen my share of PAs who start their first show by walking in with such an overblown opinion of themselves and their talent, they're offended when asked to file or make coffee. A very well-established producer I know told me when interviewing candidates for an office staff job recently, a young man made a specific point of telling him he didn't make coffee. The producer told the candidate if he himself could make coffee when necessary, his entire staff would be expected to do so as well. He told the young man if he wasn't willing to pitch in and do *whatever* it took to keep the production office running smoothly, he wouldn't be considered for the job.

It's not a question of having abilities that surpass that of making coffee, it's all about paying your dues. Too few people grasp the concept of paying dues; and what's worse, they're rarely told they have to. Walking in unprepared and being faced with an indefinite future filled with menial tasks, some people become so totally disillusioned or adopt such a resentful attitude, they sometimes quit or are let go before they wake up and get it. And some are just never asked back. They think because they've been to film school, because they're brimming with creative vision and energy, because they're bright and ready to play with the big boys, they should be exempt from tedious daily duties, such as filing, answering phones, delivering scripts, picking up lunches, keeping the office stocked with supplies or standing by a stage door for hours on end to make sure no one enters. Some think they're entitled to publicly criticize others, ask to leave early, make lengthy personal phone calls or whine about something they'd rather not do. Wrong!

It's also not uncommon to see individuals move to Los Angeles or New York with a conviction that they're going to be "discovered," some so sure, they rarely make an earnest effort to learn about the business, perfect their craft or do their homework. And then there are those who find someone interested in their ability, talent or script, and their sense of importance becomes so overinflated so rapidly, they frequently deal themselves out of the hand before the game has even begun. These situations usually lead to profound disappointment, embarrassment and the conviction that it was someone else's fault.

I see these mistakes being made all the time, but on a more personal level, I didn't fully comprehend the concept of paying dues when I started either. Luckily, it was explained to me before it was too late. While working at my second industry job, I found myself exasperated and complaining to a co-worker. I was spending a great deal of time every day running personal errands for my boss—getting her coffee, getting her lunch, going to the bank for her, etc., etc., etc. I was bright, had some previous experience and felt that these tasks were a tremendous waste of my time and abilities. My friend just looked at me and asked, "Are you ready to make the big decisions and negotiate the deals?" I had to admit I wasn't, to which he replied, "There are only two of you working in that office. If one of you has to make the deals and one of you has to get the coffee, and you're not ready to make the deals yet–where does that leave you?" Bingo! He actually made a lot of sense. It was such a basic premise, yet I had been so caught-up in resenting all the errands I was being sent on, I hadn't been able to figure it out on my own. (So much for being bright!) Until I was ready, I would have to be the one to get the coffee.

The trick is to be the very best PA, runner, receptionist, apprentice or assistant that ever existed. Short of being totally abused or exploited, don't whine or groan when asked to do something you don't want to do. Accept tasks willingly. No one is asking you to do anything just to make your life miserable. If it has to be done and falls within your sphere of responsibility, you don't have much choice. You're there as *support* staff, and your job is to provide the support, whatever that entails. Don't complain. Everyone is busy,

and no one wants to hear it. Be a pleasure to have around; be a team player; and if you have any extra time, volunteer to help others with their work. Everyone will agree that you're wonderful, and they'll all want you to work on their next picture or will want to take you with them to their next job. And in time, your talent and abilities will be recognized, and you'll have the opportunity to move up.

You'll never stand out, or truly "make it," unless you're willing to put in the extra effort, to keep learning, to perfect your craft and to keep your ego in check (at least at the beginning of your career; and hopefully, always). You can't assume anything, much less that you'll be instantly discovered. If you are—great! What a nice surprise that'll be. But those opportunities come along rarely.

If you can only remember one thing when starting *any* new position, it's this: *if you don't shine on the job you're on, it's doubtful you'll be recommended, asked back or anyone on your current job or show will want to take you with them on their next job or show.*

On the film *Joy Ride*, we had a production assistant named Jonas. It was only his second film, but he was one of the best PAs I'd ever worked with. When you'd ask Jonas to do something, no matter what it was, he'd always smile and say, "I'd love to do that for you!" to which I'd always laugh, because I'd rarely ask him to do anything worthy of such a response. But he never felt that anything was beneath him, and what he did love was just being there. He came in early and stayed much later than expected and was always there to pitch in and help everyone.

I had hired one of my ex-students, Tiffany, to work on the same movie. Tiff also had a great attitude, worked hard, got along with everyone and was eager to help, no matter the task (she'd make jokes as she walked around the office emptying trash cans each evening). She had the greatest personality and was able to make us all laugh. You could easily see how bright she was, and when the show was over, our location manager was able to get her onto his next film as an apprentice. Within two years, Tiffany was in the union as an assistant location manager.

Susan was recommended to me on a cable movie called *The Thirteenth Year*, and what a lucky day that was for me. Not only

was she willing to do anything that needed doing and not only did she have a great attitude, but she was always one step ahead, anticipating my needs as well as those of the entire production office and volunteering to handle certain tasks before the request could even leave my lips. I took Susan on my next show with me and then again whenever I could. We became friends, and I've continued to admire her eagerness to learn, knowledge of the industry and remarkable networking skills. Her career has taken off in a wonderful new direction, and as I would expect, she's doing extremely well.

Of the thousands just starting out in the industry each year, individuals like Jonas, Tiffany and Susan are rare. And it's those who are exceptional (like them) who will always be in demand and move up the fastest. So unless you're willing to anticipate the needs of others, make the coffee, empty the trash, answer the phone and do whatever else is needed—without resentment, without complaint and with a smile on your face—you may not get asked to work on anyone's next show or be recommended for any other job. And remember—sometimes all it takes is one person who thinks you're terrific to ignite your career and set it in motion.

Every job you'll ever have, from the very bottom on up, is an opportunity to learn, cultivate skills and relationships and soak up valuable information from everyone around you. Each new experience will become part of your continuing education, and how well you do once you're *in* will more often than not depend on the effort you've been willing to invest in your future.

Be prepared to pay your dues—to start at the bottom and work your way up. Give yourself time to learn, to learn *how* to learn more, to network and to gain experience. This priceless on-the-job training will make you better at whatever it is you ultimately end up doing.

> *"My philosophy is that not only are you responsible for your life, but doing the best at this moment puts you in the best place for the next moment."*— Oprah Winfrey

Hollywood Means Business—Know Why You're Here

For most of us, getting into this industry is a dream come true. If you can establish yourself and can make a decent living at it, consider yourself lucky to be working at what you love. But not everyone makes it, and you have to know when it's not right for you, in spite of your dreams. Honestly ask yourself:

- Can I handle the instability?
- Can I handle the politics?
- Am I up for the constant networking?
- Is my skin thick enough?
- Can I live this lifestyle?
- Do I have the endurance to work extremely long hours (while under constant pressure)?
- Can I deal with other people's tempers and egos?
- Do I mind giving up time with family and friends?
- Can I handle extremes?
- Can I handle the waiting and not knowing what's to come next?
- Am I willing to play the game?
- Am I willing to boldly venture outside of my comfort zone?
- Am I up for this roller coaster ride?

Several years ago, I heard that one of the major studios had an opening for a production executive, and I wanted to apply. A friend who had worked there for quite some time, however, flat out told me not to. She said I wouldn't be happy there, the politics were vicious and she didn't think I had the temperament to survive that environment. Her exact words were, "they'll chew you up and spit you out." At the time, I wasn't quite sure what that said about me, but since my friend was fairly intuitive, I took her advice and didn't apply for the job. It took me some time, however, to appreciate her wisdom, and she wasn't the last to suggest I might not be "shark-like" enough to swim in this ocean.

Not all studios, production companies or agencies, however, foster that type of environment (although many do), so it became a

question of finding the right fit for myself—knowing which companies I wanted to work for and which people I wanted to work with.

There is such a large variety of entertainment-related jobs out there, and they all require different types of personalities, temperaments and thresholds from their employees. So not only do you have to decide if this industry is right for you, it's also a question of finding the right fit within the industry. Each situation, company, job and show is different; and obviously, I've been able to find people to work for that don't treat office politics as an Olympic sport. Once you have a good sense of yourself, what you have to offer, where your boundaries lie and what you're capable of, you're well on your way to establishing a career for yourself.

Having a good sense of yourself is a great start, but know, going in, why you're choosing to accept any one particular job. Whether you're making a lot of money or working for free, working at a dream job or starting in a mailroom, working with a great team of people or for a screamer, working reasonable hours or 18 hours a day, being appreciated or working for people who don't know you exist—it doesn't matter, as long as you're getting *something* from each and every job you take. It could be the experience, the fact that you'll move one step closer to your goal, the chance to move into a better position, the opportunity to learn, the screen credit, the opportunity to build your resume, the chance to make valuable contacts, the money, the prospect of working with a certain actor or traveling to a particular location, the opportunity to work with a producer or director you admire, the pride of working on a meaningful project or just for the fun of it. It could be for more than one reason, but understand why you're there and what the payoff will be for you.

I once worked on a project that, up front, seemed fairly straightforward. It was a low-budget ski movie that was shot in Squaw Valley, on the north shore of Lake Tahoe. Our luck, it just happened to be the worst winter that area had seen in over 100 years. There were blizzards and white-outs, and the weather changed so often, we couldn't stick to our schedule for more than a half-day at a time. We were supposed to have two units shooting concurrently, but every day it was hit or miss with the weather and our schedule.

On more than one occasion, our crew became stranded out in storms and white-outs. Our office trailer was parked next to and tied-in electrically to the local ice arena (where we stored much of our gear), and one day, the roof of the arena collapsed from the weight of the snow. The trailer shook as if we were having an earthquake, so we grabbed up a few essentials and evacuated the area for a few days, quickly establishing a new office in one of our rented condos (without most of our gear and paperwork). Then early one morning, while blasts were being set off in an effort to avoid avalanches, a piece of shrapnel flew through our trailer, barely missing the face of one of our staff members. The night before we started shooting, our leading lady became ill and couldn't work the next day. The snow was so high one morning, some of us couldn't get out of our front doors. We were almost evicted from the hotel, because one of the actors brought a dog that created havoc. The topper was a beautiful private home where we shot for three nights. It took all the charm the location manager could muster to convince the reluctant owner to let us shoot there. When she finally agreed, he promised that we'd take extra safety precautions. We even bought brand new white socks for everyone on the crew to wear, so they could take off their shoes when they got there. We covered everything not being used with special tarps and laid floor-board out wherever possible. Unfortunately, there was a short in the equipment one night and sparks started flying. Our sparks burned holes in imported rugs and custom-made cabinets; and all in all, we created about $40,000-worth of damage to our horrified homeowner's pride and joy.

While we seemed to experience at least one catastrophe a day, we managed to keep shooting. But every night, I'd drag myself back to my room after working progressively longer days, getting less sleep and having to solve more problems. One night in particular, while in a very sleep-deprived state of mind (feeling as if the weight of the world rested on my shoulders), I questioned why I was doing this to myself. Was it for the money? I wasn't making much at all. Was it for the privilege of working on this particular movie? No. Was it for the appreciation and the accolades I was receiving for my part in helping to keep everything running in

light of our sequential run of disasters? No. There was no time for that. The entire production team was so concerned about getting the picture finished, we were all pretty much in the same boat, and everyone was tense and tired. After some agonizing thought, though, I finally decided I was doing it for myself, to prove that I could. I realized that in spite of my extreme weariness, this was something I was good at. My revelation included the fact that I no longer had to sell myself short or doubt my abilities. And since that show, I've always had to have at least one good reason for taking any show.

It's a toss-up as to which was a more difficult show for me—that small ski movie or *Titanic*. *Titanic* was difficult for an entirely different list of reasons, the least of which were the excruciatingly long hours, the political atmosphere of the production, the extreme personalities I worked with and the overwhelming demands of the show. While working on it, I hoped for months on end that someone else would call to offer me another job so I could quit, but it never happened. It was a time when I needed the good paycheck I was earning every week—every week for 15 months. I stayed on the film because of the money. It was as simple as that. But as it turned out, I'm very glad I did, and many good things have since come from it.

Just as you should understand why you're taking any particular job, you should have a broader understanding of why you've chosen this business to begin with. You know (or should have gathered from this chapter alone) how difficult it can be. And no one wants to work that hard at succeeding; work that hard at any job; have to deal with job instability, rejection, constant challenges and difficult people unless they have a very good reason. What's your reason? Do you truly love this business? Do you find it exciting? Is it the potential for money and fame? Has this been your life-long dream? Is this the form of artistic expression you've chosen for yourself? Do you thrive on constantly changing work environments? You're the only one who can answer the question as to why you've chosen this profession, and it doesn't matter why, as long as you know and understand the answer. Throughout your entire career, people will ask you why you decided to get into this crazy business; and it's the

passion and conviction of your answer that's going to keep you motivated and help you succeed. Success often comes to those merely because they never give up on their dreams and goals. And constantly reminding yourself of why you're in this business could very well carry you the distance. See Chapter 19 for more on how to remember why you got into this business to begin with.

Do you have what it takes? Do you thoroughly understand the obstacles? Are you fully prepared to pay your dues? Do you know why you've chosen this line of work? If so, then follow your dream, and give it your all.

"Don't give up. Don't lose hope. Don't sell out."—Christopher Reeve

— 2 —

The Good, the Bad and the Ugly

> *"Flops are part of life's menu, and I've never been a girl to miss out on any of the courses."*—Rosalind Russell

When someone outside the business asks me what I do and I reply that I work in the film industry, the comments range from "That must be fun!" to "How exciting!" to "That must be sooooo interesting!" to "Which movie stars have you met?" And there's no doubt that these are some of the same thoughts that prompted many of us to get into the business to begin with. At 19, when I was asked if I wanted to work at a television station, I thought to myself, *"Of course I want to, who wouldn't want to work at a television station?!"* All we can think of when we're starting out in this industry is how lucky we are, because who wouldn't jump through hoops to land the same opportunity? At the time, however, no one tells us how difficult it's going to be. And even if they did, we'd be hard pressed to let their warnings dissuade us, because after all, who wouldn't want to work in this business?

There are good reasons indeed to want to work in this business, as well as reasons not to. This chapter is going to explore both the pros and cons, from my point of view, as well as the views of other working professionals. I've decided not to reveal the names of those who have offered opinions, because I don't want their names and/or titles to influence your take on their comments. Suffice to

say they are individuals who work in all aspects of the industry at every career level, from top studio executives, to producers, directors and writers, to actors, agents and managers, to laboratory executives, distributors, production office staff and crew members from various departments.

Since opinions can only be arrived at based on our own personal experiences, you'll see that some views will differ, yet a common thread runs through many of them. Whether or not you're already working in this business, these lists will give you much to think about.

The Good News First

- This business is a world unto itself filled with talented, creative, smart, fascinating, passionate, inspiring people, ideas and projects. There's no pill you can take or elixir you can drink that can create the feeling of exhilaration that comes with becoming an accepted and contributing member of this universe.

- On the very first job I had, I immediately noticed that film and TV crews are a close-knit group. It didn't seem to matter what you did nor what your race, religion, sexual orientation or personal style was—everyone was accepted into this pseudo-family unit. It was pretty cool. I had never been in such a nonjudgmental, classless environment before. And now, after years of having worked in many other industry environments, I can't say they've all been quite as harmonious, but many are, and it's still cool.

- Making a movie or TV show can be exciting. There is something uniquely magical about finding the right script, making the deals and putting all the people, locations, sets, equipment and details together and watching a show come together. Whether your contribution is creative or more in the form of logistics and problem-solving, you're part of an enormous undertaking; and it's gratifying to know your efforts helped to make it happen.

- Each show or project is the beginning of a new adventure that brings with it new challenges, new experiences and new skills.

- If you're a people person, this is the ultimate people business.

- Each show or project will give you access to new contacts, new friends and future opportunities.
- Your work will rarely be boring, and you'll never be able to complain about it being the same day-in, day-out routine.
- You'll have opportunities to travel and work with people from all over the country, and often, all over the world.
- If you become a member of a union or guild, you'll be eligible for excellent health and pension benefits.
- If you work on a fairly regular basis, once you move beyond entry-level status, you should make a good (if not very comfortable) salary.
- If you're a team player, there's no better team to be on than a film crew.

Pros From the Pros

"The most expensive habit in the world is celluloid, not heroin, and I need a fix every few years."—Steven Spielberg

The following are the answers I received to the question, *To you, what is the best thing about working in this business?*

- "It's the same feeling I think I'd get from being a novelist or painter. It's the thrill of creating something that will affect someone's mind or make them smile. It's also the camaraderie and the good feelings you get working closely with other people."
- "Getting to be creative every day and working among creative, enthusiastic, artistic people. Getting paid to work in a collaborative environment in an effort to do a simple thing as well as possible: tell stories."
- "The freedom to pick and choose which projects to work on, to work with a group of talented people all for the purpose of completing a quality project, celebrating the project's completion and then beginning the process all over again, usually with a whole new group of people."

- "Starting with a blank piece of paper, which evolves into a script, which evolves into a film for all to watch on a screen. I also love the fact that I don't have to wear a tie!"
- "The variety of experiences. Each show brings new places, new things you must learn about (like camels, or prison life, or vintage airplanes, or the way people dressed in 1890, etc.). And you might work in places you would never normally even visit (on mountain tops at midnight, in blizzards, out in the open sea, underwater, etc.). You meet and deal with fascinating local people all over the world as well as with very clever crew members who have different outlooks and ways of doing things. Each project allows you to totally immerse yourself in a new world for several months, and there is a great deal of satisfaction when you have successfully completed a project you can be proud of."
- "The best is meeting new people on new projects, having old friends from past projects, seeing your name in the credits, overcoming the challenges of the job and turning the real world into a movie studio."
- "The best is the travel. I've been to places I would never have gone on my own: six months in Yugoslavia (when it was Yugoslavia); Santa Fe, New Mexico; the back roads of Montana; Georgia; two cruises in the Caribbean; New York City; Hawaii; and yes, even the cornfields of Iowa . . . just to mention a few."
- "The fun of creating something and seeing it on the screen. Being able to hire people and watch them live their dreams. Knowing that your final product, the movie, allows people to escape into another world even for a short time. To possibly impact people's lives by making them laugh, cry, be inspired, touched or informed."
- "This business is Disneyland with danger."
- "Art is joy . . . and it's the creativity, camaraderie, amplified emotions and being able to get in touch with my feelings that keeps me energized."
- "The variety . . . no two days are the same."
- "The best is the cast and crews we work with. Working intensely on a short-term basis can foster a real lovefest. The work is ardu-

ous and requires a real team effort for all to accomplish. Without the team and the team effort, life would be miserable."

- "Problem-solving. I enjoy all the details that go into filmmaking and figuring out interesting ways to complete each task."
- "It's heritage. Pretty much the same impossible miraculous thing for 100 years, born in theatre, mutated through American ingenuity into *the* standard worldwide for entertainment."
- "The union's insurance and pension plans, always working at different locations and the fact that every day is different."
- "Meeting like-minded creative people whose talents and enthusiasm inspire me to be the best I can be and allow me to constantly stretch and grow."
- "Each show gives me the opportunity to improvise, adapt and overcome."
- "To get to be a part of creating something that influences how people think and feel—possibly for a long time to come. I think the influence that film has on us as a culture is enormous. Also, I just plain love the movies, so getting to be part of making movies is the biggest kick in the world."
- "The crazy pace and opportunity for *anything* to come up has made me a tremendously resourceful and confident person. I have the belief that nothing that comes my way is too much to handle or beyond my abilities—I can fix it, find it, hire it, book it, fly it and get it no matter what it is or how crazy it may seem. The best thing is the me I am when I am operating at the top of my game."

Who wouldn't want to be part of a world as diverse, creative and exciting as just described above? On the other hand, the following list may curb your enthusiasm.

The Less Glamorous Aspects

- Networking, schmoozing, selling yourself and lining up future jobs is a full-time job in itself that *never* ends. (You have to keep it up even when working.) It's hard work, time-consuming, expensive (lunches, event fees, gifts, cards, etc.) and—often–discouraging.

If you think you can get by on your talent alone or that you shouldn't *have* to dance the dance—you're going to have a hard go of it.

- When you're on a show, you'll be working such long hours and will be away from home so much, your personal life will be close to nonexistent. You may not see friends and family members for months on end. This is tough on relationships.

- If shortly after finishing one show, you don't have another lined up right away, you may feel that you'll never work again. One of the nameless individuals who was asked to review the original presentation for this book suggested that I add a description of what he calls *post-shoot depression*. He wrote, "You get a job, whether it's your first or forty-first, and you work hard on that shoot. You think everyone is pleased with your performance. The shoot completes and . . . nothing. No job offers waiting for you. None of your contacts have work for you. Production offices don't return your calls. Or worst of all—the production company begins a new film, and you find out they've rehired half of the last crew—but not you. You'd been working 14-hour days on the shoot and suddenly you have nothing to do. You can do everything right, network extensively and still sit for periods without work. It's depressing. It's hard. But you have to live through it if you want to make it." He suggested including this in a chapter called *You're Not Alone*. Instead, I call it *The No-one's-Ever-Going-To-Hire-Me-Again Syndrome*, and it can be found in Chapter 17 under *Show Biz Survival Techniques*.

- You may never know from one year to the next how much money you're going to be making and what you'll be able to afford. So when you're working, you'll need to budget your finances, so there will be money to live on when you're not working.

- Not knowing when you'll be landing your next show, you may have trouble scheduling vacations in advance (thus not being able to take advantage of cheaper air fares).

- If you're not a member of a union or guild and you don't have a staff position with one company, you won't have health insurance nor be eligible for a pension.

- You're also likely to come across those producers and executives who constantly change their minds with no thought as to the hoops others have to jump through to restructure deals and reschedule locations, sets, permits, crew, equipment, vehicles, effects, catering and travel arrangements.
- Working with talent who come with large entourages, substantial perk lists, demands that keep on coming and snits that ensue when other cast members have trailers an inch longer or wider than theirs can often test the patience of a saint.
- People outside of the industry may find it difficult to understand why you can't hold down a steady job. When you don't work for one employer, applying for things such as home loans can get complicated.
- You need to be thick-skinned, able to repel rejection and not take disappointments personally.

Cons From the Pros

> "Ever since they found out that Lassie was a boy, the public has believed the worst about Hollywood."—Groucho Marx

The following are the answers I received to the question, *To you, what is the worst thing about working in this business?*

- "The insecurity of not knowing what tomorrow will bring. You can have a tremendous success one day, but then worry about what's next—when you'll be able to practice your craft again."
- "The politics. Because art is so intangible, this industry becomes fertile ground for untalented people, egotism, selfishness and backstabbing. It's the most disheartening and frustrating part of the business."
- "This is a business of such ups and downs—when you're down, you feel as if you've fallen off the earth!"
- "Finding your next job."

- "The competitiveness, rejection, instability, feast or famine factor and feeling as if you're riding on a razor blade."
- "The number of hoops and obstacles (i.e., money, politics, etc.) that stand between your initial intention/vision and its final execution. The need for vigilance is huge."
- "It's difficult to have a 'normal' life, especially to keep a family life. Long absences from spouse, children, family and friends are very common, and the 'location lifestyle' is dangerous for marriages and sobriety. Even in town, the long hours and total immersion in work can destroy families or at least make parenting very difficult."
- "Network interference—the lack of creative freedom afforded writers, producers and directors."
- "How *truly* hard it is to get a film made, and the fact that many well-written screenplays never see the light of day."
- "Dealing with people who forget to leave their egos at the door. People get very attached and emotional. Life is too short. It's a movie for God's sake—not life or death. We're providing fun and entertainment and sometimes forget to have fun in the process."
- "The brutal hours we're expected to work is the absolute worst followed by insane screaming directors and penny-pinching producers."
- "It's the 24/7 responsibilities that have to be carried through regardless of circumstances, language and cultural barriers . . . the bureaucracy."
- "Dealing with *big* egos . . . not just from the executives, but also from their assistants."
- "The politics and the B.S. If I had wanted to go into politics, I would live in D.C.!"
- "Dealing with unreasonable people who can't make up their minds and act like spoiled children."
- "Rejection. If you aren't good at accepting rejection, this business is not for you."
- "Age discrimination. We all face times when no one seems to want us, and that's tough. Even if I had all the money I could ever need, not working would still be awful because it means I'm not doing what I love to do."

- "The lack of vision or concern for more substantial entertainment programming."
- "How my life is not under my own control. It's subject to the whims of unions, politics, silly actors . . . oh yes, and did I mention the hours?"
- "Nepotism. You're not always competing based on skills. Also, the plethora of producers and executives who don't understand how a production really works, only how to put the financing together."
- "The worn down feeling you get when you've been under constant stress and the immediate urgency of *everything*!"
- "Runaway production—the lack of work for the workers who make the films and series."
- "The worst is the fact that when I turned 50, nobody wanted to hire me anymore. Doctors practice into their 70s, lawyers even longer. Some of our statesmen are nearing 100. What's wrong here?"
- "I don't like the short fuse some people have, because as it is, we're always dealing with stress and pressure."
- "The business is very cliquish—like in high school, and sometimes I actually feel that I'm dealing with people on the emotional level of a high schooler."
- "Dealing with people who lie to you: 'Yes, I've got the money,' 'Yes, the actor can read it' (when the actor's never even seen it), etc."
- "The delays—how long everything takes."
- "The amount of energy spent versus the payback. If you're looking for some external (praise, raise, respect) as a result of the time you put in, then you're in for some sad times.
- "Learning the ropes of who is who, who does what and who is related to who is tough and rough. Once you learn it, it doesn't get easier, but at least you know where the mines are and how to step around them."
- "The worst aspect is working on a project and having non-creative people (you can read that as 'executives' who think they're creative geniuses) demanding changes that go completely against the continuity of the project. Many times they want to

make changes only so they can stroke their own egos. The battles and fights are worth it if the project survives and stays true to the creative vision; but sometimes, decisions are made that make you want to remove your name from the credits."

It's interesting that four different people I surveyed had the same answers to both questions. They each said that the best *and* worst part of being in this business is *the people!*

You'll note that the contrast between the answers to both questions clearly highlight the overwhelming ups and extreme downs of working in the industry: it's great but frustrating, exciting but scary, fun but tough. You'll also notice that the same answer can be expressed in different ways; some simply put and others, profoundly worded. You should remember the comments that resonate the most and use them to help you evaluate your own choices.

As In Life, This Industry Is Not Fair

No one ever said that being in this business would be easy; but if you didn't already know this, let me be the first to tell you that as in life (in general), it isn't always fair either.

- It's not fair that some wonderfully brilliant scripts remain lost among stacks of screenplays lining the shelves, floors and hallways of agencies, production company development offices and studios while yet one more inarticulate, blow-em-up, car-chasing, body-slamming, overly graphic, foul-languaged, offensive, loud, violent picture is greenlit and produced for $80 million.
- It's not fair that a more qualified person loses out on a job to a less qualified individual.
- It's not fair that talent is often ignored or just isn't always enough.
- It's not fair that some people are expected to work 16 hours a day without benefits while others receive overtime, golden time, meal penalty, health insurance and a pension.

- It's not fair that the person who gets to make the big decisions and makes the big paycheck is not always the one most qualified for the job.
- It's not fair that some people make half as much as others doing the same job.
- It's not fair that you can work in this business for 30 years, but if you're not in a union, you'll retire without a pension or health benefits.
- It's not fair that one person is given a break when a more deserving one is ignored.

The answer as to why any one of these examples is unfair can be complicated and varied, depending on the exact circumstances, but suffice to say that not everyone in this business plays fairly. Politics play heavily in this game, as does nepotism, poor decisions and a certain acceptance of bad behavior that shouldn't be tolerated, but is. To make things worse, when these situations occur, there's little we can usually do about it.

I can't tell you how many times I've heard friends and co-workers exclaim, "It just isn't fair!" after losing out on an opportunity they deserved, nor how many times I had uttered those words myself. But I no longer expect an obvious or just outcome to every situation nor vehemently protest the injustice of a situation I have no control over. And while I value working with good people who are honest, unfairness rarely surprises me anymore. Cynical? A little. Realistic? Very. In this industry, you can't count on "fair."

> *"There's no business like show business, but there are several businesses like accounting."*—David Letterman

— 3 —

Key Ingredients to a Successful Career

> "*Integrate what you believe in every single area of your life. Take your heart to work and ask the most and best of everybody else, too.*"
> —Meryl Streep

No one can give you an iron-clad, money-back guarantee that once you land your first job, you're going to make it big in this business. But laid out in this chapter are the elements that will give you your best shot at it. Most of what's listed below will be covered more extensively throughout the rest of the book, but here are the key ingredients in a nutshell:

#1: Passion! Passion! And More Passion!

Passion excites, it attracts and it sells. It's contagious, inspirational and motivational. It's the single most important ingredient to propelling your career. It's the enthusiasm that makes the difference between a terrific interview and a mediocre one. It's the catalyst that often makes the difference between selling a project or not. It's the irresistible characteristic that differentiates you from your competitors. It's the magnet that pulls others toward you. It's the motivation needed to keep you in the game. And it's the driving force that keeps you going when the going gets tough. No matter what

book you pick up on this topic, what seminar or course you take, what speaker you're listening to—everyone agrees: nothing launches nor propels a career (in *any* business) as powerfully as does passion.

#2: Being Prepared

It's been my experience that unless born into the industry, few people are truly prepared for the "reel" world, whether they've been to film school or not. It's not like film school, and it's certainly not like any other business or job you've ever had. Newcomers are transported to another planet where the words "no" or "I can't" are never an option, extreme behavior is accepted, creativity and politics are equally valued, people work and talk at break-neck speeds, you work just as hard on the projects that aren't successful as you do on those that are, where anything is possible and the unimaginable happens every day.

Upon landing your first job, no matter what you've heard it's going to be like or what your expectations, it will most likely be different from anything you expect. It's so hard to prepare someone for the mixed bag they're about to encounter: the best, the worst, the competition, the vast variety of personalities and temperaments, the politics, the magical moments. It can be confusing and overwhelming at first, unless you know what you're walking into ahead of time. The better prepared you are, the shorter your learning curve, the more of an advantage you'll have over your competition, the more confident you'll be, the faster you'll be able to jump right in and the more you'll impress those around you.

How do you get prepared? Well, you're reading this book, and that's a great first step. Read as much as you can, and sign up for reputable seminars and workshops that relate to what you want to be doing. Join networking organizations and (if you're a college grad) alumni groups and talk to people who are already in the biz. Volunteer to work for free or sign up for internships through your school to gain some practical experience. Observe, ask questions and be a sponge—soak up as much info as you can.

#3: It's Who You Know and Who Knows You

Some will tell you that the only way to make it in such a competitive industry is to have the right connections, whether it be a relative, a friend or a friend of a relative. You'll hear plenty of stories about the guy who got his job because his brother-in-law is a bigwig agent, a producer who was able to package her project because her best friend is the personal chef of an A-list actor, an actor who got a part because his neighbor was the director or the PA who got his job because he's the production manager's dentist's son. Understandably so, industry professionals help their family and friends get into the business all the time (I did it for my sister when she wanted to give it a try). It's such a tough line of work to break into, any help you can get is beneficial. And while there's no doubt whatsoever that personal connections are like gold, once in, the politically connected are more often than not required to carry their own weight just like everyone else. Many will, in fact, work twice as hard to earn the respect of their co-workers and to prove they're not prima donnas.

There's no doubt, however, that you can make it without someone pulling strings for you. If you put yourself out there, are good at meeting people, make a lasting impression and use new contacts to form further contacts, you'll soon be creating your own solid connections. It's not going to be as easy as having Uncle Charlie pick up the phone and arrange a job for you, but it's done every day.

Okay. I'm sure you've heard the expression "it's who you know" a million times. And it's true. You can never know enough people in this industry. Those in positions of hiring want to work with their friends and the people they like: individuals who are not only creative, talented and hardworking, but also fun and pleasant to be around. If they don't know anyone to fill a specific position, they'll ask their colleagues and friends for suggestions. It stands to reason then that the larger your network, the better your chances of landing at least meetings and interviews, if not jobs.

But knowing a whole lot of people isn't quite the be-all and end-all it's cracked up to be. In fact, it's only half the battle. Making

sure a whole lot of people know *you* is the other half. Whether it's by helping others, providing useful information (see *I'm A Friend of Marc's And Jeff's* in Chapter 12) or creating a memorable logo, business card, website and/or demo reel for yourself, getting your name out there, being well liked and being remembered is the other part of this game.

#4: It's Also What You Know about the Industry

If this business is going to be your life's work, then learn as much about it as you can. You should be reading the trade papers (*Daily Variety* and *The Hollywood Reporter*) and other industry publications and websites whenever possible. Know who's who, who's popular, who just started his own production company, what types of movies are currently the rage, who are the newest up-and-coming actors on the scene, what television shows are getting the best ratings. Know the vocabulary, who the power players are and what the latest trends are. If someone should ask you what your favorite movie is, who your favorite director is, your favorite actor, composer or cinematographer—have an answer and know why. Have an opinion. And see as many current releases as you can, whether they're your favorite genres or not.

Learn about the industry from the inside and from its history. Access the American Film Institute's 100 Years–100 Best Films list (online at www.afi.com), and watch some of those great old classics. Read books like William Goldman's *Adventures in the Screen Trade* (Simon & Schuster), Steven Bach's *Final Cut* (William Morrow & Co.), Sidney Lumet's *Making Movies* (Alfred A. Knopf), David McClintick's *Indecent Exposure* (William Morrow & Co.) and Garson Kanin's novel, *Moviola* (Simon & Schuster), which will give you a glimpse into early Hollywood. Read the autobiographies and biographies of legendary directors, like Frank Capra's *The Name Above The Title* (Macmillan Company) and other such books on D. W. Griffith, Cecil B. DeMille, John Ford, Alfred Hitchcock, Howard Hawks, William Wyler, George Stevens, Orson Welles, John Huston and Billy Wilder. There are several

books available on the pioneer moguls Jesse Laskey, Mack Sennet, Hal Roach, Carl Laemmle, Jack Warner, Samuel Goldwyn, Louis B. Mayer, Walt Disney and Harry Cohn. There are also some fabulous biographies on acting screen legends such as Douglas Fairbanks, Mary Pickford, Charlie Chaplin, Errol Flynn, Clark Gable, Tyrone Power, Gary Cooper, Bette Davis, Katharine Hepburn, Henry Fonda and David Niven; and books on the "making of" classic films such as *Gone With The Wind, Citizen Kane, Casablanca* and *The African Queen* always make for fascinating reading.

Having passion is great, but a keen knowledge of the business combined with passion is unbeatable. Talk about magnetic!

#5: Understanding the Power of Networking

Networking and schmoozing are not dirty words, nor do they represent a practice reserved exclusively for slick, self-serving, disingenuous hustlers looking to further their own careers and ready to mow down anyone who gets in their way. Networking is part of the way we (all of us) do business, and when done the right way, it's an extraordinarily essential element to any successful career.

It's scary at first, especially if it's not something you're used to doing, but the more you do it, the easier it'll get. This is not a profession for the shy and timid; you've got to get yourself out there. Start by making friends and staying in touch with the people you're going to school with and working with. Stay in touch with your teachers and supervisors. If you live in a major film center like Los Angeles or New York, take advantage of the innumerable opportunities available to you: networking functions, entertainment-related organizations, seminars, classes, workshops, theatre groups and industry-supported charities. If you live in a smaller community, check with your local film commission office to see what's available in your area. If it's not much, start your own networking group or film club. No matter where you live or how large or small the gathering, it's important to spend time with

people who have the same interests, some of the same goals and are going through (or have gone through) the experiences you're living. Help each other, pool your resources and share information. Networking is more about giving and sharing than it is about taking. If you get into it for the sole purpose of what you can get from other people, it won't work. Be there to help and support others, and others will be there to help and support you, usually without you ever having to ask. Networking is the life blood of the business. And it's a key capable of unlocking many doors if done willingly and with an open heart.

#6: Having a Plan, and Committing to Your Success

If someone should ask you what you want to do in this industry and your answer resembles something like, "Well, I'm really not sure yet. I was kind of thinking of being a writer. But then again, I enjoy performing . . . and editing, too," or, "I think I'd like to be versatile and do a lot of different things, maybe be a location manager, a script supervisor *and* an assistant cameraman," well sorry—that's not going to cut it. Not knowing *exactly* what your goal is or being wishy-washy about it will get you nowhere, and no one will take you seriously. Knowing what you want, why you'd be good at it and how you're going to achieve your goal will impress the socks off anyone who asks. It shows passion and determination for something you love, and it's an impressive quality to possess. You can change your mind tomorrow, but when asked today what it is you want to do with your career, have a definite answer and be enthusiastic about it. Oh, and while you're erasing "I don't know" from your vocabulary, also avoid sentences like, "I want to be a . . . " Instead, use "I'm *going* to be a. . . " Turn all those wishful statements into declarations. It's much more powerful.

Deciding which direction to take should never be based solely on what sounds like fun. It also involves honestly assessing what you're good at, your temperament and the lifestyle you're up for. You should be researching exactly what each position entails, how

difficult each might be to break into and in the long run, how secure (or not) each might be. It also takes talking to people who do what you think you might want to do and gathering some first-hand perspective and insight. Once you know what it is you want, the next step is figuring out which path you need to take to get there. Set goals for yourself, write them down and tack them up somewhere where you can see them every day. A constant reminder of where you're going and how you're going to get there will help keep you on track. Also remember that life will not go according to plan if you have no plan.

#7: Standing Out Among the Crowd

If you don't stand out, you'll get lost in the crowd. With all the thousands and thousands of people vying for the same positions, you have to figure out what it is that makes you special, and then capitalize on it. Why should someone choose to help or hire you instead of one of the others standing in the same long line waiting to get their feet in the same door? Perhaps you have a distin-guished background and can offer much needed experience; you're fabulous at pitching and selling; you're brilliant at making movies on a shoestring budget that look like they cost millions more; you're a great writer, a creative genius, an inspired actor or musi-cian, a whiz in the office; you're more organized, a crackerjack deal maker, better at dealing with difficult people, will work harder, care more, will work for free or will be more fun to have around. If you don't know what it is that makes you unique, ask friends and family members, because sometimes they can see things in you that you might not be able to see yourself. If you still can't figure out what it is that sets you apart, develop a specialty or find a need you can make the most of. Whatever it is, find *something* that will allow you to stand out and be more than just another wannabe standing in line waiting to get in.

Your passion, abilities, accomplishments, goals and whatever it is that makes you special are all elements that should be woven into your personal pitch and used to distinguish yourself from everyone else. This is a selling tool you can't afford *not* to use.

#8: Donning a Teflon Coat

Unless you are very lucky, you will undoubtedly encounter your share of shark-like creatures, disappointment and rejection upon entering Tinseltown. Unfortunately, there is no inoculation you can take that will keep you immune from the worst aspects of the industry. So you have to find some way of developing a thick skin, like imagining yourself draped in a coat made of Teflon that repels all the bad stuff and keeps it from sticking. The purpose of the coat is to protect your self-esteem, motivation and passion, and to keep you from taking anything too personally, from getting depressed and discouraged and from giving up on your dreams. Don't let the sharks get the best of you, and learn to let the negativity, the frustration and the fear of failure go. If you don't get the job or the role or the show or the client you wanted, there will be other opportunities. If someone you're working for is abusive, you learn to deal with it, or leave the job—but not the business. If you can't seem to catch a break, hang in there—it'll come. You can't take "no" for an answer, and you can't let someone else's bad behavior rule your life or your decisions. This isn't a business for sissies, and you've got to be committed to keeping that coat on in all types of weather, because as bitter and gray as it can get, the sun will eventually come out.

#9: Perfecting Your Craft

No matter how much you know and how talented you are, never stop learning. Technological advances are changing aspects of our industry every day. Trends change, procedures change—there's always more to learn. Staying on top of the curve will keep you sharp, in the game and in demand.

There are always classes and seminars to take (several of which are available online or on CD and DVD) and new books are continually coming out. If you belong to a union or guild, they often offer seminars for their members. You can also access a lot of good information from the Internet. Don't get in a rut. Keep expanding your horizons.

#10: Having Good Interview Skills

We're sort of back to standing out among the crowd here. If an employer interviews ten different people for the same job in one day, a week later, she's going to be hard pressed to remember one from another, unless one of them really stood out in her mind. You want to be that one person. The ability to do well on interviews is a skill that will serve you well no matter what stage of your career you're in, no matter what business.

It starts with doing your homework and finding out as much as you can about the people you'll be meeting and their companies. What are their backgrounds? What type of projects have they been associated with? What is the company known for? What have they been successful with? Knowing about the person you're meeting will, first, illustrate your desire for the job, and second, it says you're the type of person who will put in the extra effort without being asked.

You want to walk into an interview well prepared. Not only should you come armed with the research you've gathered, but also with your personal pitch down pat and also some well thought out questions. As you'll see in Chapter 10, I'm a firm believer in there being certain protocols to a successful meeting. Of course, none of it is carved in stone and much will depend on the interview style of the person you'll be meeting and the time allotted; but the more prepared you are, the better.

More than anything, this is a chance for you to let the person you're meeting see and feel your passion and get to know you on a personal level, no matter what your experience level is. It's an opportunity for you to shine and to differentiate yourself from the nine other people who were met with that day. It's your opportunity to convey that you have the right attitude and are willing to go the distance. If you're engaging, can convey a sense of who you are and what you're all about; if you're the type of person your interviewer would like to have lunch with or have around the office or set, you'll have made a connection (and possibly even an advocate), whether you get this particular job or not. If you walk into a meeting without having done your homework, without much to

say, without a way to let this person know how special you are, you run the risk of being forgettable.

A terrific interview can often tip the scales when a decision has to be made between someone with more experience and a subdued personality vs. someone with less experience who's brimming over with passion and determination.

#11: Being Able to Ask for What You Want

Since few of us have ESP, it helps if you can be specific about what you need help with. My entire job search approach improved once I learned how to ask friends, contacts and previous employers to help me get meetings with individuals I didn't yet know (people they knew), so I could personally introduce myself and make new connections. Until I was urged to be more explicit when asking for help, I would have been too uncomfortable taking what I thought was such a forward approach.

A busy industry professional isn't going to seek you out to come spend 20 minutes with him in his office so he can give you his best advice. But if you ask for the meeting, there's a good chance you'll get it. Similarly, I don't know many people who would take the trouble to seek out someone who needs a mentor, but if you were to come right out and ask, he might very well say "yes." If you have a script or a client you want to sell, a project you want to present to an actor, a demo reel you want to submit, a director you want to meet—pick up that phone and ask. You can never assume that your request will be turned down and can never be intimidated by the fear of rejection. Sure you'll face rejection, we all do, but not always. You can't take it personally, and you can't let it stop you. It's worth taking the risk and asking for what you want, because eventually you'll get your "yes."

#12: A Winning Attitude

Someone with a winning attitude knows how to say "No problem!," moves with a sense of urgency and a "can do" spirit, doesn't

whine or complain, treats others with respect, checks his ego at the door, is accessible, reliable, a team player and is always willing to help out. He gives more than what's expected and is a pleasure to have around. These are characteristics that should become ingrained in your personality and never abandoned no matter how high up the ladder you reach. It's one more element that will elevate you above your competition, and it's the stuff good reputations are built on.

#13: A Willingness and an Ability to Play the Game

A few summers ago, I started my new USC course with the same lecture I always give during the first class. It included the best and the worst aspects of the business, misconceptions most students have before beginning their careers and what they're realistically getting themselves into. The next day I received an e-mail from one of the students informing me that she was dropping out of the class. After that one lecture, she had decided to cut her losses, because she didn't think she had what it takes to make it. I was sorry to have lost a student, but felt good at having done my job and for having potentially saved her from years of struggling in an industry she wasn't well suited for. What a waste of your time to go through film school or work a year or two (or five) in this business only to discover it's not for you. You may reach that decision anyway, at any point; so if you're going to go for it, have a pretty good idea what you're getting yourself into before you start your journey. If you're not sure, then it's time to do more research, get some insight from people who have been in the business for a long time and seriously evaluate your decision. It could save you years that would be better spent in pursuit of a career that's more fitting to your personality and needs.

Be honest. How important to you is a steady paycheck? Are you outgoing enough and if not, do you think can you learn to be more outgoing? Are you too sensitive to work around intense personalities and situations? Can you deal with the competition and find a

way to stand out among the crowd? Are you up for constantly having to sell and prove yourself? How will this career affect your desire for a family and a family life? Do you have what it takes to go the extra distance? This is one game you don't want to get into unless you're fairly certain you can win, and you really, really have to be up for it and thoroughly understand the potential risks as well as the rewards.

#14: Being Well Liked and Having a Good Reputation

It doesn't quite seem fair that while most of us endeavor to be hard-working, polite, tolerant, honorable, reliable and pleasant, others are allowed to exhibit the worst behavior imaginable. But unfortunately, that's the way the show biz cookie crumbles. If you have a proven track record of successes, a creative brilliance that's always in demand, a certain status or the ability to generate mega bucks or mega ratings, you pretty much get a free pass when it comes to conduct. I'm not suggesting that all power players are nasty, sleazy, back-stabbing, abusive, ego-driven, intimidating game-players. In fact, some are the best people you'll ever meet. I just want to point out that it's okay for some to act that way should they choose to while it's not okay for others. For most of us, to get ahead, we need to be well liked and have a fairly good reputation. And just so you know (if this makes you feel any better), should "they" ever start slipping from on high, their inappropriate behavior will no longer be tolerated either.

Forgive the redundancy, but all these elements are interrelated, and those who are the most well liked and have the best reputations are generally those who stand out among the crowd, possess a great deal of passion and have adopted a winning attitude. It's also about earning the respect of others by doing a good job, no matter what your job is; by being a team player; by helping others without expecting favors in return; and by being able to work with all types of personalities under all sorts of circumstances.

No one's got the patience for bad attitudes and bad manners or wants to work with or deal with anyone who's high maintenance unless they absolutely have no other choice. So the easier you are to work with, the more pleasant you are to have around and the better you are at your job, the more in demand you will be.

#15: A Game Plan for Getting Through the Rough Times

You're bound to have setbacks, disappointments and times in between jobs when you'll wonder if you're ever going to work again. And there will be occasions when your self-confidence, commitment and bank balance will all be wobbling at the same time. But if you have your emergency preparedness kit in place and ready for deployment at a moment's notice, you'll be back up and running in no time. Surviving the tough times involves that Teflon coat I mentioned earlier. It's also having a Plan B to fall back on, reversing the doubts and negative thoughts that run through your mind, developing some new positive mantras, learning how to *quickly* get past the disappointment and depression and being able to slightly change your course when facing a brick wall. Your survival will be a result of being persistent but realistic, having the courage to do what's uncomfortable and avoiding all comparisons to others (because there will always be someone who gets a better deal, a better job or a better opportunity; and you can't fight a stacked deck). And last but not least, a healthy sense of humor will see you through almost any challenge, big or small.

#16: Remembering the Five "Ps"

It's all about being:

- Pleasant: Letting your affable personality open doors for you.
- Patient: The tolerance needed to get you over the rough spots and through the journey.
- Positive: A winning attitude, and a conviction that you're going to make it.

- Passionate: The motivating force you never want to lose.
- Persistent: Refusing to take "no" for an answer, and refusing to give up.

> *"Nothing in this world can take the place of persistence. Talent will not; nothing is more common than unsuccessful people with talent. Genius will not; unrewarded genius is almost a proverb. Education will not; the world is full of educated derelicts. Persistence and determination alone are omnipotent."*—Calvin Coolidge

— 4 —

Career Options

When most people think of getting into the biz, they envision themselves as producers, directors, writers or actors, because these are the highly visible, coveted positions we hear the most about. And they are the crafts film schools are well known for teaching. Some students will gravitate toward cinematography, editing, production design or entertainment law; and some may even have aspirations of becoming studio executives, but I've never run into a film student who aspired to be unit publicist or a script doctor. Why? Because few even know what a unit publicist or a script doctor does.

Most industry newcomers start off in entry-level positions with aspirations of climbing to the top. Not many are aware of the enormous number of jobs and career options that exist between the bottom and top rungs of the ladder—positions that are generally easier to attain; jobs that are creative, satisfying and/or lucrative and can become stepping stones or fulfilling careers in their own right.

There are six stages to the filmmaking process: development, preproduction, production, post production, distribution and exhibition. Considering the hundreds of jobs associated with each stage and the multitudes of auxiliary businesses and services considered

part of the entertainment field, the job possibilities in this field are too great to list.

Entire books are devoted to industry job descriptions. This isn't one of them, nor (as you've already seen) is it a typical career guide. To find books that will give you a more in-depth look at career possibilities, check out the selection Samuel French Bookshops carries, which you can access online. Although there are others on the market, a couple of the books I'm familiar with include *Creative Careers in Hollywood* by Laurie Scheer (Allworth Press, New York) and *Gaffers, Grips, and Best Boys* by Eric Taub (St. Martin's Press, New York). And Phil Nemy's *Get A Reel Job* (Angels' Touch Productions) and April Fitzsimmons' *Breaking & Entering—Land Your First Job in Film Production* (Lone Eagle) both contain specific chapters devoted to job descriptions.

Since there are only so many top positions to go around, the purpose of this chapter is to open your eyes and mind to the wide variety of jobs that fall within the sphere of the entertainment industry and to cover a *few* of them in some detail. I can't tell you which jobs are easier to land than others. For that information, you'll have to do some research. But you should learn what's out there.

Freelance Vs. Staff

Before choosing a particular job or specialty field, you'll have to decide whether to pursue a staff job with one company or freelance work. Freelancing entails working from project to project in a wide variety of positions, such as actor, writer, composer, musician, storyboard artist, graphic artist, dialogue coach, script reader, script doctor or a member of a film or television crew. It's a job that has a finite term, and that term could last anywhere from one day to a year or more.

How freelancers are paid will vary, as some are compensated by the hour, the day, the week or the project. Much depends on the exact nature of the work and who's doing the paying. It's often assumed that because you freelance, you're automatically an independent contractor; but that isn't necessarily the case. Most freelancers are put on payroll for the term of their employment, and

their paychecks reflect all obligatory income tax deductions and any union or guild fringes that may apply. At the end of the year, instead of the one W-2 form that someone in a staff position would receive, freelancers could conceivably receive several.

As far as the studios, networks and major production companies are concerned, to be paid as an independent contractor, you must be incorporated and carry your own worker's compensation coverage. Smaller companies, however, may let you invoice as an independent contractor even if you aren't incorporated, as long as you supply them with your social security number. In this case, you would receive a 1099 at the end of the year (instead of a W-2) if you've made in excess of $600, and you would be responsible for your own income taxes.

Freelancers are often referred to as those out "in the trenches." Instead of working in one location (usually an office), they're known to move around quite a bit, often from location to location. They frequently work longer and harder hours while situated close to the "front" (or the set) where the real action is taking place and a project is being shot.

As a freelancer, you'll undoubtedly be spending more time and effort looking for work and could conceivably be away from home for long stretches of time. The insecurity factor is quite a bit higher than with staff work. On the other hand, people who freelance are more likely to get to travel to locations they might never otherwise see; they get time off between projects (which is wonderful, if it's not for an inordinate amount of time) and are apt to be exposed to more new people, new circumstances, new challenges and new experiences. Another thing I love about freelancing is that if I'm on a show and end up working with someone I don't particularly care for, I know that once the show is over, I can choose never to work with that person again. It's kind of the best and the worst all rolled into one and, one way or another, you end up paying for that higher degree of freedom and adventure by having to endure higher levels of stress and uncertainty.

Good staff positions are not easy to come by, so some freelance because the work (while not steady) is often more attainable. Sometimes, however, the decision to freelance or to try to land a

staff job is based on a person's circumstances at any given time in his or her life. I've known many who freelance while they're single and have few responsibilities but then move into staff situations once they're married and have children, because all of a sudden, that steady paycheck becomes more essential. On the other hand, there are many freelancers who work often and earn fabulous livings. They may not be able to spend as much time with their spouses and kids as they'd like, but their incomes can easily sustain the financial demands of a growing family. It's all a matter of circumstances and trade-offs.

Staff jobs will generally give you a good foundation, a greater sense of security, a regular paycheck, employment benefits (like health insurance), a scheduled paid vacation, more normal work hours and a more normal lifestyle. And as many companies promote from within, you could conceivably stay with one company for years. But also keep in mind that production companies do have a tendency to come and go as do executives at major studios and television networks, so there is no guarantee that once in a job, you'll be able to stay with that company indefinitely.

Those who spend years in staff jobs often long to freelance, and freelancers often crave the stability of a staff position. Sometimes the decision is made for you based on which type of job you can find first. Whether it's deliberate or happenstance, honestly look at where you are in your life and the lifestyle you think you can best adapt to before deciding which direction to follow. Like mine, your career may become a combination of staff and freelance work.

Being Part of a Crew

Being part of a crew means you're a member of the team that supervises, directs, prepares, designs, dresses, finds locations, builds sets, lights, photographs, rigs, records sound, videotapes, keeps continuity, moves the production from one place to another, prepares the talent, creates props, stunts and effects, publicizes, edits and compiles all the necessary elements to complete a film or TV show.

Each time you're hired for a show, the crew you're about to become part of becomes like a new (albeit temporary) family unit.

And just like a family, you'll have your favorites. You'll be working side by side with these people, sometimes for months on end for a minimum of 12 hours a day, eating with them, sharing goals, commiserating and conquering challenges together, and when shooting on location, traveling and socializing with them as well. Becoming friends with someone on location, you tend to build a bond that would normally take years to develop the conventional way by getting together once every month or two or three. Some of the best friends you'll ever make will be crew members you work with. You'll always have a connection to these people and feel a shared sense of adventure, accomplishment and camaraderie. And on the *really* tough shows, you may also feel that sense of closeness people share when they've been through any sort of adversity together.

Every once in a while you'll work on a show or series that's truly special. Even if the production itself isn't special, some of the people you'll work with are. So when it's over, parting can be tough. You'll never work with that exact same group of people in that exact location under those exact circumstances again. Saying goodbye to those you've become close to can feel like the end of a wonderful summer at camp. You may have fond memories of some; others will be special enough for you to want to keep in touch and have an on-going relationship with.

Many individuals have given up good, steady staff positions to freelance on individual films and television shows. You've already read about the downside to freelancing, but there is no denying that if you're a team player, there's no better team to be on than a film crew.

As you can see by watching the credits at the end of some major motion pictures, there are sometimes one-to-two hundred positions listed (especially on features that use quite a bit of CGI and/or animation), and that doesn't always take into consideration the productions that use huge construction crews or thousands of extras. Needless to say, a vast number of positions need to be filled on every show—opportunities that represent a wide array of interests and expertise in such areas as cinematography, sound, music, casting, wardrobe, makeup, special effects, visual effects, art direction, set design, publicity, etc.

Should you want to be part of a film crew but aren't sure exactly what it is you'd like to be doing, try to get work as a PA or non-union extra, so you can start learning first hand who does what and what might interest you. You can also buy one of the books I suggested earlier and start researching job descriptions.

You may also have a talent or skill that can be transferred to a production-related venue. Examples would be composer, helicopter pilot, construction coordinator (contractor), carpenter, painter, plasterer, medic, animal trainer, caterer, translator, electrician, diver, teacher, draftsman, hair stylist, still photographer, scaffolding engineer and driver. If any of these is something you'd like to consider, start lining up general information meetings with people who are already doing these jobs on films and TV shows to ascertain how you might make the transition (see Chapter 10 for guidelines on general information meetings).

Unions and Guilds

All major studios and many independent production companies are signatory to certain basic union and guild agreements, the most common being the Screen Actors Guild (SAG), which represents actors, stunt coordinators, stunt performers, professional singers, puppeteers, airplane pilots, professional dancers (which may cover swimmers and skaters as well) and extras; the Directors Guild of America (DGA), representing directors, unit production managers and assistant directors; the Writers Guild of America (WGA), representing writers; the International Alliance of Theatrical Stage Employees (IATSE or IA, also known as the "craft" locals), covering various crew classifications (each represented by their own local); and the Teamsters, with jurisdiction over drivers and location managers. There are a few others (such as National Association of Broadcast Employees and Technicians [NABET] and American Federation of Television and Radio Artists [AFTRA]), but when it comes to shooting a feature film, TV series or movie for television or cable, these are the primary unions and guilds you will be dealing with.

Many of the unions and guilds, in addition to having offices in both Los Angeles and New York, have additional branch offices in various locations around the country. The IA does not have branch offices, but does maintain individual locals in different cities throughout the country. To locate the specific union or guild branch office, or IA local, closest to you, contact one of their main offices or your local film commission for assistance.

On the West Coast, what stands between the unions and guilds, the producers who employ union and guild members, and those applying for union membership is the AMPTP, the Alliance of Motion Picture and Television Producers. The AMPTP provides services to studios and independent production companies covering all aspects of employment within the television and theatrical motion picture industry and other issues that affect the industry as a whole. They represent their member companies in industry-wide collective bargaining with the unions and guilds, including grievance and arbitration decisions and interpreting and administering agreements with the WGA, DGA, SAG, IA, West Coast studio local unions and basic crafts unions.

Not a part of the collective bargaining unit, the Producers Guild of America (PGA) is categorized as a trade organization rather than a labor union. With offices in Los Angeles and New York, the PGA came about as a result of two pivotal mergers: the 1962 union of the Screen Producers Guild and the Television Producers Guild and the 2001 joining of the PGA and the American Association of Producers (AAP), which represented a group of associate producers in videotape television. This subsequent merger created an organization that represented the interests of the entire *producing team*, which was defined as all those whose interdependency and support of each other are necessary for the creation of motion pictures and television programs. In 2002, however, the Producers Guild expanded their definition of a producing team as well as its membership base by creating the New Media Council, which covers producers of web-based projects, games, CD-ROMs and a variety of other digital and new media.

PGA members include executive producers, producers, co-executive producers, supervising producers, senior producers, line

producers, co-producers, associate producers, production managers and supervisors, post production supervisors and managers and production and post production coordinators.

The requirements for union and guild (and trade organization) membership differ with each entity, because each has its own set of variables, depending upon the classification you're seeking. It's definitely advantageous to become a member of a union or guild with benefits such as overtime, meal penalties, health insurance, pension, vacation and holiday pay, etc. Union and guild membership, although preferable to the longer hours and lower wages generally associated with non-union shows, is not open to just anyone who wants in. In fact, it's often quite difficult to join some of the unions and guilds, because a primary function of their existence is to protect the employment of their current membership by limiting the number of new members they accept.

You need only to sell a script to a signatory company to become a member of the Writers Guild. With a special talent or ability or an accumulation of three extra vouchers, you can become a member of SAG. Many other unions and guilds require that you work a specified number of hours or days at a particular job (on non-union shows) and prove a certain level of expertise in a given field. Some locals require that you work at least 30 days in a certain capacity on non-union shows to apply for placement on the union roster. Those on the roster are allowed to work only when all current union members in that classification are currently working. For more information on membership, contact the union or guild you're interested in, and they'll either provide you with requirement guidelines or refer you to the AMPTP. Also refer to Chapter 15 for further information on getting into the DGA.

Independents Vs. Studio Films

If you choose to freelance when first starting out, it might be easier for you to find work on smaller independent films. Many independents are non-union, and because the salaries and required levels of experience tend to be lower than on traditional studio/union

shoots, it's a more plentiful source of employment. And working on non-union films will give you more hands-on experience, because they're not governed by union and guild restrictions limiting what each person in each position is allowed to do. It's also easier to get an internship on an independent, as there is always a need for additional labor that won't tax the budget. So if you can afford to work for free for a while, it's a great place to get some experience, make valuable contacts and possibly earn a screen credit.

Independent films (or "indies" as they're sometimes called) are very different from traditional studio films. They invariably have smaller crews and shorter schedules and are generally financed by private investors, although some are funded by major studios operating under indie banners. At one time, being independent always meant low budget, and low budget almost always meant non-union, but now that the unions and guilds are offering low-budget (and low-low-budget) agreements, more indies are becoming signatory. These low-budget agreements allow producers to pay union and guild members lower salaries while preserving their pension, health and welfare benefits.

Since most majors handle their own financing, when you go totally independent, your financial backers and distributors will require you to carry a completion bond. For a negotiable fee based on your budget, the bond company (after making sure you have a script with an adequate schedule and budget and a reputable and insurable cast and crew) will insure that the film is delivered as specified in all financing and distribution agreements. They will review all major deals and assign a representative to oversee your picture. Bond reps will receive copies of all scripts, budgets, schedules, call sheets, production reports, weekly cost reports, etc. Should your production go through its entire budget (plus 10% contingency) prior to the completion of the picture, the bond company would take over the management of the film. This rarely occurs, however, because it's the bond company's job to anticipate potential problems before they occur and to work closely with the producer, director, cast and crew to keep things on schedule and on budget.

The following are some pros and cons of going independent, starting with the cons:

- If you're producing, you might be the one who has to raise the financing and shop the script or finished picture at film festivals and markets to attract distribution deals and dollars. It's a long road to travel with no guarantees along the way.
- Being on a tighter budget, you'll continually find yourself coveting more time, money and help and will have to be more creative and more careful about how you spend your budget dollars.
- You will undoubtedly *not* be able to afford all the locations, props, equipment, sets, effects, extras and cast and crew members on your wish list, and compromise will become your middle name.
- You'll have smaller margins for error and less time to deal with high-maintenance personalities.
- If you're working non-union, overtime, meal penalties and/or health and pension benefits may be an impossibility.

The pros:

- If you can raise the funding, you're free to make a film that's close to your heart, one with some profound social significance or one your gut just tells you will be a commercial money-maker.
- There's a growing market for indies, as significant segments of the theatre-going public are growing tired of big studio blockbusters and sequels.
- For the most part, indies will afford you more freedom in the form of creative decisions, in having to answer to fewer people and in terms of fewer regulations.
- If you're doing a non-union picture, you can use a smaller crew. Free of restrictions, a non-union director of photography can also operate the camera, production assistants and other crew members can drive their own vehicles, you can hire a two-person sound department instead of a three-person crew, and you can hire grip/electricians as needed instead of grips *and* electricians or an extra hair/makeup person as needed rather than one of each.

Working on studio films is far from a breeze, but you'll generally have the benefit of a larger and more experienced crew, a longer schedule and larger budget.

Features Vs. Television

I'm sad to report the existence of some poor misguided individuals who look down on those who work in television with a sense of superiority, because they themselves have "made it" in features (and most likely big studio features). But if they'd ever worked in television themselves, they'd know how wrong they are. If you do well in television, you'll do well in features, because it's a great place to perfect your craft and learn to work quicker, more effectively and more resourcefully. Television is very much like working on smaller, low-budget, non-union independent films inasmuch as you rarely have the luxury of big, comfy budgets and schedules. So you have to be more efficient and more creative with what you have to work with.

TV or cable movies (which are not quite as plentiful as they once were but are helpful for this comparison) will generally have a 28- to 30-day schedule and shoot five or six pages a day. A single-camera, one-hour episodic series will shoot six or seven pages a day, and each episode will have a seven-day schedule. A moderate- to large-budget feature will shoot anywhere from a half-page to possibly two or three pages a day (on a good day), and schedules will vary from 35 or 40 to 80 plus days.

On a television series (also referred to as "episodic"), the director is generally different on each episode, while two first assistant directors and two editors alternate between episodes. On a series, everything moves at an accelerated rate, and on the frequent occasions when scripts are delivered at the last minute, pre-production is handled at warp speed. You're prepping, shooting and wrapping different episodes, all at the same time. Directors seldom have the time to get much more than basic camera coverage and DPs (directors of photography) rarely have the luxury of more sophisticated lighting designs. It takes competent organizational skills, some quick thinking, creative problem-solving and a

cohesive team effort to get quality shows out and delivered to the networks on time.

For the most part, TV crews that work together for an extended period of time become close and develop family-type bonds. Working on a series generally affords a longer stretch of employment than working on a single film (especially if you're lucky enough to get on a successful series). And while the salary might not be as high as what a feature might offer, crews are usually able to work in town and go home to their real families at night.

The Majors

The top major studios include Sony Pictures (which owns Columbia and has just purchased MGM/UA), 20th Century-Fox, Universal, Walt Disney, Warner Brothers and Paramount. Major independent production companies include such high-profile and prolific producers as DreamWorks SKG, Imagine Entertainment, Jerry Bruckheimer Films, Mandalay and New Line Cinema. They're all structured a little differently yet share many commonalities.

While the studios finance the films they release, they don't physically produce the films in-house. Instead, they vigilantly (some more vigilantly than others) supervise those who do in order to protect their investments.

Staff jobs at all the major studios have always been highly sought-after. Landing such a job isn't an easy feat and often involves timing and luck as much as it does talent and ability. The politics are no different than what you'd find in any other segment of corporate America, but are challenging regardless. What surprised me when I first started working with the studios and larger production companies was the vast sea of red tape one must trudge through, which at the time made me wonder how their shows ever got made. But this is a business first and foremost, and profitability rules. Also paramount is protecting the corporation, as anything labeled *Hollywood* has always been a huge target for insurance claims and lawsuits. So if you have the patience and a fair amount of ability, happen to be a terrific politician, are adept at

watching your backside and don't mind starting off as an assistant, a studio job could be the start of a terrific career. The following is an overview of some key studio departments.

Creative

Some of the most coveted positions are those within a studio's Creative department. This tends to get a bit confusing, because the titles of the executives who run these departments state that they are presidents, executive vice presidents, senior vice presidents and vice presidents of "Production," but the division is referred to as "Development" or the "Creative Group." The president, the very head of the department, is the one who has the power to "greenlight" a property—to give the final "go" and commit the financing necessary to make the films that studio produces. Most networks and independent production companies have similarly structured development departments, and from the top to the bottom, the hierarchy of titles would generally read as follows:

- President (or Head) of Production
- Executive Vice President of Production:
 This person has most of the same authority as the head of production, except he can't greenlight productions on his own. He can, however, initiate deals and oversee large projects.
- Senior Vice President and Vice President of Production:
 These individuals oversee the development and production of films.
- Creative Executive (at least one):
 Those in this position read scripts; write story notes; generate writer, director and casting lists and help supervise development and production. Independent production companies often call those in this position "development" executives.
- Development Assistant or Story Editor:
 This person oversees the story department, which is staffed with a number of story analysts (or "readers") and is responsible for the administration, processing, reading and analysis of all incoming properties.

- Story Analysts or Script Readers:
 These individuals are either staff or freelance, and their job is to read and provide a written synopsis (or "coverage") of each script.

I've read articles stating that on average, studios receive any where from 300 to 500 submissions each month in the form of screenplays, books, treatments and pitches. Other sources indicate that many independents receive 200 to 300 submissions per month. Regardless of the exact number any one studio or indie accepts, we're talking thousands of submissions each year; and this is the department that evaluates and determines which properties are to be optioned and which are to be purchased (see Chapter 14 for more about pitching, selling and optioning screenplays). Once optioned or purchased, the scripts are "developed." Notes are given to the writers, changes are made and new writers or a succession of writers are sometimes hired to do rewrites on any given project. Budgets, director and casting possibilities, marketing strategies and the past history of similar types of films are evaluated before a decision is made as to whether to greenlight a particular property. The development process can take months or years, depending on the variables involved.

Once a project has been given a greenlight, the heads of this department will follow the project through to delivery, getting involved with creative decisions every step of the way.

If you think of yourself as a creative individual; understand proper story structure and what makes a good story; are an avid reader; think you would enjoy working with writers; have a feel for what would do well at the box office; and think you can get excited about the development process, this might be a good area for you to pursue. Just remember, the line to get in is a long one. Some suggestions for getting your foot into this particular door are:

1. First work for a literary agent and get some experience in the field.
2. Work through an employment/temp agency that's connected to one particular studio, and let it be known you'd like to temp for

a development executive. Once there, impress the hell out of everyone in the department and make yourself indispensable, forcing them to want you back on a permanent basis as soon as there's an opening.

3. Read scripts and do coverage as an intern (for free), and impress the higher-ups with your brilliant and insightful coverage.
4. Have a great connection to someone in a position to hire.

All independent production companies, large and small, have creative (or development) departments, although in some instances one or two people may handle the same duties as would a multi-person department at one of the majors. And at most independents, the head of production is also the head of the company.

Production Management

Another sought-after studio department is also referred to as "physical production." The higher level titles in this department are similar to those of the creative group. And instead of creative executives, development assistants, story editors and script readers, you might find a Director of Production, any number of production executives and possibly an Executive Production Manager. Titles will vary slightly from studio to studio or production company, but the production exec title seems to be the one most widely used.

Those in physical production routinely prepare proposed schedules and budgets for those screenplays in development to help ascertain the feasibility of each one. As projects move closer to a greenlight, the physical production team will spend more and more time researching and suggesting various location scenarios, as well as lining up necessary resources and personnel. Sometimes, a studio will give a flashing yellow light to a project and allocate limited funds to actively prepare for the probability of the greenlight that's expected to follow, making sure everything's ready to go once the light does change. So the physical production department is heavily involved in pre-production even before pre-production has officially begun. And while they don't physically produce the

film, they supervise those who do. Once a show has begun principal photography, it is physical production's objective to make sure the show remains on budget and on schedule. They monitor all major deals and contracts, budgets, schedules, call sheets, production reports and cost reports, as well as salary structures and union guidelines and rates. They recommend key personnel and have final approval on all major crew positions. Studios generally have multiple shows in production at any one time, each in different stages of pre-production and production, and the responsibilities for each are usually split between the department's team of production executives. They act as liaisons between the studio and the shooting companies and will spend time each day checking in with line producers, production managers and production accountants. Production execs will generally attend production meetings and travel to location periodically to spend time on the set and/or in the production office. It's not always easy for a shooting company to accept the presence of or input from a production exec, and there's often a certain amount of skepticism and mistrust on both sides. However, a savvy production exec knows how to work with filmmakers, and savvy filmmakers realize that a production exec can be their biggest ally should the production run into any problems. And while the relationship can be adversarial at times, it's everyone's ultimate goal to make the best movie possible.

One of my physical production executive friends equates his job to that of being a policeman. Having worked both in this capacity as well as on the other side of the fence, I can see his point of view, although I don't necessarily share it. If you are good at solving problems, proficient at budgeting and scheduling, diplomatic, patient, have excellent people skills, are a behind-the-scenes kind of guy or gal and enjoy physical production but don't *want* to be in the trenches, this is a good place to be. It's not considered creative, but it definitely can be satisfying.

The best way to score a position in a physical production department is to work on a film and impress the studio production exec overseeing your production. The next best way is through a recommendation from someone with a strong connection.

Other Departments

There are many other departments to be found within any given studio, staffed by all manner of vice presidents, directors, managers and assistants. Here are just some of them.

- Acquisitions: This department is responsible for acquiring outside properties for release and distribution—projects that may have already been developed, partially packaged, partially or fully financed and may or may not have been completed. Screenplays, rough cuts and finished films are submitted to this department for review. Acquisitions executives also regularly track independent projects and attend film festivals searching for product they feel the studio can successfully sell. Once they acquire the rights to a property, they will often make changes (such as editing, music, re-shoots) prior to its release.
- Legal & Business Affairs: These are terrific jobs for film lovers with law degrees. The "legal group" is responsible for overseeing all legal aspects of films in development and in production. Project attorneys prepare and negotiate talent contracts, negotiate union/labor agreements and supervise, negotiate and approve all show-related contracts and clearance deals.
- Finance: This department is generally made up of a Vice President, Director, Senior Auditor and Manager of Budgeting and Estimating. As a whole, they are responsible for supervising the budgeting, estimating and daily/weekly cost reporting of all studio/company films. They work closely with the production accountants and production managers and act as troubleshooters when financial problems arise or cost reports reflect impending overruns.
- Casting: Some studio shows use the services of a freelance casting director, but casting is often done in-house. Basically, the casting executive interviews actors, makes recommendations, then hires the talent selected and negotiates their contracts. But there are also times when a casting exec will, in the development stage of a project, work closely with creative execs to attach an A-list actor to the property, sometimes even before a producer or

director has been chosen. (See Chapter 5 for an in-depth description of a casting director.)

- Post Production: This department customarily encompasses a Vice President and any number of post production supervisors. They oversee the entire post process (editing, sound effects, looping, scoring, mixing, etc.), approve the hiring of the editing team, act as liaison between the post production team and the studio's creative executives and ensure all delivery requirements are met.
- Labor Relations: Staffed by legally trained executives, this department is responsible for the implementation, interpretation and administration of all union and guild collective bargaining agreements. They engage in contract negotiations and handle labor grievances, dispute resolution, and production office inquiries. They interact with and provide support to all company divisions and production entities regarding compensation, policy implementation and staffing issues.
- Production Resources (also known as Product Placement): This department procures and negotiates the use of all props, set dressing, vehicles and wardrobe loaned or given to a particular production for on-screen use. They interface with the producers, production designer and various department heads as well as the studio's creative executives, production executives, and the marketing, publicity and legal departments while coordinating the product placement deals from proposal stage through the release of the film.
- Research/Clearances: This department is staffed by individuals who read each screenplay during the development or preproduction process and prepare a research report that lists all elements of the script that must be cleared. Obtaining clearances is the process of securing permission to use someone's likeness, name, logo, photograph, piece of art, product, premises, publication, film clip or stock footage in the production; and all clearances must be secured before the parts of the script containing these elements can be shot. This department works closely with the art and production departments, negotiates and procures clearances and administers copies of all release forms.
- Music: In much the same manner, this department will research the songs and music suggested in a screenplay and report on the

licensing costs to procure these selections—often suggesting less expensive alternatives. When final determinations are made as to which music will be used, they will negotiate all applicable license fees. They sometimes help in the selection of a composer and remain involved in the entire music process, which encompasses the score and soundtrack.

- Medical: There is a medical facility on all studio lots. Most are staffed by RNs (registered nurses) and/or LVNs (licensed vocational nurses), although a couple are staffed by EMTs (emergency medical technicians).

- Safety: This department is responsible for the implementation and administration of a safety program formulated in conjunction with the Industry-Wide Labor-Management Safety Board. The program covers safety regulations that apply to all studio employees, all freelancers working on studio shows and any outside employees working at studio facilities.

- Risk Management: This department administers and oversees all studio and production-related insurance matters.

- Studio Operations (or Facilities): This department handles the running and maintenance of the studio as well as the use/rental of all studio facilities.

- Human Resources: This department governs the employment and benefits of all studio employees.

- Home Video: This department deals with all new (and old) films released on VHS and DVD. Their responsibilities include the creation of packaging designs, menus and advertising (print ads, TV spots, etc.). At some studios, the Home Video Department gets involved in DVD bonus features, while other studios have created a separate DVD Bonus Features Department. This type of work is ideal for someone who's creative and possibly has an artistic and/or a marketing background.

- Marketing: This is a busy department responsible for how a film will be sold. It encompasses the planning and creation of strategic marketing campaigns, advertising (one-sheets; billboards; magazine, TV, radio and Internet spots; theatrical trailers; etc.) publicity (generating media coverage), test screenings, product merchandising and promotions. They work closely with the

studio's creative staff, producers, directors, actors, agents, managers and publicists as well as behind-the-scenes (EPK or electronic press kit) producers and crews. (Behind-the-scenes footage is used for publicity, celebrity news magazine shows like *Entertainment Tonight* and *Access Hollywood* and is later incorporated into DVDs). The marketing department plays an important role in creating and maintaining the star power of top industry talent. They also launch various award campaigns as well as new releases at film festivals and they liaison with outside religious, civic, cultural, political and special interest groups when it involves the release of a film that could be considered controversial or sensitive in nature.

Additional studio departments would include:

- Domestic and International Distribution (the field of International Distribution is described in Chapter 5, and domestic distribution relates to the marketing, sales, delivery and collection of films, television and video productions ["titles"] the studio represents in the U.S.).
- Transportation: This department is responsible for all vehicles used to transport crew, equipment and materials, as well as vehicles used in front of the camera and mobile trailers used for cast, wardrobe, hair, makeup, etc.
- Shipping: Pretty self-explanatory.
- Wardrobe: This is the department that handles the clothing, costumes, shoes and accessories worn by actors, extras, stunt performers and photo doubles. Department personnel may also include costume designers and those who handle alterations, tinting and dying and wardrobe restoration.
- Props: A prop is anything used or moved by an actor in a scene, and prop departments catalog, warehouse and rent out props to studio shows and outside shows shooting on the lot.
- Scene Dock: This is a storage area for set pieces, flats, windows, doorways, staircases and backdrops.
- Set Construction: This is where much of the above is made.
- Paint Shop: Where set pieces, set dressing, etc. are painted.

- Sign Shop: Where signs used for a film or TV show are designed, made and painted.
- Grip: Where grip equipment is stored and rented from, and where studio grips not assigned to a specific show are given their assignments.
- Electric: Where lights and electrical equipment are stored and rented from and where studio electricians not assigned to a specific show are given their assignments.

More Staff Possibilities

Staff positions can also be found at a myriad of:

- TV and radio stations
- film, television, music video and commercial production companies
- talent, literary, music and below-the-line agencies and management companies
- unions, guilds, associations and film commissions

They would also encompass positions with companies and firms that specialize in:

- entertainment law
- publicity
- international marketing and distribution
- behind-the-scenes (also known as EPK) production
- accounting and business management
- motion picture insurance, risk management and safety
- principal and extra casting
- animation, visual and mechanical effects
- prop manufacturing and set construction
- location resources
- industry news (including the "Trade" papers)
- music (clearances, supervision, scoring)
- product placement
- equipment, vehicle, wardrobe, prop and set dressing rentals

- employment and temp agencies, career counseling and resume services
- payroll companies
- post production houses
- labs and sound houses
- video transfer and duplication
- captions, subtitles and graphic design
- script research
- film and tape storage
- stage, office and screening room rentals
- stock footage houses
- trailer production houses
- process photography
- 24-frame video playback (30 to 24 frame conversions)
- hair, makeup and wig supply houses
- raw stock (film) and videotape supply houses
- expendable supply houses
- scene shops and backdrop manufacturing
- prosthetics manufacturing
- food styling
- production-related travel and accommodations
- interactive
- acting classes/coaching and head-shot photography
- catering
- wrap parties and crew gifts
- industry-related software
- animal training
- marine support
- plants and greens
- freight forwarders
- security
- and the list goes on . . .

An Agent's Life

My first job in the industry was at a local television station, and it was that experience that convinced me I wanted to be in this busi-

ness. At the time, all I knew is that I wanted to stay in television or work on films. About a year into my job, I was laid-off because of a slow-down in work at the station. I temped for a while but basically had trouble finding the type of job I wanted. Then someone I had met at one of the employment agencies said he thought he could get me a job at one of the major talent agencies, which at the time was the farthest thing from my mind. He said that an agency was the best place to learn about the business and it was where all the deals are made. He said if I worked at a studio, I'd know what was going on at that studio; but if I worked at an agency, I'd learn what was going on throughout the entire industry. There was an opening as an assistant to a talent agent, and he suggested I go in for the interview. He said if I got the job, I should stay at least a year; and by then, if I decided it wasn't for me, I at least would have learned something and made some terrific contacts. So I went on the interview, got the job, stayed exactly a year and discovered just how right he was.

There are agents who handle actors and some who, more specifically, represent actors for certain types of work, such as television and cable, feature films, commercials or voice-overs. There are agents who just represent writers, and they're called "literary" agents. There are agents who represent musical talent, those who handle producers and directors and those who represent "below-the-line" crew such as cinematographers, editors, production sound mixers, costume designers, makeup artists, etc. And then there are agents who specialize in "packaging." In fact, the larger agencies (such as William Morris, CAA and ICM) have entire packaging departments that can draw from pools of highly talented clients. Whether it's developing a film or TV concept in-house or getting behind a client's screenplay, they have the ability to package an agency-represented writer with other agency clients, such as a producer, director and cast. A project that's packaged with two or more of these elements is a valuable commodity to a studio, and it generates substantial commissions and fees for the agency.

As in any other aspect of the industry, there are pros and cons to being an agent; and it's something that has to be right for you. If nothing else, working at an agency for a while can provide a

tremendous learning experience and become a stepping stone, taking you one step closer to your ultimate objective (as it was for me).

It can be quite thrilling to discover and nurture new talent and to help shape successful careers. If you get a thrill out of working in a super-fast-paced environment and enjoy making deals, this is for you. If you see yourself as a mover and a shaker, again, this is for you. Top industry agents are quite powerful, because they represent (and control) the talent that makes the big bucks for the studios, production companies and distributors. Salaries at the larger agencies can be substantial, and many an agent has gone on to become a top studio executive or producer.

Through the trade papers, breakdown services and word-of-mouth, agents are constantly on the alert for potential work for their clients and are continuously putting them up for various projects. They have to keep up with the latest industry news and trends and spend much of their day talking to (and following up with) studio executives, casting directors, producers, directors and production personnel—submitting head shots, resumes, scripts, demo reels—whatever's applicable. They set up meetings (attending some of them with their clients) and put a great deal of effort into prepping their clients for interviews, meetings and readings. And in the case of some clients, a great deal of hand-holding and pampering is required.

Agents negotiate all client deals and act as liaison between their clients and a studio or production when day-to-day issues arise during the development, pre-production or principal photography phase of a project. They often visit the sets where their clients are working, and some even travel with their clients.

An agent must vigilantly keep up contacts with studio executives and top producers and directors. And after a long day at the office, agents routinely go to screenings, attend performances in support of clients or to discover new talent, attend dinner meetings, attend social functions and network with both current and potential new clients. Having worked in physical production for most of my career, I'm used to working my butt off on a film; but once the filming process has been completed, I have a chance to catch my breath and take some time to myself, away from all the

hustle and bustle. When you're an agent, you never get that respite. But for those whose job *is* their life, this kind of total immersion and continual rush is what drives them.

Marc Hernandez is a literary manager. Since the jobs of agents and managers are quite similar, I asked him to explain the difference between what he would do versus what an agent would do for the same client. He said a manager is more hands-on and more involved with a client's overall career. He explained that agents could represent up to 50 clients at any one time, their prime objective being to secure employment for their client-base. Furthermore, an agent would take a client's completed screenplay and attempt to get it out on the market. A manager, on the other hand, may only have 20 clients and would conceivably take a more active role in developing and/or working with the client to make sure his script is ready to go out. As a manager, he can also attach himself to a client's project and function as a producer. A "franchised" agent is licensed and regulated by the Labor Board and customarily earns 10% of a client's earnings, whereas a manager isn't licensed but also earns 10%. (And just so you know, a performer's attorney typically will earn 5%.)

Marc does quite a bit of lecturing, and he tells anyone considering getting into this end of the business that once they get in, they better enjoy it. He goes on to say that the qualities needed to become a successful literary manager would include strong social *and* business skills; a talent for negotiating and sales; a passion for reading and developing material; the satisfaction that comes from representing the best interest of your clients (which he says isn't always easy); good networking, political and problem-solving skills; a love of the industry and a good working knowledge of movies—old movies, new movies, who's hot, who's doing what. And he says you have to like being on the phone, because you'll be generating and taking a *lot* of calls. Marc goes on to say that you need to understand the vocabulary of the industry and movies, have a passion for the business, a high degree of professionalism and enjoy getting out there and hustling. For him, it's a 24/7 way of life. He's always reading, developing new material, working with clients, looking for new clients, answering calls and e-mails,

guest speaking, attending pitch fests, watching movies, negotiating and selling, attending parties, going to meetings and pitches, keeping up on the business and networking. Just listening to him tell me all he does tires me out, but he absolutely loves it all.

The Many Faces of a Producer

I know, I know. I started this chapter by implying that I was going to introduce you to career options *other than* producing, directing, writing and acting, and now here I am bringing up the topic of producers. The thing is, few people really understand what producers do or that there are many different types of producers, so I thought the topic deserved some attention. This next section might be a bit confusing, but believe me, it's not easy to explain either.

On a feature film, there will customarily be at least one Executive Producer; a Producer; possibly a Co-producer and/or a Line Producer and at least one Associate Producer. On a one-hour episodic television show, you might see as many as a dozen producers listed in the credits.

Years ago, everyone understood what a producer did, and there weren't so many of them. More recently, however, producer credits have been confusing and nebulous, often handed out like candy at a kid's party. Producing credits of one kind or another have been afforded to key performers, the performer's manager or business partner, to financiers or the middlemen who bring financiers into a specific project. Producer duties often overlap, and the credit has at times been afforded to individuals who have never set foot on a movie set. If you happened to see the movie *Narc*, you might have noticed the multiple producers listed in the credits: nine executive producers, five co-executive producers, four producers, one line producer, two associate producers and one consulting producer— 22 in all. I can't imagine what they all did, but it's unlikely that all 22 were instrumental in the day-to-day running of the production.

In response to this unacceptable and confusing trend, the PGA has been actively lobbying to standardize producing credits and to limit them to the individuals who actually perform the duties of a producer. They have, in fact, just recently made a tremendous

breakthrough in this endeavor by announcing their plan for correcting these flaws with their new *Truth in Credits* campaign. They have clearly defined producer job duties, can accurately determine credit eligibility and have an arbitration system in place to back up those determinations. Their goal is to establish a fair and equitable approach to regulating producing credits and to restore fairness and accuracy to the credit and title of "producer."

Producer and Producers Guild member Marshall Herskovitz sums it up well by saying,

> "For almost a hundred years, producers have played an essential role in the creation of motion pictures. Who are the people who engender projects? Producers. Writers have original ideas, of course, but then they look for a producer to help develop them. Directors engender stories, of course, but usually at that moment they are acting as their own producers. It is producers who engage every day in the creation of intellectual capital. They are the mavericks, the gamblers, the people who spend five and ten years nurturing a project until it can get made. In a business once dominated by entrepreneurs, they are the only ones left who risk their own livelihood in the mad belief that a story can be great. They create, they develop, they secure financing, they put teams together, they subsume their own egos in order to keep disparate artistic visions on the same path, they stay with a project from the moment of inception until long after the picture leaves the theatre. Producers are necessary to the creation of motion pictures and television. Yet now, after a generation of the erosion of producing credits, the role of the producer is becoming so muddled and confused that we must take action to preserve the very meaning of the term."

You can go to the Producers Guild's website at www.producers guild.org to access their producer definitions and job descriptions, which cover the development stage of a (theatrical motion picture or television) project through post production, marketing and delivery.

Although I expect to see the PGA's *Truth In Credits* program effect a positive change and simplify the way in which credits are granted, the following has been the confusing norm for a very long time now and what you're still witnessing on many shows:

Executive Producer

A rudimentary definition of an executive producer is someone who supervises one or more producers in the performance of all his/her/their producer functions on single or multiple productions. On theatrical features, the executive producer may be the person who raises the funding, provides the funding, owns the rights to the screenplay and/or puts the deal together. It could be one of the principal actors whose own production company packaged and sold the project or even the line producer. It could also be an established producer who's lending his or her name (and prestige) to a project, so a less-established producer can get a film made, or an established producer supervising a production at the request of a studio.

On a television show, the executive producer (also referred to as the "EP") is often the "show runner": the Steven Bochcos, David E. Kelleys, Marcy Carsey/Tom Werners and Dick Wolfs of the industry—primary providers of television content, the ones who create, develop, sell and produce a plethora of the shows found on the TV and cable networks. In television, an EP would be equivalent to the producer on a feature, the ultimate authority and the liaison between the production and the network. It could also be a lead actor whose name and/or production entity got the project off the ground to begin with. A co-EP may very well be a less-established individual who brought his project to the show runner/EP who, in turn, sold it to the network.

Producer

A producer is basically the person who initiates, coordinates, supervises and controls all creative, financial, technological and administrative aspects of a motion picture and/or television process throughout all phases from inception to completion. On a theatrical feature, the person with this title is also referred to as the "creative" producer, because he or she will be involved with all creative aspects of the project and in conjunction with the director and the studio and/or financiers, will have significant input on the

script; cast and crew selections; production design; wardrobe; location selections; editing; musical score; marketing and so forth. This person will often be the one who acquires the rights to the story or screenplay and develops the material until it's ready to shop. He will most likely be the one who sells the project to a studio or possibly raises the necessary funding. He'll establish the legal structure of the production entity, sign all union agreements and contracts, function as liaison between the production and the studio and be responsible for delivering the completed film. Working closely with the director, he walks a tightrope, striving to protect the intentions of the writer and the vision of the director while balancing the fiscal constraints of the production's schedule and budget. The feature producer is the ultimate *buck-stops-here* person—the one who must answer to everyone for everything, but . . . he's also the one who gets to collect the Oscar® when the film wins an Academy Award. If you'd like to find out more about the job of a producer, pick up a copy of Buck Houghton's book *What a Producer Does—The Art of Moviemaking* (Silman-James Press, Los Angeles) and/or Myrl A. Schreibman's *The Indie Producer's Handbook—Creative Producing from A to Z* (ifilm Publishing).

Television producers come in many varieties. A line producer is the individual responsible for making sure a show is completed on schedule and on budget and for overseeing all "physical" aspects of the production. Staff writers and story editors have, for a while now, been given producer credits as have (in many instances) post production supervisors, who at one time were given the title of Associate Producer.

Co-Producer

On a feature, the Co-producer is often another title for the Line Producer (the definition of which is stated below). This credit could denote a less-established producer who, the first or second time out, must take a lesser credit or share responsibilities with *the* producer. It could be the lead actor's business partner or manager who comes with the package or the person who sold the rights to the property to begin with—even though he or she may have never produced before.

Line Producer

A Line Producer is also referred to as the "nuts and bolts" guy (or gal), the producer's right-hand person and the budgeting-scheduling expert who supervises all administrative, financial and technical details of the production—a distinct challenge, no matter what the show's budget or genre. This individual is responsible for all the day-to-day matters that go into keeping the show running smoothly, while striving to make sure it remains on schedule and on budget. The line producer functions as liaison between the crew and the producer and is also answerable to the studio exec (or completion bond company rep) assigned to the show. He has to have keen people and negotiating skills and be proficient at putting the right team together, putting out fires, making decisions on a dime and walking a tightrope while balancing the director's vision, budgetary considerations, the studio's concerns, union and guild regulations, the cast and crew's needs, comfort and temperament, the weather, the right locations and countless other details. Whether it's changing and re-changing the schedule to accommodate an actor's other commitments, finding ways to keep a tired crew's morale up, figuring out how to fill a stadium with people when you can't afford to pay for that many extras, knowing how to make one location look like several, or attempting to reduce the budget so the picture can be shot locally instead of having to take it to another country—it's an extremely pivotal position. And while the duties of a line producer are rarely as ambiguous as are other producing categories, the exact screen credit a line producer receives can occasionally be confusing, especially with the recent trend of giving line producers executive producer credit.

Post Production Producer

The title of Post Production Producer has been popping up on feature screen credits lately, but it's still a rare occurrence and is generally only given to those who make a significant contribution to a film. Previously, these individuals would have been given an Associate Producer or Post Production Supervisor screen credit.

At one time, there was no designation of line producer, only a production manager (or unit production manager or UPM) who performed most of the same functions. Today, a UPM can also be a line producer, although on many pictures, you'll find a line producer *and* a production manager with the production manager reporting to the line producer.

Associate Producer

Associate Producer is probably the most nebulous title of them all. It could denote someone who makes a significant contribution to the production effort, or it could be the producer's nephew. It could be the person who brought the producer and the financier together or a producer's assistant who has recently been promoted. At one time, an associate producer credit on a television show signified that that person supervised the post production, but that's not always the case any longer.

Production Management

I wanted to address the category of production management, partly because it's what I know best, and because I happen to think it's a terrific part of the business to be in.

Production management is another term for physical production. It encompasses the studio and production company execs (mentioned earlier in this chapter) who supervise the freelancers working on their shows and also those who are (back to that term again) "in the trenches": the line producers, UPMs, assistant directors, production supervisors, production coordinators (also referred to as production office coordinators or POCs) and assistant production coordinators (APOCs).

In a nutshell, the production department is a "service" department that handles the logistics for the entire company. It's the ever-so important spoke of the wheel that enables everything else to keep turning and happening. It's exhaustingly hard work and not considered creative or glamorous by any stretch of the imagination, but it's fast-paced, challenging and satisfying. And as in most

other freelance positions, there's always something new to learn, new people to meet and work with and new locations to travel to. Production is the behind-the-scenes office responsible for dispersing all pertinent information, making sure everyone involved has what they need to do their job and of ensuring that everyone and everything arrives on the set each day—on time and prepared. Production is responsible for preliminary budgeting; scheduling; negotiating for and securing a crew, locations, equipment and all outside services. They generate and distribute scripts, script changes, schedules and a plethora of other essential paperwork. They make sure all contracts and releases are signed and handle all issues relating to insurance, unions and guilds, safety, product placement, clearances and local, distant and foreign locations. Like a band of gypsies, they're used to setting up mobile and/or temporary, fully functioning units and offices almost anywhere and in no time—experts at transporting entire shooting companies to and accommodating them on just about any location in the world.

Production also tends to the comfort and needs of its cast and arranges for all cast member perks—all those extra goodies listed in their contracts (some of which happen to be the size of small phone books), such as extra-wide "popout" trailers, cell phones, TV/VCR/DVD players, microwave ovens, special food, transportable gyms, personal trainers—and the list goes on.

Unit Production Manager

The line producer is described above; and as mentioned, the UPM has very similar responsibilities. Generally the one to prepare the first complete schedule and budget, she must function as a troubleshooter and problem-solver, think on her feet and have the ability to anticipate problems before they occur. She needs to be a good negotiator and thoroughly understand the production process, because she's the one who makes the deals, hires the crew and approves all expenditures, time cards, call sheets and production reports. Good people skills are a tremendous asset to a UPM, as she must routinely interact with the entire cast and crew, a myriad of

vendors, agents and managers, union reps, studio executives (or investors and bond company reps), film commissioners, etc. She's quickly blamed when something goes wrong, not always appreciated when things go well and is well known for having to say "no" more often than others care to hear it. Having to work closely with each department to stay on top of what and how everyone's doing and to make sure they all have what they need, she's also under constant pressure to control or cut costs. It's quite a balancing act, and one must be diplomatic, creative and adept at finding compromises to do it well. And although her capabilities must be multifaceted, the skill most valued by a studio is a UPM's ability to keep a show on (or under) budget.

First Assistant Director

A First Assistant Director is the Director's right arm and the liaison between the Director and the crew. He's the one who, once all final determinations are made during pre-production, prepares and issues a final shooting schedule and a selection of breakdowns (schedules of extras, stunts, special equipment, picture vehicles, etc.). The First AD is instrumental in setting the director's pre-production schedule, and in conjunction with the director and UPM, oversees the survey and selection of shooting locations. During principal photography, the First runs the set, is largely responsible for ensuring that each day's work is completed, directs background action and supervises crowd control and is the one who yells "Quiet on the set!" On episodic television where the directors constantly change, the First AD has a great deal of input and more of an opportunity to shape the outcome of a show.

Second Assistant Director

During pre-production, the Second Assistant Director works closely with casting, extra casting and locations; goes on tech scouts ("technical" scouts are when specific department heads are taken to selected location sites to ascertain requirements needed to prepare for shooting at that location); helps with breakdowns and

clarifies all needs in as much detail as possible. She makes sure everything is ready, call times are issued and all paperwork is in order and packed for the set. During principal, she's responsible for the cast, stand-ins, extras and photo doubles, making sure they're where they're needed when they need to be there. She takes care of all on-set paperwork, coordinates the schooling of minor cast members, works closely with casting, liaisons with the production office, issues work calls, checks cast members in and out, orders extras and supervises the second, second assistant director, PAs and interns working under his supervision. A Second's rear rarely sees the top side of a chair. They're the first ones to report to set at the beginning of the day, the last to get lunch and the last to leave once wrap is called.

Second Assistant Directors usually move up to become First Assistant Directors. Some Firsts are perfectly happy to retain that position throughout their entire careers, because when working on a fairly regular basis, the salary and benefits are terrific. Those who do move up tend to become UPM/line producers, producers, second-unit directors, directors and production executives. Working as an AD is a great way to learn while amassing an extensive network of contacts.

Production Supervisor

The production supervisor isn't a traditionally standard position, but one that is continually gaining acceptance. This person is more qualified than a production coordinator, but not being a member of the DGA, he can't work as a UPM on DGA-signatory films. On some shows, the line producer and UPM are one and the same, and the supervisor helps to handle the production manager duties. Other shows are busy enough and spread out enough to use the talents of both a UPM and a supervisor.

Production Coordinator

The production coordinator sets up and runs the production office; hires and supervises the APOC and other office personnel; inter-

faces with each department head and assists them with all their needs; helps the UPM by checking availabilities and assembling the crew; obtains bids on equipment and services; places orders for film, equipment and special services; handles all distant and foreign location travel, accommodations, shipping, customs and immigration matters; makes sure all paperwork and information is generated and disseminated in a timely manner; liaisons with the set, the studio, the vendors, film commissions, agents, casting, etc.; handles all production-related insurance matters; oversees the "taking care of" the cast, making sure their perks are arranged for and ready on time; coordinates the screening of dailies; and prepares SAG contracts for day players, stunt players and anyone else whose contract isn't generated by the project attorney or casting office. The coordinator definitely has to be someone who enjoys multitasking, is super organized, detail oriented, patient, diplomatic, can anticipate the next step and be prepared, is good at problem-solving and has the ability to pack up his life and office on a moment's notice and move to the next location. It's a tough and often thankless job, but it can also be rewarding. Having done it for years, I always enjoyed putting all the little details together and watching everything come together. I loved taking care of "my" crews, being challenged, having to learn new things with each new project, negotiating good deals, constantly being exposed to new people and new experiences and feeling a great sense of pride from knowing how good I was at my job.

The following chapter continues to touch on a variety of interesting career options. Keep an open mind and learn all that's out there before choosing your path.

— 5 —

Some Other
Interesting Choices

> *"If the career you have chosen has some unexpected inconvenience, console yourself by reflecting that no career is without them."*—Jane Fonda

This chapter will offer you some additional diverse and fascinating career choices, which I describe with the help of some friends and colleagues. This may seem like an arbitrary list, and I suppose it is. But then again, I can't provide you with information on every job that's out there. There are hundreds. This is just a sampling of some of the careers I find particularly interesting. Hopefully, some of these will whet your appetite and prompt you to learn more.

Post Production

Post production is the process of assembling and completing a picture. It begins during pre-production with the preparation of a post production budget and schedule, the lining up of crew and facilities, and the planning of arrangements that must be made for any necessary special processes. Once a film has been edited, the remaining components (inserts, pickup shots, sound effects, foley, music, ADR or "looping," titles, opticals and visual effects) are assembled ("mixed") to complete the picture.

In addition to the executives who run the studios' post production departments and their in-house staff, freelance post supervisors and

coordinators are often hired for specific projects, sometimes handling multiple shows at any one time. Many of the same qualities that would make a production manager, supervisor or coordinator good at their jobs would apply equally to a post supervisor or coordinator: someone who's organized; can juggle multiple balls in the air at any one time; is adept at working with a variety of people and personality types; is skillful at budgeting, negotiating deals and solving problems, and someone who enjoys the process of assembling all the pieces and watching a TV show or movie come together. An effective post professional must also possess a thorough understanding of the process as well as a sense of objectivity. Post supervisors don't generally travel as much as their production counterparts, but some find themselves traveling when certain post processes are done at out-of-town facilities or for test screenings.

This is an administrative position that can at times be quite creative, because knowing how and when to add certain elements into the mix can make the difference between a good and a really good finished product. For many years, my husband Ron was an associate producer, handling the post production on episodic television shows. I can still remember a call he received one night from a director thanking him for having saved his show. Ron had taken a show the director thought would be mediocre and turned out a finished product that was instead being praised. It's a great feeling of satisfaction when you know you can make that type of contribution, whether you receive the acknowledgment for it or not.

My friends Nick and Cory McCrum Abdo are also both longtime post professionals, Cory being a post producer, and Nick, a producer who has spent much of his career overseeing post. Cory started by working in a cutting (editing) room, and Nick's post education started by watching dailies and sitting with an editor on his first episodic television show. Both of them strongly believe that the cutting room is the best place to start learning this end of the business.

Cory is nothing if not animated when she talks about what she does. She's proficient at logistics and budgeting, has got terrific management and people skills, is fiercely protective of her post

team and has a tenacious I'll-do-whatever-it-takes-to-make-it-work sensibility about her job. Being a "giver" by nature, she enjoys assuming the role of rescuer, solving problems and taking on innumerable daily challenges. She's enjoyed being able to travel to and work in some wonderful places (often taking the entire family along), but she says the very best part of it all is, after pouring her life's blood into a project, the satisfaction she gets from seeing the film completed and on the big screen. Similarly, Nick loves sitting with an audience and listening to them laugh in all the right places—and listening to the silences in all the right places. The worst parts for both of them are the endemic issues of politics, working with difficult people and the lack of family time with each other and their daughter.

Studio post jobs and freelance post supervisors and coordinators aren't the only positions in this field. This aspect of the industry encompasses music supervisors, visual effects supervisors, editors, assistant and apprentice editors, sound and music editors, negative cutters, re-recording engineers, projectionists, foley artists, ADR talent, title designers and all the jobs found within service providers such as laboratories, sound houses, optical houses, transfer facilities, screening rooms, equipment rental companies and facility rentals (editing bays, recording studios, offices, ADR and foley stages, mixing stages or suites, etc.).

For a better understanding of the post process and descriptions of various post positions, check out the insightful book my friend Susan Spohr wrote with her friend Barbara Clark, *Guide to Postproduction for TV and Film*, Second Edition (Focal Press). Also note the section on music farther ahead in the chapter that includes music and sound-related post jobs.

For those wanting to start off in this field, you might consider trying to find a position as an apprentice editor or an entry-level job at a major post production facility (such as a lab).

International Distribution

I find this end of the business fascinating, and it's the perfect career for a movie lover who's always wanted to be a diplomat or get

involved with some form of international relations. A foreign sales company or the international department of a studio or distribution company is responsible for the international launch/festival participation of a film along with the marketing, sales, delivery and collection of the film, television and video productions ("titles") it represents. If you were to work in this facet of the industry, you'd most likely be spending a great deal of time on airplanes and in airports, traveling to various countries and cities around the world (depending on the "territory" you cover). You'd also be attending international film festivals and markets throughout the world (Cannes, Toronto, Shanghai, Rio, Sundance, etc.) and interacting with people from all walks of life. Sounds pretty good to me!

I have a cousin named Michael J. Werner who's a veteran of the foreign sales business and co-chairman of Fortissimo Films, which is headquartered in Amsterdam and Hong Kong. I asked Michael for his thoughts on what sort of person would do well in this profession and what those interested should know about the field. The following is what I learned from him.

An international background and/or an MBA would be highly desirable, and you should be someone with an open mind, an international perspective and a relatively well-developed level of sophistication, culture, politics and history. Big Hollywood egos aren't a good match for this type of work, and you have to be equally adept at talking *and* listening. When dealing with 80 to 100 different countries, it's not likely you'll know more about your buyers' own markets than they do; and successfully pre-selling films not only requires a certain amount of humility but also the ability to create strong business relationships and generate a great deal of trust. Michael claims you have to be what he calls a "zen diplomat." A keen knowledge of business with an international focus would be extremely helpful, as would speaking more than one language.

Should you have the education, background, and the desire to get into this end of the industry, you could apply at any of the studios' international divisions, but getting in with a smaller, independent "boutique" company would most likely afford you the opportunity to get more involved, have more responsibility, learn

more and advance faster in a shorter period of time than you would working for one of the majors. For a comprehensive list of companies to contact, Michael suggests checking out The Independent Film & Television Alliance (formerly The American Film Marketing Association [www.afma.com]) to get a list of their 150 or so member companies. This is a terrific resource for sending out resumes and setting up general information meetings.

When I asked Michael my two favorite questions—what's the best thing about what you do and what's the worst, this is what he had to say:

"For me, the best thing has been the opportunity to interact with film industry professionals from around the globe. By attending numerous international markets and film festivals and meeting with filmmakers, other distributors, journalists, festival program-mers, critics and all manner of related professionals, I feel I've been able to achieve far greater insight into our common humanity than I otherwise would have found in any other profession or industry. As for the worst, it's the interaction with people who gain a certain measure of success (which sometimes comes very rapidly in this business) and then forget how to act properly and treat other peo-ple who may not be as fortunate or as lucky as they are."

Unit Publicity

My friend John Pisani has the coooooolest job. He's a unit publi-cist. If you enjoy keeping up with the latest on who's who and who's hot, if you enjoy creative writing and interviewing people, if you're outgoing and social and want to be in the thick of it—this might be the career for you.

John is assigned to one film at a time and remains with the shoot-ing "unit" throughout principal photography. He's in charge of coordinating all the publicity for the film, its actors, producers and director; and that covers all electronic, print and online press as well as any special events relating to the show. What makes John so good at what he does is his ability to multitask and interact with a diverse group of personalities in various situations in a way that allows everyone to feel comfortable with how the publicity's being

handled as well as the end result. He has this innate ability to know when to push for what he needs and when to back off and wait for a better time to approach. While John isn't required to interact with the entire crew, he does it anyway and spends quite a bit of time on the set each day. Becoming part of the crew and watching and understanding everything that's going on earns him ample credibility, so that publicity isn't treated as an intrusion, and it's easier for him to accommodate press requests for on-set interviews.

To do this job well, you have to have the ability to write—and write creatively—because your mission is to find any and all ways to make the picture you're working on sound as if it's the most interesting, exciting, scary, romantic, gripping, funny film that's ever been made. You have to be able to roll with the punches and not stress out (at least on the outside). And you'd be well served to keep up with industry news and events, as well as current and past film projects. (It would say a lot about you if you were to run into some bigwig at an industry party and be able to congratulate him on his new deal.) You should also possess a firm grasp of the "players," knowing everything possible about the actors, producers and directors you're working with or may be working with in the future. And you have to enjoy networking, setting up and attending social events.

Entertainment publicity comes in many forms. One can work for a PR agency; within a studio publicity department; as a publicist to actors, producers and/or directors or in a corporate environment handling special events. If you can land a position as an intern or assistant within any of these venues, you'll have a good place to start. If you'd like to move into unit publicity, start building contacts with actors, producers and directors or internally within one of the studios.

John claims that the best thing about what he does is that each movie presents completely new challenges and new experiences. He loves the variety, getting to interact with extremely creative people and having the opportunity to build relationships with the key decision-makers in the industry. The hardest is that there are no rules, no set standards for what he does, so what works on one show won't necessarily work for another. In other words, the logi-

cal answer isn't always the right answer. He also comments on the stamina it takes to work the long hours and to always be on call. If anything even slightly newsworthy should occur on any of his shows, he's the first one called upon to make a statement.

Publicity isn't an easy end of the business to get into, and once in, it's particularly demanding—but overall, I still think it's one of the coolest jobs around.

The Script Doctor

A script doctor is also referred to as a script consultant or script editor. It's someone who reads other people's screenplays and assists in "fixing" them, so they're ready to take out and shop. Fixing a script generally entails identifying inconsistencies in characters and dialogue; making sure the story stays on track and flows properly; making sure it's formatted, punctuated and spelled properly and that it works. A script doctor will charge by the page (and sometimes by the hour) to tell you what your script could use and then make suggestions as to how to correct the problems. Some are paid additional fees to actually do the fixes and rewriting for their clients, while many clients make the changes themselves and then resubmit the revised version for a final evaluation.

This line of work could be a good fit for writers who want to earn extra money while waiting to sell their own material or for individuals who don't feel inspired or talented enough to create their own screenplays but who have an innate sense of story and enjoy working with and helping writers. To do the job well, one should be an avid reader; understand proper story structure; have a good sense of flow; a thorough understanding of story and character development and good language skills. Having good language skills, however, isn't limited to proper English but also to the dialect that fits specific characters within a specific script. To further be able to help their clients achieve the product they need, a script doctor should also know what's commercial and which buyers are looking for which types of projects.

Sharon Espinosa classifies herself as a script editor. She started by helping friends with their scripts, and word of mouth and

several recommendations later, she was running a full-fledged consulting business. Sharon says that when she's evaluating a client's script, she imagines living each scene as she's reading it. And she spends quite a bit of time with the writer as well, wanting to know where he's coming from, how passionate he is about his project and how open he is to changes and suggestions. She said the worst part of the job is working with someone who's resistant to change. The best part is when a writer realizes the potential for his project is much greater than he thought possible; then later, once it's ready to take out, when the project is sold and produced.

People who start off as script readers or assistants to producers often become script doctors. If you're good at it, then like Sharon, start by helping friends. The word will get out, and you'll be on your way.

The Educator

Educating future filmmakers is a part of the business I thought little of before I became an instructor. In fact, before I started teaching, I wouldn't have even considered it part of the business. But it definitely is. One evening over dinner, I had a chance to discuss it with Duke Underwood, who teaches at USC's School of Cinema-Television and is also the creator and director of the summer program there. When he's not at school, he manages to squeeze in a few months each year to work on his own film projects, which he writes and directs. Duke has been doing this a whole lot longer than I have, and I wanted his take on educating filmmakers.

Duke was greatly inspired by a teacher he once had who created a spark and made a big impact on him. He now strives to do the same for others and is fortunate enough to be able to do so within an arena that encompasses his love of movies and filmmaking. He works closely with all his students, as well as all those who register for summer classes, planning carefully, staffing properly and designing classes that offer a professional filmmaking learning experience in a supportive environment. He doesn't just shuffle the students around, but is there for and available to them at anytime. He's warm, caring and helpful. He puts in extremely long hours and the red tape and politics are what one would expect at

any major university, but the positives far outweigh the negatives as he describes his job as "enriching!"

I know the feeling well. As rewarding as working on a film can be, it can also be (and often is) extremely draining. Teaching, on the other hand, fills me up in a way that's difficult to explain. All I know is that it's one of the most gratifying things I've ever done.

When teaching, you constantly have to stay on top of the latest industry news, views, films, books, trends, players and technology, so you never stop learning. Another terrific aspect of the job is the opportunity to design your own course. I was thrilled at the chance to create my one class, and Duke's been designing classes for some time now. In fact, he says it's the best thing about his job. He makes sure each class satisfies university guidelines; endeavors to offer new, challenging and innovative courses for the students, and at the same time, slants the focus of each course to his interests. Mutually beneficial to him and his students, it's still a way to feed his own passions. While teaching various aspects of filmmaking, you're surrounded by the process, talking about it, brainstorming with bright students to come up with new concepts and ideas, getting involved with student productions, bringing in (and networking with) guest speakers to interact with the class and surrounding yourself with creativity and potential.

To teach any aspect of filmmaking, a college degree and/or a certain amount of practical experience is necessary. You should be organized, patient, diplomatic, a people person and someone who can look beyond the big picture to make sure all the small details are in place. You should enjoy working with and influencing young people and aspiring filmmakers and be able to share their passion and take pride in their accomplishments. Above all, you should enjoy sharing, giving and teaching.

You won't get rich, but this is a steady, rewarding career and a significant component of the industry.

Music

This is a part of the business I've had little exposure to but have always imagined it to be extremely creative and rewarding.

Wanting to know more, I spent some time talking to Michael Brooks. Michael is currently head of production for Rafelson Media, but the majority of his career has been spent in music. Michael has been a music producer and mixer for much of his career, and he equates this position to that of both a producer and director on a film. The music producer is responsible for absolutely everything, up through and including delivery of the master recording. He said a producer can be as hands-on or -off as he'd like, depending on how much he chooses to delegate; and he's generally the one who matches the right songs to the right talent, oversees recording sessions and sometimes even joins in by playing an instrument (or most of the instruments). Often the producer is also one of the songwriters on the project. He added that the process of recording can be much more intimate than making a movie, especially when it involves just the producer, talent and engineer.

Most producers work as independent contractors, although some are on staff at record and music companies. Some take the artists they've discovered (and/or produce for) to recording companies ("labels"), attaching themselves to the deal along the way. Others have their own label and get the recordings out on the market via record distributors.

Michael's advice for those who are interested in music producing is to be prepared to supplement your income for quite a long while. With the availability of songs on the Internet and the subsequent decline in CD sales, the recording industry has been steadily declining the past couple of years; and it's harder than ever to break in. He's hopeful, however, that this trend will eventually start moving in the opposite direction.

As for the path one would take, Michael suggests having as much musical experience and education as you can get. Being a musician (especially the ability to play the piano or keyboard) is helpful, because then you speak the right language. Also, know the technology. Take recording workshops and learn as much as possible. You could get your foot in the door the same way you would on a film or at a studio by taking an internship or entry-level position at a recording studio or a studio music department. The most important thing is to meet and network with as many people as you can.

I asked Michael what he loved most about this end of the industry, and his reply was "I just love the music and have appreciated all the opportunities I've had to work with great talent. And then there are those special magical moments in the studio I'll never forget [at this point, he starts speaking slower, and his voice lowers to an almost whisper] these moments are as close to a spiritual experience as I've ever had." The worst part? "Everything else *but* the music—the big egos, the politics, etc."

With reference once again to Susan and Barbara's book, *Guide to Postproduction for TV and Film*, the following are definitions of music and sound-related positions that are part of the post process on films and television shows:

- Composer: The person who writes the original music used in a film or television show. (The music is physically produced by either hiring a group of musicians and recording on a sound stage or by using electronic instrumentation [called "electronic scoring"], which can be done out of the composer's home or a small studio.)
- Sound Design Supervisor (or "Sound Designer"): Responsible for supervising the creation of the final sound elements that make the finished soundtrack.
- Music Supervisor: Coordinates the creation of the musical score, prepares the visual materials and cue timings for the composer, supervises the music mixdown for the dub, coordinates materials for the sound mix and recommends and purchases prerecorded music material.
- Music Editor: Prepares and cuts the musical score and purchased musical cues.
- Music Coordinator: Coordinates the purchase of prerecorded music cues and assists the composer with the duplication of sheet music and other administrative duties. The person who performs these duties may also be the Music Supervisor.

Careers in music can indeed be extremely creative and satisfying, but it appears to be a tougher arena to break into than some other facets of the entertainment industry. So if you're determined

to give it a shot, you'll need an extra dose of passion and resolve to get you there.

Commercials

Similar to television and feature production in many ways, commercial production is also very much a world unto itself. While there are individuals who have the ability to jump back and forth between the two realms, many choose to build their entire careers within this fast-moving industry. Production schedules are much shorter, crews are smaller and salaries are generally higher. The paperwork is similar yet different, and instead of studios and networks, you're dealing with advertising agencies and clients. A commercial starts with a client who hires an advertising agency to promote their product or service, and the agency decides to include at least one commercial spot as part of its advertising campaign.

My friend Christine Evey has been a commercial producer for years, and she's one of the best. She explains that commercials are like tiny movies, only much faster and more intimate. You're on any one project from two weeks to two months, and working on such a tight schedule, you've got to be extremely organized, because there's less time for error. A great number of variables must be taken into consideration, things happen quickly and at any one time, something can easily go wrong. It's a fast and furious environment, and you have to be able to make decisions on a dime. Commercial producers are responsible for virtually everyone and everything on a commercial film set. The best of them remain calm under all circumstances as they tend to be the first person everyone seeks out to resolve problems, to vent, or sometimes, just for a sympathetic ear.

The qualities you should possess to do well in this position are the ability to hide any concerns or fears and handle the stress; diplomacy; major people skills; excellent management and creative problem-solving skills; a proficiency in budgeting and an understanding that complaining is not an option. You need to be ultra resourceful (just figuring it out) as the word "no" is only a last

resort. You must be prepared with an alternate solution or be extremely resolute when there isn't one to be had. Christine amazes me in the way she can set up a commercial production unit anywhere in the world and assemble a terrifically talented crew on what seems to be a moment's notice. She warns that it can be a thankless job, but an exhilarating and addictive one. From my perspective, she stands out among the crowd. No matter what type of project she's working on, Christine is gracious and respectful of everyone around her, whether they're advertising "creatives" or PAs. She gives of herself, doesn't take anything or anyone for granted and is immensely appreciative of her entire team. I am also inspired by the way she unselfishly steps out of the spotlight to let others shine.

The way to start out in this field is to land a job as an intern or PA on an individual commercial or with a commercial production company. Christine suggests that you offer your time for free on your first job. Her advice is to get in and show them how indispensable you can be, and then stay that way, adding that there are always others who would be thrilled to take your place. She also recommends remaining a PA for at least a year, enough time to get grounded, get the lay of the land, figure out which ladder you'd like to climb and make some valuable contacts.

Reality TV

Talk about fast and furious. I don't know if commercials have anything on the frenzied pace of Reality TV. I've only worked on one Reality TV show, which was a 2003 pilot that was never picked up, but I've spent time since then discussing the experience with my friend Matt Kutcher, who's the one who talked me into doing it with him to begin with.

The terminology and paperwork were slightly different than what I was used to, and it reminded me of low-budget guerrilla filmmaking, a kind of fly-by-the-seat-of-your-pants operation that's very unstructured. Matt calls it "controlled chaos." Given its very nature, you can only schedule and prepare for so much in

advance. Whether contestants are placed in everyday situations or in foreign environments, they ultimately find themselves dealing with extraordinary circumstances. An extreme rivalry is created, and the conditions participants are thrust into evoke the best and the worst in their natures, including an entire range of conse- quences and emotions (tragedy, comedy, drama, frustration and/or triumph). This might make for popular television, but it becomes impossible to predict, script or plan for what's going to take place or when those pivotal moments are going to occur. One can script some portions of some reality shows, but there will almost always be unknown variables that can't be anticipated until they happen.

Because they're all so different, schedules vary from show to show. The easier game show types may take less than a day to shoot, while another show might require 100 hours, or possibly a week, of shooting. Sometimes you're working with one camera crew, and sometimes, multiple camera crews are all shooting at various times of the day and night. The hours are long and salaries tend to be lower in comparison to other television shows or films.

I think this style of production is best managed by young people with endless reserves of energy and a tremendous amount of resiliency. To produce this kind of show, you also have to be a "big picture"-type of person and not get too caught up in the small details, or you'll miss the all-important moments. And because you can't be everywhere at once—nor is there time to microman- age others—you have to build a strong support team and trust the people around you to do their jobs. You have to have an assertive personality, be able to make reasonably sound spur-of-the-moment decisions, have good communications skills and be able to roll with the punches.

I personally prefer working on a more structured type of show, but reality shows have been quite popular for the past few years and show little sign of disappearing. They've provided substantial job and advancement opportunities for many and are ideal for those who find the frenetic pace and unknown nature of the work challenging and exciting. Reality TV certainly has the ability to

provide those so inclined with some fairly intense adrenaline rushes, both behind and in front of the cameras.

Casting

In simplistic terms, casting is the process of searching for, recommending, interviewing, setting up readings for and negotiating deals to secure the principal cast members on any given production—the term "principal" referring to those actors with speaking parts. Casting personnel work closely with actors, agents, managers, producers, directors, studio executives and assistant directors. They're always on the lookout for new talent and creative suggestions to bring to the decision-makers' table. Those making the final casting choices would include any or all of the following: director, producer, studio or network executive overseeing the project and sometimes (depending on the part), the casting director.

I spoke to casting director Susan Johnston, and in her view, a casting director has to understand the unique needs of each individual and be innately adept in psychology, whether it's in dealing with actors or their gatekeeper—agents and managers. She said the challenge is often in having to figure out why certain roles would be great for certain actors, and then having to sell them and their agents and managers on accepting the roles, all the while anticipating their needs before they even know what they are themselves. I asked Susan what qualities would make someone good at this job, and she said, "Someone who loves people, can see outside the box, is intuitive and dedicated and doesn't mind the long hours." Her favorite part is the joy she derives from connecting with people in a way that offers them their "15 minutes of Andy Warhol fame"; also discovering talent and seeing them come to life artistically with a team (director, producer, other actors, etc.). She loves choosing an "outside of the box" person for a role and gets a thrill out of helping talented actors get into SAG. I asked her about the worst part of her job, and she told me about the time an actor showed up at her front door (which wasn't easy being that she lives in a security building) at 7:00 p.m. on a Saturday night to

give her his headshot. He handed it to her with an air of entitle-ment, because he thought he was perfect for a role she was casting and the sooner he got it to her the better it would be for him. She calls this the "oooohh factor," when an actor thinks if he sees a cast-ing director in person, she will notice his greatness and get him an acting job. She said casting directors are looking for actors to be themselves, to use common sense and to be team players. She added that protocol and professionalism go a long way.

Some companies employ in-house casting executives, but many casting directors work on a freelance basis. Getting a job as an assistant in a casting office is a great way to learn this end of the business and to be in a position to move up.

Extras Casting

An often overlooked aspect of casting is the field of extras casting. Extras or "background" players are more than just a bunch of peo-ple milling around your principal characters. They create a back-drop, one more visual element of the film the viewer is drawn into. Hand-picking the people who realistically look as if they belong there and will completely blend into a story is in itself an art form.

Any one of numerous extra casting agencies supply films and television shows with their background players, stand-ins (indi-viduals used to "stand in" for principal actors for the purpose of focusing shots, setting lights, etc. but are not photographed) and photo doubles (individuals who are photographed as substitutes for principal actors, generally in long shots or from angles where faces aren't clearly seen). Once an agency secures a show, it will assign a staff casting associate to oversee the project.

At any one time, an agency may be handling one to multiple shows, supplying anywhere from a handful of extras to a stadium full. Agency coordinators will meet with members of respective production teams to discuss the number and types of extras needed, as well as the "look" envisioned by the film's creative team. This is followed by the submission of photos for considera-tion and a selection process by the director.

Once principal photography begins, the agency receives their "call" the evening before, confirming the number of extras needed and the times and location of where they're to report. Unfortunately, call time information is always subject to change, so it's not unusual for the casting coordinator and staff to have to contact and recontact (and sometimes recontact again) the few (or thousands) who are scheduled to work the following day with revised call times.

In addition to lining up new shows, casting and making sure booked extras receive all their necessary instructions and call times, the agency registers thousands of new extras a year. Whether it's a huge agency or a smaller "boutique" agency, they're all tremendous hubs of activity. And, many extras casting directors and coordinators also work on-set, away from the office, checking in and wrangling extras during the course of a shoot. Others travel with production units, setting up temporary casting offices on distant locations.

Like many other aspects of the industry, extra casting is exhausting work. You have to love working with people of all personalities, have a great deal of patience, be able to roll with the punches and above all, have that "eye" for placing the right people in the right shows. My friend Bill Dance, who has been an extras casting director for many years and has his own agency, has this advice for those interested in pursuing this career path: "A casting director has to have a real intuitive passion for people. Start off interning or assisting a casting director. If you immerse yourself in the casting process—learning everything you can—the work opportunities will present themselves."

Continuity

Someone who does continuity is also known as a script supervisor. A script supervisor is a one-person department who works on a set at the epicenter of all that's going on. This person's primary job is to match movement, dialogue, props and often wardrobe, hair and makeup from one take to the next and one scene to the next, even though two consecutive scenes may be shot weeks apart from one

another. He times each take with a stopwatch, records the type of shot (establishing, two-shot, over-the-shoulder, close-up, etc.), the camera lenses used and takes copious notes for the editor, his "lined" script being the blueprint for editing the show. The script supervisor usually sits next to the camera. He lets the director know how each scene is running time-wise and helps to make sure that each has been properly covered. He runs lines with the actors and often fills in for an actor by reading dialogue from the other side of the camera as another performer is being photographed in a close-up shot (thus allowing the first actor to retire to her dressing room or leave for the day and "get off the clock").

The script supervisor also generates a daily report and a daily log. The report indicates the shoot day, crew call, first shot of the day, time spent at lunch, first shot after lunch, last shot of the day, camera wrap and scenes, pages setups and minutes completed. This report is submitted to the second assistant director and used in completing the daily production report. The daily log is for the editor, and it's a record indicating the camera rolls used, scene numbers, take numbers, timing of each take, camera lenses used, page count of each scene shot and a shot description list. Lots of detail, lots of things to keep track of.

To do this job well, you have to have a good eye and a good memory, be extremely detail oriented, organized, good at multitasking and politically adept at dealing with diverse personalities. You should also have a good working knowledge of what everyone does on a set, as you'll be interacting with many other departments.

The best way to become a script supervisor today is to start by taking a course. Just make sure it's a reputable school, and get references from past students if possible. You'll also want to network with other script supervisors, who for the most part, are good about sharing tips.

The hours are long and your work isn't done at wrap, as you generally still have notes to complete for the editor; but for someone who wants to be in the thick of it and involved with every shot of a film, this is a terrific job.

I wanted to be a script supervisor at one time and a wonderful script supervisor-friend, Lloyd Nelson, let me shadow him on a

show he was working on. After he'd finish his notes at the conclusion of each take, he'd quiz me: "On what word did that actor remove his glasses?" "When did he set down his beer mug?" In one exterior scene, an actor was dunked in a water trough, and the next day, he was filmed walking into the building. At that point Lloyd asked, "How wet is he supposed to be?" You really have to pay attention and have this innate ability to take it all in. My career as a script supervisor never panned out, but I always admire those who do it well.

Lloyd has done everything from episodic to several years' worth of Clint Eastwood features. He started off as an actor and dialogue coach, but eventually wanted something more stable. He's retired now, but I asked him what his favorite part of the job was. He said he loved having the responsibility associated with a difficult and important job and the prestige that came from knowing he was good at what he did. He loved being right next to the camera and being able to work with top industry talent: the directors, actors, DPs, editors and all the other crew members, many of whom became life-long friends. The worst part was just the fact that he didn't have his own crew or department. There was no one to help him out, especially when he was just starting and mastering his craft. But master it he did, and then some.

Location Management

A location manager represents an entire film production and is generally the first person the outside world meets. His job is to help realize the director's artistic vision by finding practical locations where the company can shoot. If what the director has envisioned isn't available, the location manager often has the formidable task of selling the director on the merits of alternate sites. He has to know what constitutes a suitable location (entailing much more than mere physical appearance) and is able to do so based on his working knowledge of site fees, permits, regulations, restrictions, fire safety, security issues, insurance requirements and whether a specific property can accommodate an entire cast and crew plus extras, vehicles, equipment, a catering tent, etc.

A location manager has to be quite the politician. He must deal with the entire crew, location residents and property owners, their neighbors, film permit officials, film commissioners and representatives of various film, city and government offices. Depending on the circumstances of any one show, that list may include individuals representing railroads, hotels, private businesses, circuses, race tracks, theme and ballparks, schools, etc. His solid relationships, people skills and good reputation may make the difference between getting a last-minute approval on a permit, a date change on a location or the closure of a stretch of highway when needed.

Ever the ambassador, part of his job is to convince dissenting residents and store owners who don't want a film company shooting in their neighborhood to sign a consent release. He also endeavors to win over nervous residents and property owners who have qualms about having a film crew on their premises. Then, should the crew or any of the equipment being used cause damage to the property or the experience not go as well as the property owner had hoped, it takes a true diplomat to make sure everything is restored—the property as well as the relationship. His objective is to satisfy the property owners (knowing he can call on them again for another show) and make sure they don't leave the experience with a negative impression of film companies.

He has to be adept at negotiating, have the resources necessary to temporarily close down roads and major highways when necessary, figure out how to get entire film companies into remote shooting locations and be able to rearrange months of planning and permitting on a moment's notice when the shooting schedule changes.

The location manager spends a good part of the pre-production process in a car on his own or on "scouts" with the director, producer, production designer and first assistant director (and then later on "tech" scouts with various department heads once locations have been selected and secured). He spends more time out and about than in the office, and for some people, that's just the way they like it. And he takes a lot of photos of various locations to present as possible shooting sites. I've known several location

managers who, as a result, have evolved into avid still photographers. You have to have a good eye, so you can look at a building, a home, a street, a town, a cityscape, a view and know that it can be shot to look as if it belongs to another place in another time. That same good eye enables you to spot locations that until that time had only resided in the director's head.

I spoke briefly to my friend Ned Shapiro, who's one of the best location managers I know. It's Ned's feeling that not many location managers start off with this position in mind, but land there nonetheless. For those who might like to pursue it as a career, he suggests starting out as a PA and then seeing if the job appeals to you. He said it takes someone with a lot of patience, a sense of humor and a thick skin. What he loves most about what he does is working out of town occasionally. He loves meeting interesting people and learning how the real world works.

Studio Operations and Administration

My friend Jack Kindberg didn't start out with the goal of running a major motion picture studio; nor is it a part of the business one would traditionally go to film school to pursue. Jack just fell into it, and for the past several years, he's been President of Studio Operations and Administration for Sony Pictures Entertainment. He's been managing film lots for several years now—first the smaller Culver Studios, then both Sony and Culver and now just Sony. He's good at it and enjoys what he does. So what exactly does he do?

Overseeing approximately 20 different departments that employ somewhere around 250 people, he keeps the studio running efficiently while seeing to the needs of and providing many of the following services to the personnel and productions housed on the lot: stages, offices, screening rooms, equipment, set construction, set dressing and props, set construction, wardrobe, transportation, medical services, food services, an athletic club, a paint shop, etc. In addition to the 250 or so full-time employees, 75 more are brought in as needed, and some departments, such as security and food services, are outsourced. Jack's team advertises and rents

studio facilities to outside productions; they work closely with the community; provide studio tours; host special events; continually implement upgrades to stages, equipment and services and coordinate with the various studio divisions and groups to make sure everyone has what they need to operate.

All studios are different based on their size and whether or not they're a union lot. When Jack was managing Culver Studios (a much smaller lot), instead of 20 or so departments, they had eight. Instead of a mailroom that employs 30 people, the Culver mailroom employed one person to do the sorting, and someone from each department or production would stop by each day to pick up their own mail. Instead of the 250 vehicles the Sony Transportation Department houses, the Culver lot kept five vehicles. And instead of a permanent studio staff of 250, Culver had around 80. Overall, full-time jobs that involve servicing the studio or producer clients are more secure than the highly sought-after creative or physical production studio positions, and most of these employees work a sensible eight hour-day. Salaries will also vary depending on whether it's a union lot (and whether employees are union members).

Many of the studio departments are operated by craft employees, such as sound technicians, grips, electricians, etc., who have chosen to work in permanent jobs rather than freelancing on a show-to-show basis. As for those who work directly in operations and administration with Jack, many started out in other studio capacities and worked their way up.

What makes Jack good at what he does? Besides being a terrific manager and team leader, he's extremely customer service-oriented, understands production needs, is adept at negotiating, eager to help his clients and responds quickly to their problems. He said his job is different every day, and he enjoys meeting new people and watching all the new shows come in. He prides himself on his people skills and on being as fair as possible. I asked him how he handles highly political situations, and he said he tries to get people to understand other perspectives. And his advice for everyone: "Don't take your work home with you at night." Because he deals with a wide range of people from top corporate executives to

production personnel to PAs, he's astute, accessible and endeavors to meet everyone's needs while providing a safe, comfortable work environment for all.

This is rarely a facet of the business people clamor for, but more than anything, it's because they don't know much about it. It's challenging, extremely people-oriented and great for those who enjoy problem-solving. For those who are looking for more security within the industry, it's one of your safest bets.

New Media

I'm sure you've been hearing a lot about new media lately, and you may not quite know what it's all about. Brian Seth Hurst, Chairman of the Producer's Guild New Media Council and Governor of the Television Academy's Interactive Media Peer Group, finds it difficult to describe this burgeoning field in one sentence but says it's basically the use of digital technology as a means of telling and distributing stories and information. He said new technologies have spurred the creation of so many different platforms in which to deliver content—it's huge!

Platforms for new media would include interactive television, CDs, the Web, DVDs, wireless devices (PDAs and phones), console games and virtual reality experiences. It would encompass all types of video and arcade games, as well as entertainment-based informational and service-related interactive displays that can be found at museums, amusement parks and shopping centers (often called location-based entertainment, or LBE) and electronic kiosks (booths) that are like ATM machines and can be used for information or entertainment.

Whether it's using digital technologies to tell stories, educate or market and sell, the jobs in this field would involve DVD producing and authoring, creating program content, visual effects and digital animation, flash animation (for the Internet), interface design and computer programming. And for those interested in marketing, new media is a powerful tool in the advertising and launching of new films, products, businesses or even a cause. Carolyn Miller, author of *Digital Storytelling*: *A Creative Guide to*

Interactive Entertainment (Focal Press) says this is a creative and fun industry for writers. When I asked her about writing jobs in this field, she used the Internet as just one example, pointing out that writers are needed for story-based serials, games, animated stories, journalistic outlets, online magazines and promotional purposes. She explains that when you write for new media, whether it's for a video game, the Internet or other platforms, you're developing characters, writing dialogue and dealing with story structure and plot points in just the same way you would for more traditional venues, though some new skills are also involved. She said some writers take on the larger task of becoming content designers (or "info architects," as they're often referred to in informational or training projects), and are involved with the overall thrust of a project, whereas others may just be hired to write chunks of text, dialogue or clues. She said writers are needed for all forms of new media.

If you'd like to learn more about the field of new media, more colleges and universities are offering programs and internships in this field than ever before. And just start researching: check out books and articles, and do a Web search on the topic. I'd also highly recommend Carolyn's book, *Digital Storytelling*.

I hope this, as well as the previous chapter, has opened your eyes and started you thinking about the many different career choices within the realm of entertainment. I've only touched on a handful, but there are many, many more out there. Take some time to read, ask questions and explore what this business has to offer. Choose some options that fit well with your skills, strengths and interests, and then evaluate what it takes to get into those facets of the industry. Don't take the first thing that's offered without knowing what your options are.

— 6 —

Life Will Not Go According to Plan If You Have No Plan

"I always wanted to be somebody, but now I realize I should have been more specific."—Lily Tomlin

There's a dry cleaners about ten minutes from where I live, and they have a marquee out in front. But instead of displaying something like, "Tuesday's Special—Shirts Laundered & Ironed—99¢ ea.," they display words of wisdom. It was always interesting to drive by and read the platitude-of-the-week. Then one day, a few years ago, I was driving by, and the marquee read, *Life will not go according to plan if you have no plan*. To me, this wasn't the usual fortune cookie type of advice; it really struck a chord. Oh, I had been to seminars and read books that touted the importance of setting goals, but until this moment, I hadn't personally related this advice to *my* life. How often and for how many years had I let circumstances dictate my jobs and my career? Too long. And how often was I disappointed over an outcome I could have had more control over? Too many times. How often had I sat down and really made a plan for myself? Seldom. Why? Because in such an unpredictable business, I didn't know I could. For someone who considers herself to be fairly intelligent, I'm not sure why it took driving by a words-of-wisdom-touting dry cleaners to make me understand that even in this industry, there is power in planning and setting goals.

Finding Your Passion

> *"You have to have a dream so you can get up in the morning."*
> —Billy Wilder

Before you choose your goals and decide the direction you're heading, find your passion and define your dream. The road to get almost anywhere in this industry is laden with potholes, detours, traffic jams and rough terrain, so find a destination that excites you, or it won't have been worth the journey.

Take a few minutes, find a quiet place to sit, and ask yourself:

"What it is that makes me want to jump out of bed in the morning?"

"What do I love reading about, watching, talking about?"

"What makes my toes curl and my adrenaline surge?"

"What would I be willing to give up sleep for?"

"What am I good at and love doing?"

"Whom do I envy and why?"

"What motivates me?"

"What's my favorite thing to do when I have some free time?"

"What do I dream of doing some day?"

"If I could be anywhere right now, doing anything, where would that be?"

"Do I dream of being famous or well-known or am I more of a behind-the-scenes kind of person?"

And let's not forget monetary considerations:

"Is having a steady paycheck important to me?"

"Does the thought of making at least a six-figure income excite me?"

"Do I see myself living in a big house and driving an expensive car?"

"Is doing something I love more important than making more money doing something else?"

"What would I want to do with my life if making money wasn't an issue?"

The answers to these questions should give you a fairly good indication of what you're passionate about and what's important to you. Once identified, think of these insights as your personal GPS system or the driving force that's going to keep you moving in the right direction.

Know Where You're Going and How You're Going to Get There

Just wanting to be in the entertainment industry isn't enough. You need to know what you want to do in the industry and which facet of the business is going to be the best fit for you. These are questions only you can answer, but evaluating your responses to the above-listed questions will help. So will realistically researching your career options and soliciting the advice of those who currently occupy the positions you covet. Also keep in mind that you can change your mind at any time. You can change your mind ten times if you'd like. But right now—today—you should have a decisive goal and direction.

Once you have a goal, a destination, the next step is figuring out how you're going to get there. Just beware that you'll probably be starting at the bottom of the ladder and working your way up; and there's no definitive way of knowing exactly how long it's going to take to progress from one rung to the next. So be patient while you continue to learn, perfect your craft and skills and work your way up. The most important thing is being on the *right* ladder.

A lot has been said and written about choosing the right career path. I've known individuals who have progressed up certain suggested paths. Some make it all the way, and others don't. And some who make it to the top arrive via alternate routes. There are no guarantees here, nor is anything impossible. You can only give it your best shot and take the route most likely to get you where you want to go.

Common sense plays a big role here. Just think about it . . . if you want to be a writer, working in a production office isn't going to help you much. If you want to be a literary manager, it wouldn't pay for you to take the test to get into the Assistant Director's

Training Program. And if you want to be a casting director, being a script reader isn't where you belong. Be realistic.

- If you want to be a director: Start off as a set PA or become an assistant to a director. And if you possibly can, make your own film (low-low-low budget if need be, and even if it's only 20 minutes long), so you can shop your talent. Many actors move into directing. I've known some first assistant directors and script supervisors who have as well, although those routes are not quite as common.
- For actors: All you can do is practice your craft whenever and wherever possible and put yourself in situations that will create opportunities for you to meet producers, directors, casting directors, agents and managers. Take classes and workshops, join local theatre groups, work with kids who are learning to act, network with other actors and offer to create monologues and read lines with each other. Spend as much time immersed in your craft as possible and stay visible.
- If you want to be a (creative) producer: Start out as a PA, an assistant to a producer, a writer or a script reader, story editor, etc. (via the development track). You might also get some basic production and/or development experience under your belt, form your own company, option and sell a marketable project and attach yourself as a co-producer the first time out. Once you've established some credibility, you can move into a producer capacity.
- If you want to become a production manager or line producer: Get into the DGA by way of the Assistant Director's Training Program or by working the designated number of days as a second assistant director on non-union shows. Then work your way up the ranks of second AD, first A.D., UPM and so on. It's not the easiest route, but you can also work your way up via the production office starting with a job as a production secretary, then assistant production coordinator, production coordinator, production supervisor, non-union production manager and finally, line producer.
- The post production route: The best place to start is as an apprentice in an editing room; also, as an assistant to a post supervisor

or post producer or at an entry-level job at a post production facility.

- If you want to be an agent: You'll probably be starting in an agency mailroom or as an assistant to an agent.
- If you want to write: Start out as a script reader, a development assistant, an assistant to a writer or a script doctor, or get a nine-to-five job, so you have your evenings and weekends free to write. Continue to take screenwriting courses and join a writers support group.

Sometimes you need to possess certain skills and talents before you can land specific jobs. For instance, you wouldn't be hired as a composer if you didn't have the talent to write a musical score. You wouldn't be hired as even an assistant hair stylist unless you already had the training and ability to cut and style hair. And you wouldn't be hired as a script supervisor if you weren't already proficient at that job. But in most instances, you can start out as an intern, mailroom clerk, PA, assistant, apprentice or receptionist, in any department or at any company and work your way up. A beginner in an accounting department starts out as a file clerk but could eventually become a production accountant. An apprentice editor who makes the lab runs and picks up the bagels in the morning could be a highly sought-after editor one day. A second assistant cameraman who loads film magazines, orders raw stock and tallies camera report totals could one day become a well-known and very well-paid director of photography. It doesn't matter what you're doing as much as where you're doing it. Again—it's all about being on the right ladder.

Setting Goals

> "Most of us serve our ideals by fits and starts. The person who makes a success of living is the one who sees his goal steadily and aims for it unswervingly. That is dedication."—Cecil B. DeMille

When you commit to an ultimate career goal, you need to be specific. Instead of just, "My goal is to become a line producer," how about, "My goal is to become a line producer on major feature films with at least a $20 million budget, and I will be working on at least two films a year?" Better that way, huh?

Once you've targeted your ultimate career goal, you'll need to define the smaller goals essential to reaching the big one. Keeping with the example of the line producer objective, here's the checklist you might prepare for yourself:

- Apply for the Assistant Director's Training Program Test.
- Collect required days on non-union shows or complete training program (if accepted).
- Become established as a second assistant director.
- Become established as a first assistant director.
- Become established as a unit production manager.
- Become established as a line producer.
- Work exclusively on feature films with budgets in excess of $20 million.
- Consistently work on at least two features a year.

Or your checklist might look something like:

- Establish a production entity.
- Find at least three marketable properties to option.
- Sell at least one of those projects.
- Co-produce my first show.
- Sell a subsequent property.
- Become established as a producer.

Or as simple as:

- Mailroom
- Assistant's Desk
- Junior Agent
- Agent

Try tacking this onto your checklist:

In one month, I will be ————————————————.
In six months, I will be ————————————————.
In one year, I will be ————————————————.
In five years, I will be ————————————————.
In ten years, I will be ————————————————.

I'm a big advocate for writing out goals. Besides, clearly defined goals that are written down are generally reached more often than those that aren't. And I'm not talking about writing your goals on a pad of paper or on the computer where they'll rarely been seen. I'm talking about index cards, 5 × 7 pieces of card stock or 8-$\frac{1}{2}$ × 11 checklists that you can tack onto a bulletin board, the side of your computer monitor, on your office door, wall or refrigerator door—anywhere you'll see them every day. I hand print mine using a thick, black felt-tip pen. Committing to a goal and writing it down is empowering. Keeping it in front of you keeps you focused.

Keeping Yourself on Track

When it comes to certain aspects in my life, I'm very undisciplined. Sound familiar? If you know you need to write so many pages, make so many calls or set up so many meetings each day or each month, and it's not happening, one way to keep yourself on track is by creating a support system for yourself. Get together with a friend or two who are all in similar situations and working toward specific goals. Start by defining your ultimate goals and then brainstorm until you can come up with a consensus as to what it'll realistically take to reach them. Set some quantifiable (and again, realistic) daily, weekly and monthly goals for yourselves and work out a system to check in with each other on a regular basis, so you can report on your progress. Define your biggest stumbling blocks as well, so you can brainstorm on effective ways around them. It's helpful having buddies you can call when you're stuck, over-whelmed, depressed or frustrated, because they understand

and will help you get up and running again. There's no doubt that it's always easier to succeed within a nurturing, supportive environment, and having friends who are as invested in your progress as you are in theirs is the best—much preferable to going it alone. Plus just the fact of having to account to others on your progress is motivating.

If you're not able to assemble a personal support team, you can still keep a record of your progress. And whether you're in this alone or with a team, the chart on the next page should prove helpful. Using your own headings, of course, you can chart your accomplishments by the day (coming up with a weekly total), by the week (adding up to a monthly total) or by the month (tracking a yearly total). This one happens to track weekly accomplishments and monthly totals.

The chart is more effective when kept in conjunction with a support group, but if you don't have the personal support, use the chart anyway. If you're not keeping up your end, it won't take long to notice the correlation between low numbers, fewer accomplishments and a career that isn't moving as rapidly as you had hoped. It'll provide some incentive for you to stay on track. No matter how it's derived, the added incentive will generate results, and results will help you reach your goals faster.

Managing Your Time

Another large part of keeping yourself on track has to do with effective time management skills. Have you ever had one of those days (or several) where you do a little of this and a little of that and don't really get much accomplished? All of us have at one time or another, but if it happens too often, you're not using your time as efficiently as you could. If you don't manage your day properly and set boundaries for yourself, your productivity will fly out the window. The trick is to schedule your time carefully—all your time, not just meetings, coffee dates and massages.

Start by making a list of everything you want to accomplish in any given week (you can do this by the day, too, if that works

KEEPING ON TRACK

(choose the activities that best suit your line of work and goals)	Week of: (date)	Week of: (date)	Week of: (date)	Week of: (date)	MONTHLY TOTALS
Pages Written					
Scenes Completed					
Drafts Completed					
Screenplays Completed					
Pitches Made					
Submissions Made					
Articles Completed					
Recommendations Garnered					
Calls Made					
Letters Written					
Resumes Submitted					
Meetings Set Up					
Meetings/Interviews Attended					
Thank-You Notes Sent					
Trades Read					
Scripts Read					
Movies Seen					
Classes/Seminars Attended					
Networking Events Attended					
New Contacts Made					
Contact Follow-ups Made					

better for you). Include everything (work, pleasure and household duties): writing, going to class, making calls, social functions, setting up and going to meetings, writing and answering e-mails, reading, rehearsing, exercising, going to work, networking lunches and coffee dates, going to movies, watching TV, time with your family and friends, shopping, laundry, grocery shopping, etc. Then put your list in order of priority and indicate how much time you'll realistically need for each item on the list. There will be weeks when you have to spend a lot more time on certain items than you normally would, but that will just depend on what's going on in your life and at work at any one time. If you're like me and almost everyone else I know, you'll never have enough time for everything you want to accomplish, which is why you're arranging the list by priority. Okay, now take a week's worth of day planner pages that are broken down by the hour and start slotting in the items from your list—the most important ones first. Schedule in as much as you can from your list, giving yourself the time needed for each activity and then adding some extra time to that (allowing for unexpected developments). If everything won't fit, perhaps you should think about getting up earlier in the morning or staying up a little later at night. If you're already doing that, and you still can't squeeze it all in, then you'll have to drop some of those nonessential activities, at least until your priorities change. You might also consider scheduling the more personal tasks during the early morning or evening hours or on weekends—during non-business hours.

If you're having difficulty scheduling your days, pick a few items from your list and ask yourself, "What's the worst that can happen if this doesn't get done on this day or during this week?" If the answer is that you'll have to reschedule a coffee date for the following week or eat leftovers for dinner for the third night in a row, the world won't come to an end. But if it means you won't be turning in your script on time or won't be prepared for a big pitch meeting—that's not good. So be sure to schedule in the most essential items first.

When you've scheduled time to be with your family or friends or time just to relax, give yourself that time and thoroughly enjoy

it without thinking about all the other work you have to do. It's amazing how guiltless you can feel taking the time to have some fun once you've scheduled it in. And when it's time to get back down to business, use that time productively. Unless it's specifically related to the work you're doing, don't stop for long chats on the phone, incessantly check your e-mail or fixate on all the other things you'd rather be doing. As difficult as this is for me, sometimes I have to refrain from answering the phone all together, and just let the messages go to voice mail. As someone who has prided herself on being a skillful multitasker and someone who *wants* to do it all, even I have had to learn to say "no" more than I'd like, just because there aren't enough hours in any one day for everything I'd like to do. And when I try to do too much, too many important things don't get done at all or don't get done well. So I've learned to be more discriminating with my time, prioritize my "to do" list and schedule my days. I get a lot more accomplished this way, and you will, too.

Should you find yourself veering away from your goals due to family matters, vacations, illness, moving, whatever—that's normal and perfectly okay. Just get back to business and back on track as soon as you can.

Your Vision and Mission

Another way to keep your goals in front of you is by creating your own personal vision and mission statements. Businesses, organizations and institutions do it every day. It lets employees, stockholders, customers and the public know what they stand for, what their goals and intentions are and how they intend to realize their objectives. These powerful statements are effective tools that can be used by individuals as well.

A vision statement expresses your optimal goal. It's a short, succinct and inspiring statement of what you intend to become and to achieve at some point in the future.

Where do you see yourself being five years from now? In choosing a direction, you should have a mental image ("vision") of the possible and desirable future you see for yourself. What are the major

elements of your vision? What are the key qualities? Sit quietly for a few moments and think about some of those same questions posed to you earlier in this chapter. Think about what excites you, what inspires you, what would give your life meaning, in which direction you see yourself moving. Record your ideas and combine them into a single statement. That's your vision.

A mission statement provides an overview as to how you're going to achieve your vision. It should elicit a positive emotional response, make you feel more challenged and committed, direct you toward building on your strengths, aid in screening major decisions, address the trends and opportunities in your area of interest, and meaningfully differentiate you from your competitors. After your vision statement, add your mission statement. It shouldn't be more than a few paragraphs long.

Here is an example:

Vision Statement: In five years I will be a successful and sought-after producer.

Mission Statement: For the past seven years, while working as a unit publicist on major motion pictures, I have endeavored to establish solid working relationships with top industry producers, directors, writers, actors, agents and managers, as well as studio development, publicity and marketing executives. I'm tightly plugged in to the press and have developed the keenest of networking skills. And while spending countless hours on film sets, I continue to watch and learn and understand the role of the producer.

I have recently begun searching for properties to option—well-written screenplays that are both compelling and commercial. Armed with an excellent reputation and unparalleled access to the industry's top talent, I will be in a position to package and sell my projects, either on my own or in conjunction with an established, high-profile producer. My relationships will serve me well in assembling a quality crew. And my ability to work well with actors, studio executives and the media alike will be a tremendous asset. Lastly, my understanding of the entire filmmaking process will be a great asset as a producer. After my first film has been released and deemed a success, I will be in good standing to continue the process. Starting with the second film, however, I will no

longer have to attach myself to an established producer, because I will then have the credibility to get into any door in town.

Being in the Right Place at the Right Time

Having a goal and a plan is powerful, but let me add one more ingredient into this potent mix, and that is making sure you're prepared for the opportunities that come your way. I'm sure you've heard the expression, "Something good is going to happen. I can feel it. It's just around the corner." To that I say, "If you place yourself at the right intersection, you're more likely to be in the right spot when luck gets there." You have to be ready for the breaks that come your way, even if they don't seem like breaks at the time. The way you do that is to continually put yourself out there, whether it's at networking functions, volunteering to help out for free or just shining at whatever it is you're doing. The more you do, the more people you meet, the more likely you are to be at the right place at the right time. Here are a few examples:

I worked with Robert on two different shows. He had a background of working on low-budget films and documentaries. On the first picture we did together, he was the director's assistant, and on the second, he helped out in the production office and procured our stock footage. Somewhere along the way, he was asked to work for free one weekend as an assistant director on a very, very, very low-budget film, which he gladly did. Someone on that project noticed his abilities. It was that person who later recommended him to be the production manager on another film, this one with a slightly larger than minuscule budget. Having accepted the job, Robert then asked another co-worker of ours, Susan, to be his production coordinator. While on that project, one of the investors took notice of both Robert and Susan, and ultimately offered both of them terrific positions with his new production company. So Robert went from being a barely paid, incredibly overworked production manager on an ultra-low-budget film one day to a production executive the next, all as an indirect result of having worked for free one weekend.

Lachlan was new to Los Angeles when he signed up for my USC summer class. That was where he learned about Film Industry Network. Knowing he had to start networking, he began attending meetings. It was only the second meeting he came to when he found himself sitting next to a very warm, friendly woman named Missy. They introduced themselves to each other, and Lachlan soon learned that Missy was about to line produce a small film. Missy found out that Lachlan had a financial background. Jump to the tag line, and Lachlan not only ended up working on Missy's film, but he was also able to line up jobs for some of his classmates as well.

A bright college grad, Bob started his career as an office assistant for an independent production company, spending much of his day making coffee for board room meetings. He had heard there was an opening for an Office PA on one of the company's TV movies, so he interviewed for the job and got it. Once there, Bob came in early and stayed later than necessary. While efficiently handling his job, he learned everything he could, helped everyone he could and read everything he could get his hands on. He was soon anticipating the needs of his supervisors, keeping one step ahead of the workload and becoming indispensable. When that show was over, the company moved him onto another production, where his next job was to assist the production accountant. He learned that position quickly; and it's a good thing, because eventually the accountant had to leave the show, and Bob was asked to replace him. It was while working as a production accountant that an associate producer was needed on short notice. He was already there, had proved to be both bright and a quick study, and had captured the eye of a top company executive. So Bob was asked to fill those shoes as well. He eventually became a producer, and then a producing partner in another prominent production company. One would say this might never have happened if Bob wasn't so bright, and others could say he was lucky to be in the right place at the right time. My take is that when the positions opened up, he was hard to ignore because he was bright *and* because he had made such an extraordinary effort to learn, to help out whenever he could and to support his co-workers. He was ready for the opportunities that came his way.

Jackie applied for a job as a writers' assistant on a television series but was told the position had been taken. She asked if she could come in for a short meeting anyway, so the woman who did the hiring could get to know her, just in case another position should open up at a later time. The woman reluctantly allowed her to come in, and then found herself so taken with Jackie, she recommended her the very next day to a friend who just had happened to call looking for an assistant to work for a group of writers on another TV series. Jackie got the job!

The moral of the story: You never know where an opportunity is going to come from or who's going to be the one to notice your potential and give you that pivotal break. It could be someone you worked with three projects ago or someone you just met at a seminar.

The combination of knowing what you want, having a plan to get there and being ready for anything that comes your way creates an incredibly powerful catalyst for realizing your dreams.

> *"I think luck is the sense to recognize an opportunity and the ability to take advantage of it. The man who can smile at his breaks and grab his chances gets on."*—Samuel Goldwyn

— 7 —

Starting Out

> *"Take chances, make mistakes. That's how you grow. Pain nourishes your courage. You have to fail in order to practice being brave."*
> —Mary Tyler Moore

When first starting out in this business, many of your decisions will be based on your interests and goals. This chapter will provide some additional considerations to factor into your choices. In making a plan to achieve your goals, you want to be sure it's realistic and feasible.

Moving to Tinseltown

If you're moving to Los Angeles or New York or just getting out of school and trying to make it on your own for the first time, do you have enough seed money to pay for rent, utilities, phone, car maintenance, auto and health insurance, food and miscellaneous expenses for several months until you can generate an income? Can you afford to live alone or do you need to find a roommate? Do you know the lay of the land and how you're going to be getting around? What are you going to do if you can't find an industry job right away? What if you can't find a job that pays enough to cover all your expenses or you have to work for free for a while just to get your foot in the door? Do you have other skills to fall back on? Do you even know what the job market is like? And even

more basic, what type of lifestyle are you up for, and where would you be happy living? Before you make any move or strike out on your own, do your research, know what you're up against and be prepared. Here's some advice from my friend Alison. She's a writer/director who moved to Los Angeles from Maine about three and a half years ago, and these are her thoughts on just starting out:

"Here are a few things to consider if you're moving to a town like L.A. or New York: First, how many people do you know there? Make contact with each of them, and invite them to lunch or out for coffee. I also joined a bike team, which has nothing to do with the business, but it got me out, and I met some terrific people. It's all about creating a community for yourself.

Consider moving into a house or apartment with a bunch of roommates who are in the biz or just starting out like you. The rent is cheaper, and you'll be exposed to more people. And after a day of beating the streets, you'll have someone to come home to and sit on the couch with. My roommates became my community, and I cannot imagine starting life here without them. It wasn't until later that I moved into my own place. Next: pick a neighborhood you like and one that feels comfortable to you. Since I'm a water person, I just knew I had to live near the ocean. That helped.

Be prepared to get out of the house to meet people. Accept every invitation. There are always tons of parties and events where you can meet people in the 'business.' Your true friends will eventually come to the surface, but in the meantime, you will be building your Rolodex and learning how to get places. In no time at all, your social calendar will be filled and you'll be able to pick and choose what you want to do. Buy a city map book (here in L.A., it's the *Thomas Guide*), so you can get around.

Focus on your goal. I worked as an AD when I first moved here, and while I loved my time on the set, I never had any time off to write. The benefit of constantly working on sets is getting to meet new movie people, and when you want to do your own project, you'll have tons of friends who can help you. The disadvantage is that you can become known as just another crew person who 'really wants to direct.' After a while, I ended up taking a straight nine to five office job so I could write. The hours aren't so long, and I have my evenings and weekends to work on my own projects.

Take classes or join workshops. Figure out what kind of person you are and what kind of discipline you need to get your work done. Do you need deadlines? Do you need structure? Do you need a schedule? If you do,

Continued

create it for yourself. Make your art your first priority after making money. Money is imperative, since the only thing more stressful than not getting your work done is money problems. Remove your money problems so you can focus on your work. But if you don't make your art your top priority after having enough money, you just won't do it. Some people opt to make their art their top priority instead of earning a living. I know two who threw caution to the wind when it came to finances, went deeply into debt and had sketchy loan sharks threatening to break their knees. Terrifying. One now has a seven-picture deal with Miramax. The other just signed a three-picture deal with Fox Studios after over five years of playing financial Russian Roulette. He is still crawling out of the hole, but both guys made it. It's a path, but you have to have balls of steel to take it. Not for me, and anyway, I had enough debt from student loans and my car to not want any more. But if you have the opportunity to devote yourself 100% to your art, you'll probably get there.

Set yourself up. Do you have a computer? A car? There are some basics you need to survive in a big city, and you've got to have them. They don't have to be expensive, but if you're couch surfing and it's hard to access e-mail, how are you going to get your call times? Make yourself accessible."

Being a Big Fish in a Small Market or a Small Fish In a Large Market

Most major feature films and TV productions originate from either Los Angeles or New York, where thousands of people are capable of filling the same job and there are never enough jobs to go around. And while the actual locations for these shows could be just about anywhere in the world, when shooting remains in the U.S., the cast and most key crew positions are almost always hired from the show's home base. In general, only support crew, bit acting parts and extras are hired locally. The only exception to that is when shooting in other countries, such as Canada, where a much larger percentage of the cast and crew is hired locally because of government restrictions protecting their industry jobs. But in terms of the U.S., it's safe to say that once you get outside of the major metropolitan areas such as L.A., New York and Chicago, major feature film, network and cable TV production

jobs are not as plentiful. But that doesn't mean that these cities and towns don't have their own (sometimes thriving) entertainment-based community. There are many areas all over the country where local TV, commercials, documentaries and corporate films are produced regularly and where local filmmakers produce their own projects as well as work on projects originating from elsewhere but shooting in their area. It may take a while to get established in a smaller market; but once entrenched in a local production community, the competition is less ferocious and your chances of staying employed are sometimes greater than they would be if you were to live in a larger market. The cost of living is generally less in smaller communities, and there are many benefits to *not* living in a big city. The type of projects produced in smaller markets may be less prestigious and smaller budgeted, and the salaries may be less, but there's something to be said for being a big fish. You can find out how production-active each state is by contacting their film commission. State film commission officials will also let you know which of their cities have their own film offices.

The ability to live and raise your family in a smaller city or town has become more feasible than ever before, especially for those who can transmit their work (writing, visual effects, graphic design, etc.) over the Internet. Many others, besides being part of the local production community, make themselves available to travel and work on shows shooting in other locations. It's generally easier to do this once you're established and don't have to be in L.A. or New York for frequent interviews. So many feature films are being shot on locations around the globe anyway, it rarely matters anymore where someone lives, as long as they're willing to travel.

Skills to Fall Back On

It's important to have a way to earn a living while you're waiting for your big break or in between jobs. It's something that those new to the industry don't think enough about, because everyone wants to believe that once you land your first job—that's it—you're

on your way. It works that way for some people, but not for all. It's also easy to ignore the necessity of a back-up plan when you're young, don't have too many expenses, can live with roommates and share costs and you're anticipating the career you've imagined for yourself. But as you'll see and as you've been told, it's an insecure and unstable industry, so as you get older, want to buy a house, get married, start a family (you get the picture), financial security becomes more of an issue. I don't mean to come off as the voice of doom and gloom here, but I've seen this happen to so many people who counted on working more steadily, on being more successful or on being able to sustain their success. It's not always enough to save money while you're working to get you through the lean times. Sometimes you need a back-up plan to see you through. And the best time to figure that out is when you're young and just getting started.

What other skills do you have? When I was just starting out, I typed scripts between projects, and when my husband, Ron, wasn't on a show, he was building furniture. I know people who design websites, cater parties and write articles for magazines. One friend in the business works as a computer consultant when not on a show, and someone else makes and sells jewelry. If you don't have other skills, you can always take a class or two and learn one. I know someone who has his contractor's license to fall back on, another obtained a commercial license to drive big rig trucks and still another went to bartender school. Keep in mind, however, that you want something that's going to give you some amount of flexibility. You're still going to need time to pursue your career and be available for meetings and interviews. You'll also need to be able to replace yourself should a new show or job come along.

Having skills you can fall back on will keep you busy, keep your mind active and some money coming in. It'll save you from the agony of waiting for the phone to ring and from going nuts during dry spells. You'll also feel more secure. I don't know about you, but when things don't go as planned or finances get tight, I always ask myself, "What's the worst that can happen?" If you have a Plan B, the worst never seems so bad. Check out more about Plan B jobs in Chapter 17, *Show Biz Survival Techniques*.

The Merits of Working for Free

If you're not having much luck landing a job, consider working as an intern. It may not sound terribly appealing, but if you can afford to do it even for a short period of time (like a day or two a week), it's one of the very best ways to get your foot into any show biz door.

I once took a job as a second unit UPM and worked for a very astute line producer named Jonathan who, at the time, specialized in non-union features. My first day on the job, he took me on the set and pointed to an individual. "See that camera loader?" he asked. "He worked for free two shows ago. And the second AD over there, she worked for free three shows ago." His routine was to hire interns and give them a chance to ask questions, learn and figure out what they were most interested in doing while working in PA positions. After working for free and proving themselves capable on an entire show, he'd hire them again on his next show, give them more responsibility and pay them a small salary. They'd learn more each time and get paid more on each show, until eventually, they'd be ready to assume an actual crew position. Voicing my astonishment, he said that's how he had started. He knew no one when he first moved to L.A., had no connections and couldn't get a job. But he did have a little money to hold him over. After doing some research, he approached the production executive at the company he most wanted to work for and volunteered to work for free. The exec politely turned down his offer, but he was persistent, and they eventually relented. He quickly proved his worth and was soon moving up and getting paid. When he left that company sometime later and started freelancing, he made it a point to help other newcomers in much the same way. When I mentioned to Jonathan that I'd feel uncomfortable hiring people to work for free, he explained that it was part of their education—just like going to school. And just like school, if you do well enough, there's a paying job for you at the end of your term.

Then there was Billy. I had been working on a TV series, and this very energetic young man came to see me at the beginning of the season. He said he wanted to be my assistant, to which I promptly

told him how sorry I was, but that there was no money in the budget for me to have an assistant. He then offered to work for me three mornings a week, for free, if I'd agree to train him. We worked out the details, and oh my, was he amazing—bright, fun to be around and quickly indispensable. It was the perfect arrangement until one day a few months later he told me he wasn't making enough at his part-time job and would have to find something full-time and leave the show. I couldn't lose Billy, so after practically begging my supervisors to some how, some way find the money in the budget, we were able to find enough to pay him to stay with the show on a full-time basis.

My friend Stephen lived in the midwest, and one day, a film came to shoot in his town. As soon as he could, he made a beeline for the production coordinator's office and offered to work for free. She politely said they didn't need any more help. But he came back every single day until she finally gave in.

Another colleague of mine suggests that if you want to start out as a script reader to look in the *Hollywood Creative Directory* and target production companies that don't have studio deals, because those are generally the ones that could use the most help. Pick one or two of the companies you'd like to be associated with and offer to cover three scripts for them, for free. Certain agencies and management firms will also accept help with script coverage. No matter which company it is, however, they will most likely ask for coverage samples from you beforehand, just to make sure you know what you're doing. If it's something you enjoy, you have a good sense of story and are good at it, they'll take notice and you'll have a much better chance of landing some on-going (paid) reading assignments or perhaps even a full-time job.

These stories and examples are not unique. They happen all the time, and it's a great way to start a career. The problem is, in the past few years, it's become impossible to intern for a major studio or production company in California unless your internship is a direct placement from a college or university's official internship program. Some states, such as California, mandate that you can't have employees working for nothing *unless* they come through a sanctioned school program and are able to earn school credit.

It also becomes a worker's compensation issue should someone who's not on your payroll get injured on the job. Some of the smaller, independent, non-union companies are still amenable to accepting interns to work on shows under certain circumstances, but there aren't as many of them as there used to be (even though there's always a need for extra help). And at the moment, these regulations don't seem to affect script readers in quite the same way.

Since most shows shooting on distant location will hire local PAs, you might consider offering to travel to location at your own expense, assume the costs of your room and food and work as a local, preferably for a salary, but if not, then as an intern (if it's allowed). If they agree but can't afford to pay you, you will not only *not* make any money, but it will cost you to be there. If you can afford it though, and it's a show you want to work on, it might be worth it. You can sometimes bunk in with someone else on the crew and can almost always take advantage of catered lunches on the set and craft service snacks.

When you're a student and accept an internship through your school, you must adhere to very specific guidelines. In some schools, students are required to attend an internship course that helps prepare them for their upcoming assignment, sets strict guidelines as to the terms of their assignment and gives them access to an advisor who acts as both mentor and liaison between the student and the company. Because they are earning school credit for their work experience, students are generally required to prepare written and/or oral reports based on their internship experience. A company that wishes to recruit an intern must also agree to explicit guidelines that govern the intern's days and hours of work and specific duties. In an effort to afford students the best possible learning experience and to prevent their job responsibilities from being nothing more than a steady stream of menial tasks, the company is typically required to guarantee that an intern will be exposed to a limited amount of company information, have some access to executives, be allowed to sit in on an occasional meeting, attend dailies, etc. The intern's supervisor is also required to complete written evaluations on the intern's

performance. Each school varies, but two to four units of credit are typically afforded to a student participating in an internship program.

Whether or not you come through a school program, the goal of any internship is to make yourself useful, work hard, learn as much as you can while you're there and show everyone how terrific you are. If you're going to work for free, try to volunteer your time with a person or company you want to work for or on a specific show you want to work on. You may be able to exchange your time for free lunches, mileage money and a screen credit on the film. If nothing else, you'll have the opportunity to make new contacts, gain some much-needed experience and add the show to your resume.

I'd like to suggest that if you do work as an intern, and it's not through a school program, you get a deal memo (just like the rest of the crew) spelling out the details of your arrangement. In a fast-paced and frenzied environment, people can forget and misunderstandings do occasionally occur. But if you've been promised screen credit, mileage reimbursement or free lunches, and it's in writing, chances are, you'll receive what's been agreed to.

The Mailroom

The mailroom is a great place from which to work your way up, and agency mailrooms are especially well known as starting points for agents, managers, producers and studio executives. Many extremely successful, well-known industry icons, such as Michael Ovitz, Barry Diller and David Geffen, started their careers in a mailroom.

Agency mailrooms can be grueling. The hours are long and the pay is rock-bottom. As in any other entry-level position, it's a world in which the word "no" does not exist. It's nonstop sorting and delivering of mail, photocopying scripts, distributing faxes, making deliveries and pick-ups, doing personal errands for agents, reading and covering scripts, filling in for assistants when they're out, helping out at agency events and parties and so on, and so on, and so on. Your hope is to stand out, get noticed and

get promoted to a "desk" (a job as an assistant to an agent) as soon as possible.

Most agencies require their trainees to have college degrees, and of the thousands of applications they receive each year, only a handful are chosen. They look for someone with a passion for the business and a certain level of professionalism. Knowing something about the industry and the terminology is helpful, and they're always on the lookout for someone who's going to hustle. Those who work in the mailroom together are generally friendly and supportive, but as can be expected, a certain competitiveness, overt or not, is endemic to this type of work environment. Stints in the mailroom can last from several months to a couple of years, and everyone's jockeying for position.

Helen Roger runs the mailroom at CBS Studio Center. She has three people working under her supervision at any one time, and each commits to being there for a year. There's a waiting list to get in, and her applicants aren't required to have college degrees, although it certainly doesn't hurt. She looks for people who show a willingness to work and the ability to be team players. She prefers the "doers" to the "talkers" and expects her crew to work hard when they're there. In the course of their day, the mailroom staff has the opportunity to network with a multitude of people from various departments all over the lot, as well as those who are working on shows being shot there. Several are able to line up better jobs for themselves and leave before their year is up.

Politics often seep into the mailroom by way of nepotism, and it's not uncommon for the children of those closely connected to agents, managers, high-ranking agency clients and executives to be preferentially hired before all other applicants, especially during the summer. But it's no different when you're on a production and the director's son or the producer's wife's sister's next door neighbor is suddenly given a job as a PA. Once in the job, however, they're all expected to carry their own weight, the same as everyone else. A job in a mailroom doesn't guarantee anyone a meteoric rise to Hollywood bigwigdom. Like any other entry-level job, it's just a way in and a start. The rest is up to you.

I'd like to recommend a terrific book called *The Mailroom—Hollywood's History From The Bottom Up* by David Rensin (Ballantine Books), which will give you more insight into the workings and politics of an agency mailroom than you'll ever need to know. Rensin travels behind the scenes and through sixty-five years of show business history to tell the real stories of the marvelous careers that began—and in some cases ended—in the mailroom.

Temp Agencies

If you have the necessary qualifications, a great way to explore various industry jobs is to sign up with one or more of the temporary employment agencies that specialize in entertainment-related jobs. Each agency varies slightly, but in general, most place individuals in jobs as receptionists, assistants, executive assistants and in technical, creative, accounting and legal positions. Some handle production-related jobs (from PAs to production coordinators), and one agency owner said she handles the full gamut, placing PAs and receptionists, all the way up to CFOs.

Most of these agencies are located and/or headquartered in Los Angeles. Their ratio of resumes received each month compared to the number of placements made is pretty lopsided, but if your skills are sharp, you have a personality to match and you're patient, you have a shot at it. An agency will also look at where you've interned prior to taking the plunge into the work force. Having interned for a major studio or well-known industry company will set you apart from other entry-level applicants.

Once an agency sends you out on a temporary assignment and the client is pleased with your work, you'll be called again; and many temp jobs lead to permanent positions. This gives you the opportunity to see where you'd like to work, and gives employers who like you the opportunity to request you on a full-time basis as soon as there's an opening in their company or department. This was one of the ways I earned a living early on in my career. Whenever I wasn't on a show, I'd call the temp agency I was signed with, and they'd put me on their availability list. It was never too

long until I had a job, some of them lasting quite a while. At one point, they sent me to a well-known production company to work for a producer while his assistant was on a leave-of-absence. When that assignment was over, someone else's assistant was going on vacation, so they asked if I'd work for him. Two weeks later, they found another position for me in their production department, and there I stayed until the company was sold two years later. You never know where you're going to end up. Someone I know who had only worked in production (and only wanted to work in production) signed up with a temp agency when work slowed down for her, and she found herself working in the home video department at one of the studios. It wasn't anything she had ever even thought of as a career possibility before, but here was a job she found creative and challenging—and it was steady. They liked her enough to offer her a permanent job, and she took it.

My friend Aubbie Beal moved to Los Angeles with the objective of temping until she found exactly what she was looking for. She held out, turning down several offers of good, permanent positions along the way, and last year, landed the job she wanted. Here's some great advice on temp agencies and temp assignments from Aubbie (although it's excellent advice for *anyone* who will be working as an assistant):

> "If you are able to type faster than 40 words per minute, they'll be very impressed. For software, you should be proficient in (or at least familiar with) Filemaker Pro (most phone sheets/call logs are done this way), Outlook, Lotus, or Now Up-To-Date scheduling systems (in my experience, Outlook has been the most popular), and of course, Excel and Word. Specify if you're experienced with PC or Mac platforms (hopefully both), and always highlight any and all software programs you know, even if you are only coarsely familiar with them and/or think they will never come into play. The more you know about computers, the more they will understand you are computer-savvy and can handle the unique internal systems they throw at you, such as internal script submission logs or talent databases. But be prepared to really show that you can work in any program you say you can (in other words, don't lie). I wrote that I am proficient in

Continued

PhotoShop, Quark, PageMaker, PowerPoint, etc., and very occasionally do minor tasks in those applications. It wasn't much, but it impressed them and went a long way in their opinion of me.

Some offices still use Amtel and DataTel to announce calls (although most younger executives now use Instant Messenger). If you've never used these machines before, don't worry—someone in the office should be able to give you a very quick lesson. After that, by all means, add it to your resume.

Understand the basic principles of PDAs, two-way pagers and Blackberries (such as how to sync them up and charge them). Many execs carry these devices but will expect you to take care of the basic maintenance. You may even have to program a cell phone or two in your career as a temp.

Many temp agencies not only give typing tests and software tests in any application you say you're proficient in, but they also give basic grammar, spelling and proof-reading tests. Be prepared! You only need to get "average" scores on any of these to get accepted and placed, but if you score in the 90th percentile on them, you'll seem to instantly get preferential treatment and the choicest gigs.

If you've worked on phones at other offices, try to find out specifically what type of systems they were (brand names and models) and mark them down on your application. Companies love it when you not only have experience with busy phones, but when you also know their particular phone system. Sometimes the hardest part of a gig, especially on a busy desk, is figuring out the peculiarities of the in-house phone system (transferring and conferencing calls, especially). Because you may come in on short notice and have nobody there to train you, knowing the phone basics ahead of time will really make a difference.

Be familiar with the Internet and handy industry sites. You'll get a lot of questions thrown at you that need quick and accurate responses. Who reps this actor? What are this writer's credits? What was the DBO for this director's last five films? What movies are being released this December? How did horse-themed movies fare in the last 10 years when released in the summer?

More importantly, use common sense when on a desk. Be punctual. If possible, be early on your first day of a new assignment to review any notes the regular assistant may have left you, and become familiar with the computers, phones and layout of the office. After you've reviewed the "temp notes" from the regular assistant, ask your boss if there is anything she would like you to know about her work style, preferences for receiving calls, names of important people who may call frequently, what her

Continued

priorities for the day are, etc. If you run out of things to do, always ask for additional tasks, but learn to recognize when finding more "work" for you is more of a chore for your boss than she has time for. If there is downtime and your boss has admitted she has no more work for you, sometimes it's okay to ask permission to read a trade magazine, script or book. Just remember to use your judgment, ask permission and don't let it distract you from your job. No matter how slow it is, never make personal calls during business hours. Even during your lunch break, make personal calls away from your desk.

If you temp for an industry executive for any length of time and feel like you have made a good impression, you may ask the executive or the regular assistant if they would mind writing you a general letter of reference. Most of them will gladly do it (if you indeed have been someone good to work with), or they may even ask you to write your own letter for them to review, edit and sign. Having respectable names on the letterhead of industry companies will be invaluable when it comes to getting into the temp pool of that other company you want to work for or an honest-to-goodness full-time job. It will set you apart from the massive number of other applications they receive. You've been road-tested, and other executives aren't afraid to vouch for you. That's huge.

Do not, under any circumstances, give your temporary boss your resume or ask for a job. For most companies, it's the quickest way to get yourself fired from that agency or at least never get placed again. You may tell an executive that you have enjoyed working with him and would be glad to return if there was ever another assignment, but *asking* for a job is a big no-no. If they tell you they'd like to consider you for a permanent position, thank them graciously, and let them know your temp representative will be in touch. Then, follow up with your temp agent to make sure your resume is submitted for the position."

The following are some industry-related employment and temporary agencies:

Comar Agency (The)
9615 Brighton Way, #313
Beverly Hills, CA 90210

310/248-2700 (fax: 310/288-0205)
www.comaragency.com
resumes@comaragency.com

Force One Entertainment
9663 Santa Monica Blvd., #714
Beverly Hills, CA 90210

310/271-5217 (fax: 310/271-2439)
resumesla@forceoneentertain-ment.com
additional location in New York

Friedman Personnel Agency
9000 Sunset Blvd., Suite 1000
Los Angeles, CA 90069

310/550-1002 (fax: 310/724-7222)
www.friedmanpersonnel.com
resumes@friedmanpersonnel.com

Star Staffing Services
9250 Wilshire Blvd., #200
Beverly Hills, CA 90212

310/278-0520 (fax: 310/278-4269)
www.starstaffingservices.com
bh@starstaffingservices.com
additional location in Torrance, CA

Agencies Affiliated With Specific Studios:

Adecco (*Universal Studios*)
801 N. Brand Blvd., #185
Glendale, CA 91203

818/241-9909 (fax: 818/241-7697)
www.adecco.com
additional locations worldwide

Aquent (*Disney*)
6100 Wilshire Blvd., #410
Los Angeles, CA 90048

323/634-7000 (fax: 323/634-7696)
www.aquent.com
main office in Boston, MA (617/535-5000)
additional locations worldwide

Co-Op Temporary Service
(*Fox, UPN & Paramount*)
8447 Wilshire Blvd., #210
Beverly Hills, CA 90211

323/655-1009 (fax: 323/655-7201)

Spherion (*Warner Brothers*)
3400 Riverside Dr., 5th Floor
Burbank, CA 91522

818/972-0044 (fax: 818/972-0099)
www.spherion.com
additional locations in U.S. & Canada

Ultimate (*20th Century-Fox,
MGM, E!/Style*)
2121 Ave. of the Stars, 2nd Floor
Los Angeles, CA 90067

310/369-0295 (fax: 310/369-8585)
www.ultimatestaffing.com
additional U.S. locations

Network Opportunities

Major television networks in California and New York offer a variety of entry-level opportunities—internships and *Page* programs among them. Many local television stations throughout the country also offer various career opportunity programs for students and entry-level applicants.

NBC's page program in Burbank, California lasts a year, and those accepted work as part of the Guest Relations staff as a liaison between the network and the general public. Pages conduct

tours, perform various audience services for network shows and are used as "floaters," meaning they're assigned to work in different departments within the network on either short- or long-term assignments. NBC requires candidates to have a four-year college or university degree with a preferred minimum 3.0 GPA. In addition, related broadcast experience (such as campus radio or television, newspaper or internship positions), computer proficiency, demonstrated leadership, a strong work ethic and an outgoing personality all play an important role in the application process. NBC offers other programs as well, among them an internship program, an Entertainment Associate Program (for those interested in the development and management of entertainment programming), a News Associate Program (providing opportunities for outstanding aspiring journalists) and a Sales Associate Program (giving accepted applicants the opportunity to explore all aspects of sales and marketing, including research, customer service, advertising, business development, technology, Internet and desk experience). Check their website at www.nbcjobs.com to see which programs you qualify for and when they're accepting applications. They are not all for beginners.

CBS' page program provides participants an entry-level opportunity on a part-time basis. Applicants must be able to work three full days a week at varying hours and handle a flexible work schedule, including morning, afternoon and evening hours. CBS pages are responsible for escorting audiences to various show tapings as well as assisting staff members of CBS' leading daytime (soap opera) series and various other duties. To apply, you must be a senior-level college or university student or recent graduate, reliable, possess strong communication skills and have a positive attitude. CBS News offers internship opportunities for undergraduate and graduate college students majoring in journalism, broadcasting and/or communications and other programs, too. For more information on what CBS has to offer, check out their website at www.cbsdiversity.com/internship.shtml.

Then there's the Emma L. Bowen Foundation, which was established by the media industry to help increase access to permanent

job opportunities for minority students. The foundation's program is unlike other internship programs in that students work for a partner company (the networks among them) during summers and school breaks from the end of their junior year in high school until they graduate from college. During that five-year period, students learn many aspects of corporate operations and develop company-specific skills. Corporations guide and develop minority students with the option of permanent placement upon completion of their college degree. Students in the program receive an hourly wage, as well as matching compensation to help pay for college tuition and expenses. Mentoring from selected staff in the sponsoring company is also a key element of the program.

Partner companies and the foundation's staff work together to recruit students through local high schools and colleges and academically-based pre-college enhancement programs. Student applications are provided to qualified candidates; minority students with a cumulative GPA of 3.0 or better and an interest in the media industry are eligible to apply. Student applications, teacher recommendations and academic records are reviewed by foundation staff and forwarded to the partner company. Approximately 40 to 45 new students are added to the program each year. The Foundation also maintains a talent bank for use by media companies recruiting minority employees. For more information on applying to this program, go to www.emmabowen-foundation.com.

Other Considerations

Another great way to start out in the biz is to work as a non-union extra. Whether you have acting aspirations or just want to see how a set operates, it will give you a good chance to get the lay of the land and to make some contacts.

If you've recently moved to a new town (like L.A. or New York) or just graduated from school, this is the best time for you to join a networking organization (and more than one if possible). The more

people you meet, the sooner you can start connecting and building relationships. You'll meet people who have been through exactly what you're going through and will be able to pass on helpful tips as to where to look for work, who may be hiring, who's offering the best workshops and who to meet if you want to get into a certain end of the business. It's also nice to get suggestions on the best and most affordable places to eat, to live and to shop, on local doctors and even on things like how to go about finding a roommate. Just get involved and put it out there. You'll be surprised how much help you'll get back. You can't survive in this business without it.

If you live outside of Los Angeles and New York, a great place to get connected is through your local film commission. The purpose of a film commission is to promote and aid film production in a particular city, region, state or country. Film commissions are government sanctioned and are found throughout the United States and in many other countries as well. Some film offices are independent entities, some operate as part of various governors' offices, and others are divisions of tourism boards. Most are members of the Association of Film Commissioners International (AFCI), an international, nonprofit, educational organization of government employees serving as film commissioners. The association's purpose is to act as a liaison between the visual communications industry and local public and private sectors to facilitate on-location production, and to stimulate economic benefit for member governments. You can find a full list of AFCI-member film commissions on their website at www.afci.org. Many individual film commissions have their own websites that can also be accessed through afci.org.

Stop by and meet the staff at your local film commission office. Maybe even offer to help out a day or two a week. Without being aggressive about it, make sure they know (and hopefully like) you. You want to be on their list of people they recommend when asked for crew suggestions, and you want to be listed in their production resource guide. Most film commission offices have hotlines or websites that announce upcoming productions scheduled to shoot in their region. If you're there once in a while or make a habit of checking in, you might get a heads-up on a lead—you never know.

And being a friend of the film commission staff is also a way to entrench yourself in the local entertainment community. They're a potential resource for meeting and connecting with other filmmakers in your area

> *"Hollywood is an extraordinary kind of temporary place."*—John Schlesinger

— 8 —

Job Search Strategies

> *"You've gotta be original, because if you're like someone else, what do they need you for?"*—Bernadette Peters

Looking for Work Is Uncomfortable

I don't know anyone who likes looking for work and having to sell themselves. Besides being hard work in and of itself, for the most part it's pretty uncomfortable. We each want to think we're smart enough and talented enough that any company or production would be happy to have us, that they should all be lined up outside our doors waiting to offer us jobs. Unfortunately, it doesn't usually happen that way. Someone once told me he equated what we go through in this industry to having to "beg"; and at times, it certainly can feel that way—*unless* you tell yourself that it's just part of the game. Everyone does it, and it's an accepted part of doing business in this business.

Your mother probably told you not to brag about yourself. You've always heard that humility is a virtue. You're probably also uneasy being around people who toot their own horns too loudly. And now all of a sudden, you're being told to get out there and *sell* yourself, stand out among the crowd, let others know how special you are. The prospect of having to sell yourself can be scary, and just the thought of trying to get meetings

with busy, important people who don't know you can be terrifying. But the simple truth is that you have to adopt a new mindset and get those old messages out of your head; because if you don't toot your own horn, no one else will do it for you and no one will know what you have to offer. You have to venture outside of your comfort zone, learn how to effectively sell yourself and start making those calls—or you might as well be in another line of work. It's what we have to do in order to get work and to survive in this industry; and if you don't, you'll be left in the dust by the competition that passes you by. The only good news I can offer you at this point is that the more you do it, the easier and less terrifying it becomes.

Finding Your Market

A couple of chapters ago, you read about the importance of knowing what you want and setting goals for yourself. Your next step is figuring out where you should be working and who you need to meet. Armed with the knowledge of where you're headed, it's to your advantage to target the employers who are doing what you eventually want to be doing and the companies that can provide the learning experience you need instead of just taking the first job that comes along. The best of both worlds is an employer in your targeted market who's also in a position to hire. The next best thing, if there are no current job openings within your targeted market, is to make contact with the people you need to meet and to ask for their advice. You'll learn more about doing this in Chapter 10, when you read about the value of general information meetings. But in essence, you'll be requesting a meeting (and assuming the meeting takes place), you'll get the opportunity to introduce yourself, ask some valuable questions, make a connection and stay in touch. This person then becomes part of your network and may be the source of future job possibilities and/or other valuable connections.

Depending on your area of interest and your goals, ask yourself questions like these, the answers to which should help you start forming your list of likely targets:

- Which studios, companies or individuals are making the types of projects I'd most like to be working on?
- *(If your quest is being a literary agent)*: Which agencies represent the writers I most admire?
- *(If you're an actor)*: Which casting director credits do I notice the most, and who are the ones who cast my favorite films and TV shows?
- Which companies have the best reputation for being a good place to work?
- Which companies have the reputation for promoting from within?
- Which executives, producers or directors do I most admire?
- Who among those I've heard guest speak at a seminar or class have impressed me the most?
- Which companies use the technology I'd like to be involved with?
- Which companies tend to be more successful than others?
- What new trends are starting to emerge in the industry, and which companies are involved?
- Which studio exec just started his own production company?
- Who just landed a multipicture studio deal?

Now, to find the answers to all these and similar-type questions, you've got to do your research. That might include:

- Faithfully reading the trade papers (*Daily Variety* and *The Hollywood Reporter*) and other industry publications. If you can only afford one or two each week, I recommend the *Reporter*'s weekly edition that comes out every Tuesday. It's just loaded with good information.
- Check out *Production Weekly* (www.productionweekly.com) and West Coast Production News (www.wcpnews.net). They're subscription-based listings of all upcoming productions and include detailed contact information, as well as shooting locations.
- Try to find someone who receives the UTA (United Talent Agency) Joblist, and have him forward it to you. UTA puts out a terrific list of job availabilities once or twice a week.

- Reference the *Hollywood Creative Directory* (available at Samuel French Bookstores or online at www.hcdonline.com).
- Check out industry-related websites (many of which are referenced at the back of this book). They contain a wealth of information and provide news, reviews, casting information, job listings, seminars, publications, etc.
- Stay on top of studio and network positions posted on their respective job websites.
- Sign up with employment and temp agencies that specialize in industry-related positions.
- Join networking organizations, attend industry-related events and talk to people. You can pick up lots of good information and make valuable contacts this way.
- Ask friends, people you went (or are going) to school with, those you've worked with, anyone you know who's in the business, and *brainstorm*! Just put it out there. Let everyone know what your goals are, ask for advice, solicit the opinions of others, ask for introductions.

The information you need *is* out there, and it's yours for the taking. You just have to do your homework!

Likely Targets

To help you keep all the information you'll be collecting organized, I've created the following two forms for you to use as templates. They're to keep track of the companies and individuals you're targeting as likely prospects. The first form (*Likely Targets*) can be used to collect information on several companies. The second (*Company Profile & Follow-Up*) serves the same purpose, but it gives you the opportunity (and more room) to profile one specific company at a time.

 Fill out as much as you can to start with, and by the time you've read the next couple of chapters, you'll know how to get your cover letter and resume ready to send out, who to call and what to say. By then you'll be ready to start setting up meetings.

LIKELY TARGETS

COMPANY Address Phone/Fax#	TYPE OF COMPANY, SIZE, SPECIALTY	DESIRED CONTACT Title E-Mail Address	ASSISTANT'S NAME Direct Phone# E-Mail Address	DATE CALLED	DATE LETTER & RESUME SENT	DATE OF MTG.	RESULTS	SENT THANK-YOU NOTE √	DATE(S) TO FOLLOW-UP

COMPANY PROFILE & FOLLOW-UP

COMPANY_____

ADDRESS_____

_____PHONE NO._____

_____FAX NO._____

TYPE OF COMPANY_____

SPECIALITY_____

TITLES OF COMPANY SHOWS *(if applicable)*_____

DESIRED CONTACT_____

TITLE_____

DIRECT PHONE NO._____E-MAIL ADDRESS_____

ASSISTANT'S NAME_____

ASST'S DIRECT PHONE NO._____E-MAIL ADDRESS_____

REFERRED BY_____

He/She: ☐ called to recommend you ahead of time ☐ gave permission to use his/her name
☐ wrote you a letter of recommendation

DATE FIRST CALLED_____SPOKE TO_____

RESULTS_____

DATE SENT LETTER & RESUME_____DATE OF FOLLOW-UP TO SENDING RESUME_____

RESULTS_____

DATE OF MEETING_____TIME_____ ☐ General Info. Mtg. ☐ Interview for a Specific Job

IF MTG. IS FOR A SPECIFIC POSITION, TITLE OF JOB OPENING_____

MET WITH_____TITLE_____

RESULTS OF MEETING_____

☐ Can use contact's name as a reference ☐ Possible mentor ☐ Sent Thank-you Note: Date_____

DATE(S) TO FOLLOW-UP	RESULTS

Now there's no guarantee your first job (or even your second) will be with the company or individual you most want to work for, but you should be able to land something that will at least get you moving in the right direction. And whether you initially land the job you want or not, you'd be well served by taking the time to identify your target market, contacting the people you need to meet, staying in touch with them and making it a goal to work for your top one or two choices in the future. It's also a way to keep you on track heading toward your ultimate goal.

Learning How to Sell Yourself

My friend Suzanne Lyons is an independent producer and co-founder of Flash Forward Institute, a wonderful organization that helps people jump start their careers. When she lectures, she tells her audience they have to think of themselves as the CEOs of their own companies—the premise being that the product your company is selling is *you*, and if you're not successful at selling your product and aren't out there giving it all you've got, your product won't sell and your company won't survive. So the trick is to learn how to best sell your most prized product—yourself.

One of the most valuable things I've learned from Suzanne, and her partner Heidi Wall, is how to develop a personal pitch, and it all starts by having you figure out exactly who you are, what you have to offer, what you're passionate about and what makes you unique. Whether it's at a job interview or general information meeting; whether you're trying to set up a meeting or are interacting with people at a networking function, seminar or social event, you'll find numerous occasions to sell yourself. Sometimes you'll get thirty seconds to pitch, sometimes a minute or two; so it's good to have a couple of different versions. Regardless of the length—let me jump back to the being-the-CEO-of-your-own-company metaphor—because it's certain that the better your pitch, the more successful you'll be at selling your product.

You can start developing your personal pitch by defining who you are. What are your strengths and abilities? What are your accomplishments? What makes you interesting? What

are you passionate about? What makes you special? Who are you as a person: do you have a terrific personality, a great sense of humor, a willingness to go the distance, a strong work ethic? What is it about your past experiences that can attest to the fact that you're creative, clever, a fast-thinker, a team player, a problem-solver, a risk taker? The trick is to be able to capture your essence—who you are and what you're about in a very concise manner. Once you've developed your pitch and start using it, it'll become more natural and get easier to recite.

If this will help, use the following exercises to start defining yourself:

#1. List your three top goals:

#2. List three unique things about yourself that most other people don't know.

#3. List three of your biggest accomplishments (personal or professional).

#4. List three special skills—things you're good at (i.e., organization, problem-solving, other languages, getting along with difficult people, leadership, team building).

#5. List three things that excite you and make you want to jump out of bed in the morning.

#6. List three hobbies or interests.

#7. List three of your strongest qualities (i.e., patience, creativity, sense of humor).

The Personal Pitch

Here are some examples, which are all based on real people and real experiences:

Hi, my name is Ben. I grew up in a small town in the midwest where my father owned and operated a movie theatre. I was like the kid in *Cinema Paradiso*. I hung out in the projection booth, picked up empty popcorn boxes, took tickets at the door and watched every movie my dad played over and over and over again, memorizing the dialogue and re-editing scenes in my head. For as long as I can remember, I knew I wanted to be an editor. I have a good sense of story and rhythm and can stay objective even after watching a scene over and over again. I also don't mind sitting in a dark room by myself for hours on end. I've been taking editing and post production classes for the past couple of years and am finally ready to apply as an apprentice. I'm willing to do whatever it takes . . . and I make great coffee. My popcorn's not bad either."

Hi, my name is Haley. This business has always fascinated me, and since it all begins with good stories, I decided that that's the part of the business I want to be in. I discovered in school that I'm not as good at writing as I am at working with other people's writing, helping them with plot and character development. I enjoy reading and working with writers and plan on becoming a literary agent or manager. I know I have a lot to learn, but am ready to pay my dues and have been applying for mailroom or assistant jobs at all the major agencies.

Hi, my name is Jon. I've been acting since I was a kid, did a couple commercials and a few bit parts on some old TV series; but I eventually came to the realization that I was never going make it big in front of the camera. But I still enjoy working with actors, because I really understand them, and I think I have a good eye for talent, too. So I've decided to get into casting. I've been interning with some casting directors I know—just to learn this side of the business better . . . and I really love it.

Hi, my name is Eliana. I know this sounds strange when almost everyone in this town wants to be a director, actor or writer—something creative and glamorous, but I want to be a production coordinator. My parents had a business, and I used to help out in their office all the time. I love movies and thrive in an office environment, so what better job could I have? I'm organized, learn fast, am a people-person, efficient, good at multitasking and am definitely a behind-the-scenes kinda gal. I know it's hard work, but I'm definitely up for it.

Hi, my name is Will, and I just graduated from film school. I'd always wanted to work in this industry and have decided to work as a PA for at least a couple years before deciding which path to take. This way, I'll have a chance to observe, ask a lot of questions, learn and figure out what it is that most interests me. I played sports all through school and have always been on one team or another, so I'm sure I'll fit in well on a crew. I thrive on challenges, move fast, and am also a computer nerd. So if anyone needs help with their computer, I'll be right there.

Hi, my name is Nathan. When I was six years old, I started rounding up the kids in the neighborhood to put on plays that I wrote. They were pretty funny, if I do say so myself, and we charged our parents ten cents a ticket to see the plays. When I was 12 my mother sent one of my screenplays to Steven Spielberg. And you know, he actually answered. My mother framed his letter, and it's still hanging over my parents' TV in the den. I wrote in school and had a few things published, but now I'm seriously pursuing my screenwriting career. I'm starting out as a reader and took a part-time job at a coffee house, so I can afford to intern for a while until I land some steady employment. Would it be okay if I were to send you a few samples of the script coverage I've done?

The examples are all a little different, but as you can see, they convey something interesting and unique about each of the individuals as well as their skills, accomplishments, passions and goals. You can't fit everything about yourself into every pitch. It'll depend on how much time you have and who you're pitching to. But weave as much of yourself as you can into each pitch. You can also have different pitches for different occasions. Practice reading your pitches to friends. Start feeling comfortable about selling yourself.

I had a student this past summer named Chris who's a skydiver. I suggested when he works on his pitch he add something like, "I've heard how tough this business can be, but it doesn't scare me. I jump out of airplanes for fun." Make your pitch memorable, so you're memorable.

The Recommendation of Others

Nothing gets you in someone's door faster than a referral from (or connection to) someone they know. When a prospective employer reads your cover letter, and it states that someone she knows recommended you contact her or when a potential employer reads your resume and is acquainted with an individual you've listed as a supervisor or reference, your credibility quotient will instantly go up a notch or two. Those in a position to hire will always rely on the recommendations of people they know and trust over taking a chance on an unknown entity.

Once you assemble your list of likely targets, ask your friends, co-workers, classmates, anyone you know if they know any of the individuals you'd like to meet. Should one of your contacts know someone you'd like to meet, ask that person if she'd be kind enough to make a call on your behalf to recommend you or to help set up a meeting. Be sure to let her know how much you'd appreciate the help. (You might even express your gratitude by inviting her out to lunch or dinner. It never hurts!) If for some reason, however, she isn't in a position to make a call for you (too bad, there goes that nice dinner), ask her if you could use her name as a reference. A direct call on your behalf would be preferred, but use of her name would be your second-best way in.

Another time when receiving a recommendation from others is helpful is when you're up for a specific job. There have been a couple of times when I've been up for positions I really, really hoped to get; and each time, although totally unsolicited, a couple of close friends and colleagues made calls to my prospective employers to extol my attributes. On one occasion in particular, one of my producer friends called an executive I had interviewed with, even though the two of them had never met. Whether you ask for the help or it's volunteered, it's always a boost for you when someone can call on your behalf.

You Never Know Where It's Going to Come From

You never know where a recommendation is going to emanate from, because:

- the person sitting next to you in a film class today could be directing his own movie within the year and in a position to offer you a great job.
- a production accountant you worked with three shows ago could be in a position to recommend you for a fabulous film.
- the assistant you're calling to set up an appointment with her boss could have her boss' position within six months' time.

- the PA you're working with could sell his own project and be producing his own movie the next time you see him.
- the casting director's assistant could be your biggest fan and in a position to book you on a sizable feature show once she starts her own casting agency.

You can never underestimate how quickly some careers will take off or how easily someone who likes you (or your work) can help your career. I've been recommended by and have received the help of people from whom I've least expected it, so respect others and do your best to impress, always and in everything you do.

Being Able to Ask for What You Want

Being able to ask for what I want is also something I learned from Heidi Wall and Suzanne Lyons. For years, when between shows, I'd call up everyone I could think of, tell them all I had just completed a film, and ask if they'd please keep me in mind should they have or hear of any openings. Sometimes that strategy worked, but not as often as I would have liked. At dinner one night, Heidi told me I had to be more assertive in asking for what I want. I told her I'd be uncomfortable doing that. (So as you can see, the whole looking-for-work-is-uncomfortable-thing applies to me as well). Anyway, Heidi finally persuaded me to give it a try—to be more direct.

I think the trick for me has been in learning how to tactfully make a request without coming across as demanding or presumptuous. What I've learned, too, is that most of the time, people are happy to help you with specific requests, as long as they know what it is you need, and that saying "let me know if you hear of anything" is often just too vague.

At the time I had been freelancing as a production supervisor, and as many contacts as I had, I realized I didn't know enough line producers (the people who hire production supervisors), and I didn't know all the studio production executives in town (individuals who are in a position to recommend production supervisors). So

the first thing I did was to invite two friends to join me for lunch, both of whom either know or regularly work with any number of line producers. Over lunch, I explained that I needed their help and asked if they'd each give me the names of five line producers they knew whom I might contact using their names as references. Bingo! Done! I got my list and started setting up general information meetings.

Of the studio executives I didn't know, I was able to set up general information meetings with each of them, except two. From having worked at Orion some years back, I knew all the studio production heads were part of something called the "The Grog and Chowder Society," and they met for regularly scheduled dinners to socialize and discuss common interests. Knowing that it was a fairly tight-knit group, I called the nicest production exec I knew to solicit his help. At the time, Bill Ewing was Senior Vice President of Production Administration for Sony Pictures. I had first met Bill a few years earlier, after having requested a general information meeting with him. I had stayed in touch, he had recommended me for a film at one time, and he very graciously agreed to meet with any number of my students each summer. Bill was one of those people I'd call whenever I finished a show, just to check in. So this time, instead of asking him to let me know should anything open up for me there, I asked if I could come see him. Being the great guy he is, he immediately scheduled a time for me to come in. Then once there, I explained my quest to meet the two other executives. He immediately picked up the phone, and in succession, got each of them on the line. His exact words were, "you've got to meet this woman!" He was my hero, and I was able to get my meetings. Heidi was my hero, too, because without her urging me to be more direct, I never would have asked for this type of help, nor would I have realized how much better this approach works.

Shameless Self-Promotion

Part of the job hunt is getting your name out there and finding ways to create memorable impressions. One way to do that is by using what the latest buzzword refers to as "branding." Start by

creating a company name for yourself, something that encapsulates all your endeavors and possibly your personality as well. Once you've thought up a name you'd like to use, see if it's available by filing for a DBA (doing business as). Check with the county clerk's office in your city. They can guide you through the process of creating a DBA. The information is available online as well. Just do a search under "Fictitious Business Name" and the name of your city. The cost runs somewhere between $20 and $30. Beware, however, that when you do the search, you'll notice services that will do the filing for you. You can use them, but they're more expensive, and the process is fairly simple to do yourself.

Once the DBA has been finalized, the next step in the branding process is to have a logo designed for your new company. There are a few ways to accomplish this. If you have a friend or relative who's a graphic designer (or even claims to be one), you can ask him to design it for you. You can also go online and search for "logo design." You'll see a plethora of online logo design solutions such as www.execulogo.com, which offers original logo designs for a reasonable price. There's also an affordable software package available called Logo Creator. This is an easy-to-use novice-friendly program for Mac or PC that guides you through creating your own custom logo.

Next, you'll want to get an e-mail domain name. While you probably already have an e-mail address, having your own domain creates a more professional impression. There are a zillion places to research and register domains online, such as domain.com. The pricing options vary, as do the services each provides, so check around on the Internet before choosing one. Either way, you'll want a domain that has your business name in it. With most of the registration services, when you type in your name, if it's not available, they'll offer you other options. For example, say the name of your company is XYZ Productions. If XYZProductions.com isn't available, possibly XYZProductions.net or XYZProductions.tv might be or even XYZProd.com—you get the idea.

The best way to go about this is to have one company both register and host the name. Registering a domain is sort of like buying a mobile home. You can buy it from a dealer, but they won't let you

live there. Hosting is more like the place where you get to park your home. One good hosting and registering company is www.kyvon.com. They offer low-price e-mail hosting and registration services. Basic hosting will cost you about seven dollars a month. So once you register your domain, you now have an e-mail address that includes the name of your company. Say your name is Nathan and your company is (still) XYZ Productions—your e-mail address would then be nathan@xyzproductions.com. Owning your domain also means you have a website address, and using this same example, your website address would be www.xyzproductions.com. Whether or not you use it, it's registered, and no one else can take it. If you want a site but aren't a web designer, there is a myriad of resources for easy online designs. For instance, www.squarespace.com offers an easy web set-up service that walks you through the process. Their basic fee is around seven dollars a month.

Now you'll want to have some business and note cards printed up with your new company name, logo, e-mail address and perhaps website address. Again, the magic of the Internet can help you out. A company called www.vistaprint.com has a good selection of predesigned cards and they can also print up your stationery, envelopes and post cards. Another business card service is www.overnightprints.com. They too have predesigned business card and post card options you can create online, or you have the option of uploading your own logo. Microsoft Word has some templates for stationery and envelopes you can drop your own logo into. Then there's always your local print shop that specializes in letterhead, envelopes and business cards. I don't suggest using the business card sheets you run through your inkjet printer. You may have this great logo, e-mail and website address, but homemade business cards just don't look as professional (although when you're in a pinch, they're better than nothing).

The Film Industry Network logo is an analogous shark "FIN" with sprocket holes running down the sides of the fin, and the fin sits atop a slogan that reads: "Learn to swim with the sharks . . . but not as bait." Both the logo and the slogan never cease to attract attention, and grabbing someone's attention is always a

good way to attract a potential new member. It's no different with personal logos. Coming up with a clever name and logo can be challenging to say the least, but once you do, you've got one more tool to use to help other people remember who you are. The ultimate goal here is to create a "hook"—an idea or image that will cause someone you've previously met to be able to say, "Oh yeah, you're the guy who . . . " It'll also allow you to be able to say, "Hi. I'm the guy who . . . "

My friend Michael calls his company Moon Over Madness and his whimsical logo is a great yellow crescent moon sitting over the earth at night. My friend Dan calls his company Jet Propulsion Pictures, and his logo depicts a boy sitting in an old-style coin-operated rocket ship ride with JPP emblazoned on the tail fin and fire coming out of the exhaust. Dan has note cards with the same unique logo on front, and he puts them to good use. Upon meeting someone he'd like to stay in touch with at a networking function, seminar or social function, he suggests they exchange business cards. Dan will make a note on the back of the other person's card, jotting down where they met, the date and any other pertinent pieces of information he'd like to remember about the person. Then later that evening or first thing the next day, he writes to that person using one of his personal note cards, letting him know he enjoyed meeting him and promising to be in touch soon to set up a subsequent conversation or perhaps a meeting for coffee or lunch.

My friend Stephen doesn't use a company name, but he did create a killer business card for himself. The front of the card is a picture of him sitting in a director's chair, on the phone, surrounded by equipment. It appears to be a candid someone took on the set one day; and it's just a shot of him at work, but it's so him.

Being that my hobby is still photography and I make my own photographic greeting cards, I'm a big one for sending out cards using some of my favorite photos. I use them for thank-yous and for just staying in touch. They're different, they're hand-made and they make an impression.

Whether you're ready to brand yourself with a company name and logo, have come up with the perfect hook or send out unique

note cards, the least you can do is get yourself some good quality, professional-looking stationery and have business cards made up with your name and contact information. The more creative the card, the better. Most people include a title or job description on their cards. What attracted me to Vivian VanLier when I was looking for someone to lecture on resume-writing was the title she used: *The Resume Goddess*. (Vivian uses different titles and explained that the goddess-one doesn't work with corporate executives but does seem to attract a large percentage of her show biz clientele.) Many actors will include a headshot on their business cards. Make it creative and make it memorable. Also be sure to include at least an e-mail address and cell phone number, so you're easily accessible. If you feel it necessary to include a mailing address but don't want to list your home address, rent a mailbox.

Another attention-grabber is an attractive website. More and more industry professionals are creating their own websites that contain their bio, list of credits, photos of themselves on the job, clips of their work, etc. Another important calling card is a demo CD. Whether you're a director, actor, cinematographer, special effects supervisor, editor, production designer, costume designer, makeup artist, visual effects supervisor, composer and/or sound designer, demo CDs are a worktool standard and a great way to promote your talent.

When it's all said and done, and as mentioned in previous chapters, the very best way to land a job and make a lasting impression on others is to just do your best and be your best, no matter where you're working or what you're doing. If you shine, others will notice. If you're passionate and have a great attitude, you'll stand out in the crowd.

— 9 —

The Resume
and Cover Letter

> *"There is no such thing as a person that nothing has happened to, and each person's story is as different as his fingertips."*—Elsa Lanchester

The Resume Pile

Studios, networks, production companies, agencies—anyone doing business in the entertainment industry collectively receives hundreds of thousands of resumes each year. And while there are times when having a well-written and professional-looking cover letter and resume is absolutely necessary, because this is unlike any other business, rarely will sending a resume to someone who doesn't know you (or know *someone* who knows you) result in a job. For the most part, you'll be lucky if submitting your resume will even elicit a form letter response politely thanking you for your interest in the company and informing you that at present, there are no openings.

Resumes and headshots arrive in droves every time a new production is announced or a new company is formed. Production office personnel will generally file incoming resumes by position or department: Production Assistants, Casting, Camera Department, Assistant Directors, Location Managers, Art Department, Editorial, etc. The assistant production coordinator or production secretary

sorting the resumes will hold on to some of the PA resumes, give specific set PA resumes to the second assistant director and turn the rest over to respective department heads in charge of hiring. If a department head hasn't yet been hired, the resumes for those positions may go to the production manager or line producer, may end up in a file cabinet or not even make it as far as the file cabinet. It's extremely rare when individuals are hired for key positions based on their resumes alone, as producers, directors, line producers and production managers each bring with them a list of individuals they've worked with before and hope to bring onto their new show. Resumes submitted by agents have a slightly better chance of attracting attention, especially if the agent is known to the line producer or production manager.

Resumes that come into studios and production companies are often passed on to individual production units or filed for a while. Other industry-related offices similarly file incoming resumes for a certain period of time.

On a show, a resume will be seriously looked at only when it belongs to someone who has been recommended by a reliable source, when it's someone the producer or director has heard of and would like to meet with or when someone's recent credits are being reviewed. Occasionally, a resume comes in at *just* the exact right moment when someone with certain qualifications is needed, and the job seeker will be invited in for an interview. And every once in a while, a busy production office in need of an extra PA or two will sort through a pile of resumes when they're desperate for extra help and have run out of people they know and people their co-workers, friends and contacts know. But no matter what the reason a resume is being considered, it won't be given a second glance if it's not professionally written and easy to read.

Your resume is your calling card, and it says a lot about you, in more ways than one. Whether it's the rare occasion when it's snatched out of a massive resume pile, pulled out of a filing cabinet, sent in upon request or presented at a meeting, it could mean the difference between you getting a job—or not.

The Cover Letter

A cover letter isn't written for the purpose of *asking* for a job. Even if you're responding to a specific opening, it's basically an introduction to you and your resume. While your resume lists the details of your background, the cover letter is more conversational in tone. And while your resume is fact based, your cover letter can be slightly more creative and a way to inject a bit of your personality and background into the presentation. A well-written and professional-looking letter should prompt someone to *want* to read your resume and possibly want to meet you as well.

A cover letter should be no more than a few paragraphs, one page at the most. The people reading it are busy and won't even bother if it's too long. But on the other hand, it shouldn't be too short either. Merely stating, "In response to your ad for an administrative assistant, please accept my enclosed resume" doesn't say enough about who you are and may get passed over as quickly as one that's too wordy. The first paragraph of your cover letter should indicate who you are and why you're writing. (Are you writing to ask for a general information meeting, in response to an ad you saw posted for a specific job or to someone who's about to start assembling a crew for a new show?) The second paragraph should tell the reader a bit more about you and should summarize your background, talents, special skills and goals. And a final paragraph should state something to the effect that you're looking forward to meeting this person soon and appreciate his or her consideration (see more detail on this further ahead).

The only time it's acceptable to *not* submit a cover letter is if you're an actor/performer. Your resume and headshot says it all, and a cover letter is not necessary.

As for what a cover letter should look like, start with a simple, professional-looking font (like Times New Roman, Palatino, Arial, Helvetica or Geneva)—nothing fancy. Use decent-quality $8\frac{1}{2} \times 11$ paper. Limit your paper to white or off-white. Don't use anything too colorful or too cutesy. Next, it should be typed in proper letter format. Handwritten cover letters will almost certainly be tossed out, those with spelling errors will usually be discarded post haste

and, often, those that are poorly formatted are likely to land in the recycle bin. If you're not sure what a proper business letter looks like—the margins, the spacing, how to address someone, how to close your letter, etc.—look it up on the Internet. I've received cover letters (if you could call them that) written in pencil on tiny scraps of note paper and on three-hole lined paper that had been ripped out of spiral notebooks with the jagged, torn holes along the left side of the page—*not* a good idea. Another big no-no is not running your letter through a spell-checker. Misspelled words are grounds for instant dumping. When you consider all the cover letters and resumes being submitted each day, if you want to be taken seriously, and if you're even going to have a chance of having yours read and considered, it needs to look professional.

If at all possible, your cover letters should be addressed to *someone*, not just "to whom it may concern," but a department or the name of a show. If you're looking for a job as a PA, for example, you would submit your resume to the production coordinator, and you would find out the name of the production coordinator before writing your letter. As an apprentice editor, you would submit your resume to the assistant editor, and the same thing—you would find out the name of the assistant editor before sending in your letter and resume. There is no guarantee, but if you address your letter to an individual, it might somehow find its way to that person's desk instead of automatically landing in the resume heap on the floor or buried in a file cabinet. Be sure to verify the spelling of the name of the person you're addressing your letter to and that person's title. Also, make sure you have his or her gender correct (I know both men and women named Terry, Pat, Alex, Robin and Michel). A cover letter with a misspelled name, an incorrect title or a salutation addressing a Mr. instead of a Ms. (or vice versa) could be tossed into the trash instantly without that person ever having looked at the attached resume, because it clearly says all it needs to say about you—that you didn't care enough to check.

Moving on to the content of your cover letter—while they're not all going to be the same, many of the elements will remain consistent. Your first paragraph is an explanation as to who you are and why you're writing, and this is where the most differences will occur from letter to letter.

You may have previously called in to check on employment opportunities or to set up a general information meeting and been asked to submit your resume. In this case, you might start your letter with, "As per our phone conversation of September 27th, attached please find a copy of my resume." Or, you could write, "Thank you for taking the time to speak with me last Thursday. As per your request, attached please find . . ."

You may have an acquaintance or friend in common and may have secured a recommendation, in which case you would start with something like, "I am writing to follow up on a recent conversation you had with our mutual friend, Penelope Producer. My name is Wallace Wannabe, and as I'm sure Penelope has told you, I'm an art director and have just completed working on *Gone With The Wind II–Scarlett's Revenge*" (you get the idea). Or, if this situation is more appropriate, "My name is Wallace Wannabe, and Penelope Producer suggested I contact you."

The person you're writing to could be someone you met at a party or event or someone who lectured at a seminar you attended, in which case you might start off like this, "My name is Wallace Wannabe, and we met at last month's Studio City Pitch Fest." Or, "My name is Wallace Wannabe, and I was in the audience at the seminar you spoke at yesterday evening. I was quite inspired by what you had to say and wanted you to know how much I appreciated your insight and advice."

You may want to contact someone you worked with a long time ago. In that case, how about, "You may not remember me, but we worked together a few years back on *My Right Foot*. I recently read that you're about to start a new film—congratulations! As I would very much enjoy any opportunity to work with you again, I have enclosed a copy of my updated resume."

Another good way to introduce yourself is by letting the other person know that you have a specific skill, talent or expertise he could use. Example: "My name is Danny Diver, and my specialty is underwater cinematography. After having worked on several dozen features that have shot on, in and under water, I'm certain I'd be an asset to your upcoming production of *Water World II*." Or, "My name is Nancy Newcomer, and I read in the *Hollywood*

Reporter that you are scheduled to shoot a remake of *Lassie Come Home* in my hometown of Corn Stock Junction. I would very much like to be considered for a PA job on your film. Having lived here all my life and having worked on several local TV shows, I have the experience, connections and desire to assist you in securing locations, local crew, extras, equipment and services."

If you're applying for a specific job opening, "My name is Nancy Newcomer, and I am responding to your ad for a receptionist." Or, "As per your listing in the most recent UTA Joblist, please accept my enclosed resume as application for the Intern position you are seeking to fill."

If you would like to apply for a show that you've been told has already been staffed, give it a try anyway with something like, "I understand your production office is already fully staffed, but from past experience, I know that circumstances can change and occasionally new positions do open up. Therefore, I have enclosed a copy of my resume for your review and would very much appreciate the opportunity to come by for five minutes one day, just to introduce myself to you."

Hearing that someone has been promoted to head a new division, or has started his or her own company is always a good reason to be submitting a resume. In situations like these, your letter might start out like, "Congratulations on your new post as head of XYZ Independent Pictures. My name is Holly Woodland, and if you have started assembling your new staff, I would appreciate the opportunity to introduce myself to you and to throw my name into the hat."

If you're requesting a general information meeting, make it clear—you're not looking for a job. Here's an example: "My name is Wallace Wannabe, and I recently moved to the Los Angeles area after graduating from film school in Boston. In an effort to learn more about how this industry truly works and the field of visual effects in particular, I am writing to request fifteen minutes of your time. I would greatly appreciate the opportunity to introduce myself to you and to ask you a few questions. I am certain the insight and advice you could provide would be of tremendous benefit to me."

Your second paragraph should be a short version of your pitch, which focuses on your experience, special talents, skills and accomplishments, what you're passionate about and what you have to offer. It should capture the essence of who you are. If you're responding to a specific job opening, be sure to describe your attributes in a way that best fits the qualities they're looking for. Here are a couple of examples:

"I have wanted to work in the film industry for as long as I can remember, but two years ago I graduated from Northwestern with a degree in political science, because my family didn't want me going into the film industry. After graduation, I got a job as an intern to a senator in D.C. I was there a year, but all I kept thinking about was how much I'd rather be working on a film. So I have come back to the Los Angeles area and am determined to make it. I'm willing to do whatever it takes and will be the best production assistant anyone's ever had. I'm dedicated, good at resolving problems, quick to anticipate the next step and manage to stay fairly calm while others around me are freaking out. I also learned a great deal about politics during my year in Washington and am pretty good at dealing with big egos and VIPs."

Here's the second paragraph to a letter I helped one of my students with this past summer.

"Last year I switched professions to become a junior talent manager at ABC Management. After twenty years of experience in business, career supervision, image building, public and media relations, strategic planning and problem-solving, talent management seemed a natural next step for me."

Okay, now for the final paragraph—the wind-up. The biggest mistake I see people make is when they write, "Looking forward to hearing back from you." I don't think so! If the person you're sending your resume to doesn't know you, don't expect a reply. Too busy and too many resumes—it won't happen. Instead, mention that you will call her office in a few days. Here are some examples of a final paragraph:

"Attached please find a copy of my resume. I will call your office in a few days to see if I may set up an appointment to meet with you."

"Attached please find a copy of my updated resume. I would be happy to answer any additional questions you might have regarding my background and experience and if possible, would appreciate the opportunity to come in to introduce myself to you in person. I will therefore call your office next week in the hope of setting up an appointment."

Here's a final paragraph I used in one of my letters a couple of years ago (this person had met me once and already had a copy of my resume):

"I realize that at present, you have no openings, but when the time comes to expand your department, I hope you'll remember how much I'd like to be part of your team. I can't think of a more desirable situation than to work for a company like XYZ Entertainment and to be part of a production department headed-up by two individuals I both like and respect. I will therefore be checking in with both you and Jim from time to time and hope to be working with you in the not-too-distant future."

It's always a nice touch to end your letters with, "Thank you very much for your consideration."

Resume Guidelines

Just like with a cover letter, a resume should be professional looking and typed using a simple font on good-quality $8\text{-}\frac{1}{2} \times 11$ paper. If you can keep it to one page, that's great. It shouldn't be longer than two pages. Again, the people on the receiving end are busy. If it's too long, they won't even bother. If it's not easy to read, they won't read it. If you've misspelled words or names, it's in the trash. And this is not the time to be cute and creative. Just the facts—that's all anyone wants to see.

If you plan on attaching your resume to an e-mailed cover letter, the subject of your e-mail should reflect the purpose of your letter, such as *In Response To Your Ad For An Administrative Assistant*, or, *Film Student Seeks A 10-Minute General Information Meeting*. Your resume should be in a Word or PDF format (which will make it eas-

ier for most people to download and open), and the title of the attachment should be more than just "Resume." Make sure your name is included, such as *Wallace Wannabe Resume.doc.* This way it's less likely to get lost in a sea of other downloaded resumes on your recipient's computer.

There are many experts who can tell you how to properly format your resume, but they'll all suggest something a little different. As someone who reads a lot of resumes and is often in a position to hire, I can tell you that specific formatting guidelines don't matter as much as whether a resume is easy to read. I don't like to have to search for the information I need, nor does anyone else. The order in which I prefer to see the information presented is this:

- name and contact information
- objective or job title (What do you do? Very important!)
- summary of experience (optional)
- work history (list of jobs or credits, listing the most relevant first)
- additional experience (relating to your work in other businesses or other facets of entertainment)
- education
- special skills, talents and abilities

Because incoming resumes are filed by category, department or job description, it's important to have an unambiguous objective, specialty or job title (in large, bold letters) under your name and contact information, so at first glance, it's obvious which department, office or file folder your resume belongs in. If it's too hard to figure out what it is you do and what you have to offer, your resume is doomed for the old recycle bin. If you're not sure, you can always indicate that your objective is to secure an *entry-level position.*

Just as important as it is to make clear exactly what it is you do, make sure you don't list more than one job title or specialty at the top of any one resume. It's okay, for example, if you indicate

(at the top of your resume) that your specialty is post production management and then go on to list shows where you may have worked as an associate producer, post production supervisor or post production producer, because it all falls within the same area of expertise. On the other hand, you wouldn't want to indicate (on any one resume) that you're an editor, script supervisor and production manager, even if you're brilliant at all those jobs. If you do, no one will take you seriously, and you'll severely limit your employment opportunities. Take someone looking for an editor: she wants the very best and most experienced editor her budget can afford. Given the choice between someone who's a part-time editor and another who had always wanted to be an editor and has been doing it for a while, there's no contest. It's okay to list "other skills" within the body of your resume, but if you want someone to consider you for a job as an editor, then the job description listed at the top of your resume has got to read: *Editor*. Resumes that come in from people who do multiple jobs can't be easily categorized and are the first to get tossed or buried. You'd think that being a multifaceted "total filmmaker" would be an asset, but unfortunately, it won't mean much unless you're making your own film.

If you're one of the many people who does have a fragmented body of experience, it's perfectly acceptable for you to create more than one version of your resume, each emphasizing your background and expertise in the type of work you're applying for. In fact, if you know exactly what they're looking for, you can customize your resume for each company you submit it to.

Once your career and job title are established, you don't have to list your job responsibilities, because everyone knows what a development executive does, what a literary manager does, what an art director does and what a casting director does. But when you're starting out, it's helpful to prospective employers to know exactly what your duties were on previous jobs. Also indicate the dates you worked for each employer and who you reported to. Here's an example of a format I like:

NANCY NEWCOMER
nannew@xyz.com
Phone: 555-3456 - Cell: 555-1234

PRODUCTION ASSISTANT

Employment History

August, 200X–Dec., 200X *"Scarlett's Revenge"*–XYZ Productions
Position: Key Office P.A.
Supervisor: Katie Kandu, Production Coordinator
Duties: Assist with all production-related
paperwork and office management; answer phones;
runner; craft service; photocopy and file

January, 200X–July, 200X *"My Summer Vacation"*–Hollywood Films
Position: 2nd Assistant Camera
Supervisor: Leo Lenscapp, 1st Assistant Cameraman
Duties: Complete camera and film reports

October, 200X–January, *"The Monday Afternoon Show"*–ELH Entertainment
200X
Position: Intern
Supervisor: Beverly Fairfax, Production Manager
Duties: Assemble possible future guest biographies
by researching trades, newspapers and magazines;
filing; photocopying and answering phones

This is how I've set up my own resume:

NAME
Contact Information
Job Title

PRODUCTION WORK HISTORY
I have worked both freelance and in management staff positions, on features and television, on large and small budgeted shows, both union and non-union, within the U.S. and internationally.

(Title I Received)	(Type of Show, i.e., feature film, TV pilot, etc.)
(Name of the Show)	(Producing Company)
	(Supervisors:)

I list an entire page full of credits just like these in this columnar format. And my *Additional Experience* of being an instructor and author is listed on a second page.

You can also do it this way:

| (Name of Show) | (Your Title) | (Producing Company) |
| | | (Supervisors:) |

Here are some other resume tips.

- If you're in the process of changing careers, note that in your *Summary of Experience*, and briefly highlight the beneficial skills you bring with you from your previous career.
- Update your resume after each job.
- Prospective employers do check facts and references, so while you may want to enhance your resume a bit, don't out-and-out lie or exaggerate too much. It could come back to haunt you.
- If you only work on a show for a day or two (as a "day player"), on reshoots or second unit, indicate that. Don't let others assume

you worked on the entire production, because this could also come back to bite you in the butt.

- List everything—even internships. Especially when you're just starting out, everything matters, even school productions.
- Unfortunately, age discrimination is a reality in this business, and because of that, many experts recommend that you only list the last ten years-worth of your credits. On the other hand, you may have a credit that's more than ten years old, but is a pivotal part of your career, and you don't want to cut it out. This is another instance when you might want to consider who you're submitting to and customize your resume appropriately.
- It's perfectly okay to attach a letter of recommendation to your resume, but don't attach too many. Don't overdo.
- In an effort to do something different and creative, consider introducing yourself and your resume via CD. Have a friend operate the camera, or set it up on a tripod. Start by introducing yourself (let your personality come through) and go through your pitch, including a brief rundown of your credits. This is an especially unique way for people who live out-of-town to apply for work.

Advice From the Resume Goddess

In the previous chapter, in the section on self promotion, I mentioned how spotting the title of *The Resume Goddess* led me to Vivian VanLier. I'd like to thank Vivian for her help with the next part of this chapter as well as the sample acting resume. Vivian is a certified career coach with a national reputation for providing career management and resume writing services to professionals and executives throughout the U.S. and internationally. She has earned three prestigious credentials as a career coach and resume writer and works extensively with individuals in the entertainment industry. I felt her input would be an asset to you as well as to the chapter.

The Resume

People outside of key entertainment industry markets often have misconceptions about how to write an entertainment-related

resume—and misconceptions about the industry itself. The per-
ception outside of "Hollywood" is that the entertainment industry
is glamorous and high paying. While this is true when it comes to
a handful of top executives and performers, for the most part, it is
an industry driven more by passion for the creative arts than by
working conditions or pay. Where this relates to resumes, under-
standing the protocols of the industry is paramount. And just like
any other field, those in a position to hire are looking for your
understanding of the challenges, needs and environment of the
industry, specific job and work environments and how you add
value. A potential employer is going to be more interested in what
you can bring to *his* business, office or show than in what *you* want.
Furthermore, "seeking a challenging job with growth potential" is
not only a boring, overused statement to add to your resume, but
again, it's about *you* and what *you* want, *not* about what you can
offer others. They're also *not* wowed by flashy, over-the-top, glitzy
presentations. Gimmicks don't work. They've seen them all and
are not going to be impressed.

There are three basic areas of the entertainment industry that
apply to all segments, including motion pictures, television, music,
theater, media, etc.: (1) the business end, (2) the creative/perform-
ance end and (3) the production end, although this is somewhat
simplistic inasmuch as film and TV production alone covers the
development, pre-production, production, post production, distri-
bution and exhibition facets of "production."

Resumes for core business-related functions, such as Accounting
and Administrative Support, are basically the same as they are for
any other industry with the addition of specific industry-related
procedures. And as to the formatting and development, they are
like any other business resumes, with the inclusion of industry-
specific verbiage. At this point, it should be noted that the over-
whelming majority of people in the industry *must* enter at an
entry-level position and work their way up.

Where resumes are vastly different is in some areas of produc-
tion and of course, performance. Production and performance
resumes are highly structured and formulaic, *not* highly creative.
In general (although there are exceptions), they are columnar in

format, and provide succinct information about past credits. Screeners are looking for what you've done, what you've worked on, who you've worked with, training (as appropriate) and special skills (as appropriate).

You'll have to know what needs to be on your resume. If you're just getting started, you'll have to identify your goal, how you've actually gained "experience" and what your "skills" are. In performance and some production areas, one might be represented by an agent, and if this is the case for you, your agent might prepare your resume or tell you how it should be structured.

Other differences on entertainment industry resumes are:

- For acting: Personal information *must* be included: height, weight, eye color, hair color; sometimes appropriate age ranges for parts. Format the resume so it can be cut down to 8 x 10 inches, because it'll be stapled to the back of a headshot. Dancers and models also will affix their resumes to photos.
- Make sure that guild memberships are noted prominently, e.g., SAG, AFTRA, Musicians Union, WGA, DGA, etc. This matters!
- For actors, musicians and production personnel with agents, you'll probably be asked to leave space for the agent's label. Where the label goes is the agent's preference.
- Resumes for performers and (some) production professionals are usually one page, and as new credits are added, older, less significant credits are taken off (although this is not a hard and fast rule). Personal information is *not* included on production or music resumes.
- If your expertise is a creative one, such as cinematography, costume design, art direction, production design, etc., your resume will be credit-based. Depending on the specific situation and your reputation, you might include summary at the top of the first page.
- Understand what's required for the specific position you're applying for and demonstrate your ability to excel in those areas. For example, a concert tour manager may have to be able to handle finances, coordinate travel, seek rehearsal venues, source and

negotiate with vendors for merchandise, act as liaison with the media, even ensure the sobriety of roadies and performers!

• Common themes that run through just about every entertainment industry position is the ability to work in a fast-paced, deadline-driven environment, interact with diverse temperaments, the ability to respond to ever-changing environments and a willingness to consistently go beyond the requirements of the job!

Once you as an artist or production crew member are established, you may no longer need a resume at all. Resumes for established professionals are typing jobs and don't require creative writing. All that matters are your most recent credits: what you've worked on and with whom (directors, producers, studios, production companies, etc., depending on your specific profession).

For an entry-level resume, you'll have to be able to identify when you've used the appropriate skills that are needed to succeed and what relevant experience you have, even if it's only been in school films or plays.

Here are some questions, the answers to which will help you to create your resume and cover letter:

• Are you a member of a guild or union? Which one?
• Who did you study with?
• Do you have any special training?
• What are some of your special skills or talents? (actors)
• What technical abilities do you have; what equipment do you work on (audio, photography, etc.)?
• What are your credits to date? (film, television, commercials.)
• What differentiates your work?
• Have you received any award nominations?
• Have you received any awards?
• Where have you performed? What role did you play?
• Can you demonstrate that you can perform/work effectively in a very fast-paced environment with critical deadlines?
• Are you well organized?
• Are you good with detail?

- Do you have good "people" skills?
- Can you work with diverse temperaments?
- Are you a self-starter?
- Are you good at following directions?
- Are you a team player?
- Are you energetic and willing to work long hours (for low pay!)?
- Are you an avid movie fan? Do you see a lot of new releases? Have you seen a lot of classics (which helps you to be knowledgeable about the industry)?
- Are you a good problem solver? What are some examples of when you had to "think on your feet" and solve problems quickly and effectively?
- Are you flexible in adapting to an ever-changing environment?

An Acting Resume

The basic layout of an Acting resume is shown on p. 176.

The Follow-Up

If you've sent in a resume, you'll want to verify that it's been received. If you've ended your cover letter with, "I'll call your office within the next few days to see if I may set up an appointment to meet with you," you've got to follow through. Call back in a few days, no longer than a week, and be prepared for what you might encounter on the other end of the phone. The people you're calling and their assistants and receptionists get tons of these calls each day from individuals just like you seeking work, meetings and just a couple minutes of their time to see if their resumes have arrived. Most are busy and some quite quick to say, "I'm sure your resume is here, and if there's an opening or we need extra help, we'll be in touch." Or, "Sorry, we're all staffed up, but we'll keep your resume on file."

 Although I go into this in much more detail in the next chapter, your mission is to win over the gatekeeper. You rarely (if ever) ask for the person you addressed your resume to. You ask for his assistant, and you either learn the assistant's name before you talk to her, or you ask her name once you're on the phone with her.

SANDI STARLETTE
Member SAG / AFTRA

Ht: 5'4 Contact Information (Phone only)
Wt: 110 Or
Eyes: Green Agent's Label
Hair: Blond

MOTION PICTURES

Role	Film Title	Director/Producer
Role	Film Title	Director/Producer
Role	Film Title	Director/Producer
Role	Film Title	Director/Producer
Role	Film Title	Director/Producer

TELEVISION

Role	Film Title	Director/Producer
Role	Film Title	Director/Producer
Role	Film Title	Director/Producer
Role	Film Title	Director/Producer

COMMERCIALS

Role	Company / Product	Director/Producer
Role	Company / Product	Director/Producer
Role	Company / Product	Director/Producer
Role	Company / Product	Director/Producer
Role	Company / Product	Director/Producer

TRAINING

B.A. in Acting, New York University, NY
Ana Bechtelle workshop at the L.A. Center Stage
Emilo Nunez, Broadway Professional Studio, New York, NY
Sandy Dupre Dance Academy, Hollywood, CA

SKILLS

Dance (ballet, jazz, tango); Singing (musical comedy, pop, rock); Russian, French and German Dialects, U.S. regional accents; Ice Skating, Roller Skating, Golf, Basketball, Hockey, etc.

If you're looking for a PA job on a show, you'll want to ask for the production coordinator or assistant production coordinator. If you're not sure who to ask for, befriend the secretary or receptionist who answers the phone, and always ask for the name of the person you're speaking to (if they haven't already announced it themselves upon answering the phone). Okay—so let's just say the name of the person you want to talk to is Barbara. You're going to call her during non-peak hours, usually before 10:00 a.m. or after 5:30 p.m. However, some offices open early (like 8:00–8:30 a.m.) and stay open long after 6:00 p.m., so if you can find out the hours she's there, the earlier or the later you can call, the better. First thing in the morning is always a pretty good bet, because chances are, the phones won't be ringing off the hook, and Barb won't be frazzled yet. You're going to be upbeat, pleasant and know what you're going to say ahead of time, so you come across confidently and succinctly. If you sound hesitant or meek, ramble or speak too softly, you'll lose her in a flash. In times like these, I write down what I'm going to say before I call, and then practice until I'm comfortable enough to pick up the phone.

You'll start with, "Hi, Barbara, my name is _____." And then something like: "I sent a letter and resume to Robert Bluford last week, and I was wondering if you might help me by finding out if he's received it yet." Of course Mr. Bluford has also received fifty other resumes during the past week, and yours is undoubtedly in the pile somewhere. Not only that, but chances are, Barbara isn't going to want to stop what she's doing to retrieve it and may just tell you she isn't sure if it's there or not. But then you could say something like, "Barbara, I could really use your help. I just moved to L.A. (or just graduated film school, or am just in town for this week, or just finished another project—whatever fits your situation) and was hoping to be able to meet Mr. Bluford, even if it's only for five minutes, and even if there are no current job openings there. It would mean a lot if you could find my resume and put it on his desk, so he's sure to see it. And if it would be easier for you, I'd be happy to fax or e-mail you another copy. Then if it's okay, I'd like to check back in with you tomorrow or the next day." You're not going to whine or sound desperate, but you are going to

solicit her help. And you're going to be so nice and so charming, she's going to *want* to help you. If it's a bad time for her or for Mr. Bluford, ask when it would be more convenient to call back. If you reach a dead end, politely ask if she'd mind if you check back in with her in another couple of weeks. Be persistently charming and charmingly persistent (contrary to popular belief, persistent doesn't have to mean annoying). If you sense Barbara has the time and is willing to listen, give her a short version of your pitch. Turn her into your ally. The better she knows you and the more she likes you, the more she'll want to help you.

This approach may not always work, but it's your best bet. If you're submitting your resume via a reliable referral, it has a good chance of seeing the light of day. If you're submitting your resume to someone who doesn't know you (nor anyone you know), you can never assume he's going to respond by inviting you in for an interview. That almost never happens. But you have to at least *try* to keep your resume from getting buried in some heap or file cabinet. When you check in a few days after your resume's been received, you can't acquiesce if Barbara tells you they'll keep it on file and call you if there's an opening. You have to at least *try* to win her over and gain her help. I've seen this work. And at one time, I was Barbara, and being her, I did help certain individuals who knew what they wanted, asked for my help and were extremely nice. I also know a writer who was able to convince a development assistant to pull his script out of a tall submission pile (where it had been totally buried) and stick it on her boss' desk, where it got immediate attention. It's always worth the effort to try.

When to Use a Bio

A bio is an overview of your experience, special talents and skills, affiliations and accomplishments. It doesn't list your employment history or credits the way a resume does, but instead, notes specific events, projects or achievements that are pivotal milestones in your career. A bio is narrative in style and is written in the second person. Some are written to reflect personal attributes and others are strictly professional in tone.

If you're new (or even fairly new) to the business, stick with your resume. That's what prospective employers want to see at this point. Bios are often requested only after someone has built up a body of work. They're primarily used for publicity purposes and are common worktools for producers, directors, actors, cinematographers, production designers, costume designers, casting directors, composers and editors. If you're going to be teaching a class, sitting on a panel, giving a seminar or writing articles or books, you'll need a bio. If you're putting a business plan together to attract financing for a project, applying for a job where your credits are already known, opening a new production company, agency or business or land a mid- to high-level position within a studio or any other high-profile industry-related business, you'll need a bio.

I have a one-paragraph bio and one that's a page long. It's like your pitch; it's good to have different versions for different occasions. If and when you're requested to submit a bio, it's a good idea to have someone else write it for you. They'll be more objective. If nothing else, have someone who knows you and your background read it and offer notes. Agents and managers will often write bios for their clients as do publicity agents and studio publicists. You can also have a professional resume writer (like Vivian VanLier) write your bio for you. You want it to be well written and to accurately encapsulate your entire professional history.

Safeguarding Your Resume and Headshots

The following was written by the Screen Actors Guild for the purpose of providing tips for actors as to how to safeguard their privacy on resumes and headshots. And because it contains helpful suggestions that would apply to everyone, not just performers, I asked SAG for their permission to reprint the information, and they've consented. Here it is:

We all know a headshot is an essential part of an actor's job search. It's like your glossy passport into the industry. As a

Continued

performer seeking roles, you must constantly provide it, along with certain personal information, to agents, managers and casting directors. But use caution. Unauthorized strangers with bad intentions can sometimes gain access to your image and information, then repurpose, digitally alter, or sell them on the black market without your knowledge. While SAG continues to work with auction giant eBay in an effort to thwart this activity, it wants to offer some fundamental tools that will help protect you and your family. Guard your reputation and keep your confidential information private!

#1. Do not give your Social Security Number (SSN) to anyone unless you have been hired, even if it's being requested. When signing in at an audition or filling out a size card, use your SAG member ID number.

#2. Never put your SSN on your picture or resume.

#3. Wherever possible, use your agent or manager's phone number and address rather than your personal information. If you cannot use an agent or manager's contact information, consider getting a cellular phone or pager. If you want to include a mailing address, a personal mailbox will work.

#4. To help prevent your photograph and resume from being used inappropriately, include a disclaimer such as the following: "Property of [your name]. For casting purposes only. Not intended for sale or commercial use."

#5. When having headshots taken, ask the photographer to include language in the contract stating that it is a "work for hire." Otherwise, you do not own the copyright to your photographs (even if the photographer gives you the negative).

#6. Before you submit a picture or resume for any project, you may want to contact the Guild to determine if the project is signatory to the appropriate SAG agreement. You can also check this information online. Go to www.sag.org, log

Continued

into the members only area and click on "Get Work." Here SAG members can enter a production name and check its signatory status. If it is not a SAG signatory project, the risk of your personal information remaining confidential may be compromised.

#7. To safeguard against your image or personal information being displayed or sold on the Internet, periodically run a search for your name on eBay and conduct a general search of the Internet using one of the major search engines.

#8. If you choose to promote and market yourself online through the creation of a website, do not use your personal contact information when registering your domain name. We suggest you follow guideline number three above when deciding what contact information to use.

#9. Like most people these days, you probably use e-mail. We suggest you maintain multiple e-mail addresses for different purposes. For instance, it may be useful to maintain a *private* e-mail address; a *professional* e-mail address for agents, casting directors and managers; a *registration* e-mail address for registering on a website that requires your e-mail or at which you can receive general e-mail; and a separate *fan* e-mail address for fans or the general public.

#10. Always assume your online communications are not private. Do not provide sensitive personal information (phone number, password, address, credit card number, Social Security number, health information, date of birth, vacation dates, etc.) in chat rooms, forums, e-mails or in your online biography.

#11. Above all, remember to use common sense and trust your instincts. If you are asked to provide information that you are uncomfortable with, or that seems inappropriate to the situation, think twice before you provide it. If there is doubt, confirm whether it's necessary with someone in a position of authority.

Continued

The following is a partial list of online resources that offer information about protecting your privacy:

- Federal Trade Commission Privacy Initiative: www.ftc.gov/privacy/
- Privacy.org: www.privacy.org/
- The Electronic Privacy Information Center Online Guide to Online Privacy Resources: www.epic.org/privacy/privacy_resources_faq.htm

No matter how easily your resume and cover letter could get lost or buried on its way to its intended recipient, you can never underestimate the importance of well-written and professional-looking documents. They not only attest to your experience and skills, but also to your motivation, level of commitment and intelligence.

If you have further questions about preparing your cover letters and resume, make sure you seek advice from individuals who specialize in entertainment resumes, because the guidelines are different than they are in other businesses. Don't waste your time or money on books or resume experts if they don't know this particular industry.

My thanks again to Vivian VanLier for her help with this chapter. Vivian is the president of Advantage Resumé & Career Services and can be found on the Internet at www.CuttingEdgeResumes.com and www.CareerCoach4u.com

— 10 —

Interviews and Meetings

> *"I have ten commandments. The first nine are, thou shalt not bore. The tenth is, thou shalt have the right of final cut."*—Billy Wilder

Whether the outcome is a job, and whether the setting is a formal office or informal get-together for coffee, the goal of any interview is to make a connection with the person you're meeting. By making a lasting impression as well as an effort to stay in touch, there's a good chance this person will hire you in the future (or recommend you to others). He will definitely become the newest member of your network.

Since everyone you meet is a potential new connection or link to a future job, you not only have to make the most of each meeting, you have to be able to capture the other person's attention in a very short span of time. You can't walk into a meeting without being prepared and knowing what you're going to say. There are too many people vying for that opportunity, and unless you stand out among all the others waiting in that same long line hoping to get through that same door, you won't have much of a chance.

People in positions of hiring aren't always looking for expertise and talent, and they know, especially when meeting individuals seeking entry-level positions, few of the candidates are going to have much (if any) experience. Simply put, they're going to hire

people they like and have a good feeling about. They want to see something in you that will convey a sense that you're a team player, are willing to do what it takes to make it in the industry, have an abundance of stamina and won't complain, are sincere, have a willingness to learn, have the capacity to be a problem-solver and have the insight to anticipate the needs of others. They're attracted to those who are bright, sharp and intuitive. They want to hire someone who's interesting, has a sense of humor and a terrific personality—someone they'll enjoy being with during long work days. And they'll be drawn to individuals who have a passion for the industry.

These qualities aren't merely prerequisites for landing entry-level positions. They will serve you well, whether you're already working in or wanting to work in this business (or any other business, for that matter). This industry doesn't, nor will it ever, suffer from a lack of smart, ambitious, talented individuals. Some are sought out solely for their exceptional creative abilities or deal-making prowess. But more often than not, people hire the people they know, are most comfortable with and like. Sure, you have to possess certain skills relative to the jobs you apply for, but we're not talking about the level of competency needed to perform brain surgery or send men to the moon here. There are a lot of equally qualified and talented people in this industry, and the one who lands the job or role or client may have a tad less talent or ability than the next guy, but he may be more fun to have around, be more interesting, have a better attitude, complain less or be better connected.

Since you will undoubtedly be meeting and interviewing with individuals who don't know you, your goal is to make them like you and want to get to know you better. It doesn't have to take long for you to impress someone with your unique qualities, passion and enthusiasm. An intuitive interviewer will soon discover that you're interesting, bright, hardworking and determined (you are, aren't you?). And it should take no time at all for anyone to see that you have a good sense of humor and are fun to be with (you're that as well, right?).

Chapter 8 will have already prepared you for the necessity and value of developing a pitch for yourself, so if you don't already

have a personal pitch, you should at least be thinking about one or practicing on friends. To reiterate something else covered in Chapter 8, don't forget that the very best way to get a meeting with someone you don't know is through a referral from a mutual friend or acquaintance.

There's More Than One Kind

I bet you didn't know there are different types of meetings as they relate to interviews. There's the standard "it's-the-same-in-every-business" interview for a specific job opening, which you may have already experienced, and then there are the following three types (which are explained in greater detail within this chapter).

My favorite is the **general information meeting**. This is a meeting *you* ask for. It could last five minutes or an hour, depending on the circumstances. Its purpose is for you to introduce yourself to someone you admire, someone who's doing the type of work you aspire to, someone with a great deal of knowledge about a facet of the industry you're interested in and/or someone you might want to work for some day. Your goal is to learn, gain some insight and hopefully make a connection.

Then there's a **pitch meeting**, which is a meeting at which you pitch (attempt to sell) a script, packaged project or a concept. See Chapter 14 for much more information on pitching.

Lastly, there's the **door-to-door approach**. This is not a formally scheduled interview, but when it works, it's a great way to get to people you want to meet.

Getting Past the Gatekeepers

Your career will move at a snail's pace, if at all, if you're the type who sits at home waiting for the phone to ring. You also can't rely on the hope that if you send out resumes, someone will see it, be impressed and call to invite you over for an interview. That *could* happen, but if I were you, I wouldn't hold my breath. If you want to meet specific people and want them to know who you are, one of the best ways to make that happen is to take the initiative. Set

up the meetings yourself. It's not quite as easy as it sounds, and it often requires all five of my favorite "P" words: passion, persistence and patience as well as being pleasant and positive to make it happen, but it's done every day. Keep in mind, however, that your first step will most likely be getting past the gatekeepers who guard the people you want to meet.

The person you want to meet is most likely a busy person, and her time is stretched thin. She probably has an assistant (sometimes two), and there may also be an office receptionist, all of whom are responsible for screening calls and keeping countless numbers of job hunters at bay. If she spoke to everyone who called looking for a job, she'd never get her work done nor have time to talk to the people essential to her current projects. Those guarding her domain are the gatekeepers. Unless you have a direct connection to the person you want to meet or have been recommended to her by someone she knows, you'll first have to win over her assistant, or you go no further.

This concept isn't difficult to understand, and you'd think everyone would just automatically get it, but they don't. Individuals just starting in the business (without connections or recommendations) call producers, directors and the heads of departments and/or companies every single day. They can't get through to them, their calls are not returned, they get discouraged and they get nowhere. Here are some tips to help you get somewhere:

- Know the assistants' names before you call (you can ask the receptionists).
- Call him or her by name.
- Briefly introduce yourself and be precise about why you're calling.
- Be nice!
- Be sincere.
- Ask for their help!
- Thank them for their time and help.
- If they like you, they *will* help you!

Before you call anyone, know what you're going to say. Keep it short and to the point. In other words, make your point quickly.

Write out what you're going to say ahead of time, and practice saying it several times until you're comfortable with the words. No one's going to have the time or patience for a long, drawn-out monologue or a stammering, insecure voice on the other end of the phone.

If an assistant works in a stressful environment, he might be stressed himself, curt, maybe even rude. He may also put you on hold five times before you can get two words out of your mouth. Keep in mind, though, that he probably gets about a gazillion calls like this every day from people just like you who want to set up a meeting, submit their latest demo CD, have their script read, or apply for a job. But don't let that dissuade you from giving it your best shot. If you're doing everything right and it's still not working, put that Teflon coat on and persevere (call at least once a week and kill him with kindness). If an assistant tells you his boss is too busy right now (she might be in the middle of a project), ask when might be a better time to call. The assistant may suggest you call back in a week or three months. Whenever it is, make a note to check back in with him at that time. Your patience will usually pay off. Most assistants do respond well to a pleasant voice on the other end of the phone. And who could resist someone who makes them laugh (you can do that, right?)

I've worked on both sides of the fence. Having been a gate-keeper who shielded my supervisors from unnecessary calls and interruptions, I've also been won over by many whom I've helped get meetings that wouldn't have happened otherwise. On the other hand, I'm still very much among the legions of those who must on occasion solicit the help of assistants.

Appreciate what an assistant can do for you, and do something nice for him in return: a thank-you note for taking the time to talk with you, to help you get a meeting, to refer you to someone else to talk to. Maybe even slip a Starbucks or Blockbuster gift card in that thank-you note. Everyone wants to feel appreciated. And don't think of it as buying their help as much as you are earning it by being thoughtful. Years ago, I worked with a young man who sent flowers to all the assistants he wanted to win over, and I always laughed to myself thinking him quite the brown-noser;

but brown-nose or not, this guy got in to see more producers and executives than anyone else I knew. His investment paid off.

Preparing for an Interview

No matter what type of meeting you're having, your preparation will basically be the same. Here's your list.

- Do your homework on the person you're going to be meeting. If it's an individual, what is her background? What type of projects has she worked on? What is her reputation? Ask friends, and get on the Internet to look her up (www.imdb.com is a good start). And if this person you're about to meet works for a specific company (or studio), know something about the company as well. Who are the other principals in the organization and/or department? What type of projects do they specialize in? What films have they made? How well have their films done? If you've been reading the trades and doing your homework, you will know; and you'll know if this is the type of company you'd like to work for.
- Doing your homework also means discovering what your prospective employer's needs are so you can sell him on the value you would bring to his business, office or show.
- As discussed in Chapter 8, prepare your pitch. This is your way to concisely convey a sense of who you are, what you're passionate about, what you're good at, what makes you interesting, what makes you unique and what someone can expect of you—all without rambling or taking too long to get through it. Practice your pitch. Talk to a mirror or grab a friend and role play. You might feel silly at the time, but it *will* help.
- Prepare a list of questions you're going to ask the person you'll be meeting. Plan on asking for general advice and/or information, but also about the company and about him and his past experiences. You can prepare the list of questions to take with you or commit them to memory.
- Even if the person you're meeting is already in possession of your resume, plan on bringing an additional copy with you.

- If you're not familiar with the location of the meeting, look it up on a map or online. If the meeting is in an area you're not familiar with, you might want to consider taking a drive over there the day before (if at all possible, at the same time of day as your meeting), so you're sure to know where you're going and how long it's going to take to get there. You don't want to get lost or be late!
- Figure out what you're going to wear the evening before. Guys don't go through this, but for you women—try on the outfit you *think* you want to wear, and keep trying things on until you're sure of what you'll be wearing. Lay out your clothes and make sure everything's clean and pressed and anything that needs to be shined (like shoes or jewelry) is spiffed up.
- In addition to getting directions, the night before, make sure the car's gassed up, you've organized any materials you're bringing to the meeting, your cell phone is charged and the names of the people you'll be meeting (including the assistant's) and their phone numbers are noted on your Palm Pilot or the small notebook you'll be taking along.

What They're Looking For

> *"I don't want any yes-men around me. I want everybody to tell me the truth even if it costs them their job."*—Samuel Goldwyn

This is one of the topics for which I sought the opinions of my friends and colleagues in the business. Those I surveyed are working professionals, individuals representing diverse segments of the industry, all of whom are in a position to hire. The question posed was, *"What do you look for when an applicant walks through your door?"* The following are their responses:

- "I want resourceful, energetic problem-solvers—self-starters who are not afraid to admit they don't know everything. And I look for people who have endless amounts of stamina and remarkably good health, both mentally and physically."

- "I look for enthusiasm, intelligence, curiosity, passion and attention to detail."
- "I look for a creative thinker, team player and quick decision-maker."
- "I look for the 'spark,' then at a person's body language and presentation."
- "I look for intellect, passion, accountability, compatibility and dedication to purpose."
- "I look for a great attitude and someone who is going to look me in the eyes. I couldn't care less about experience."
- "I look for integrity, creativity, a good sense of humor, someone who is hard working and able to relate well to other people."
- "I look for different things depending on the job. For department heads and line producers, I need strong ethics, lots of experience and aesthetic talent. For entry-level jobs, I need intelligence, flexibility, personality and energy."
- "Personality is important. People have to 'fit together' when they spend so much time confined in the workplace."
- "I look for someone with the ability to hit the ground running, a person who knows how to think ahead and will instinctively know to come in a little earlier and stay a little later than expected. I also look for an underlying sense of responsibility to the project and to the team. I appreciate the skills people bring with them and have learned not to rely on intelligence alone."
- "I look for good references from people I trust. Credits are way overrated; unless you know what the person really did or how well they did it, it doesn't really matter what shows the person worked on. Also, genuine enthusiasm for the project, and a realistic outlook on what it will take to get the job done. I don't like people who act like they know it all or who tell me how many pictures they have brought in under budget."
- "I look for efficiency, impeccability, integrity and then talent and passion. Without the first three, the talent is irrelevant. Movies cost way too much, and to expect anything less of people is crazy."
- "I look for reliability mostly. I want someone who will be around to help when needed, no matter what it takes. A lot of people say

they don't mind starting at the bottom, but when the reality of it hits them, many become frustrated and quit."

- "I look for enthusiasm—someone who is bright and has the same feeling about the industry I do. Someone who doesn't think of it as 'work' but as a welcome challenge, and fun!"
- "I look for someone who is hard-working, doesn't mind the long hours and days, and works well under pressure. Having a good attitude helps!"
- "I look for intelligence, personality, ambition and an undying passion for movies."
- "I look for someone who thinks enough of him or herself to come in well groomed and neatly dressed. Then I look for someone who is excited to be there."
- "I look for a good attitude, a willingness to work and leadership qualities (or the potential for these)."
- "I look for someone who is smart, willing to put in the time to learn, not just expecting to start at the top . . . also someone who is funny and easygoing."
- "I look for energy and calmness both. You can tell when someone will be a go-getter and be willing to do what it takes to get the job done."
- "I look for someone who is flexible, self-starting and has whatever it takes to do the job—without much concern about their personal comfort or the money they'll make."
- "I look for enthusiasm more than experience and somebody whom I will enjoy being around when the going gets tough."
- "I look for drive—a relentless drive to do whatever it takes to get the job done, regardless of the hours or conditions placed upon them. Not someone who'll stab you in the back for your job, but someone who can deliver the goods when given the opportunity. I'll take a newbie with drive any day over a jaded vet with five shows under his belt."
- "I look for confidence and honesty. I don't want a person who is going to try too hard to impress me. I want him or her to look me in the eyes. I'm impressed by someone who is smart enough to have done research on me and/or my company prior to our

meeting. Much of my decision is just based on a feeling I have about this person."

- "I look for people who are sincere and not too rehearsed. I'm drawn to those who come from their heart and find a way to convey, 'This is who I am!'"
- "It's a vibe you get from someone. Everyone gives off a certain energy, and I play off of that. It's very rare that I look at a resume. I just have a conversation with the person. I couldn't care less where they went to school."
- "I look for individuals I would enjoy having around and going to lunch with."
- "I look for someone who is accepting of the creative environment, who is flexible, who takes initiative and communicates well."
- "The folks I want are clean, smell good and are the type who look for solutions instead of confrontations."
- "I think a young person should be idealistic, but also pragmatic. Someone a bit older should be pragmatic, but also idealistic. I look for someone who is a team player, has discretion and knows how to work well with others."
- "I want a person who has worked with others in the past. I always check references and look for someone who is a team player and not difficult to work with."
- "I look for people who approach their work truthfully. I value experience, intelligence and interest. I want to work with someone who has the ability to know when he's exceeded his depth and can ask for help."
- "Personality is a big issue for me. I look for someone with the qualifications, but also the right chemistry to get along with six to eleven other people who will all be working closely together in one department."
- "Humility is very important to me. Having to deal with big egos and a lot of baloney already, I don't want to be around anyone who has an overwhelming personality. I want to surround myself with teammates I can rely on, no matter what the hour or what the job requires."

- "I'm often more interested in what people do outside of their experience in film. Do they rappel mountains? Do they sail? Do they like to fix up cars, or are they mathematical whizzes? These things often tell me more about what a person can do than their previous film credits. I also look for people who know how to work with problems. And I hate screamers."
- "I look for talent, experience, dedication, maturity, passion, and most importantly—integrity! When you spend 12 to 16 hours a day with people, you want them to be individuals you like!"
- "I look for people who have a great sense of humor, are self-sufficient and are also organized."
- "I look for an eagerness to learn, someone open to new ideas and ready to dig in the ditches with the rest of us fools."

As you will notice, very few of the above comments mention *experience*. The answers to my survey illustrate that the most valued qualities are enthusiasm, passion, integrity, a sense of humor, creativity and the abilities to be a team player, solve problems, work long hours and get along well with others. I can't stress enough how important it is for you to convey to all your potential employers that you are a person who possesses these very sought-after characteristics.

Here are some common interview questions you should be prepared to answer at any meeting.

- Tell me about yourself.
- What would you say are your greatest strengths?
- What are your greatest weaknesses?
- What are your goals?
- Why should I hire you?

"Why should I hire you?" is a common question. Examples of some good answers are, "Because I'll be the best_____you've ever had." "Because I move quickly and my favorite two words are 'no problem.'" "Because I'll check my ego at the door, do whatever needs to be done and I'll do it with a smile on my face." "Because I'll make your team stronger." And here's a good answer my friend Ira Shuman always recommends: "Because I'm here to make you win."

The General Information Meeting

This is one of the very best (and most rewarding) aspects of the classes and seminars I teach. Once my students understand what a general information meeting is, how it works, how valuable it is and that they're capable of setting one up (on their own), it changes everything. It's as if I've handed them a magic key that will unlock countless numbers of doors, each representing a new possibility.

This is a meeting *you* ask for. This is a way you can take your career into your own hands and create your own opportunities.

A previous chapter on job search strategies should help you decide who to set up general information meetings with as well as how to locate the people you want to meet. It's a good idea to keep these names and their contact information on your *Likely Targets* form also included in that chapter.

Whether you're about to graduate or have never spent a single day in film school, let it be known that you will soon be entering the job market. If you have just moved to town or are in the process of changing careers, be up front about who you are and why you are requesting the meeting. And although your primary goal is to make a new connection, your stated purpose is to introduce yourself and ask a few questions (thus, to gather advice and/or "general information").

You are *not* going to be asking for a job, and you are not going to be asking for more than a fifteen- or twenty-minute meeting. If the person you are asking to meet with offers you a job or help in any other way, that will be entirely her choice. If she wants to spend more than fifteen or twenty minutes with you, that will also be her choice. You are not asking for much, and you are proposing a situation that will not put her on the spot. This makes it easier for her (and/or her assistant) to say "yes" to a meeting. *If* she likes you, she may choose to help, just as she may choose to spend more time with you.

Even if you have an agent, don't let that stop you from setting up your own general information meetings. I've known individuals who have had agents from some of the largest agencies in town,

and I've seen them sit month after month waiting for their phones to ring. Having an agent is no guarantee that he or she will get you a job or sell your projects. On the flip side, having many clients, an agent's time is generally stretched thin to begin with. If you're having trouble setting up a particular meeting on your own, ask your agent to make the referral or to actually set up the meeting for you, but also get out and meet as many people as you can on your own.

You can use the general information meeting theory as a follow-up after submitting a resume. Call about a week after sending your resume. Confirm that it arrived, and ask if you may come by for a quick meeting to introduce yourself. It doesn't matter if someone else got the job or there is no current position for you. You want to meet them and have them know you, because you never know when there will be another opening. People don't always work out in the positions they're hired for, the company may need an additional person at some point or someone you meet at this company may like you enough to recommend you to someone at another company. Ask for that fifteen-minute meeting. You want to introduce yourself to them for future reference, whether or not they have a current opening. It will be worth your time and effort to make another connection.

It doesn't happen at every meeting, but many of my students have come away from general information meetings with offers of internships and jobs, leads to other meetings, invitations to observe shoots, insightful information and definitely new contacts they can stay in touch with. Jenny Hedley, one of my former students, had this to say about her experience:

"When Eve assigned our class two general information meetings, I was both excited and intimidated by the sanctioned opportunity to meet with people I admire within the entertainment industry. I delivered my pitch to the president of an entertainment division, who referred me to a president of post production, who referred me to a post production supervisor, who referred me to an editor who hired me as a post production assistant. I might still be contemplating the first steps to take in my pursuit of a job if not for this valuable lesson on the power of a general information meeting."

Once some of my students get comfortable going on these types of meetings, there's no stopping them, and they continue meeting countless numbers of industry professionals. The good thing is that you don't have to be a student, nor do you even have to be in this business to benefit from this type of interview.

Seven Steps to a Successful General Information Meeting

You've got your first meeting lined up (for example's sake, let's say it's with a female studio executive). Now what?

#1. Walk in, shake hands, make eye contact and thank her for taking the time to meet with you.

#2. Always acknowledge the person you're meeting. You'll have done your homework, so you'll know what you're going to say in advance. It could be a compliment on her past accomplishments, on the company's latest film, etc. If you hadn't been able to find any background information on her or the company, admire her office view or decor.

#3. Since this is a meeting you've asked for, take the lead by saying, "Let me tell you a little about myself." Then, launch into your pitch.

#4. Next, say something like this: "Let me tell you why I'm here . . . these are the things I'd like to learn more about, and I thought (or so-and-so suggested) you'd be a good person to talk to." It's now time for your (intelligent and well-informed) questions. Since you're there for such a short period of time, limit the questions to a scant few and keep them concise. Also, don't forget to engage her in talking about herself. People generally like talking about their own experiences and will be flattered that you're interested enough to ask.

#5. Sit back and listen.

#6. Thank her again for her time. Then ask if she might have any specific advice she could share with you or suggestions of other people you should meet.

#7. Ask if you may please stay in touch. This could be via an occasional e-mail or checking in with her assistant from time to time. Remember, you want to make a connection, and it won't happen if you don't (or aren't invited to) stay in touch. At the same time, you don't want to leave her with the impression that you'll become a stalker. So ask the question, and then let her take it from there as to what form of contact she'd be most comfortable with.

If the meeting is going to last longer than the fifteen or twenty minutes you asked for, you'll know; because she'll possibly ask you some questions and/or offer more advice, suggestions or leads.

Since you're reading this book and not attending one of my classes at the moment, I can't threaten you with a lesser grade if you don't start going on general information meetings, but my guess is that your career will take a lot longer to materialize if you don't.

The Door-to-Door Approach

When you hear people referring to the fact that they pounded the pavement and kept knocking on doors until someone would talk to them, this is the method of job hunting they used. If you're taking the door-to-door approach, you can't expect too much, too soon. And if you do get a chance to talk with anyone, it may only be for the briefest amount of time. Yet it does work for some.

There are people who can stroll onto a studio lot as if they belonged there or walk into an office building for one reason, but manage to stay on without being asked to leave. I've always been a little uncomfortable doing this, but certain individuals (definitely more risk taking than I) are quite adept at pulling it off, even with heightened security becoming the norm.

Gatekeepers who work at studios, production offices, agencies, etc., are generally pretty busy and (as mentioned) often stressed. They get stacks of resumes each week and numerous phone calls

each day from people looking for work. Some are too busy to respond to the resumes, and they'll keep the phone conversations to a minimum. There are also those receptionists and assistants who have conveniently forgotten that they could easily be the one on the other end of the phone. But whether it's a question of being busy or dismissive, they will occasionally respond more favorably to an unexpected drop-in.

The theory of the door-to-door approach is to drop by unexpectedly. You can't be dismissed as easily when you're standing in front of them. Be as wonderfully pleasant as you possibly can, and ask the receptionist if you could see the assistant of the person you'd ultimately like to meet. (And once again, if you call ahead of time, you can find out the assistant's name.) Ask for just a moment or two to introduce yourself and hand her your resume. Acknowledge that she's busy, and promise not to take up much of her time. At this point, you might want to say something to the effect that you prefer submitting your resume in person rather than being yet another faceless resume in the stack. Ask if her boss is in and isn't too terribly busy, if you might be able to stick your head into his office to introduce yourself. As with the general information meeting, the purpose of this isn't to land a job, it's an opportunity to pitch yourself, very quickly create an impression and hopefully make a connection.

And you never know, if someone has the time and is impressed enough by your pitch and/or introduction, he may invite you in to sit and talk a while. If he isn't in, perhaps his assistant will set up an appointment for you to come back at a more convenient time for a general information meeting. If you cannot get through to the person you were hoping to meet (or he's not in), pitch yourself to his assistant. If the assistant won't see you, pitch yourself to the receptionist.

The practice of going door to door equally applies to making new connections once you're working. If there are people in other offices down the hall or in other parts of the building working for other companies or on other projects, make it your business, as you pass their doors, to stop for a minute or two and introduce yourself. Find one or two you might like to have lunch with, occasion-

ally drop by with a cup of coffee or just to say "hi" and be helpful if the need ever arises. Gradually get to know them, and at the same time, let them know you. I've seen this situation lead to future jobs and terrific new contacts, because once you're on a job, it's much easier to connect as a neighbor from down the hall as opposed to being a stranger who unexpectedly stops by with a resume.

Meeting Etiquette for All Occasions

- Call the day before to confirm your meeting for the next day. This holds true for formal meetings and interviews as well as casual lunches. People get busy, schedules get backed up, something unexpected develops, day planners are accidentally left elsewhere, someone forgets. It's always a good idea to confirm.
- The proper dress for industry meetings is nice-casual—stylish, but not too corporate (unless you're interviewing for a big corporate position or at an office where you know the dress standard is more formal). And you want to be well groomed. That means clothes neatly pressed, dog hair and dandruff brushed off, pleasant-smelling breath and no severe hairdos, loud colors or intense fragrances. No tank tops, t-shirts, shorts or flip-flops. If you have several visible body piercings, keep the hardware to a bare minimum. If you have multiple tattoos, keep most of them covered. Women: don't overdo the makeup or wear exceptionally tight clothing, short skirts or spiked heels. Guys: (pressed) khaki slacks and a nice shirt are acceptable. If you have long hair, tie it back neatly. Yes, this is a business in which individuals are free to create their own style, but that's usually after you've already gotten your foot in the door and have proven yourself. You want to play it safe and be conservative on those early meetings, so don't walk in looking outrageous. You want to make a good impression, not take the chance of putting someone off before they get to know how terrific you are.
- Make sure you refer to the person who recommended you (if that is indeed the case).
- Be on time.

- Turn off your cell phone and pager.
- Have a good idea of what you're going to say before you get there.
- Always shake hands and make direct eye contact.
- Don't forget to smile and breathe.
- If you're nervous, say you're nervous.
- Linda Buzzell, author of *How To Make It In Hollywood* (HarperPerennial), says that one of the two deadliest sins you can commit during a meeting is to be dull. To that end, make sure that sparkling personality of yours comes through loud and clear. If you're not interesting, you're going to lose the interviewer's attention quickly.
- Having a good sense of humor will take you far and is always appreciated.
- Linda Buzzell declares that the second deadliest sin is being desperate. To that end, don't ever let anyone know that if you don't get this particular job, you won't be able to pay your rent this month. Whether it's true or not, no one wants to know about your troubles. And placing someone on the spot like that is quite off-putting.
- Don't try too hard to impress. Be sincere. Be real.
- Don't lie about your background or embellish much. Prospective employers do check references.
- Don't bad-mouth previous employers.
- Plan on bringing a small notebook or pad of paper with you, so you can take notes during the meeting.
- Never interrupt while the other person is talking.
- In addition to once again thanking the person you're meeting for his time, be sure to thank his assistant for helping you set up the meeting.

Don't Let Them Scare You Away

As prepared as you are when you walk into any interview, you will never experience two that are exactly alike. Some people you meet with will end up doing most of the talking, and some will allow you to talk more, so they can spend more time summing you up.

Some will happily respond to questions you have about them, and others won't want to talk about themselves at all. Some people you meet will make you feel comfortable right off the bat, and you'll click with them instantly; others will be more formal and distant. Then there are those who will go to great lengths to discourage you from a particular job or from working in the industry in general. They'll tell you how awful it's going to be, about all the menial tasks, personal errands and long hours you'll be expected to deal with. They'll ask why you want to do this when you'd be much better off in another business. You'll find some of the people you meet will be encouraging, yet others will try to scare you away. Those who fit the latter description are doing so as both a warning and a test. They want to make sure you thoroughly understand what you're signing up for, and based on your responses, they'll also be able to tell how badly you want in. It's their way of weeding out the ones who don't have the right attitude and aren't willing to go the distance and do whatever it takes. And of course, the right attitude is "I'd love picking up the bagels in the morning, and I'd be more than happy to wash your car for you every Friday afternoon. And by the way, how do you like your coffee?"

Follow Up after Your Interview

An important part of making a connection with someone new is going to be your ability to maintain that connection. A good first step would be to send a handwritten note on a nice card, thanking the person you met for her time (and possibly for her advice and/or help). Consider writing your note on a unique-looking card. If it's special enough, it might get saved. I use photographic cards I make myself, and people tell me all the time that they can't throw them away. And when left out on someone's desk, credenza, or tacked onto a bulletin board, it's a constant and subtle reminder of who you are (and how considerate you were to have sent it).

Acknowledge the assistant who helped you set up the meeting as well. Many assistants get little recognition, and a small gesture like a thank-you note could mean a lot. Besides, don't

forget—today's assistant could very well be tomorrow's executive, and a person who takes the time to be thoughtful is often remembered.

Some people choose to send small gifts along with their thank-you notes. A gift definitely makes more of an impression, but you have to be careful not to overdo it, because it could make the recipient feel uncomfortable and create the opposite effect you had intended. It's fairly easy to slip a Starbucks gift card, Blockbuster gift card or a few lottery tickets into a thank-you note. You don't have to spend much, and they're always appreciated. Beyond that, there was that guy I knew who was notorious for sending flowers. And there was another guy who got up at a Flash Forward seminar I once attended who told the audience how he had sent a prospective employer a box of cinnamon buns, along with a note that said, "If you choose me for this job, I'll work my buns off for you." (If I remember correctly, he did get the job.) My girlfriend Barbara, during the course of a meeting she had with a studio exec, discovered that the exec liked to go hiking but didn't know of many trails in the L.A. area. So along with her thank-you note, Barbara sent this woman a book called *"Day Hiking in L.A."* Way to go, Barbara!

If I've met with someone I really want to impress, I may send him or her a copy of my other book (*The Complete Film Production Handbook*). My hope is that having the book on their office shelf will be a constant reminder of me, and that it might even occur to the recipient that if I've written a book on film production, I might just be pretty good at what I do. Unfortunately, I can't afford to pass out a book to everyone I meet with, but when I do, I know it's appreciated, whether or not the gesture results in a future job. I've often wrapped up little bundles of my handmade note cards to give as gifts and have occasionally given gift certificates to Samuel French Bookstore (for those who aren't familiar with it, it's my favorite store for industry-related books and publications of all kinds). Whatever the gift, it doesn't have to be (and shouldn't be) expensive. As your mother used to tell you, it's the thought that counts.

Beyond the initial thank-yous, it's important that you stay in touch on a fairly regular basis. As long as you're pleasant about it, don't worry that you're making a pest of yourself or that you're turning off prospective employers. Everyone understands that this is standard operating procedure. Make an effort to keep track of your meetings and when it's time to once again check in with each of your new contacts.

Years ago, I worked for the head of production of a medium-sized independent production company. There was a young man named Perry who would call once a week, just to say hello and check in. He was extremely pleasant, and nothing if not persistent. The conversations never lasted long, and we actually got to be quite phone-friendly, discussing our weekends or movies we had each seen. His tenacity was rewarded when a job opportunity finally presented itself on one of the company shows, and he got it.

The first time I met my friend Stephen, I was interviewing him for a job on *Titanic*. Before I could hire him, though, he was snapped up by someone he had previously worked with. But Stephen made it a point to stay in touch, and he would call me just as he was about to wrap each of his shows. He would tell me about his latest project, what he had learned and where he had been on location and always ended the conversation by telling me he hoped he'd be able to work with me someday. Fortunately, he called one time shortly before someone else who was to have worked with me on *Joy Ride* backed out of the project. Being fairly fresh on my mind, I called Stephen, and he was soon able to jump onto the show with me. The end result was that we both enjoyed working together, have long since become friends and are now supportive of each other's careers.

Following up and staying in touch does pay off. It doesn't even have to be after a meeting; it could just as well apply to people you meet at a party or networking function and/or to the people and executives you work with on any job. It's easy to lose touch once you move on to other projects and start working with other people. Just sending an e-mail or card once in a while will remind people of who you are, what you do and that you'd like to work with them again.

Being Available

Once you start going out on meetings, you never know when you're going to be called for a job. And sometimes, there are jobs that need to be filled immediately. This means you have to be readily accessible.

Everyone in this business should have an answering machine, but more importantly, you need a pager and/or cell phone. There have been times when I've needed an extra production assistant so badly that I'd just go through my list of PAs and hire the first one I could reach. If you're just going to rely on your answering machine, you may be out when that call comes in; and in the time it takes for you to get home and return your calls, someone else will have been easier to reach and will have gotten the job.

It happens all the time. For example, last year I submitted my resume for a job I had heard about and the very next day received a call from a producer who wanted to know how soon I could come over to meet with him. I was there in an hour. He called a second time on a Sunday, wanting to know if I could come by again, this time to meet his partner. He got me in the car just as I was pulling into a car wash, and once again, asked if I could come over right away. I was there in half an hour, and the car stayed dirty for a while longer. My actions not only told him I wanted the job, but also that I was flexible.

Sometimes I get ample notice before starting a new show, and sometimes I don't. My friend Phil called once from South Carolina, where he was working on a show for HBO. He explained that he had been brought in at the last minute to replace someone and needed me on a plane the next morning to help him get this show ready for shooting on Monday. It was one hectic evening, but I made it. There's also my friend Ira, who will occasionally call and say, "So . . . can you start tomorrow?" You don't always get reasonable notice, but if you're not flexible and don't go for it, you could easily miss a good opportunity. That doesn't mean you never make plans for fear that an important call will come in. It means that you go ahead and make plans, but be prepared to change them if necessary.

A Final Note on the Subject

Earlier in the book I discussed the fact that in this business, you have to continually expand your network, meet people and sell yourself. Well, going on meetings and interviews is one of the most effective ways to accomplish that. It's scary and often intimidating, especially at first. Generally, the more meetings you go on, the easier it gets—unless you're extremely shy, in which case it's always a bit uncomfortable. You may also wake up one morning like I did and wonder why, after having been in this business for many years, you still have to go through this ritual. In the summer of 1991, after having been laid off at Orion, I went on dozens of interviews. But it was slow that summer, and most of those I met with told me I had a terrific background and they wished they could hire me. Unfortunately, they had no openings at the time and told me to check back in six weeks, check back in a couple of months, check back in three months. I hit a wall, and couldn't go on one more meeting. Some would say that when you hit a wall like that, you have to force yourself to keep going, but I ended up taking a break from the meeting circuit. I eventually got back into the swing of it, and having taken the hiatus, I came back with a much more positive attitude.

We have to put ourselves through this ritual of meetings because it's the nature of the business. Whether our meetings turn out successful or not, whether we run into a few rude gatekeepers or not, we have to keep that Teflon coat on and keep going. Everyone does it, and the trick is to do it with a great attitude. If you can't, you'll only be limiting your own opportunities. Although job hunting is not particularly fun, it can be interesting, because you never know who you're going to meet or what any meeting might lead to. So whether you're out pitching yourself, your clients or your projects, understand it's a way of life for us and a very necessary part of our profession. So get out there, impress the hell out of everyone you meet and smile!

— 11 —

No One Ever Said It Would Be Easy! What You Can Expect Once You Land Your First Job

> *"Laugh at yourself, but don't ever aim your doubt at yourself. Be bold. When you embark for strange places, don't leave any of yourself safely on shore. Have the nerve to go into unexplored territory."*—Alan Alda

Good PAs and Assistants Are Worth Their Weight in Gold

There is never a shortage of people willing to take entry-level positions, and as previously mentioned, exceptionally *good* PAs, "gofers" or runners, assistants, receptionists, mailroom workers, pages and apprentices are extremely rare. Being one of the good ones is the very best way to differentiate yourself from your competition. Walking into your new job, prepared and knowing what's expected of you, will not only impress your new employers, it will be a great relief to them as well. Add the right attitude and a large dose of extra effort, giving them more than what's required or expected, and you'll soon be totally indispensable and someone they will definitely want to keep around.

This chapter will allow you to be one step ahead by knowing what to expect when you get your first job.

Basic Job Responsibilities

When you start in an entry-level position, whether it's in a mailroom, at an agency desk, a studio, post production facility, production office, casting office, network or any other industry-related company, the following are some of the tasks you will most likely be asked to do:

- Answer phones and keep a phone log.
- Place phone calls for your supervisor (this is often called "rolling calls," because the assistant is expected to start lining up the next call as his boss is winding down the previous call). (Knowing how to use Filemaker Pro would be helpful for this as most phone sheets and call logs are done this way.)
- Set up appointments and screenings, make lunch reservations and travel arrangements—and sometimes, remake them and remake them again and then remake them once again. (Knowing how to use scheduling systems such as Outlook, Lotus and Now Up-To-Date would be very beneficial for this.)
- Help with your boss' electronics, such as programming cell phones and synching up and charging PDAs, two-way radios and Blackberries.
- Type and distribute letters and memos. (You should be proficient in Microsoft Word.)
- Distribute incoming mail and paperwork (scripts, schedules, memos, budgets, videotapes, CDs, etc.) and vital information.
- Handle incoming and outgoing mail.
- Do research (credits, bios, resumes, stock footage, etc.).
- Oversee shipping and receiving (by keeping logs, distributing incoming packages, preparing waybills, etc.).
- Oversee the upkeep and maintenance of the office machines (copier, fax, computers, printers, etc.).
- Run errands (deliver scripts, make airport runs, pick up supplies, etc.).

- Photocopy (scripts, schedules, call sheets, production reports, etc.).
- Duplicate videotapes and burn CDs.
- File.
- Fax.
- Keep the office tidy.
- Move furniture and equipment.
- Make coffee.
- Take lunch orders and fetch food.
- Shop for food and snacks (for the office, for meetings and for your boss).
- Prepare the conference room for meetings.
- Keep a well-stocked kitchen area.
- Clean the office kitchen and wash coffee mugs.
- Order office supplies.
- Carry equipment and supplies.
- Help staff members unload their cars.
- Personal chores: these duties could range from shopping for others in the office who are too busy to get out themselves to washing your boss' car, walking his dog or running his errands (bank, cleaners, lunch, tennis racquet repair, gas station, dog groomers, etc.).

If you're working as a PA on a set, you might be asked to do anything from the above list, or any one of the following:

- Guard the set's perimeter.
- Wrangle extras and/or children.
- Inform actors they're needed on set.
- Pick up an actor, producer or director and drive him or her to the set each day (and then back at the end of their work day).
- Help to keep the set clean.
- If allowed, pitch in to help the crew when necessary.
- Help wrap a set at the end of the day.

Come Equipped

The following are some things you should have with you when you start your new job.

- A well-running car
- Auto insurance (in most states, a person's own insurance is primary)
- A membership in an auto club that covers roadside emergencies
- An accurate watch
- A cell phone and/or a pager
- A map book
- A pad of paper and pen (try to use the $8\frac{1}{2}\times 11$ yellow ruled tablets that are perforated at the top. That way the sheets can't fall out and get lost)
- A day planner (or PDA)
- Comfortable shoes
- Extra clothes (sweatshirt, jacket, etc.) kept in the trunk of your car (for layering as the weather changes)
- A flashlight

More important than what you bring to any new job is showing up well groomed. You're probably thinking to yourself right now, "Duh! Isn't that common sense?" Sadly, no. You'd be surprised how many people show up looking rumpled or in need of a shower. Well groomed doesn't mean wearing the latest, most expensive fashions, but it does mean you should be clean, neat and presentable. And dress appropriately. You wouldn't wear hard or high-heeled shoes on a sound stage or out at most location sites, but rather soft-soled shoes or tennies. And within a production environment, flip-flops or open-toed sandals can be just as dangerous as high heels. And you can dress fun or chic, but until your phone is ringing off the hook with job offers or you've become famous because your films are making a fortune, avoid extreme styles.

Proper Phone Etiquette

If part of your job is answering phones and taking messages, don't underestimate the importance of this task. It takes someone who is bright, quick and patient to do it well. Doing a good job on the phones will gain you extra brownie points and get you noticed.

On the other hand, you could be the brightest kid on your block, but sounding dour instead of upbeat, terse instead of friendly, or unsure instead of competent can quickly negate all the positive qualities you have to offer.

Here are some phone tips:

- Be polite, pleasant and upbeat.
- Be professional.
- If several lines are ringing at once, don't let them all just ring while you're on another line. Stop to answer each line and ask the callers to please hold.
- Don't leave people on hold for too long. If the person they're waiting to talk to is on another call, give them the option of holding a while longer or being called back. If they choose to hold, check back in with them every once in a while, so they know they haven't been forgotten. Also make sure they want to continue holding.
- Don't yell across the room for someone to pick up a line before putting your caller on hold.
- Take the time to get names right, and ask the caller to spell his name if in doubt. (It's terribly embarrassing to return a call to someone when his name or number hasn't been written down correctly.)
- Screen calls: ask who it is and what it's regarding and help answer questions when you can without having to interrupt your supervisor.
- Don't be afraid to ask; get as much information as you can from the person calling:
 Who do they need to talk to?
 Where are they calling from?
 What is their phone number?
 When can they be called back?
- If a caller asks if your supervisor is in, don't automatically say "Yes, just a moment," and then upon finding out that your supervisor doesn't want to or can't talk to this person at that particular time, come back and use the old "he's in a meeting" line. Instead, when asked if he's in, it's safer to tell the caller you'll

check if he's available. You would then report that you're sorry, but he's not available at the moment and could someone else help the caller, or can the call be returned later? This way, you're not having to imply that your supervisor is purposely trying to avoid the call.

• Be considerate, empathetic and as helpful as possible to people who are calling to look for work, and never forget that it could be you on the other end of that phone.

No matter where you're working, it's best to answer the phone in the manner expected in that office/environment, but always add "(your first name) speaking" or "this is (your first name)." In production offices, for example, very rarely will you hear someone answer the phone with the name of the show. They usually just answer by declaring, "Production!" It's much friendlier to have someone greet you with, "Production, this is Katie," and it's nice to know whom you're talking to.

Know Who You're Answering To

If you end up working in a heavily-populated environment (like a mailroom, production office or on a set), you'll find you have a lot of people telling you what to do or asking you to do things for them. You'll need to address this issue when you get hired, at which time, you'll ask (or be told) whom you will be answering to. It should be no more than two people, and ideally, it will be one individual only.

It's totally counter-productive to respond to many, because while everyone thinks his or her immediate need is of the utmost importance, you're not only running around like a headless chicken, you may be completely unaware of current priorities or the fact that your supervisor is waiting for you to return to handle a more urgent task.

If all requests, however, go through your supervisor, she should know at all times where you're most needed. Therefore, if someone asks you to do something, don't do it without checking with your supervisor first, and don't ever just say "no," you can't or

you're not allowed to take orders from others. Politely explain that it will be taken care of, and relay the request to your supervisor. She will then juggle tasks between you and other PAs/assistants/clerks to make sure everything gets done in a timely manner.

When I set up a production office, I put out "Request for Pickup/Delivery" slips that department heads, Accounting and the producer and director's assistants can fill out and submit. The assistant production coordinator usually evaluates all the requests and schedules the PAs' time, so everything is covered in the most time-effective manner possible.

What to Do When Starting a New Job

- Be happy to be there, because even though it probably won't feel like it, this is the first step (or a continuation) of your journey, and you're on your way.
- Introduce yourself to everyone. Shake hands and make eye contact.
- Make sure you have keys to the building and office and all necessary security codes.
- Learn who everyone is. Memorize staff, cast, crew and vendor lists.
- Read the script, office manual and anything else you can get your hands on to familiarize yourself with the project you're working on, the company you're working for and the people you're working with.
- Become a sponge! Pay attention to everything going on around you, and soak up whatever you can. Get the lingo down, the procedures and the routines. Take notice of where the power lies and who's really doing what. You may not be in the rooms where the deals or decisions are being made, but you'll overhear phone calls, pick up on bits of conversations throughout the office and by the coffee machine and get a glance at incoming memos hot off the fax machine. Take notes, read anything you can get your hands on, ask questions, be observant and just absorb as much as you can. It's all around you for the taking, as long as your radar is up.

- Ask about preferences (how should you be answering the phone, how does your boss like certain things arranged or handled, what sort of snacks does she prefer, etc.).
- If you are going to be sent on errands (or "runs" as they're more commonly referred to), find out the places you'll be going to the most, and make sure you know how to get there.
- Get used to going *everywhere* with a note pad and pen. If your boss calls you into his office, make sure you're always prepared to take notes. Get used to writing down anything you need to remember, to do, to save or to track.
- Learn how to use the phone system and office machines (copier, fax, network printers and preferred computer software), as well as the office-issued cell phones and pagers.
- Learn office/mailroom/set/studio protocol and get a sense of the prevailing politics as soon as possible.

What *Not* to Do When Starting a New Job

- Don't ever tell anyone you just completed an expensive education at film school so you wouldn't have to do things like run errands and wash coffee cups.
- Don't openly criticize others, the way the project (or company) is being run or decisions that are being made. I once had a PA who, in front of an entire office full of people, declared that the producer had no business treating people so badly. Another show, another PA, upon answering the phone loudly announced, "That (bleep, bleep) writer is on the phone." It's not your place to make those types of comments. You're entitled to your opinions, but they're not to be voiced publicly. If it's imperative that you express such an opinion to *someone*, talk to your supervisor in *private*.
- Don't whine ("Do I have to?"), don't roll your eyes and don't groan when asked to do something you don't particularly want to do.
- Don't make excuses. If you've made a mistake, admit the error and offer to fix it. Let your supervisor know the mistake won't happen again.

- Don't complain to anyone but your supervisor (and only in private).
- If you have a problem with the way a co-worker is treating you, don't yell or be rude. Talk to that person in private.
- Don't bad-mouth your supervisor or co-workers. It _will_ come back to bite you in the butt.
- Don't gossip about your supervisor or co-workers.
- Don't display a cocky, know-it-all attitude.
- Don't be argumentative or interrupt others' conversations.
- Don't make your supervisor have to come find you.
- Don't go over your supervisor's head.
- If you don't have an answer, don't say, "I don't know." Say "I'll find out."
- Don't assume—ask. There is no such thing as a dumb question!
- Don't spend time on personal phone calls, unless it's of the utmost urgency.
- Don't ever say, "It's not my job" or "I'm too busy."
- Don't sit or stand around with nothing to do.
- Don't make too many weeknight plans, and don't ask to leave early unless it's an emergency.

Becoming Indispensable

- No matter what you're asked to do, do it willingly and with a smile. Be a "can do" type of person and the first to say, "No problem, I'll take care of that for you!" Be the best gofer, receptionist, photocopier, mail-sorter, lunch-getter anyone's ever seen. Give it your all. Do more than anyone would possibly expect of you.
- Follow through! When asked to do a task, let your supervisor know when it's been completed (before he asks you). If you can't get to that task right away (for whatever reason), let your supervisor know as soon as possible, so he can assign it to someone else. When someone is counting on you to complete an assignment, don't wait until you're asked to say you couldn't do it or didn't have time.
- Taking "follow through" in a slightly different direction: if you are asked to do something and you run into a road block—can't

get an answer, can't find something or reach someone—look for ways around the road block. There's usually more than one way to obtain the information you need or to find what or whom you're looking for. Ask your co-workers, contacts and/or friends for advice and search out resources on the Internet and in reference books. In some situations, "no" just isn't an alternative; and you have to find a way to make something happen. But if your supervisor allows you a little leeway and you've absolutely exhausted all your resources and are still at a dead end, let him know ASAP, so he can give you some suggestions or possibly alter his directions a bit.

- Anticipate the needs of others, and be one step ahead of them. For example, years ago when I was coordinating, Phil Wylly yelled from the other room, "I can't find Dick Church's number. Can you please get it for me?" Well, I not only walked into his office with Dick's number, but under the number I had written, "Dick's wife's name is Jeannie." He had spoken to Jeannie before, but I knew he'd forgotten her name; and if she were to be the one to answer the phone, I knew he'd want to be able to say "Hi, Jeannie . . . "

- Be polite, don't be loud and don't use vulgar language.

- Be sensitive to the needs of the person you're working for.

- Be a good listener.

- When your "to do" list becomes overwhelming, *prioritize* each individual task, and ask yourself how each task will affect that day's work—and then the next day's work. What has to be prepared before the 10:00 a.m. conference call your boss has scheduled? What has to be completed before the FedEx guy shows up at 5:00 p.m.? What has to be done before you go home for the day? What has to be prepared for the next day's work? If you don't have a good sense of priorities, go through the list with your supervisor, and let him help you organize your list.

- Before you go home each evening, go through that day's "to do" list with your supervisor and report on the status of each item on the list. Ask him what's on tap for the next day.

- Be willing (and eager) to come in early and stay after hours, without being asked!

- Let your supervisor know where you are at all times. Check in often when out.

 When you're done with a task and have nothing else to do, ask what you can do next. Volunteer to help others in the office, find a need and fill it (clean the copy and kitchen areas, check for faxes, make sure the copier, fax machine(s) and office printers are all fully stocked with paper, make a fresh pot of coffee, etc.). Never just sit and wait for something to do.
- When anything changes, be aware of the domino effect, and consider the other aspects of the production/project that will need to be altered as well.
- Check the copying you do to make sure all pages are there and in the correct order, each page is completely legible, the holes are on the correct (left) side and all pages that are supposed to be stapled are (you'd be surprised how many people don't check).

The Reliability Factor

It will not only be crucial for you to master new tasks with each new job, but also to establish yourself as someone who's reliable and dependable, a person others can count on, no matter what. If, on the other hand, you tend to be a bit flaky, too free spirited, don't take direction well or are less than punctual, your days in this business will most likely be numbered.

 When you're given a time to show up for work, be there on time, or preferably early. (Coming in early and staying later than expected will always earn you extra recognition.) Your supervisors and co-workers will be relying on you to help get the day started, the scripts out, the calls made, the appointments set, the phones answered, the conference room set up for a big meeting. Few things make a worse impression on an employer than tardiness, unless it's habitual tardiness (although it rarely gets to that point, because people get fired all the time for being late).

 If you know you're going to be late, call your supervisor as soon as you realize you won't be showing up on time. If you have a legitimate reason, and it's a rare occurrence, you should be fine.

Being reliable entails having a well-running car, a dependable alarm clock, an accurate watch and the ability to find your way around without getting lost. It means having taken care of as many personal obligations as you could *before* starting your new job, so you don't have to try to squeeze them in or ask for time off once you're on the job. Whether it's for doctors' appointments, having your car tuned-up or taking off early to attend a class, asking for personal time off isn't as accepted in most entertainment jobs as it is in other lines of work, because the work is generally intense, and your not being there could be problematic.

Being reliable is following through on tasks, no matter how many road blocks you encounter along the way, anticipating the needs of others and possessing a general ability to take and follow orders (without complaint, argument or attitude).

Another way to earn a reputation for being reliable is by offering to help others with any special skills you may have. No matter where I end up working, because of my lack of computer skills, I'm always in search of someone I can rely on to help me with my computer. It's the same way when a co-worker speaks a foreign language and becomes indispensable when working on a location where that language is spoken. It's easy to become reliant on those with special skills and abilities as well as those who are just always there for the people they work for and with.

A Sense of Urgency

Expect to perform your tasks faster than a speeding bullet, because everyone will expect you to have a sense of urgency. There's nothing worse than a rookie who doesn't move or work quickly even after you explain the need for him to do so. I could have discussed this under *Becoming Indispensable*, but it deserved its own section, just because it's such an important part of what's expected of every entry-level employee.

It's been my experience that no matter how big the budget, the company, the office or the set, there never seems to be enough help or enough time. In production especially (although I've seen equally frenetic mailrooms, casting agencies, agents' offices and

post facilities), it always feels as if there is more to do than there is time in the day to do it all, so we rapidly move from one task to another and keep working until we hit a wall and then drag ourselves home for the night. A PA or assistant doesn't have the luxury of leisurely strolling through his or her duties, because there is always more waiting to be done, even if it's not evident at the moment. If on the rare occasion there is truly nothing more to do after a certain task is accomplished, there will be, because that's just the nature of the biz.

This doesn't mean that work is done carelessly, cars are driven too fast or time can't be taken to ask questions or to be courteous, but whenever possible, move quickly! There's too much to do, and time is too valuable to waste.

Keep in mind that an entry-level employee who doesn't move quickly or one who spends too much time on personal calls or has too much idle time is an employee who looks as if he doesn't have enough to do and can be easily eliminated.

Accepting Boundaries

On a movie for television I once worked on, I was asked to hire the wife of the producer's friend (who also happened to be a producer) to assist me. After having established a career in another business, she had taken several years off to stay home and raise her children. This was her first job back in the work force, and she was more than eager to jump into the thick of things. Let's call her Jane. Anyway, Jane was a take-charge kind of person used to making decisions and giving orders, which turned out to be much more problematic than helpful since her position rarely allowed her to make any major decisions. She found it extremely restrictive to have to check with me first before giving out certain types of information, but as I kept explaining to her—what may seem obvious isn't always the case. She didn't yet have the experience, nor did she usually have all the facts to make an informed decision. While checking with me first was not an unreasonable request, Jane strove for some autonomy and paid little attention to my directions.

Every day when Jane's kids arrived home from school, they called her at the office to check in, and I'd hear her ask them if they'd done their homework and chores. When one of them would argue with her or question what he had just been asked to do, she would emphatically reply, "because I said so, and I'm the mom!" Well, one afternoon when I wasn't in the office, Jane gave out some information without checking with me first, and as it happens, the information was incorrect. Not only that, but it was a costly mistake that got both of us in trouble. Once the dust settled, I sat her down and simply said, "Jane . . . in this office–*I'm* the mom." She got it—finally.

Being resourceful, reliable and indispensable are all things you should strive for, but don't go *too* far by overstepping your bounds, even if *you* think you're ready. You have to know who your "mom" is and when to defer to the guidelines imposed by others. If you're working for someone you're comfortable with, it's perfectly okay for you to *ask* if you might take on a task that falls outside your sphere of responsibility or to ask for an explanation as to why a specific decision was made (so you can learn). But don't just assume it's okay for you to make decisions or give out vital information without checking with your supervisor first—even if you are bright, talented and bursting to have more authority, because as I said to Jane, you may not be aware of all the facts that have to be taken into consideration *before* decisions are made or certain info is released.

Also keep in mind that even if you are aware of all the facts and have the experience to make a well-informed decision, don't usurp your supervisor's authority. For no other reason, respect your chain of command, which even on teams, does exist. And whether your instincts are right or wrong, you'll always win the trust of your supervisors if you keep them in the loop.

Working Around Celebrities

Once you start working in the biz, your days as a "fan," while not over, will change forever. Your enthusiasm for being around celebrities must be greatly restrained, because if you're going to be

working around the powerful and famous, your job will be as support staff, not as a devotee in search of an autograph. When meeting a celebrity for the first time, it's okay to say something like, "It's a pleasure meeting you. I'm a big admirer of your work." But leave it at that, and go no further. No matter how cool it is to be working around an idol of yours, you need to remain professional, helpful and respectful of their privacy. You're not there to badger them with questions, or gossip or to act like a star-struck fan. Nor should you assume a sense of self importance because of your proximity to a famous person. If you're working with or around a celebrity who wishes to become your bud, you'll know it; but don't overstep your bounds, and even then, tread lightly.

My very first job in the industry was as a production assistant on a celebrity fund-raising auction for a local PBS television station. One day, the woman in charge of lining up high-profile personalities for a promo event asked me to follow up on invitations that had been sent out. She wanted me to call a long list of celebrities who hadn't RSVP'd to the event to see if they'd be coming. My first reaction was sheer terror, followed by the words "I can't do that!" She said, "Of course you can," then handed me the list and walked away. Well, my dread quickly dissipated when I discovered that the people I was calling weren't answering their own phones, and some of the numbers weren't even theirs, but belonged to their "people." I was greatly relieved to be getting secretaries, assistants, agents, managers and answering services on the line and was happy to be able to leave a message with each of them.

About a week later, as I was returning back from lunch, a co-worker stuck her head over the second floor railing where our production offices were located and yelled down at me, "Hurry up, you have a phone call." I asked if she knew who it was, to which she replied, "I don't know—some guy." So I ran up the stairs, and slightly out of breath, answered my call, only to hear this very recognizable voice on the other end say, "Hi, is this Eve? This is Henry Fonda returning your phone call." It took me a moment to speak, but I finally got the words out. We talked about the upcoming promo event, the fund-raising auction, what he wanted to donate to the auction and about how much he enjoyed the station's

programming. I was professional; I thanked him, hung up and then went absolutely nuts. I screamed, I jumped up and down and I yelled at the top of my lungs, "I just spoke to Henry Fonda!!!!!" I'm sure everyone on the lot could hear me.

It was so many years ago, but I was so excited and had been such a huge fan of his. I still smile every time I think about what a thrill it was to talk to him. And as many celebrities as I've talked to and have worked with (and there have been many) in all these years since, Henry Fonda will always be my favorite, because he was my first.

Beware! Warning! Bumpy Road Ahead!

While most entry-level jobs are synonymous with an industry-style boot camp, the regimen takes some getting used to and the experience may not be quite what you expected. They can also be challenging and exciting times that present you with a whole new world of possibilities. And most of the individuals you'll be working with and reporting to, while expecting a lot, are decent people. Not all will have enough time to thoroughly train you, but some will assign their underlings to train you, and many will cut you some slack while you master your learning curve. Unfortunately, though, some employers are not as generous, and some take the term *paying dues* to a whole new level. I hope you're lucky enough to avoid the latter, but should it not happen that way, don't be surprised.

Being the lowest man or woman on the totem pole, you may be required to work endless hours of overtime (often without extra pay) or sixth and seventh days. You'll be working your butt off for slave wages and may end up wondering how you're going to make next month's rent. You may very well be expected to forego a lunch hour and regularly scheduled breaks to eat at your desk or on-the-go. And don't expect much recognition or expressions of gratitude for all your efforts. If you get it, great, but everyone's busy and few will take the time to thank you for doing what's expected.

Not being in a union or someone who makes the big bucks, you'll be much easier to take advantage of and exploit than anyone

else on the staff or crew. Not that this happens all the time, but it's certainly not uncommon. You may be asked to haul heavy pieces of equipment that are almost bigger than you are, deliver scripts to unfamiliar and poorly lit neighborhoods after dark, spend an entire day detailing your boss' car or pull an all-nighter working with a crazed writer who has to churn out vital script changes for the next morning's shoot–all tasks you never imagined would be part of your job description.

You'll also be an easy target for blame and bad moods and are likely to get yelled and screamed at by people who are incredibly impatient, under incredible amounts of stress and can't for the life of them remember your name—so they'll call for you by yelling, "Hey, kid!" Too bad they can't remember what it was like when they got their first job in the business. And while there's no excuse for bad behavior and treating others poorly (no matter what their position), there are (unfortunately) individuals in our industry who find newbies totally expendable and easy to replace (which isn't entirely untrue). I've known producers who are notorious for being so hard on their assistants, they go through them almost as often as they change their underwear. Some last a little longer than others, but while working for people like that, few last long. If not fired, many voluntarily leave.

Over the years, and especially in the beginning of my career, I had more than my share of getting yelled at and being underappreciated and overworked to the point of sheer exhaustion. I've gone home crying, totally deflated, devoid of any self-esteem, suffering with gastritis and wondering how I could have ever thought I wanted to be in this business, yet something always kept me coming back and moving ahead.

I go into this in more detail in Chapter 16, but should you find yourself in this unfamiliar and scary territory, you have a few choices, two of which are: you can quickly develop a thick skin and learn not to take these assaults personally, or if your working conditions become too unbearable, you can always quit. You don't want to make a habit of quitting jobs, but rarely would a future employer hold this against you, especially if your previous employer is known to be a screamer or someone exceptionally hard on his or her assistants.

Relax and Lighten Up

When you find yourself obsessing about whether you're doing a good enough job, if you're moving fast enough, when you're going to screw up again or just how you're going to survive your first job, take a step back, take a deep breath, stop worrying so much and lighten up! Don't stop giving it your all, but at the same time, give yourself permission to walk around with a smile on your face. Above all, retain your sense of humor. If you don't have much of a sense of humor to begin with, acquire one. Learn to laugh at your own mistakes and at the absurdity around you (without offending anyone of course); be open and approachable; retain an easygoing, light-hearted, fun persona (without going overboard) and you'll be the person others will be drawn to. You'll be the one who stands out, and your magnetic personality will serve you well throughout your entire career.

When you start an entry-level job, no one will expect you to have much experience, but you will be expected to jump right in—get involved, learn as much as you can as quickly as you can, have a great attitude, move fast, anticipate the needs of others and be there to help and support your co-workers.

It could take six months or three years to start moving up from the lowest rung on the ladder, but if you're patient, it'll happen. Come in earlier and stay later than required, finish tasks sooner than expected, give more and do more than you're asked, and eventually, instead of just helping and doing things for others, you'll have others wanting to help you. Don't complain, keep a smile on your face and an imaginary "Can Do" written across your forehead. Forget that you're overqualified to be making coffee and delivering scripts and picking up the bagels and cream cheese for the morning meeting. You're there to learn and to get noticed. Be prepared and walk in with confidence, because you know what's expected of you, and you're there to deliver.

"The only safe thing is to take a chance."—Mike Nichols

— 12 —

Networking and *Schmooching*

> *"The best time to make friends is before you need them."*
> —Ethel Barrymore

When I started in the business, one didn't hear buzzwords like *networking* and *schmoozing* (or as one of my former international students, who had never before heard this word, mistakenly put it, networking and *schmooching*). At that time, no one was writing books and giving seminars on the topic. It was obvious from the beginning, though, that people preferred hiring their friends. I would see two individuals up for the same job, and the one more qualified didn't automatically get it, sometimes because the producer partied with the other guy or the one getting hired was a relative or a former classmate. It reminded me of high school where the most popular kids always had the most dates.

During the early part of my career, my networking activities were limited to staying in touch with individuals I had worked with (or for)—those I had connected with on some level. I'd always been fairly adept at relating to others on a one-to-one basis but was more reticent when it came to facing an entire group. I did, however, eventually become part of an organization comprised of production coordinators, and then sometime later, attended a few functions hosted by Women in Film. But my WIF experiences left much to be desired, because at the time I was a staff production

supervisor, and I found myself deluged with calls from other women I had met at these functions, all looking for jobs. Not one of them just said, "I think we'd have a lot in common, let's get together for lunch." That kept me away from networking functions for a very long time.

But if you're in this business long enough and take the time to observe how successful people operate, you don't have to be a genius to catch on to the power of networking. The phrase, *it's not what you know but who you know,* is definitely true, so it stands to reason that the more people you know, the better your chances are of making the right connections. And it isn't just knowing people that counts—it's having them know you as well—and *like* you, too.

According to Donna Fisher and Sandy Vilas, authors of *Power Networking* (MountainHarbour), a personal referral generates 80% more results than a cold call. Seventy percent of all jobs are found through networking. Most people you meet have at least 250 contacts, and anyone you might want to meet or contact is only four to five people away from you.

Building a network means you have to get out there and start meeting people and creating relationships. If you've been to film school, your classmates should be your first network. You'll meet people at other classes and seminars, on internships, on jobs, at industry-related events, at meetings and functions sponsored by specific networking organizations, by volunteering to help out at industry-related charities, at parties: the possibilities are endless for anyone willing to make the effort.

Once you start meeting people, you'll find that you connect with certain individuals. Those are the people you want to build relationships with. Whether it's lunch once every month or so, playing golf or tennis, going to functions together or dating, a relationship between two people who work in this industry will naturally result in those individuals wanting to help and support each other's careers.

I know, I know. It's easy to talk about networking and another thing to get out there and do it. I'm convinced that some people are just lucky enough to be born with a "schmooze gene" that makes it practically effortless for them to interact, kibitz, commu-

nicate, connect and deal with almost anyone. And for others, it's a painfully difficult process. For those who aren't born with the schmooze gene, take comfort in the fact that you can start out by networking in small incremental ways, and it does get easier once you commit to doing it. Start with something simple, like inviting your supervisor to lunch and letting her know how much you enjoy working for her.

Swimming with Sharks

Once I started teaching my USC summer class, I found myself talking a great deal about the benefits of networking and schmoozing. I'd also listen to the guest speakers I'd bring in who, unsolicited, would reiterate and emphasize the significance of networking from their own perspectives. I would routinely have students do research on networking organizations and always stressed how important it is for them to keep in touch, because they are each other's first network.

For the students who would bond with me and with each other, the most difficult part of the class is when it ends, and they realize their new source of encouragement and feedback is over. And it was hearing that disappointment each summer, in addition to having just spent the previous six weeks discussing the significance of networking that made me start thinking of starting a new networking organization, one that would supply a continuing source of learning, resources and support.

There are several good networking groups out there (Women In Film included), and many offer a snack (or a meal), a guest speaker or panel and a chance to mingle, which is beneficial in its own right. But what came out of working with film students and knowing what they and others truly need was a vision for an organization that would go one step further in helping to further the career goals of its members. So in November 2000, I put the word out to friends, colleagues and former students and reserved the back room of a neighborhood restaurant. Seventeen of us showed up for that first meeting. It is now four years later. Our group became known as Film Industry Network (or FIN for short). We're a nonprofit

corporation that meets monthly at a major studio and has a sizable membership that includes people of all ages from all facets of the industry and varying career levels. We, too, offer snacks and guest speakers, but we also have ongoing committees and programs that do indeed further careers. And our catchy motto is, *Learn to swim with the sharks . . . but not as bait.*

Being involved with FIN from its inception, I've seen first hand and many times over, people making great connections; helping each other; finding opportunities, mentors, job leads and new friends. The best thing, like the class, is the support. It's great to know you're with a group of people who understand what you're going through and share your passion for the industry. And many of our members belong to more than one organization, which only multiplies their chances of making meaningful connections.

The Secret

If you view networking as just something you *have* to do to get ahead and to get other people to help you with your career, you're in the wrong game. It needs to be a two-way street and become part of your life, a part that freely gives to, shares with, helps and supports others. Think of the film, *Field of Dreams*, where Kevin Costner's character keeps hearing the voice say, "If you build it, they will come." Apply the same theory to networking: If you build the right foundation, are willing to give of yourself and are patient, good things will come back to you. It's kind of like the old what-goes-around-comes-around theory.

As in any other competitive business, you will always run into those individuals who are too into themselves and too ambitious to see the benefit of helping others. They're unwilling or are extraordinarily selective about putting themselves out for anyone else, sometimes doing so only if there's something in it for them. But from my perspective, this business is also made up of good, talented, creative, hard-working individuals who *are* willing to help each other. This big secret seems like common sense, but so many people just don't get that it works. I've seen it happen (to myself and to others) too often not to be a firm believer and practitioner.

In this industry in particular, networking should become part of who you are, because by supporting, giving to and sharing with others, you ultimately enrich your own life and career.

I'm a Friend of Marc's and Jeff's

It took me a while to learn the power of networking. It took another several years to be able to verbalize the secret of truly successful networking. And it took meeting Marc Hernandez and Jeffrey Gund to make it all so easy to understand.

I had first met Marc Hernandez in July 2001 when he was a guest speaker at a Film Industry Network meeting. His story fascinated me. At 34 years old, Marc gave up a six-figure income in commercial real estate to pursue a life-long dream of working in the film industry. He took a job in the mailroom of a major literary talent agency for $350 per week. Upon graduating from the mailroom, he became an assistant to a literary agent. Placing about 100 phone calls a day for his boss, he would briefly chat with the assistants of the individuals his boss wanted to talk to. While talking to these various assistants, he would ask them for their e-mail addresses.

By the end of his first year, he had accumulated more than 600 e-mail addresses. He then capitalized on a relatively untapped resource by finding websites that listed script sales. Soon, Marc was sending out the latest industry news, what scripts were being sold, who was hot, who was out and where upcoming parties and job openings were to the now 2,800 people on his e-mail list. Information being power, he was handing other assistants and junior executives a rare gift.

His e-mail network became a kind of a Hollywood newsletter, a site where he and others could post information about what was happening in town. Wanting to get to know the faces behind the voices and e-mail addresses, Marc also became known for the mixers he'd organize, being able to fill up cool local hangouts with more than 500 "power assistants" at any one time. His e-mail list kept growing and eventually included top-level executives who were also eager to know what was going on. Marc moved up to become a literary manager with an independent management/

production company, and a year later, left to begin his own management firm.

Being in such a competitive business, it's rare to find people generous enough to gather and share so much information with so many. And not only has this information been the source of jobs and valuable connections to countless others, but building his massive network, helping others and making the effort to get to know as many people as he can has also been a key element to his own success. His first job as a literary manager was a result of sending out an e-mail asking if anyone knew of any openings. He now uses the same network in searching for clients and screenplays.

Marc was the first one I heard say, "It's not just who you know, it's who knows you." And he was able to get his name out with every single e-mail he sent—e-mails that, at one time, went to 6,600 individuals who would then forward his information on to others in their own network.

Jeffrey Gund has a similar story. Jeff is a composer and sound designer, and I knew his name long before I had ever met him. I'd be sitting at the sign-in table at crowded FIN meetings and would ask people I didn't recognize if this was their first meeting and how they had heard about us. A frequent response was, "I'm a friend of Jeff Gund's." Attendance was always higher when Jeff's friends showed up, and I soon learned that, like Marc Hernandez, Jeff had a very special e-mail network, and he was kind enough to pass on our meeting notices. He also had a lot of friends.

I finally met Jeff, a nice, soft-spoken guy who would come to FIN meetings when he could. I eventually asked him if he'd put me on his famous list and also if he'd come to speak to my USC students about networking.

Jeff's Info List, as he calls it, started out small. He simply read about a job in the trades he thought a couple of his friends might be interested in hearing about. Or he'd hear about a seminar or networking event or party, and he wanted to share the information. Pretty soon, his friends were forwarding the information on to their friends, and Jeff would be at a party, and someone would mention his e-mail list, and then a handful of people would ask if they, too, could be added to the list. This "list" soon became well

known, and organizers of events and seminars started offering discounts to Jeff's friends if he'd send out their notices, because once out on Jeff's network, a good turnout was certain.

Jeff eventually ended most of his e-mail announcements with, "mention my name at the door," or "when you RSVP, let them know you're a friend of Jeff Gund's." He was able to get his name out there while allowing others to benefit from the information and the discounts. Jeff eventually started co-sponsoring events and parties, and his endorsement of any function was like gold.

Of the over 4,000 individuals on his e-mail list, Jeff knows a great number of them and is endeavoring to meet as many of the others as he can. Some end up on the list through a referral, so it's not surprising that several know his name before they know his face, like the woman he met at a party once. He struck up a conversation with her, and after a while, finally got around to introducing himself. After he said, "Hi, my name is Jeff Gund," she proceeded to say, "No, you're not!" It took him a while to convince her of who he truly was.

Jeff spends a large portion of every day sorting through a tremendous amount of incoming seminar, party, casting and job notices; deciding what to send out and adding new names to the now many lists broken down by where people live, what their particular interests are, etc. He has never charged anyone to be on his list, and to be able to keep it that way, he's currently seeking corporate sponsorship. Only recently has Jeff started receiving small fees for promoting certain events. Other than that, he's never been compensated for the endless hours he puts into this benevolent enterprise.

The purpose of the Info List remains to help others. The only e-mail Jeff has ever sent out on his own behalf was when he needed to move and asked for suggestions on apartment availabilities. Yet, while it takes up a good part of each day, and he has never directly asked for job leads for himself, work has definitely come his way as a result of his unselfish efforts. This, he was recently happy to tell me, has included a couple of truly exceptional high-level opportunities, which I was extremely pleased to hear about, because if anyone deserves a fabulous opportunity, it's Jeffrey Gund.

Anyone (meaning you, too) could start an e-mail list like Marc and Jeff did within your circle of friends, co-workers and contacts, or you could find your own way to give something back and provide a valuable service to others. It just requires a commitment of time and a desire to help. And while there is a considerable amount of responsibility associated with this type of undertaking, the rewards are equally considerable. Because in addition to the new friends, sense of community, gratification at helping others and/or the connections and job leads that come from it—the effort itself exemplifies the true meaning of networking.

The Giving Part of Networking

No matter where you are in your career, and even if you don't know enough people to start your own e-mail networking list, you can always find something of yourself to give to others. If you're a computer whiz and someone you know is having a computer problem, offer to help. If you hear of a job opening that isn't right for you but might be right for someone else, pass on the lead. If you hear of a seminar or a networking event you think a friend or classmate might get a lot out of, forward the information or invite her to go with you to the function. If someone you've met on a job is moving, offer to help schlep boxes.

The best and easiest way to give in this business is to volunteer. Give as much time as you can afford, by working as an intern, volunteering at industry-related charities or events, giving a day or two a week to your local film commission office, getting involved with industry-related organizations or helping out at networking functions. Even coming to work early and staying later than expected for no additional salary is a way to give of yourself and help others. And if there are no networking organizations or film clubs where you live, start one.

This is a very comfortable way to meet people, make valuable connections and get noticed without having to utter one single word about the fact that you're looking for work or hoping to move up in your career. Once people get to know you, like you and appreciate the time you're putting in to help out, they'll just natu-

rally want to get to know you better. And as you get to know one another, and possibly become friends, what you're looking and hoping for will become a natural part of your conversation. And once again, let me remind you that in this business in particular, people help and hire the people they know, the people they hang out with and the people they like.

Granted, giving of yourself, volunteering and helping out whenever possible is an investment in your career; but you have to do it willingly, openly and from the heart. If you do it solely for the purpose of getting what you can from others, your disingenuousness and insincerity will eventually become evident. When you willingly help others, then others are happy to help you. If they see you as selfish and only out for yourself, you won't get far.

The "How To" Part of Networking

Every summer as my USC course winds down, I ask for suggestions as to what I could do the following summer that would make the class better. A couple summers ago, a student of mine named Andy Stoll said that throughout the course I stressed how vital it is for them to network, stay in touch and continually meet new people, but beyond the steps needed to set up a general information meeting, I didn't go into enough detail as to _how_ to network. I realized Andy was right. Knowing it's important isn't the same as knowing how to do it. The following section provides some useful tips on _how_ to network.

Dealing With Shyness: I'm well aware of how painfully tough it is for some people to even show up at functions and walk into a room full of strangers. They know they _should_, that it could be helpful to their careers, but it's terrifying. Every once in a while I will see someone walk into a FIN meeting, find a seat in the very last row and stay there until the program is over, leaving quickly afterward, so they won't be expected to mingle and talk to others.

I believe there are different reasons for shyness. You may have grown up without having learned certain social skills. You may, as many of us do, fear possible rejection. It could also just be part of your intrinsic personality. I used to worry much more about

rejection than I do now, but I also still think of myself as a shy person. Several who know me might laugh at that remark, but teaching, standing in front of a microphone, going to functions where I don't know anyone and just meeting new people is a continuing challenge for me. I almost didn't get into teaching because of my dread of public speaking and for fear of what my students might think of me. Would my high, little voice lack authority? Would I sound knowledgeable enough to convince them that I knew what I was talking about? When I turned my back on them to write on the blackboard, would they think I had a big butt? Go ahead and laugh, but when you're insecure, these are the kinds of things you worry about.

But I really wanted to teach, so I pushed myself to do it. And although it gets easier each year, I've never gotten over that same first-day-of-school fright I felt as a kid when I stand before a new group of students every summer. I've read books where authorities discuss ways to conquer shyness, but I think that, for some of us, it's something that can never be totally conquered, although there are definite steps one can take to make it a lot less onerous.

If it's rejection you're worried about, you just have to take the risk. The first step to taking control of your career is to venture out of your comfort zone. Easy to say, hard to do at first, but once you start, you'll see. It'll get easier, and it'll be well worth the effort. If it's a case of learning proper social skills, this chapter should help; but there are also countless numbers of easy-to-find books and resources devoted solely to the topic. If you're fundamentally shy, do as my brother Peter suggests when facing something difficult, and that is to merely put one foot in front of the other and start walking in the right direction. No matter what the reason, in this business, interacting with others is a necessity; so there's no hiding in a corner behind the huge palm plant and refusing to come out. It'll get easier with time, and opening yourself up to new people and new experiences will truly make a difference in your career, as well as in your life. To help you get over this hump, here are suggestions for attending an event where you won't know anyone.

- Ask the hosts if they need any help and volunteer at the event (by helping out at the sign-in table, helping with refreshments, handing out brochures, etc.). This gives you a specific job and a reason to greet and interact with others.
- Ask a friend to go with, and once you're there and a bit more comfortable, split up.
- Introduce yourself to the host or group organizers, who are usually more than happy to introduce you to others.
- Approach someone standing alone in the back of the room who looks as shy as you. He'll probably be the easiest to talk to.
- Realize it's not considered rude should you wish to approach a group of people and join in on their conversation.
- Be the first to say hello.
- Start with a smile, a warm handshake, and just say, "Hi . . . my name is _____."
- It's perfectly okay to admit you're shy.
- Set a reasonable goal for yourself to get to know just two new people at the event.
- Try to relax and have a good time!

Body Language: When out to meet new people, your body language will let others know how approachable you are. For instance, standing in a corner with your arms folded across your chest and your eyes focused on your shoes is a good way to say, "I'd really rather be left alone!" On the other hand, open arms, a smile, direct eye contact and a warm handshake upon introduction equates to, "I'm ready and willing to meet you." When sitting with someone, leaning back and looking bored, distracted or looking around to see if there's someone else you'd rather be talking to tells the other person he's not terribly interesting, and you'd rather be elsewhere. Leaning slightly forward, making direct eye contact and nodding occasionally will indicate that you're listening and interested. Along the same lines, a friendly tone of voice goes a long way to make others feel at ease.

 Preparing for Small Talk: Do some research before attending an event. One way is by reading the trade papers and catching up on the latest industry news, what movies are hot, who recently scored

a five-picture deal at a certain studio, what this week's box office numbers were. If there's going to be a guest speaker at this event, get on the Internet and find out whatever you can about this person. If the event is sponsored by a particular organization, learn as much as you can about the group. Know what's going on in the world. Come prepared with topics in mind.

Starting a Conversation:
- A simple "Hi, my name is _____" is always a good way to start.
- "So what end of this crazy business are you in?"
- "Tell me a little about yourself."
- "You look like someone I should know."
- "We've never met, but I'm a big fan of your work."
- "That speaker was terrific, wasn't he?"
- "I've never seen you at any of these events before. Is this your first one?"
- "This is my first time here. Have you attended any of these seminars before?"
- "Are you a member of this organization?"
- "I'm new in town. Have you lived here long?"
- "Amazing how the latest Jude Law movie is doing. Have you seen it yet?"
- "Did you get stuck in that horrendous traffic, too?"
- "I love your outfit!"

Remembering Names: If you're like me, you forget a person's name within two seconds after it's told to you. To help you remember, when introduced to someone new, repeat his name to yourself five times. Then rhyme it with something and/or think of someone else who has the same name. It'll help if you can *say* his name out loud, as in, "Hi, Joe. It's a pleasure to meet you."

Communication Assets:
- Passion! Excitement!
- A warm smile and a warm handshake.

- Be sure to make eye contact.
- Start a conversation instead of waiting for someone to talk to you.
- Introduce the person you've just met to others, so she doesn't have to do all the work herself.
- Be positive.
- Be charming.
- Be fun to be with.
- A well-groomed appearance.
- Good manners and respect for others.
- Be genuinely interested in and curious about the people you're talking to.
- Ask questions.
- Be a good listener and encourage others to talk about themselves (most people like talking about themselves).
- Be genuine.
- Have an opinion, but respect the fact that everyone's entitled to their own beliefs, even if they're not beliefs or opinions you share.
- Discover common interests and experiences.

Communication Liabilities:
- A dour-looking face.
- A negative attitude.
- Taking yourself too seriously.
- Having to be the center of attention.
- Showing up in inappropriate clothing.
- Talking too loudly (or too softly).
- Talking down to someone.
- Smoking.
- Drinking too much.
- Excessive use of foul language.
- Overdoing the name-dropping.
- Bad jokes.
- Bad manners.
- Kvetching and whining.
- Being overly critical.

- Talking too much (or too little).
- Looking everywhere else but at the person who's talking to you.
- Getting too familiar (physically or verbally) with someone you've just met.
- Having such forceful opinions that you leave no room for friendly discussion or differing views.
- Interrupting.
- Bad-mouthing or gossiping about others (you never know when the person you're talking to could be a friend of the person you're talking about).
- Starting every sentence with "uh," "like," "man," "dude" or "you know."

Saying Good-Bye:
Whether it's just time to go or you're not connecting with the person you're talking to, here are some suggestions for ending a conversation:

- "It was a pleasure meeting you. Good luck with your current project. I'll look forward to running into you again at another one of these functions."
- "You'll have to excuse me, but there are a few other people I haven't had a chance to say hello to yet."
- "Nice talking with you, but if I don't get out of here soon, I'll turn into a pumpkin."
- "Please excuse me. I have to say hello to a friend."
- "You'll have to excuse me. I need to get something to eat. Nice meeting you."

If you've just met someone you'd like to stay in touch with, exchange cards, phone numbers and/or e-mail addresses, and say something like:

- "I think we have a lot in common. How about getting together for lunch one day next week?"
- "I'd like to continue our conversation. Would you mind if I called you in a day or two to set up a lunch or coffee date?"

Tips from Heather

My writer-producer-instructor-author-lecturer-consultant-mentor-friend Heather Hale is in the process of writing a book about networking. Because she's such a wealth of valuable information, I've asked Heather to let me share a couple of her extremely helpful suggestions with you. It's advice that makes a great deal of sense and is incredibly useful.

HH Tip #1: Not all networking is equal. You may be going to networking events, but are they the *right* events for you? Are they serving you well? Are you making the right connections? Make an effort to meet and network with the people who have the ability to take your career to the next level—not just with the people you work with all the time or the people who do what you do.

HH Tip #2: If meeting new people is uncomfortable for you, and you're feeling hesitant about attending a networking event, take a friend along and work as a tag team. Split up when you get there, and have your friend introduce herself to and strike up a conversation with the person *you* would most like to meet. After they've been talking for a while, walk up to your friend, and let her introduce you. Addressing the other person, she'll say something like, "Oh, do you know _____?" (meaning you) and then possibly add a comment or two relating to what you do, a recent accomplishment of yours, why you two should get together—you get the picture. It's a great way to meet and let someone you'd like to know, know about you, without having to do the hard part. Just be sure to repay the favor by doing the same for your friend.

Your Network

Here is a form to help you keep track of the people in your network.

MY NETWORK

NAME COMPANY TITLE	ADDRESS PHONE/FAX# E-MAIL ADDRESS	ASSISTANT INFO. OTHER NOTES	HOW / WHERE DID YOU MEET? TYPE OF RELATIONSHIP (THROUGH FRIEND, @ SOCIAL FUNCTION) (CO-WORKER, CLASSMATE, ETC.)	DATE OF CONTACT	FORM OF CONTACT (Call/Note/Lunch, etc.)

— 13 —

Getting Through
the Next Door

Once you've gotten your foot into Door #1, you can't stop there. Looking for work, keeping up contacts, continuing to learn, networking and continuously creating new industry relationships is a job in itself, and for as long as you're going to be in this business—it never ends.

The Cultivation and Maintenance of Contacts

Not all your industry relationships will be the same. Some will become life-long friends, and others will remain as just co-workers and casual acquaintances. Some may function as mentors; others will be individuals you choose to mentor. And many will become the source of valuable help, advice and support throughout your entire career. No matter how close you are, how well you know someone or how often you see him, industry relationships are like gold, and it's essential that you protect your investment.

It never hurts to keep your name out there, fresh on the minds of others (as many others as possible), because once you lose touch for any length of time, it's easy to lose the connection as well. You're

probably thinking to yourself right now, "Yeah, yeah, so who's got time to stay in touch with all these people? Not me!" Well, we all have busy lives, and it's not always easy, but scheduling in time to stay in touch with your industry friends and contacts is part of your job. And it's also going to be a contributing factor to your success. There will be times when it'll be easier to do this and of course, you won't have time to stay in touch with everyone to the same extent, but sending someone an e-mail even every few months is well worth the effort and enough to preserve a connection.

As you spend time establishing and cultivating your industry relationships, remember that when you get together with others, conversations don't *always* have to revolve around the business, especially when you're outside of a work environment. In fact, many industry professionals get tired of constantly talking about their work and the biz and are happy to be with someone who shares other common interests and can discuss their kids, books they've read, decorating, sports, cars, favorite vacation spots—you get the idea. I know I've mentioned this before, but it bears repeating: when you become friends with people in this industry, you don't *have* to tell them you're looking for work. If they like you, enjoy your company and consider you a friend, they'll instinctively want to be helpful and supportive.

Whether they're former classmates, people you've worked with, individuals you had interviewed with (whether or not you got the job), those you had general information meetings with, their assistants who helped you get the meetings, people you've met at networking or social events or individuals you've met through other friends, the following are some suggestions for staying in touch and keeping connected:

- Set up periodic meal or coffee dates.
- Invite others to go to screenings or movies with you.
- Tennis anyone? Or possibly golf, hiking, bike riding, poker or any mutually enjoyed activity.
- Offer to help out when you know help is needed (with things like proofreading, yard sales, moving, pet sitting, bringing food to a sick friend, etc.).

- When you hear of an event you'd like to attend (industry or non-industry), invite others to join you.
- If you like to entertain, have dinner parties, backyard barbecues, brunches. This not only keeps you connected to others, it gives you a chance to help others connect.
- In the age of e-mails and instant messaging, receiving a hand-written note once in a while is a real treat, and it's a nice way to stay in touch. And if you know when someone's birthday is, send a card.
- E-mailing certainly has its advantages. It's a great non-intrusive way to send quick notes that others can read and respond to when they have the time. When it comes to instant messaging, however, I suggest *not* IMing others unless you know for a fact they don't find it intrusive.
- Group e-mails are a nifty way to reach several people at the same time. Many of my students communicate with their classmates that way.
- A good reason to get in touch with someone is when you've just finished a project. You might want to share your experiences, stop by with an updated resume, let someone know you just finished working with a friend of his or let him know you're once again available for work.
- If you're in a position to do so when a film of yours has been completed and is about to be screened, invite friends and contacts to a screening. Or if it's a TV show, send out post cards letting them know to watch the show at the specified date and time.
- The same would hold true if you were to have an article or book published. Send out e-mails or post cards announcing the book or article. And should you be lucky enough to have a book signing, get those invitations out to as many people as you can think of.
- When you've got a new CD or DVD of your work (whether it's music you've composed, a monologue you've written and/or performed, a film, short, documentary, etc.), send them to the people who mean the most to you and definitely to those who have been instrumental in shaping or elevating your career. It's a way of saying, "Thanks! Look what I've been able to achieve with your help and support."

- Every time you have a new demo DVD made, send it out to past and potential employers.
- Whether it's for one of my summer classes or for the Film Industry Network, contacting certain individuals and requesting that they guest speak or sit on a panel is a great way for me to stay in touch with them. Along the same lines, each summer I ask a group of my industry friends and contacts to donate 15 to 20 minutes of their time to meet with one of my students. Networking on behalf of my students or FIN is a worthy pursuit that also affords me the opportunity to reconnect with people I like, respect and don't see often enough. If you join any type of an industry organization and volunteer to work on a committee, chances are, you too, can put yourself in a position to make or keep up some terrific connections on behalf of the organization.
- The best is when you can just pick up the phone and call someone you haven't seen or talked to in a while. You're not calling to ask for anything specific, and whether you're looking for a job or not shouldn't even enter the conversation. You just want the other person to know you've been thinking of her, wanted to say "hi" and wanted to know how she was doing. You may hesitate to call for fear of "bothering" someone, but it's been my experience that more often than not, most people are glad to receive these calls. If you're concerned, start your conversation with, "Is this a good time, or should I call back when it's more convenient for you?"

There's Always More to Learn

Technology is constantly evolving, creating advances in fields such as visual effects and animation, cinematography, post production and new media. Production entities come and go. The most cost-effective shooting locations change regularly along with respective exchange rates and government incentives. Executives move from one studio to another. What's hot today is lukewarm six months from now. Screenplays of one genre that are selling like hot cakes this month may be passé by next year. Every few years, renegotiated union and guild contracts affect changes in scale wages,

benefits and working conditions. And the "A" list of talent (repre-
senting the biggest money-makers in the industry) varies from one
year to the next.

There's always something new to master, to keep up with, to
stay on top of. Whether or not it's required of you, continuing to
learn about this industry as well as the latest developments in your
specific field will serve you well. It will allow you to be better at
your job; and it demonstrates that you're willing to put forth the
extra effort to invest in your future. Being more knowledgeable,
you'll be able to talk more intelligently about industry advances
and trends, and others will look to you for answers, because you'll
have built a reputation for being well informed.

Here are some suggestions as to how to take advantage of what's
out there to learn more and to keep learning.

- Read the trade papers (*Daily Variety* and *The Hollywood Reporter*)
 religiously, even if it's only one or two a week. And subscribe to
 or pick up other industry publications as often as you can. There
 are also scores of show biz-type magazines you can buy or access
 online.
- Check out the scores of available industry-related websites that
 contain a wealth of information, and get used to using them on a
 regular basis.
- Attend networking events, especially those that offer guest
 speakers, panel discussions, special programs and any other
 opportunity to learn.
- Frequent film libraries, such as those found at schools and IFP
 (Independent Film Project, east and west).
- If at all possible, visits museums such as the American Museum
 of Moving Images (also accessible online) and the Museum of
 Radio & Television (in Los Angeles and New York).
- When you're just starting out and working as an assistant or PA,
 ask if you can sit in on an occasional meeting.
- If you live in a larger film community, there are always
 classes, workshops and seminars to sign up for. If necessary,
 travel to attend those that specifically relate to your areas of
 interest.

- Frequent bookstores that specialize in industry-related books or one that has a good entertainment (or "film") section. Start collecting books that will assist you in your work and those concerning your chosen field.
- If your area of interest is physical production, obtain union and guild contracts or books that summarize the contracts, and familiarize yourself with basic union and guild rates and regulations. Get to know union and guild representatives.
- Also if applicable, collect production manuals from previous employers, or make copies of manuals your friends may have from other studios and production companies. Each one has useful information that the others don't.
- Say you're working on a show as a PA, production secretary, APOC or POC and you'd like to learn more about production equipment—talk to representatives from the equipment houses your company has accounts with. Ask questions, and if possible, make arrangements to stop by when it's convenient. Someone should be available to show you the different types of equipment and to explain how the equipment is used. Keep copies of updated equipment catalogs for reference.
- When you've been on a job for a while and the time is right, ask your supervisor if you can sit in on a meeting once in a while. If and when you're allowed to, don't say anything (you're basically a fly on the wall). Just sit quietly in the back, listen and learn.
- Also after you've been on a job for a while, ask to take on tasks above and beyond your normal responsibilities, and let your supervisors know you're ready to learn more.
- If you'd like to learn more about the post production process, ask for a tour of the lab your company uses.
- Here's something fairly simple: Get used to taking notes on things happening around you and save copies of any work-related paperwork that comes your way. Some of it may come in handy for future reference.
- Go to annually held production-related conventions and trade shows, such as NAB (National Association of Broadcasters), Cinegear Expo, Entertainment Technology Show, Locations

Trade Show, DV Expo (East and West), E3Expo (electronic enter-tainment), Screenwriting Expo 3, etc. These types of conventions are great for collecting information, attending seminars and mak-ing new contacts. Information, dates and the locations of each of these (and more) can be found online.

- Have a good working knowledge of computer software pro-grams that will help you with your work.
- Stay in touch and network with others who work in the same general field as you. It could be through a union, guild, indus-try-related organization, or just a group of friends and acquain-tances. Exchange information, share tips on solving common problems, discuss changing industry trends and help each other make new contacts.

Finding a Mentor

I've never known anyone to jump out of bed in the morning and announce to everyone he sees that day that he's decided to become a mentor. Nor have I ever seen an ad in the trades placed by an individual looking for someone to mentor. It's not something most people actively seek, although I personally know several individu-als who have thought about how nice it would be to mentor some-one just starting out in the industry. The thing is, they rarely get past the thinking-about-it stage. But when asked to mentor one particular individual, many will agree to do so—are even flattered and happy to make the time. From the other side of the fence, it can be very intimidating to ask someone to be your mentor. But if done the right way, you'll be surprised how many will agree to the arrangement.

Individuals at all levels of their careers need mentors, not just those starting out, and you may already have a mentor and not realize it. Sometimes it just happens as a result of a relationship you've developed with a teacher, a supervisor at work or possibly even someone who had granted you a general information meet-ing. It could be someone you've met through your union or guild or at a networking function. A mentor is merely someone who is wiser than you as it relates to a specific subject matter or line of

work you're learning, heading toward or have embarked upon and whose help, insight and support are immensely valuable. It's anyone who teaches you, is willing to give you the time to ask questions and explain things you need to learn, is interested in you and (to one degree or another is) invested in your success. Having the ability to access years of knowledge, advice and experience is priceless, as are the life-long bonds that are often formed as a result of mentoring situations.

There may be people you don't yet know—but know of—whom you would like as mentors. These are generally individuals you admire for their expertise, reputation and accomplishments. Before even approaching someone to ask if they'd consider mentoring you, there are some things you should take into consideration.

- A mentoring relationship is not to be used as a networking opportunity, and a mentor is not a person whom you pitch your project to, ask for a job or use to get to someone else. If your mentor chooses to help you with your project, with a job or to make connections, it will be entirely up to him.
- Time with a mentor should not be used to learn the very basics of the industry. Your mentor's time is valuable and shouldn't be squandered by having to explain things you should have already learned by way of classes, books and entry-level jobs (like basic terminology and job descriptions).
- You should thoroughly research your mentor, his company, credits, background, etc. before approaching him.
- When approaching a potential mentor who doesn't know you, it's important that you propose a professional arrangement with preset boundaries. Your mentor needs to know that you won't be a stalker, how much of a time commitment she'd be responsible for and when the commitment would end. This doesn't mean that the relationship wouldn't continue after its designated stop date, but again, that would be her choice. It's like asking for a ten-minute meeting instead of an hour of someone's time, even though many meetings stretch out to an hour. It's not as intrusive on her time and is much easier to agree to.

- Drawing upon the guidelines set up by FIN's mentorship program, we suggest that mentoring terms last for no more than three months. I know others that last for six months, but that should be the max. Our program allows for one 30-minute face-to-face meeting, the time and place to be at the mentor's convenience; one 15-minute phone call each month with the mentor; and two e-mail contacts per month (e-mails to contain no more than three questions and are limited to a half-page in 12-point font). I know this sounds incredibly restrictive, but it tells the prospective mentor that you respect her time. Again, it usually stretches into more frequent contact, but that has to be offered by the mentor.
- Having a mentor is a gift. Don't be late, disrespectful or presumptuous. Be gracious, open and appreciative. The tighter the bond that's created, the more likely it is that the relationship will continue.

The best way to request that someone be your mentor is by letter. Before you start the letter, however, make sure you have the correct spelling of your potential mentor's name and her correct title. Also make sure it's typed and printed out on good-quality 8½ × 11 paper. Start by stating your reason for writing. Next, introduce yourself by offering a short version of your pitch. Include some interesting facts about yourself, your life, your accomplishments, interests, passions and goals. Mention your strengths as well as your biggest stumbling blocks. You really have to be able to convey a sense of who you are beyond the facts stated on your resume. Your next paragraph should outline the guidelines you're proposing. End the letter by thanking her for her consideration and promising to call her office in a few days to follow up (which of course you will do).

Don't send the letter until it's been through a spell-checker, and have a friend look it over—someone who can give you objective feedback as to how it reads.

If you don't live in a major entertainment community, you can contact your film commission office to see if there are any industry professionals living in your area who might consider mentoring

you. It's also perfectly okay to request that someone who lives in another city be your mentor. You wouldn't have physical access to this person, but phone and e-mail communications would prove immensely valuable just the same.

Having an Agent

Only once you've worked your way up the ladder a bit, have scored big at a film festival, sold a script or been offered a terrific deal or position, do you have enough credibility to seek the representation of an agent. This is a classic Catch-22 situation if there ever was one, because it's so much more difficult to establish yourself without the help of an agent, yet you're not likely to attract agency representation without having first established some amount of credibility and success.

As previously mentioned in Chapter 4 under a section called *An Agent's Life*, actors have agents (sometimes more than one), as do most established writers, producers and directors. There are also agents who specialize in representing below-the-line crew positions, such as production designers, directors of photography, editors, costume designers, production sound mixers, etc.

For actors and most writers, having an agent is vital. While studios and production entities will accept screenplays from agents, entertainment attorneys, managers and producers, actor submissions are primarily made through agents. Good agents with solid producer, director, casting director and studio relationships are quite adept at getting in to pitch or submit their clients and/or their work. Some of the larger agencies also package their own projects, which provides even further opportunities for their clients.

Many actors and writers have agents, managers and attorneys (and some, publicists as well). While having this level of representation is a personal choice, I know many top industry professionals who land their own jobs and then have their attorneys negotiate their deals—that's it—just one attorney. But if the work isn't coming to you, you don't particularly like selling yourself and can't seem to stay on top of potential job possibilities, then having an agent could prove quite beneficial.

You generally need at least a few substantial credits under your belt before you can start shopping for an agent. The better your resume, the more salable you become. Some agents will only take you on if you truly have an impressive list of credits. There are others, however, who are more willing to take the chance on newer, up-and-coming, less-proven talent, as they themselves are more likely to be newer agents who are building their own client base and (like you) establishing their own reputation.

When shopping for an agent, you want one who specializes in your facet of the industry. Ask friends and contacts for leads, and do some research on whomever you're considering, because this person will hopefully become a significant part of your career. You can access lists of agents through your union or guild, on the Internet, through your local film commission, and if you're in Los Angeles or New York, in a large selection of reference books and resource guides. You'll also have to decide if you want to be with a large, prestigious agency with a lot of clout (and a lot of other clients) or a smaller agency, with possibly less clout, but where you'll get more personal attention.

When submitting a request for representation, make sure your resume looks as professional and impressive as possible and include your demo reel (on videotape, CD or DVD), script or portions of your portfolio in the package. You'll need these to sell an agent on you before he can start selling you to others.

Your agent will be submitting you and/or your work, following up after interviews or submissions, negotiating your deals and, hopefully, offering helpful advice and direction on your career. Once an agent agrees to represent you, and you feel good about the arrangement, you'll be asked to sign an agency contract, binding you to this relationship, usually for a year. During this time, your agent will receive a 10% commission on your salary, whether he lands a specific deal for you or just negotiates a deal you were able to score on your own. (Some agents will agree to take only 5% on jobs that you land totally on your own.) If you were to land an executive position, your agent would most likely take his percentage during your first year of employment with that company.

Having a good agent can be of great benefit to your career, but it doesn't take you off the hook as far as looking for work, networking and keeping up contacts. Having representation is not an excuse for you to stop looking for opportunities whenever possible. An agent with as many as 50 clients at any one time can't possibly take full responsibility for your career. So use your agent more as a partner, to help line up general information meetings, to submit you or your work, to be a source of information and to negotiate your deals, but don't give up your own quest, because your career is ultimately your responsibility.

Making Your Own Film

Another way to get in the next door and propel your career is to create a demand for your work by making your own film, music video, commercial, short film or documentary: a very smart move especially if you want to establish yourself as a director. Power players won't usually take a chance on an unknown. You have to prove yourself first. So as talented as you may be, if you don't have anything to showcase your work, you're drastically reducing your opportunities. Creating your own footage is an effective calling card, and it can be a tremendous asset to launching and building a career that would otherwise take years to establish.

With all the new, innovative and constantly evolving technology, shooting and editing your own film is more affordable and more feasible than ever before. Although many people still prefer to shoot their projects on film, the accessibility (and again, affordability) of DV (digital video) cameras and DVD cameras are creating a whole new world of possibilities for aspiring young filmmakers.

Whether you make videotapes and DVDs to hand out to everyone you know, showcase your project through the Internet or at film festivals or host private screenings, they're an ideal way to sell your talent, your goals and your passion and to set your career in motion. Additionally, a short film or documentary could be an impressive fund-raising tool for a full-length feature, just as a short demo could be an effective method of selling a new TV show.

Did you ever see the 1989 Kevin Bacon movie called *The Big Picture*? In it, Kevin's character plays a film school graduate whose award-winning short film gains him big accolades and a big Hollywood deal to make the film of his dreams. But one thing leads to another, and everything falls apart. He goes from being the hottest new filmmaker in town to a nobody in no time. Ultimately, he and his friends decide to make their own little film, their way, without any studio interference; and voilà! Surprise, surprise! It's a big hit and our hero is back in demand. Well, these types of stories actually do happen, and a prime example of that is director/writer Luke Greenfield.

Luke graduated film school with an award-winning short, and the night after USC's First Look Film Festival, he had an agent. The agent sent him on several meetings, he sent scripts out and pitched projects but couldn't seem to get his career off the ground. At the same time, he was writing. One particular screenplay was called *Echo Lake*, which he co-wrote with two actor-friends of his. Producers they had pitched it to suggested they package the project with big-name talent. But they thought, if they could have packaged it themselves, they would have. Deciding their only option was to make the film themselves, they set out to raise their own funding.

Eventually through personal family friends of one of his co-writers, Luke and company were able to raise $30,000. They used it to shoot a ten-minute film based on a scene from *Echo Lake*. It was a four-day, 35-mm shoot, and they called it *The Right Hook*. The problem was, they shot their wad before they could develop the footage. It took them another year-and-a-half and $100,000 worth of favors and donated services to finish the project. As Luke explained, when it's for free, you can only use someone else's equipment, facilities and services when they're not otherwise being used. From the time he landed his agent until the time *The Right Hook* was completed, approximately four-and-a-half years had elapsed. Before it was completely finished, however (it hadn't yet been mixed), he transferred it to videotape and showed it to a few people. It didn't take long for this original, funny story about men's fears of approaching women at bars to get into the right

hands; and before he knew it, Luke was being offered a job direct-ing Rob Schneider in *The Animal* for Happy Madison Productions (Adam Sandler's production company). This led to *The Girl Next Door* for New Regency and 20th Century-Fox and a subsequent multi-picture deal with New Regency.

Film students have the luxury of making their own short films at the school's expense. The equipment, the crew, the cast: they have access to everything they need, and they graduate with a finished product to market. Sometimes that's enough to get their career going, sometimes it's not. Some people wait until they've worked in the business for a while before they make their own film. They give themselves time to learn, to build relationships and to be able to produce a more professional-looking product. I met a post pro-duction supervisor a few years ago who had been working on an episodic television series for quite some time. When she announced that she wanted to make her own little film, a large part of the crew she had been working with offered to help out for free. They shot over the course of a few weekends using donated equip-ment and vehicles.

Most of these first-time projects are done on a shoestring. Friends and relatives are often called upon to loan money, loca-tions, food, wardrobe, props, their animals, vehicles, whatever they can. They help build and decorate sets and work in whatever crew capacities they're able to. Some people recruit free labor from film schools and others solicit interns who can use the experience and screen credit. It's not uncommon for rookie filmmakers to max out their credit cards or take out a line of credit to defray production costs. Sometimes, crew and/or equipment rental houses will agree to defer their salaries and rental fees, taking the chance that they'll be paid if and when the project lands a distribution deal.

Some people shoot on weekends when they're not working at their nine-to-five jobs or for access to locations or equipment not available to them during the regular work week. It's also not unusual for filmmakers to shoot their projects in smaller commu-nities where they don't have to worry as much about permits and restrictions and where a majority of the residents are thrilled to have them there (unlike shooting in a big city where permits can be

pricey, restrictions are plentiful and neighboring residents and store owners often see a film shoot as an unwanted intrusion).

I can't give you an average cost of these types of films because of all the variables: the format you're shooting on, the cast, the locations, the length of your film, if you become signatory to any union or guild contracts, if you can secure free or deferred labor and services, etc. An actor/writer/director friend, Warren Vanders, and his actor/producer partner, Matt Valenti, recently made a 47-minute short (shot on 16 mm) called *Touched*. In addition to using this piece to showcase their talents, their primary objective is to use it to raise the funding to do a full feature length version of the same property. Warren said they begged, borrowed and happily took advantage of all their friends and relatives who donated time, expertise and services. They ended up spending a total of $25,000 to make the film, but he said it would have cost ten times that amount had they had to pay for everything. The items they had to pay for included camera rental, DV tape, film stock, SAG fees, food for the cast and crew, one small location site fee, insurance, some equipment rentals, some materials, a few crew salaries, a limited amount of wardrobe and a one-year license fee for use of a copyrighted song.

If you want to raise financing for your film, there are several books and websites available just brimming with good information on the topic. Also be aware that there are various sources of funding and different requirements for each, such as:

- Pre-sale rights: This is when a distributor will agree to pay in advance for the rights to distribute a film.
- Public money: Subsidies and grants for filming.
- Private money: Investors looking to put their own money into a film. Often a finance company has a network of investors behind it who wish to invest this way.
- Gap financing: A gap can often occur between the pre-sale total and the total production cost of the film. Some banks and finance companies will lend this gap.
- Tax shelters: States and countries that offer tax breaks for shooting on location in their area and for hiring a certain percentage of your crew locally.

- Bank loan: This is usually based on pre-sales. Banks are not in the business of investing in film. They lend money to producers to help cash flow, but also require strong pre-sales agreements to be in place before discounting them against production finance. If you have some substantial collateral, you might be able to take out a loan against a home or a business.

Before you begin your quest for film financing, consult an entertainment attorney. If you can't afford an attorney, there are legal services you can access for free. In California, for example, there's a non-profit organization called California Lawyers for the Arts (www.calawyersforthearts.org). An attorney will present you with the proper guidelines and help you form a legal entity. Once you know what has to be done, you might be able to do much of it yourself, like filing for a business license and opening a bank account. You'll want to prepare (or hire someone to prepare) a shooting schedule and budget, have business cards and letterhead printed up and possibly a website designed. You may need promissory note forms, which you can find at a stationery store or online. Then there's a business plan, which is an essential tool in procuring investor financing.

A business plan starts with an executive summary, which includes information on the proposed film in the form of a synopsis or treatment, a copy of the agreement evidencing proof of screenplay rights, comparable box office performances, proposed production details, a copy of the budget, your proposed distribution approach and your strategy for funding the picture. The plan will include a current industry overview and an assortment of exhibits, such as resumes of the principal participants, copies of all option and acquisition agreements, a financial statement, letters of interest and/or intent, press coverage (if any exists) and financial projections. Depending on the stage at which financing is sought, you may be able to include other exhibits such as a title report, copyright search report, chain of title documents (including a certificate of authorship for the screenplay, copies of your copyright registration, copyright assignment and distribution agreement[s],

a completion bond commitment letter, the final screenplay and shooting script, cast and production credits, feature stories on lead actors and the director, production stills, casual cast photos, agreements relating to the film's music, the MPAA rating certificate [if available] and an Errors and Omissions [E&O] certificate of insurance.) There are no formal rules governing the contents of a business plan, so producers can be somewhat flexible in assembling the package.

To learn more about film financing and business plans, I suggest a terrific book called *Filmmakers and Financing–Business Plans for Independents* by Louise Levison (Focal Press). There are a few websites worth checking out as well: www.movieplan.net, www.filmproposals.com and www.moviepartners.com/index.php?action=BusinessPlans. You can also hire someone who specializes in preparing business plans for film financing to do one for you. I recommend Peter Davidson of Davidson & Company in Los Angeles, but your attorney should also be able to provide you with recommendations.

When all is said and done, the most essential ingredient to making your own project is to start with a great story and a well-written script. You could be a supremely gifted director, producer, actor, production designer, costume designer, cinematographer or editor, but it's difficult for talent to shine through when it's steeped in poorly written, unoriginal, uninteresting material. A terrific story can transcend poor cinematography, mediocre acting and little or no production value. It also has the amazing ability to highlight genuine talent.

Don't ever stop attempting to walk through the next door, and the next one after that and the next one after that. Identify your talents, strengths and accomplishments, and exploit them. Find new avenues of opportunity for yourself by continuing to network, learn and perfect your craft. Preserve valuable industry contacts, find mentors (and perhaps an agent), and if at all feasible (and it's something that will further your goal), make

your own project and create a powerful selling tool for yourself. Don't ever stop and "settle" for a fraction of your dream, because you have doubts as to what you're capable of achieving. You *can* do it!

> *"So many of our dreams at first seem impossible, then they seem improbable, and then, when we summon the will, they soon become inevitable."*
> —Christopher Reeve

—— 14 ——

Pitching and Selling

Pitching Is Just Part of the Game

If you plan on becoming a successful producer, writer, agent, manager, distributor, development or production executive—you will undoubtedly have to master the art of pitching. Pitching is the first step in selling a screenplay; a story; a concept; a completed film; a pilot; an actor for a specific part; or a writer, director, cinematographer, production designer, composer or editor for a specific project. And if you're not pitching a project or talent, you're pitching yourself in an effort to line up your next job. It's done a gazillion times every single day, at all the studios, agencies and production companies; during office meetings; over lunches, dinners and drinks; at parties; at film festivals; at pitch fests; over the phone; via websites and by e-mail. It's a huge part of the Hollywood game, and those who are good at pitching have an enormous advantage.

A pitch can be a door-opener, an ice-breaker, an introduction, a relationship-builder. It can create intrigue, curiosity and excitement. And it's a great way to disseminate information.

To simplify matters, I'm going to limit this chapter to the discussion of pitching *projects* (completed screenplays, book rights, treatments and life-rights packages) as opposed to talent or completed projects in search of distribution. In this context, a skillful pitch will grab a buyer's attention within the first few moments, and those accomplished in the art of pitching will have the ability to ace a sale based largely on his or her passion for the project being sold. Suffice to say, however, the basic principles are the same, no matter what or whom is being pitched.

On the Lookout for Good Material

While there are some companies that will only accept completed screenplays, and some agents who will tell you that you can't sell a project without a script, it's done every day. There are many producers who sell ideas and concepts, backed up often by just a short treatment. Some can sell an idea with just a verbal pitch, and many make very good livings by selling compelling stories they've found in newspapers or magazines. It could be a story heard on the radio, a television magazine show or even a news broadcast. Good stories are all around us, and many producers routinely have others helping them scout for material. They're always on the lookout for fascinating, gripping, touching and larger-than-life true stories that would make good films. One of the projects I'm currently out pitching came to me via my brother Peter, who knew a man who, during WWII, had been a hero and had an awe-inspiring story to tell. You never know where it's going to come from, so those who are writers, passionate about producing or just want to help bring a quality product to the big (and little) screen—keep your eyes and ears open for good material. Remember, though, you won't have the right to shop these stories around until an option agreement is in place with the person (or persons) whose story it is, but once secured, the story's yours to shop.

The same would hold true for a book. If you read a book you feel would make a terrific movie, find out if an option is available. You would start by calling the publishing company, and they could

point you in the right direction. If an option is available, if you can negotiate an option price that's fair and affordable to you (I suggest doing this through an entertainment attorney) and you secure a signed agreement from the author (or whomever else may hold the rights), then you have the authority to shop the book around as a potential film.

If a production company or studio finds the idea, story or book you bring them riveting and commercial and your passion for the project contagious, the sale can be made, even without a completed screenplay. Then either the studio, network or production company will retain a writer of their choosing to write the screenplay; or sometimes the producer will come in with a suggestion for a writer he thinks would be right for the assignment—someone who is already interested in the material.

Scripts, Scripts and More Scripts

If you're not a writer but a producer who's searching for good, completed screenplays you'd like to option and attempt to sell, just start putting the word out that you're looking, and don't forget to state the genres you're interested in (or you'll be overloaded with submissions). Let your friends know, your relatives, the people you went to school with, people you meet at networking functions, find the appropriate websites to post on, take out a small ad in a trade publication or screenwriting magazine, put up a notice at some film schools and contact instructors of screenwriting courses. There are countless numbers of ways to get the message out there. A good script doesn't have to come from an established writer. It could come from anywhere. In fact, the less known the writer, the less expensive the option fee.

Once the word is out, be prepared for an onslaught of scripts coming your way. You'll have a lot to read, and most won't be well-written enough, compelling enough, commercial enough or something you can get behind. You'll be lucky if you can find one or two that will knock your socks off. And if you do, grab it up before someone else does.

First Things First

Before you commit to any property, and even if it's your script, make sure you have a basic understanding of what constitutes a good story. Next, is it structured and formatted properly? Is it the right number of pages? If you're not sure, go to www.samuelfrench.com or www.writersstore.com, and order one of the many books available on proper screenplay structure. Most of the books will also give you a rundown of the screenwriting software available that will allow you to write (or convert) your script into the proper format.

Then, make sure you're using white 8½ × 11, three-holed paper, a proper script cover and brads in the top and bottom holes to bind your screenplay together (don't use three-ring notebooks or spiral bindings). And check your spelling and grammar, and then recheck it. If your screenplay isn't submitted in the proper format, presented correctly or deemed professional, it could very well be tossed before one single word is read.

Your next step would be to register your project with the Writers Guild of America, which you can now do online by going to www.wga.org.

And once again, if you plan to pitch a script or treatment based on a book or on someone's life story, make sure you have a signed legal agreement proving that you have an option on the rights. If not, you'll have to find out if an option is available and then negotiate a mutually agreed-upon price. If the property belongs to someone you know well, and you both agree, you can option it for the outrageous sum of $1, as long as some money changes hands. I don't suggest taking options for less than a year and would extend that to 18 months to two years if possible. The agreement should be prepared (or at least approved) by an entertainment attorney, and once prepared, it will most likely have to be sent to the other party's attorney, publisher or agent for approval.

You can't sell anything until it's properly structured and formatted and unless you have the legal right to do so.

Becoming One with Your Material

Before you can sell your project to anyone, you have to know it intimately yourself—the story, the characters, the setting. If it's based

on reality, know the history behind the story. Do your research and be ready to answer questions that are bound to come your way.

Be able to explain what it is that makes this project unique and compelling. Be able to convey the irony, the humor, the conflict and the heart of the story. If you're not excited about what you're selling, how can you expect a buyer to be? Why does this story have special meaning to you? Who do you envision as your lead cast? What type of audience would it appeal to? What makes it commercial? How do you see it being marketed? One of your main goals is to be able to make your buyers see the movie poster in their minds by the time you've completed your pitch.

What other films could you equate your project to? This industry is big on *high concept* comparative descriptions, especially when you're comparing your project to others that have done big box office numbers. Examples would be *Agent Cody Banks*, which sold as a teenage James Bond, or *Alien*, which sold as *Jaws* on a spaceship.

A pitch should start with a succinct, compelling logline (the essence of your story in one sentence) that will grab someone's attention. You can't underestimate the significance of a catchy logline, because it's the first thing a buyer will hear (or read if you're writing a query letter) and could mean the difference between immediately grabbing someone's attention or losing that person's interest on the spot. My producer-writer-friend Graham Ludlow likes to give the example of what he thinks the perfect logline for *Liar, Liar* might be, which is: A lawyer suddenly discovers that he can no longer lie.

Your pitch should have a beginning, a middle and an end, although you don't have to compress the entire story into the pitch. The goal is to be able to convey the essence and heart of the project, just enough to entice the buyer to want to know more, to ask questions and to want to read the script.

Some experts will tell you that a pitch shouldn't last more than 15 minutes; others will tell you to get it down to five minutes. My feeling on this is that you should have a 30-second pitch, a one-minute, five-minute and 15-minute version. That way you're prepared, no matter what your time allotment or circumstances.

Memorize what you're going to say ahead of time, so you don't have to read from notes, and practice. Practice in front of friends and family members, in front of a mirror, in front of your dog; just keep practicing until what you have to say sounds natural!

Perfect your pitch to the point where your audience can visualize the action, the characters and the setting. If it's a comedy, you want them to laugh. If you're selling suspense, you want them holding their breath. If you're describing a battle, they should be ducking bullets and shrapnel. Make them see, feel and experience your story.

Knowing the Market

Many writers write screenplays based on what they know and create stories that are very personal to them, but they're not necessarily properties that are marketable. Do your research and know your market. Know who you're pitching to and what they're looking for. What type of product does this company produce? Who are the producers and directors they generally work with? What do they currently have in development, on the air or in release? Know what's selling and who best to sell to.

Research the studios, networks and companies that do the types of projects you have to sell. Some production companies, for example, only do big action pictures; some specialize in comedies and still others are always on the lookout for true-life stories. There are production companies that specialize in reality TV and others that do only sitcoms. Do your research by reading the trade papers as often as possible, go through the *Hollywood Creative Directory* and check out various industry websites to find out who's buying and who's selling what.

What happens if you've got a project that isn't the right genre or period du jour, and no one seems terribly interested in looking at it? In that case, you have a couple choices. You can either sit on it for a while hoping that trends will start shifting in your favor, or you can just tenaciously keep plugging away. If the project is powerful, well written and something you're unwaveringly passionate about, your chances may be fewer, you may not get in nearly as

many doors with it and it could take a whole lot longer to sell, but if it's that good, and you're that patient, it could happen for you.

Targeting your market also means researching the budgets of projects produced by specific companies and being able to ascertain whether a similar-sized budget would accommodate your script. It also means knowing which companies have studio development deals. In television, you'll want to know who the most successful show runners are—the producers and writers who create a majority of the popular series.

Not every project is right for every buyer, and just common sense will often dictate the best fit for your project. If you know what's out there by going to movies, renting videos and DVDs and watching television, your gut will usually tell you if what you have is studio or major network material or a cable movie or a smaller, independent feature. Don't waste anyone else's time or yours trying to sell your project to the wrong buyer.

Should you choose the independent route, there are companies that produce features and documentaries by securing their own financing and distribution. If you decide to raise funding for a project without the benefit of working through an established indie company, you'll want to thoroughly research everything you can get your hands on pertaining to creating a business plan; raising capital; completion bond companies; setting up a new entity and becoming legally compliant; production, post production and standard delivery requirements; and film festivals, markets and distributors.

Packaging

You will always increase your chances of selling a project if it's packaged well. Packaging means "attaching" talent. The higher profile the talent, the better.

Development executives who greenlight scripts that don't do well at the box office or in the ratings are not likely to hold on to their jobs for long. Consequently, they're going to be *extremely* selective about what they buy. Not that anyone has a crystal ball and knows for sure what's going to be a hit, but if they're fairly

certain a project will generate a decent return, they're more likely to consider it a possibility.

So what's going to convince them a particular project's worth buying? How about if Jennifer Aniston was attached, or Tom Cruise? Yep . . . that'll do it, because it's a pretty safe bet that any film either of them would star in would attract a good-sized audience and generate considerable revenue.

But you don't always need a Jennifer Aniston or a Tom Cruise. Any time you can attach any A-list talent, you increase the salability of your property. And while the attachment of a popular actor is always the most appealing, the inclusion of a well-known director or writer could also mean the difference between a sale and a pass. As good as a project may be, the buyers are going to take as few risks as possible. Add to that equation the odds of getting your project read, bought and produced compared to the number of projects submitted each year, and you'll know why smart packaging is so valuable.

Why "smart" packaging? Because if you attach an actor (for the lead role) who doesn't have enough name-value to draw people into theatres or your package includes a writer or director that no one's ever heard of before, you run the risk of making your project *more* difficult to sell. If you're pitching a project as a movie for television or cable, then attaching lesser known or unknown talent shouldn't affect the sale of your property quite as much. But even if you're doing a low-budget indie feature, the more recognizable the talent, the better your chances of attracting a major distributor. Needless to say, the more you can bring to the table, the more desirable your project will be.

Makes sense, right? Okay, but now you're probably asking yourself, "So how would I go about attaching talent to my project?" Good question, and unless you have some terrific connections, it's not *quite* so easy.

If you go through an actor's agent (especially one who doesn't know you), *most* will want a firm commitment and some big bucks up front before they'll even read it. Not a good way to go, since you probably haven't even sold the project yet. Going through an actor's manager, publicist or attorney might be a little easier, if you can get to them. The best way, however, is to get the script directly

into the hands of the actor. But since you probably don't know him, you've got to find someone who does. Your agent (if you have one)? A friend? A friend of a friend of a friend? All good, if they can get it there. I recently heard of someone who was able to submit a script through an actor's nanny. Sometimes, the actor you want may have his own production company; and if so, your submission could be made through his development executive.

You have to be relentlessly assertive and creative when finding your path to an actor, whether it's finding someone who knows someone who knows someone who knows the person you want to connect with (otherwise known as the *Six Degrees of Separation* theory) or by going outside of the proverbial box. One friend of mine, a producer who, after failing to connect with a number of name actresses for the leading role in her indie feature, decided to go to the UK, where performers' agents don't require an upfront commitment of capital, and where she was able (without too much effort) to attach a well-known English actress to her project.

Once you connect with a specific actor, and he reads and likes your project, he may commit to doing it whether it's something his agent would have advised him to do or not. And sometimes, if passionate enough about the material, talent will sometimes agree to perform in a film for scale wages plus a percentage of the profits and/or for a producing role.

Getting Your Material in Front of the Buyers

> *"Nobody knows anything. Not one person in the entire motion picture field knows for a certainty what's going to work. Every time out it's a guess—and, if you're lucky, an educated one."*—William Goldman, *from Adventures in the Screen Trade (Warner Books)*

Once you figure out your market, have your project as packaged as it's going to get and are ready to get it out there, your next step is to line up your pitch meetings or connect with buyers who will

agree to read your project. If you're going to be submitting directly to a company, check out the *Hollywood Creative Directory* and find out who the development executive is at that company. If you don't have a direct connection to the president of the company, someone a little lower on the food chain may be more accessible to you.

There are several ways to get your project out there: Some companies will tell you they don't take unsolicited material unless the submission is made via an **agent, manager or attorney**. If you happen to have an agent or manager, great, but you can't rely on that person, agency or firm to sell your projects for you. Often, though, if you give your rep a list of the companies you'd like to submit to, she can often set up pitch meetings, and may even opt to go with you. Your agent or manager can also handle submissions for you. Since not everyone has an agent or manager, you can also have an attorney make a submission for you. A savvy entertainment attorney with solid industry connections would also be in a position to set up pitch meetings, as many also function as "producers' reps."

If you're a more established writer and you have an agent, your agent may control where your script is submitted. In this case, the agent might also call a producer the agency represents or someone he has a relationship with (someone he thinks would be right for the property) and give the producer permission to pitch it to the studios. The producer would then become part of the package. The agent, who would also have access to top talent, may actually end up packaging the entire project.

If you're a writer looking for representation, the Writers Guild of America has a list of agencies that will consider first-time writers. You might also contact some literary management firms as well, as it's generally easier to get a manager than an agent. And ask friends and contacts for suggestions on agents and managers and to make referrals on your behalf. Sometimes a recommendation from a current client is enough for an agent to consider taking on an unknown.

You can **partner up with an established producer** or company that has the connections you need. It's a good way to get your foot in some doors; and once your project sells, you'll discover you have enough credibility to get into those same doors on your own next time.

If you're looking for a producer or production company to partner up with that has done projects similar to yours in the past, your best reference (again) would be the *Hollywood Creative Directory*.

Although the majority of shows sold to studios and networks are via individual producers, production companies, agents and managers, there is one company I'm familiar with called *The Solley Group* (www.solleygroup.com) that serves more as a consulting and sales firm, but in the cable marketplace only. If they feel you have a commercial project, for a fee, they will help you develop and sell your project to a cable network.

Use your contacts, people you work with or used to work with, former schoolmates, friends, individuals you meet at networking functions, your mom's next door neighbor whose son goes to school with the daughter of a producer you're trying to connect with—anyone who knows anyone who knows the people you're trying to reach.

Some people, without the benefit of representation or any connections at all, will **cold call** various buyers. Under these circumstances, you might want to skip the development executive and skip down a couple rungs to the story editor or development assistant; and you'd know their names, because you will have looked them up ahead of time, in what? Right! The *Hollywood Creative Directory*.

If you're professional, personable, can speak with a certain amount of authority, can quickly convey passion for your project (a project that would be just *perfect* for this company), then *perhaps* the person on the other end of the phone will listen to what you have to say. But you'll have only a minute or two to grab her attention, so what comes out of your mouth next better be good. Have your logline ready and a very short version of your pitch. If the story editor (or development assistant) doesn't end the call at this point, solicit her help in setting up a pitch meeting for you, or ask if you can submit your script. If you get the go-ahead to send the script in, she'll most likely ask you to sign and return a Submission Agreement and Release Form first, which will legally protect you as well as the production entity.

If you're a writer you'll find that your cold call will receive very little consideration, if any. If you're calling as a producer, you may be given a few minutes to quickly pitch your project.

Because cold calling is not always the best way to go for those new to this game and frequently requires nerves of steel to successfully pull off, many people will submit **query letters** to their targeted buyers. A query letter should be no more than one page, and it's a way to introduce both you and your project and to request permission to submit your project. Just as with the cover letter you submit with your resume, make sure to address your query letter to a specific individual (most probably the development executive). Call first to make sure you have the name and title spelled correctly and you know the gender of the person you're addressing. When introducing yourself, you want to include any information that might pertain to your experience (or accomplishments) as a writer or producer (like if you've won any screenwriting contests, sold other projects, etc.). When it comes to a description of the project, start with the title, genre and the logline. Make sure you mention where you can be reached. For useful tips on writing an effective query letter, go to www.wga.org/craft/queryletter.html. If the producer or development executive is impressed with your query letter and intrigued with your description of the project, you'll be contacted.

When you look in the *Hollywood Creative Directory* or find contact information for a specific production company on a related website and an e-mail address is noted, it means that company is open to e-mail queries. In that case, you have a better chance of your letter being read if it's e-mailed, as opposed to sending it through the postal service.

Producers and production companies that accept queries generally receive so many, they rarely have time to respond to them all. So if you don't hear back from a company you've queried, assume they're not interested. If someone does respond to your query or logline, you should have a short synopsis ready to send as a next step. A one-paragraph synopsis and a more detailed one-page version are good to have, and I would send both. Copy and paste your synopsis into the body of an e-mail, and send it that way instead of

attaching it as a separate document. (A lot of people won't open attachments for fear of viruses.) If the buyer is still interested, he will (if you're not represented) ask you to sign and return a release form and return it along with a copy of your project. If you don't hear something within a couple months, you're entitled to follow up and find out the status of your submission.

Monitor the various screenwriting magazines, networking organizations and websites (www.moviebytes.com in particular; www.scriptforsale.com is another good one) for **screenplay competitions.** Producers, agents and managers will routinely take note of winning screenplays for option consideration. Be careful, though; there are so many out there now, you'll want to look for the competitions that have developed solid reputations.

Pitch fests and pitch marts are becoming increasingly popular. They're the perfect venue for less-experienced screenwriters (and producers) and those with no representation to pitch their project to established producers, development executives, agents and managers. The fees to attend vary, but the valuable exposure along with the networking opportunities they afford are generally worth the cost. It's sort of like speed dating. You're generally given five minutes per pitch; and when the bell rings, you're out of your chair and pitching to the next buyer. If you plan on attending a pitch fest, walk in prepared to pitch more than one project or concept. You could be seconds into your primary pitch when a buyer tells you it's not what they're looking for and she isn't interested, but then in the next breath, will ask what else you've got. Get your money's worth out of your allotted time, and come prepared with three or four pitches.

Handing a buyer a screenplay during a pitch fest while they're frenetically being bombarded with concepts and stories is not a smart move. Most will appreciate being handed a one-page synopsis of the pitches they like, to which you can follow up with a polite e-mail several days later. You want them to be sold on the idea of your project and to request the screenplay (or more info) once they've had a chance to digest it.

There are many pitch fests held each year, and a lot of people pack up their dreams and travel from far and wide to attend them.

To make sure you're attending one that's legitimate, do a little research before you sign up. Find out if the entity sponsoring the pitch fest is an established organization that's been around for a while, check out reviews from reputable sources, such as the trade papers, the Writers Store and some of the bigger screenwriting magazines. And find out the level (and names) of the executives who will be attending to hear the pitches. If they're not top-level executives and established producers, you might want to pass on that one.

Here are some pitch fests to check out.

- Screenwriting Expo 3 (www.screenwritingexpo.com/pitchfest. html). Held once a year at the L.A. Convention Center and billed as the largest conference and trade show for screenwriters in the world, they also offer a wide selection of seminars and workshops.
- The Great American and The Great Canadian Pitch Fests (www.pitchfest.com)
- Ken Rotcop's Pitchmart (www.pitchmart.com)
- NATPE (The National Association of Television Program Executives) now offers a "Pitch Pit" at their yearly national conference (www.natpe.org).

Then there's the ability to **submit your project online.** There are several websites where you can post your logline and/or a short pitch. Here are a few of them.

- www.Moviebytes.com
- www.ScriptShark.com
- www.Inktip.com
- www.Hollywoodnet.com

If you regularly monitor these websites, you'll also find posted listings of producers and production entities looking for specific types of projects.

If your project is as good as you believe it is, then any company that agrees to read it or allows you to pitch it to them is giving you

a terrific opportunity. But keep this in mind—they're not just doing *you* a favor—you're doing *them* a favor as well, because you've got a great property they're going to want. So don't be timid, and get it out there!

Pitching Tips

- After creating a list of potential buyers, plan on pitching first to the company least likely to take your project. You'll benefit from the practice and any notes they might give you.
- Before going out to pitch, do some research on the buyers you'll be meeting. Be familiar with the type of projects their company has previously done or is developing and on what individual buyers have produced.
- Bring no more than one or two people to a pitch meeting.
- Be warm, friendly and professional. (It's okay to be a little nervous.)
- As in the general information meeting described in Chapter 10, start by acknowledging the person you're meeting with (good time to mention how much you enjoyed one of her past films), and then tell her a little about yourself. Next, instead of, "Let me tell you why I'm here . . . " (which is what you'd say in a general information meeting), you can say something like, "Let me tell you about this terrific project."
- The more excitement, emotion and passion you can generate, the better. Passion sells big time! I can't tell you how often I've heard stories of pitch meetings where afterward, the buyer had commented that the project was just so-so, but the seller's passion was what won him over.
- Be able to convey the key elements of and turning points in your story, such as the enormous obstacles your hero must overcome, the conflict, the irony, an outcome that defies all odds.
- It's always good to bring in a prop or two, photos, charts, etc. to support your pitch. It helps a lot!
- Take notes during pitch meetings, tweak your project and resubmit it if the door is left open to do so.
- Be open to buyers' suggestions for changes.

- Don't ramble or oversell.
- Don't bad-mouth other projects, writers or producers during your pitch.
- Don't interrupt when someone else is talking.
- If you don't know the answer to a question you're asked, don't fake it. Promise to get back to the buyer with an answer.
- If you're asked for further information pertaining to your project, plan on sending it in, e-mailing or delivering it in a timely manner (before the buyer loses interest).
- As in any other meeting, thank the person you're meeting for his time. And if this is a contact you'd like to develop further, send a hand-written thank you note.
- If you don't hear back from the individual(s) you pitched to, wait at least a week to follow up. You can follow up by phone or e-mail, but if you send an e-mail, make sure your subject line clearly indicates who you are and that you're following up on (the name of your project).

Taking This Route to Become a Producer

For those of you who want to be producers and don't want to start in a typical entry-level position, for those who have been in the business for a while and want to move into producing, and for those who have an alternate source of income to see yourself through until your first sale is made—this is a good way to go:

First and foremost, you need to have found and secured some *good* material. Next, you have to know the market: who the buyers are, what they're looking for, how to reach them, what's selling and what's doing well at the box office. You've got to have the ability to recognize what constitutes a good and commercial property, know as much about packaging as you can and how to pitch. And don't forget to network, network, network! Get to know as many development types, producers and writers as you can, and give them the opportunity to get to know you.

Next, come up with a name for your new production company. Research the name to make sure no one else has it, and file for a DBA (*doing business as*). All this can be done on the web (see

Chapter 8 under *Shameless Self-Promotion*); and at this point, you don't have to incorporate. For a more professional-looking address, think about renting a small mailbox on a major street. Also, make sure you have access to a capable entertainment attorney.

Once you have your DBA, have some high-quality business cards made with the name of your new company (and a logo designed if you can) and list yourself as "Producer" or "President" of the company. Now, make up some letterhead and envelopes with your company name and logo, and, while you're at it, some small note cards you can use for thank you notes.

Once you have product to sell, all your ducks are in a row, you have legal representation and some amount of credibility (because you're attached to a production entity now, albeit a new one)—you're ready to get out there and hustle.

Also consider this: several independent producers, knowing that agents and managers don't have enough hours in the day to shop everything their clients generate, will contact the agents and managers they have relationships with and offer to shop some of their projects around for them, which again, upon a sale, would make that producer part of the package. If you don't know any agents or managers, figure out who it is you'd like to meet, and set up some general information meetings. And of course, it's much easier to connect with an agent after you've gained some credibility by selling your first project.

Selling a script will get you a producer's fee. Selling a script that gets produced will earn you a larger fee and a screen credit. Learning how to truly produce a film, however—that takes experience. My advice: learn from others who have been doing it for a while, and if you're in a position to do any of the hiring, hire the most competent people you can find. Build a great team and learn from everyone around you. The stronger the team, the smoother your film will run and the more you'll shine.

The Odds

If you've been around this business for a while, you've walked into studio, production company or agency offices and witnessed the

stacks of scripts on top of desks, shelves, file cabinets and credenzas and piled up on the floor, sometimes waist high—lining entire walls and hallways. The Writers Guild of America registers over 40,000 pieces of material per year. And while they can't give us the exact percentage of screenplays, treatments, synopses and outlines that represent film- and television-related submissions, it's safe to say we're talking about tens of thousands each year. Those are the same tens of thousands mentioned earlier in Chapter 4 (in covering the function of a creative team) that studios and production companies (as well as agencies and management firms) collectively receive each year in the form of screenplays, treatments, books and pitches.

If you can get past that first hurdle, and an agent, manager, producer, production company or studio accepts your screenplay submission, whoever is assigned your project will generally only read the first 30 pages. If he likes what he's reading and it's holding his attention, he may continue. If he's not interested, he'll stop right there. Sometimes, it takes only the first ten pages for a script to end up in the discard pile. Furthermore, I've been told that it often takes reading 100 to 150 scripts until one is determined to be worth optioning or buying.

Once a property is optioned or purchased, there is no guarantee it will be produced. Talking before a Film Industry Network group recently, a development executive from one of the smaller studios reported that they buy approximately 10 scripts for every one project that gets made, and the other (larger) studios will buy up to 25 for every one made. The ones that don't get made get lost in what some refer to as "development hell." They get hung up on script changes, casting issues, landing the right director—or someone at the studio decides it's just not that commercial after all.

The last statistic I have to offer is one from the MPAA (Motion Picture Association of America), which reported that in the year 2003, a grand total of 473 films were released in the United States. You don't have to be a mathematician to understand that the odds of selling a project that gets made and released is minuscule compared to the many thousands that are shopped around each year. That's why your best ally in this quest is to understand the rules of

the game, know what the buyers want, have a fabulous project you're passionate about selling and be able to deliver one hell of a pitch.

It Only Takes One!

> *"Everyone told me to pass on* Speed *because it was a 'bus movie.'"*
> —Sandra Bullock

I'm sure you've heard stories about certain projects being "out there" for five or ten years before being made, and I've no doubt they're all true. If you're convinced you have a great project and it needs to be made, then don't give up. Don't take "no" for an answer. Sometimes the good ones end up getting buried on a dusty shelf somewhere just because the writer or producer gave up after the third or fifth pass. They didn't keep going. Every time someone passes on your project, it just means you haven't gotten it to the right person yet. It's just going to take *one* person (the right one) who's going to love your project as much as you do and be in a position to say "Yes—we'll buy that!" or "Yes—we'll be happy to finance your script!" Be patient and persistent, and keep pitching!

Teaching others how to effectively pitch is big business. Numerous books, audio tapes, courses and seminars are available on the topic. Research Samuel French Bookstore, Amazon.com, *Script* and *Creative Screenwriting* magazines and The Writers Store (all accessible on the web) along with a multitude of other resourceful websites.

— 15 —

Reel Production

While this chapter focuses solely on the physical side of production, the information it contains is useful for anyone in the industry (agents, managers, distributors, composers, attorneys, etc.). Because the more you understand about how a production office is set up and run and how a set functions, the more knowledgeable you'll be about the business in general and the more effective you'll be at dealing with the people who reside in production offices and on sets as they relate to you and your work. You'll also come to realize that at one time or another, most facets of the industry intersect with one another.

The Production Office

For those working on a specific film or TV show, this is where it all starts. Casts and crews and vehicles and equipment don't magically appear at a designated location site on a specific day at an exact time and start unloading, rigging, setting up, dressing, rehearsing, lighting and shooting unless a team of people seeing to every little detail makes it all possible. The "office" could be set up on a major studio lot, in a high-rise, in an old warehouse, a bungalow, a trailer, a

mobile home, a hotel room or out of someone's car; but it always serves the same purpose. It's the driving force behind any production. Its significance and contributions are rarely fully recognized, and there is little correlation between how hard you work and the ratings or box office success of a film. Let's face it. Who's going to watch a movie or TV show and think to themselves, "Wow! Great production coordination on this one!" or "Gee, whiz. I loved the accounting in this movie!"

Coming from years of having set up, run and supervised production offices, I've witnessed the overwhelming feeling many rookies have upon walking into one for the first time. This is not something film schools generally prepare their students for, so let me give you an overview of how they're set up and operate. If you'd like further information on this topic, I suggest you pick up a copy of my other book (if you don't already have it), *The Complete Film Production Handbook*. In it you'll find a much more detailed explanation of the production and accounting procedures that emanate from the production office (covering pre-production through wrap). Also included is a wide assortment of the most commonly used forms, checklists, releases, contracts and sample lists used to facilitate an entire production. If this is an area of the industry you're interested in, knowing what the paperwork looks like will be invaluable to you. The book also contains a great *Daily Office To Do List*, which will give you a better idea of what a day as an office PA looks like.

The production office is the heart of a production. It's the communications and operating center where, among other things . . .

- scheduling, budgeting and cost reporting take place.
- the crew is hired after their deals (salary plus extras that include guaranteed hours, screen credit, travel, housing, per diem, etc.) are negotiated.
- necessary services are lined up.
- deals are negotiated with vendors, and equipment, film and tape stock, vehicles, materials, supplies and catering are ordered.
- vital paperwork and information are generated and distributed.
- contracts, releases and agreements are processed.

- insurance coverage, completion bonds, clearances, license fees, location sites and permits are secured.
- cast perks are seen to and arrangements are made to get actors into Wardrobe and have them fitted for wigs and prosthetics.
- stunt work, aerial work and effects are planned.
- the look and colors of the film are decided and sets are designed.
- special requirements such as picture vehicles, animals, mock-ups, miniatures, boats, helicopters and models are purchased, rented, fabricated and/or rigged.
- travel and hotel accommodations are made for all show personnel working on distant location.
- shipping, customs and immigration matters pertaining to all foreign locations are handled.
- stages are secured, as are post production services and facilities.

. . . and where what seems like millions of details are managed, problems are solved and crew needs are met every day. (If you'll refer to Chapter 4 under *Production Management*, you'll find the delineation of responsibilities relating to the line producer, UPM, production supervisor and coordinator explained in more detail.)

Every show is set up a little differently. Sometimes an art department will choose to work at a different location to be closer to the set construction, the transportation department will work out of its own self-contained trailer, the wardrobe department will work out of a wardrobe house and the prop master will work out of a prop house. There are also shows where everything is set up at the same location. Generally, however, production offices house:

- at least one executive producer.
- at least one producer.
- the director.
- the production manager and/or production supervisor.
- the production coordinator.
- the accounting department–generally one to three (independently locking) offices, depending on the size of the accounting staff and the size of the offices.

- the location manager and one or two assistant location managers.
- two or three assistant directors and a couple of set PAs.
- the transportation department (coordinator, captain and a driver or two).
- the unit publicist (generally for two weeks before the start of principal photography).
- the art department (production designer, art director, set designer, set decorator, lead person, a set dresser or two, property master, assistant property master, art department coordinator and perhaps an art department PA).
- although not in the office all the time (and then only during prep) desks and phones are normally set up for both the stunt coordinator and director of photography (DP).
- a bullpen area for the assistant production coordinator, production secretary and at least two office PAs.
- an area for meetings.
- a kitchen or area that can be set up for craft service.
- a separate office or bullpen area for photocopying, faxing, assembling scripts, etc.

The line producer answers to the producer. The UPM and/or production supervisor answer to the line producer. The production coordinator answers to the UPM or supervisor. The assistant coordinator, production secretary and PAs work under the supervision of the production coordinator. The art director, set designer, set decorator, property master and art department coordinator report to the production designer. The entire accounting department works under the supervision of the production accountant. The location manager works closely with the director, production designer, producer and line producer. The first assistant director is chosen by the director and works closely with the director, line producer and UPM. The second assistant director is chosen by and reports to the first assistant director. And it's the production coordinator who is primarily responsible for setting up and running the office.

Each office has a central information center (which is generally the reception area or a portion of a bullpen area manned by the

APOC, production secretary and/or PAs), where departmental envelopes are hung; messages are posted; out-baskets are labeled and set out for *Outgoing Mail, Overnight Delivery Packages, To The Set,* and *To The Studio* (or parent company); deadlines for outgoing mail and overnight packages are posted; extra copies of crew lists, contact lists, the latest script changes, schedules, day-out-of-days, maps, request for pickup and delivery slips, etc. are stacked (or placed in hanging envelopes); start paperwork, time cards, I-9s and other payroll and accounting forms are available; a menu book and an office supply catalog are available to look through; local phone books and maps are kept; extra office supplies, mailing supplies and interoffice envelopes are stored; and waybills, fax cover sheets and other commonly used forms are available.

Because work days are so long (ranging from 10 to 15 hours a day, sometimes longer), it's not uncommon for a production office staff to work in staggered shifts. It makes the hours a bit less brutal for some of the staff, and the office is covered at first call or at the start of the business day (whichever is first) through wrap or the close of the business day (whichever is last). Even when the crew call is not early in the morning, someone is available to set up the office for the coming day, be available to deal with vendors and accessible to prepping and rigging crew members who start early. And when shooting nights, many productions require coverage in the office through wrap.

For people who work all hours of the day and night, have little or no time to shop or cook and who these days are more health-conscious than ever, most production offices have a better stocked kitchen than you might have at home. The kitchen (or "craft service") area is commonly stocked with an assortment of food, juices, snacks, fruit, etc., as well as a variety of headache remedies, antacids, cold medicine, vitamins and protein bars.

Accounting is a big part of any production office. This department is headed by the production accountant, who is essentially the guardian of the production's purse strings. The department as a whole is responsible for opening vendor accounts; processing check requests and purchase orders; paying the production's bills (accounts payable); processing payroll; dispersing petty cash;

making sure studio or production company accounting procedures are being adhered to and that all State, Federal, union and contractual obligations are being met as they come due. They also play a major role in preparing insurance claims.

On their first day on a new show, crew members are given a packet of paperwork. This packet may include some or all of the following: a payroll start/close slip, a U.S. Immigration I-9 Form, a box rental inventory form, a blank deal memo form to be completed and approved by the UPM (the deal memo may also come from the production supervisor or coordinator), a set of safety procedures, a crew information sheet and a memo outlining the production's accounting policies. This memo will generally cover procedures pertaining to payroll (paychecks are issued on the fourth work day of the following week, usually Thursday), box rental, vendor accounts, competitive bids, purchase orders, check requests, petty cash, production-owned assets, automobile allowances and mileage reimbursement.

During pre-production, while based out of the production office, members of the production team are scattered—scouting locations, having meetings, reading actors, working on script changes, supervising the building of sets, working on the schedule or budget, etc. This is a time when good communications are essential and when everyone needs to be aware of everything else going on around them. Once pre-production is over and principal photography begins, the director, assistant directors, DP and stunt coordinator work exclusively from the set. Members of the transportation, art, prop and location departments are in and out of the office, as is the producer, line producer, UPM and unit publicist. It's a bit less crowded and noisy once shooting begins, but nonetheless busy.

Prep doesn't stop when filming begins. As long as there is shooting to be done (and changes that occur), there are preparations to be made (and remade). Once principal photography begins, the goal of the UPM, assistant directors, production coordinator and the rest of the production staff is to keep one step ahead of everyone else by making sure sets are ready on time; special elements (e.g., equipment, prosthetics, picture cars, animals, etc.) are there

when needed; filming progresses as smoothly as possible; unexpected problems are resolved quickly; the director and DP are getting the footage they envisioned; the studio is happy and being kept well-informed; the set remains harmonious and the show is running as scheduled and as budgeted.

Also during the shooting period, an assortment of paperwork is sent in from the set each night (waiting for the office staff when they arrive each morning). It's copied, filed, acted upon and/or distributed as needed. The weather is closely monitored and cover sets are planned. A call is made to the lab each morning to make sure there are no problems with film sent in for processing the night before, and dailies are scheduled. Runs are coordinated between the set and the office throughout the day, and cars and drivers are arranged for actors whose deals include being picked up and driven home from the set. New equipment is continually being ordered, and equipment no longer needed is returned. There is constant communication with vendors, new purchase orders are generated and pickups and deliveries are scheduled. If on a distant or foreign location, on a road show that is constantly on the move, or if more than one unit is operating at one time from different locations, there is a continuum of travel and hotel arrangements to be made, new crew members starting and others wrapping, new locations to set up and others to strike, a voluminous amount of shipping to coordinate and travel movements to keep. Quantities of film or tape stock, office supplies, materials, expendables, etc. are constantly being monitored, inventoried and reordered as needed. Script and/or schedule changes are continually being generated and distributed. New cast members are starting all the time, necessitating new contracts and deal memos, wardrobe fittings, additions to the cast list, travel plans (if necessary), etc. Call sheets are delivered, faxed or e-mailed in from the set toward the end of each shooting day and photocopied. Maps and safety bulletins are attached, and "sides" are prepared for the next day's shoot and sent back to the set with the call sheets. And in between a steady flow of problem solving and budget balancing, UPMs and production supervisors make their way through stacks of POs, check requests, invoices and time cards in need of approval. All in all, the

production office represents a fine-tuned operation that keeps the production running smoothly and continuously advancing toward completion. While what goes on behind the scenes is rarely heard about, it's a facet of the filmmaking process that should never be underestimated.

A Reel Set

Walking onto a real set on a real movie or TV show is very different than the set of a student film. First of all, your crew is much larger. And second, there are unwritten protocols and rules of behavior that you wouldn't necessarily know unless someone were to tell you or you happened to learn them the hard way.

Deciding what to shoot each day starts with what's reflected in the shooting schedule. Adjustments are made to accommodate changing weather conditions, availabilities of certain locations or pieces of special equipment or the possibility that the show is running behind or ahead of schedule. Once the first assistant director, director and line producer agree with what's to constitute a day's work, it's reflected onto a call sheet and distributed the evening before.

Actors and stunt performers are given work calls to accommodate the time it takes them to get through wardrobe, hair, makeup and prosthetics, and crew members are likewise given call times to accommodate the amount of prep time they need. More time is always needed when shooting in a new location. Less set-up time is required when returning to a long-standing set on a sound stage or other interior location. When shooting on a distant location, drive time to and from the set is also factored in to the work day.

Each day is different. Sometimes a succession of scenes is completed, sometimes just portions of one scene. Much will depend on what type of show it is, the schedule and budget and how complicated any particular scene is. A one-page scene of two people sitting at a table talking is going to take a lot less time to shoot than a one-page scene full of car crashes, stunts and explosions. One complicated scene (such as one on a battlefield) could take several days to accomplish (as well as multiple cameras and second units).

Much will also depend on the amount of coverage any one scene is given. Low-budget films and TV shows with inflexible schedules and budgets don't have as much latitude when it comes to creative lighting and camera moves.

Let's just say you have a scene in which several people are sitting around a table talking and having dinner. Coverage would normally begin with a master shot, often achieved with a wide-angle lens to encompass everyone who's in the scene. Subsequent coverage might include two-shots, close-ups, over-the-shoulder shots and high- or low-angle shots. If the table is outside on a rooftop, the director might want an aerial shot (captured via helicopter). The more coverage the director is able to get, the more footage the editor has to work with. Every time the camera is moved, however, another set up is created, and lights, equipment and sometimes flats (walls) must be moved to accommodate the shot. If the entire scene is played out in the master, then each subsequent set up represents a portion of that scene, sometimes requiring many takes until the director is ready to move on. Multiple set ups and takes equate to a lot of waiting around, and those new to working on a set are always surprised at how slowly things move (especially on features).

The same basic sequence of events occurs over and over again throughout the day. They are:

1. Rehearse: The director works with the actors as they go over their lines and get a sense of the scene.
2. Block: Decisions are made as to where the actors will be standing, how the scene will be lit and where the camera(s) will be placed. Once finalized, the principal actors are dismissed (to deal with wardrobe, hair, makeup, prosthetic fittings, etc., or to just relax and go over their lines in their dressing rooms). At this point, the stand-ins are brought in for the purpose of lighting.
3. Light: The DP and gaffer are now in charge of lighting the set as per the director's wishes.
4. Shoot: Once the set is lit, the stand-ins are dismissed and the principal actors are brought back in to shoot. (It is the second

assistant director's responsibility to make sure the actors are ready once the set is ready for them.)

If you're going to be working as a set PA, here are some things you should know.

- Wear comfortable (and quiet) shoes.
- Have extra clothing in your car and backpack to cover changes in weather (extra sweatshirt, T-shirt, socks, gloves, boots, hat, warm jacket, rain gear); also sunglasses, sunscreen and a bandanna.
- Consider getting yourself a walkie-talkie belt (which can usually be found at an Army-Navy surplus store or a sporting goods store) or a waist pack to accommodate a walkie-talkie, cell phone and pager. It'll make it a lot easier for you to lug that stuff around all day.
- Keep a three-ring binder with the schedule, day-out-of-days, crew list, pager/cell phone list, contact list and the script (with all the latest script revisions). Most ADs and set PAs also carry legal-size metal clipboards with a hinge on the left side. They refer to it as "my tin." The outside is flat and great for writing notes. The inside is used to store call sheets, production reports and a few basic supplies. They can be purchased at specialty stationery stores or online.
- Your basic set supplies, or "kit," should contain pens, pencils, white-out (the roll-on type is the best), a small flashlight, note paper or a mini notebook and reduced versions of the crew list, one-liner, cast list, cell phone/pager list, contact list, etc. They won't all fit inside your clipboard, but you might get them into a fanny pack or work belt; and they should be carried around with you at all times.
- As a PA or trainee, you'll report to the 2nd AD.
- Read the back of a call sheet, learn crew job titles and how many of each are going to be on the set
- Learn basic crew terminology: what is a DP (and who is he/she)? What is a gaffer? A best boy? If you're told to get a grip, he's probably the guy with the hammer sticking out of his back

pocket; the electrician is probably the guy with a pair of gloves sticking out of his back pocket and clothespins on his sleeves, etc.

- Learn the names of the cast and crew as quickly as possible.
- Learn where each department is located (wardrobe, makeup, camera, etc.) so you can find people quickly.
- Know the phone number for the stage or location.
- Learn the paperwork as soon as possible.
- Start familiarizing yourself with union and guild guidelines.
- Learn military time (or keep a chart with you for easy reference).
- When you're asked to do something, do it quickly and report back that it's done. Don't make your supervisor have to come find you and ask if it's done.
- Always give the impression that whatever you've been asked to do is going to get done quickly. If for some reason you can't accommodate a request, let your supervisor know immediately, so other arrangements can be made. (There is always a sense of urgency on a set, and delays are costly!)
- Show deference to strangers on the set, as you never know who they are.
- Have a sense of when to be quiet, even when quiet hasn't specifically been called for. If in doubt, be quiet.
- If you see something that might be hazardous, mention it to your supervisor.
- If you see someone smoking, ask them to please stop, and if they don't, advise your supervisor.
- Never introduce yourself to a director or an actor because you're a big fan and/or to ask for an autograph. You'll meet them soon enough in the course of your job; don't bother them unnecessarily.
- Stay out of the director's and actors' line of vision. Stay *behind* the camera.
- Never take still photos on a set unless you get prior permission from the Director of Photography.
- Never sit down (except at lunch or to do paperwork).
- Be the last to take lunch—after the actors and entire crew.
- Keep your conversations on the walkie/talkie short and to the point (or go to another walkie channel).

- If you have nothing to do and have permission from your supervisor, help the crew out whenever possible. (Again, never stand around with nothing to do.)

Getting Into the DGA

If you think you might like to pursue a career as a DGA assistant director, there are a few different ways to get into the guild. While not the easiest to qualify for, the best route is via one of the official training programs.

- Headquartered on the West Coast is the Directors Guild—Producer Training Plan (Assistant Directors Training Program), which was established in 1965 by the Directors Guild of America and the Alliance of Motion Picture and Television Producers. To qualify for this program, you must first apply to take the yearly test. Applications are submitted by November 5th, and the test is given in late January. To qualify to take the test, you must be at least 21 years of age, have employment eligibility to work in the United States, a high school diploma and at least one of the following: (1) a Bachelor's or Associate's degree from an accredited college or university, (2) certification that you are a currently enrolled student who will complete your coursework and graduate with a Bachelor's or Associate's degree no later than June 24th, (3) written proof that you attained at least the level of E-5 in a branch of the U.S. military service, or (4) two years (520 actual work days) of full-time paid employment in film or TV (or its part-time equivalent). You may also use a combination of college credits and work experience to meet the eligibility requirements.

 The test is offered in Los Angeles and Chicago and eligible applicants must pay a nonrefundable testing fee of approximately $75. One to two thousand individuals take the test each year. Of those, half generally do well enough to move on to what's called the "assessment center," where group interviews are held. Half of those who make it through the group interviews are asked to come in for individual interviews. Of those, 15 to 20 individuals are chosen to become part of the 400-day program that includes

on-the-job training and a series of curriculum-based seminars. To find out more about the program or to download a test application, go online to www.trainingplan.org. The number of the DGPTP is 818/386-2545.

- The two-year New York Assistant Directors Training Program accepts, on average, 250 to 300 applicants each year, and five to seven are accepted into the program. Applicants must be U.S. citizens or permanent residents. A four-year degree and some industry experience are recommended but not essential. The written part of the test is offered in late February. Preliminary interviews are held in April, and final interviews are held in May. For more information on New York's program, call their office at 212/397-0930 or check it out on the web at www.dgatraining program.org/geninfr.htm.

- You are allowed to work *third area* on a union show until you've accumulated 120 work days. Once your days (and all required substantiation) has been accumulated, you can apply to be placed on the Third Area Qualification List, which is administered by DGA Contract Administration (DGACA). The DGACA will inform you if everything is in order, and a copy of that letter along with your application package will be passed on to the DGA. The Guild then has 30 days in which to agree or object to your application. If they have no objection, you are then placed on the Qualification List, and it's up to you whether to join the DGA.

 Third area is considered anywhere *outside* of the Southern California area which extends from San Luis Obispo to the U.S.-Mexican border *and* the New York triborough area. For a second assistant director, first assistant director, unit production manager or associate director/technical coordinator, 75% of 120 required days must be spent with the actual shooting company and no more than 25% may be spent in prep or office work. For directors, 78 of the 120 days shall have been in directing the actual shooting of film or tape. Likewise, stage managers or associate directors in the live and tape television industry employed 120 days *or* six years in the nationwide feed of television motion pictures are also eligible to be placed on the Qualification List. For

further information on applying for the Third Area Qualification List, check out the DGACA website at www.dgaca.org.

- On the West Coast, to be placed on the Basic Qualification List, you would have to work on non-union shows for a total of 400 days as a 2^{nd} AD, 1^{st} AD, UPM, technical coordinator or associate director/technical coordinator. The Basic List is also administered by the DGACA. For ADs and UPMs, no more than 25% of those days may be spent in prep and 75% must be spent with the actual shooting company. For directors, at least 260 days shall have been in directing the actual shooting of film or tape. Stage managers or associate directors in the live and taped television industry must be employed 400 days *or* six years in the nationwide feed of television motion pictures.

- The New York-based DGA Commercials Contract Administration administers the Commercials Qualifications List, which covers the New York and Southern California areas as well as third area. Check out their website (www.dga-cql.org) for specific requirements for placement on the Commercials Qualifications List as a 2^{nd} AD. Any individual who has been placed as a Commercial 2^{nd} AD is eligible for "interchange" to the New York Basic List in the same category. To be eligible to "interchange" to the Southern California Basic List as a 2^{nd} AD, you will need to upgrade to a Commercial 1^{st} AD. This requires documentation of having worked at least 150 freelance days as a 2^{nd} AD, with no fewer than 75 days of work on commercial productions.

- If you are working as an AD or UPM on a non-union film that becomes a signatory during the course of the production or are hired early on before a new production entity signs a DGA contract, you may work on the show as an "incumbent." Should you become an incumbent, you will be in a position to join the DGA, but you'll also find yourself in kind of a Catch-22. Once this show has wrapped, you cannot work on other DGA shows until you've fulfilled all your days, nor can you go back to working non-union shows to get your days. If you don't have your days by the end of that first show, you have to get the remainder by working other shows for that particular company, working third area or by being an incumbent for other companies.

When it comes to actual DGA membership, initiation fees, dues, etc. are handled directly through the Guild. Be sure to check out their website for further membership information. It's www.dga.org.

The Production Team

I know this gets confusing, but the production team (as opposed to the studio's creative team whose members are given production titles) refers to "physical" production and those who physically prepare for and supervise the shoot of any given project. The Producers Guild of America defines the producing team as those responsible for the art, craft and science of production in the entertainment industry.

Physical production encompasses the positions most newcomers are aware of, but at the same time, they're not always sure who does what. Even people who have been in the business for a while are sometimes unclear as to exactly who performs which functions on any given show. While some duties can only be performed by individuals who occupy specific positions and others can be accomplished by a number of different people, depending on the parameters of the project, there is no doubt that production requires team effort.

From where I sit, there is a core group that comprises the production team, and they are, the:

- Producers
- Director
- Line Producer
- Unit Production Manager
- Production Supervisor
- First Assistant Director
- Second Assistant Director
- Production Accountant
- Production Coordinator

Think of casting directors, location managers, post production coordinators and the studio and network executives assigned to your show as auxiliary team members.

Unfortunately, it doesn't always happen this way; but the ideal is a team that works well together and where members understand and support each other's boundaries and goals. In other words, should you find yourself with a producer and director (or any other members of the team) who don't see eye to eye and can't find enough common ground to get along—you're cooked! An adversarial relationship from within this group becomes a problem for everyone. On the other hand, efforts made to collaborate on shared common objectives, enhanced by a mutual respect for one another, will inspire the cooperation and loyalty of the cast and crew, will be helpful in promoting a pleasant working environment and will favorably influence your schedule and budget. Once you have a viable script and either a studio deal or outside financing in place, this is the group of people who will take these elements and make them into a movie. The mood and temperament of the production team is going to permeate the entire project and affect everything and everyone involved. It therefore behooves you to put together the very best team you can.

Based on the six phases of any film–*development, pre-production, production, post production, distribution and exhibition*–some members are involved in more than two phases, but everyone on the team is involved in both pre-production and production. These phases represent the putting together and coming together of all elements necessary to shoot a show.

The job responsibilities attributed to members of the production team will vary depending on whether the film is being made for television, cable, theatrical or Internet release; and on the project's budget, schedule, union status and location. The following is a chart that illustrates job functions (that range from acquiring the rights to a story or script through the submission of delivery elements) and indicates which position or positions generally fulfill those responsibilities. For a more in-depth interpretation of how a production team functions, primarily from the perspective of the production manager and first assistant director, I recommend a book entitled *The Film Director's Team* by Alain Silver & Elizabeth Ward (Silman-James Press).

PRODUCTION TEAM JOB RESPONSIBILITIES

Note: The position of PRODUCER represents a combination of producing positions. Other positions are also combined as their duties overlap and vary from show to show.

	STUDIO	PRODUCER(S)	DIRECTOR	CASTING DIRECTOR	LINE PRODUCER/ PRODUCTION MANAGER	PRODUCTION SUPERVISOR/ COORDINATOR	1ST ASST. DIRECTOR	2ND ASST. DIRECTOR	PRODUCTION ACCOUNTANT	LOCATION MANAGER	POST PROD. COORDINATOR
Acquire rights to story/script	X	X									
Select & hire writer/have script written	X	X									
Select & hire the Director	X	X									
Select & hire the Line Producer/UPM	X	X									
Prepare preliminary budget & schedule	X	X			X						
"Pitch" the story & sell the script		X									
Make the studio deal and/or arrange financing & distribution		X									
Open bank account(s)									X		
Signatory to bank account(s)	X	X			X				X		
Arrange for completion bond and union/guild bonds as necessary		X			X						
Arrange for the legal structure of the production entity	X	X									
Prepare a more realistic board, schedule & budget					X						
Prepare a cash flow chart									X		
Sign all union agreements and contracts		X									
Select & hire a production designer	X	X	X								

Job Responsibilities - Pg. 2	STUDIO	PRODUCER(S)	DIRECTOR	CASTING DIRECTOR	LINE PRODUCER/ PRODUCTION MANAGER	PRODUCTION SUPERVISOR/ COORDINATOR	1ST ASST. DIRECTOR	2ND ASST. DIRECTOR	PRODUCTION ACCOUNTANT	LOCATION MANAGER	POST PROD. COORDINATOR
Submit script to research company		X			X	X					
Secure all necessary clearances & releases		X			X	X					
Secure insurance coverage	X				X						
Set-up vendor accounts									X		
Approve invoices, check requests, purchase orders & time cards					X	X					
Select visual effects company & coordinator	X	X			X						
Get bids on equipment					X	X					
Check crew availabilities					X	X					
Request specific crew members	X	X	X		X						
Select 1st Asst. Director & Script Supervisor			X								
Negotiate crew deals					X						
Prepare crew deal memos					X	X					
Issue memo re: accounting procedures to department heads									X		
Investigate potential product placement deals		X			X						
Liaison with unions & guilds		X			X	X					
Apply for permit to employ minors (if applicable)				X	X	X					
Issue pre-production schedule					X	X	X				

Job Responsibilities - Pg. 3	STUDIO	PRODUCER(S)	DIRECTOR	CASTING DIRECTOR	LINE PRODUCER/ PRODUCTION MANAGER	PRODUCTION SUPERVISOR/ COORDINATOR	1ST ASST. DIRECTOR	2ND ASST. DIRECTOR	PRODUCTION ACCOUNTANT	LOCATION MANAGER	POST PROD. COORDINATOR
Cast film	X	X	X	X							
Prepare cast deal memos				X							
Station 12 cast members				X		X					
Select locations	X	X	X		X					X	
Secure locations		X			X					X	
Arrange for film permits, location parking & neighborhood approvals (if necessary)										X	
Work with the production designer in establishing the look of the film	X	X	X								
Approve wardrobe, sets & special props		X	X								
Make sure necessary script re-writes are made in a timely manner		X									
Set-up & run the production office						X					
Hire assistant production coordinator & production assistants						X					
Prepare & submit Taft/Hartley reports				X		X					
Sign-off on a final budget	X	X	X		X				X		
Create final board & schedule					X		X				
Create one-liner & day-out-of-days							X				
Negotiate equipment deals					X						

Job Responsibilities - Pg. 4	STUDIO	PRODUCER(S)	DIRECTOR	CASTING DIRECTOR	LINE PRODUCER/ PRODUCTION MANAGER	PRODUCTION SUPERVISOR/ COORDINATOR	1ST ASST. DIRECTOR	2ND ASST. DIRECTOR	PRODUCTION ACCOUNTANT	LOCATION MANAGER	POST PROD. COORDINATOR
Order film & equipment					X	X					
Create & distribute crew list, cast list, contact list, etc.						X					
Issue purchase orders						X			X		
Handle time cards & payroll									X		
Line-up special requirements such as animals, blue/green screens, backdrops, mock-ups, miniatures, etc.					X	X		X			
Prepare a breakdown of extras, stunts, vehicles, effects & multi-camera days							X	X			
Disseminate scripts & all essential paperwork & information						X		X			
Work with film commissions & local authorities		X			X	X					
Arrange for location travel & hotel accommodations					X	X					
Handle shipping & customs (when necessary)						X					
Prepare welcome packages						X					
Arrange for cast physicals & performers' special needs						X		X			
Procure cast head shots for stunt & photo doubles						X		X			

Job Responsibilities - Pg. 5	STUDIO	PRODUCER(S)	DIRECTOR	CASTING DIRECTOR	LINE PRODUCER/ PRODUCTION MANAGER	PRODUCTION SUPERVISOR/ COORDINATOR	1ST ASST. DIRECTOR	2ND ASST. DIRECTOR	PRODUCTION ACCOUNTANT	LOCATION MANAGER	POST PROD. COORDINATOR
Inform Wardrobe of cast info. (including sizes)						X					
Officiate at production meetings					X		X				
Arrange rehearsals & still photo sessions		X				X	X	X			
Set-up editing rooms											X
Line-up lab, sound house & dubbing facilities					X						X
Submit copies of production reports to SAG on a weekly basis						X					
Set-up accounts for sound transfers, video transfers, etc.									X		X
Issue certificates of insurance						X					
Complete & submit Workers Compensation claim forms						X					
Oversee day-to-day production	X	X			X	X	X				
Responsible for keeping the production running smoothly		X			X						
Enforce safety guidelines & hold safety meetings					X		X				
Constantly monitor budget & schedule	X	X			X				X		
Continually balance the artistic integrity of the film while maintaining the budget & schedule		X			X						
Liaison between the crew & the director							X				
Liaison between the UPM & the director							X				

Job Responsibilities - Pg. 6	STUDIO	PRODUCER(S)	DIRECTOR	CASTING DIRECTOR	LINE PRODUCER/ PRODUCTION MANAGER	PRODUCTION SUPERVISOR/ COORDINATOR	1ST ASST. DIRECTOR	2ND ASST. DIRECTOR	PRODUCTION ACCOUNTANT	LOCATION MANAGER	POST PROD. COORDINATOR
Assist the director w/production details, coordinate & supervise cast & crew activities and facilitate an organized flow of activity on the set							X				
Issue work calls				X				X			
Prepare maps to location(s)										X	
Order stand-ins & extras								X			
Prepare call sheets & production reports								X			
Sign-off on call sheets & production reports					X		X				
Coordinate the delivery of film to the lab & the screening of dailies						X					X
Handle insurance claims					X	X			X		
Prepare & issue weekly cost reports									X		
Check and/or distribute weather reports						X		X			
Call for "QUIET ON THE SET!"							X				
Prepare daily schedules for talent & determine cast & crew calls							X				

Job Responsibilities - Pg. 7	STUDIO	PRODUCER(S)	DIRECTOR	CASTING DIRECTOR	LINE PRODUCER/ PRODUCTION MANAGER	PRODUCTION SUPERVISOR/ COORDINATOR	1ST ASST. DIRECTOR	2ND ASST. DIRECTOR	PRODUCTION ACCOUNTANT	LOCATION MANAGER	POST PROD. COORDINATOR
Make sure minor cast members secure necessary work permits						X		X			
Secure extra releases & SAG contracts signed on the set								X			
Set-up on-site school room & procure teachers and baby nurses (when necessary)						X		X			
Secure police & fire officers, security & emergency medical vehicles (when necessary)					X			X		X	
Direct background action & supervise crowd control							X	X			
Liaison with actors on the set							X	X			
Liaison between the production office & the set								X			
Distribute walkie-talkies on the set								X			
Liaison with the caterer						X		X			
Distribute paperwork sent in from the set each night						X					
Supervise daily wrap								X			
Supervise the work of DGA trainees & set production assistants								X			
Supervise wrap at the end of principal photography					X	X					
Contact vendors to make sure all rentals have been returned					X	X					

Job Responsibilities - Pg. 8	STUDIO	PRODUCER(S)	DIRECTOR	CASTING DIRECTOR	LINE PRODUCER/ PRODUCTION MANAGER	PRODUCTION SUPERVISOR/ COORDINATOR	1ST ASST. DIRECTOR	2ND ASST. DIRECTOR	PRODUCTION ACCOUNTANT	LOCATION MANAGER	POST PROD. COORDINATOR
Compile list of remaining inventory purchased for show & decide whether to sell or store	X				X	X			X		
Collect remaining invoices for last week's rentals & any L&D (lost & damaged) ltmes						X			X		
Inform vendors of forwarding address & phone number									X		
Arrange for wrap party and cast & crew gifts		X			X	X					
Submit final union/guild reports						X			X		
Issue post production schedule											X
Oversee post production activities											X
Compile list of screen credits	X	X			X	X					X
Turn-over files, inventory of company assets, log of insurance claims & notes re: pending issues					X	X					
Close-down production office						X					
Turn-over delivery elements		X									X

— 16 —

You're Not in Film School Anymore, Toto

> *"There are certain shades of limelight that can wreck a girl's complexion."*—Audrey Hepburn

Don't Count Those Chickens Just Yet

> *"There is no point at which you can say, 'Well, I'm successful now. I might as well take a nap.'"* —Carrie Fisher

I'm sure you've heard the expression, "Don't count your chickens until they've hatched." Well, that's never been more true than as it relates to this industry, because:

- Having an agent doesn't mean the agent will line up work for you.
- Having the most wonderful project in the world doesn't mean it will ever sell.
- Getting a part in a movie doesn't mean you won't end up on the cutting room floor.
- Having a producer, actor, studio or company like your screenplay doesn't mean they'll buy it.
- Having a company or studio option your project doesn't mean it will get made.

- Knowing you're perfect for a job or a role doesn't mean you'll get it.
- Having a fabulous meeting or interview, and/or being called back for a second or third meeting, doesn't necessarily mean you'll get the job, sell the script or land the show.
- Having a gorgeous face, gobs of personality and talent to boot doesn't mean you'll be discovered.
- Finding investors doesn't mean they'll be able to come up with enough money or that they won't back out.
- Just because you have a steady job today, doesn't mean it will last forever or that the company you're working for won't fold or your boss won't be let go (meaning you might be, too).
- Just because you become successful doesn't mean you will remain successful.

I realize how negative this sounds, but you have to be aware that these things can and do sometimes happen. Without losing your optimism, your passion or your dreams, just be careful! I've fallen into this trap myself, even though I know better, because when you come so close to landing a great job, a role, a deal, an opportunity, and you want it sooooo badly you can't think of anything else, it's only natural to get excited. Who wouldn't be thrilled when a producer says he loves your project, or when you have a great interview, or when you're up for a big film or when someone promises to help you? But try not to get *too* excited until whatever it is, is 100% firm—and don't spend the money until it's in your hands (or safely in the bank), because, unfortunately:

- The competition is enormous. It's simply a case of too many applicants and too few jobs to go around.
- Deals fall through every day (even ones that look like "sure things").
- Good screenplays can take years to sell, if they sell at all.
- Production companies occasionally go under and/or are taken over by new management.
- Studio and network regimes come and go.
- A picture or two that doesn't do well can rapidly knock a producer, director, actor or writer off the "A" list.
- The most competent and talented people aren't always the ones who get hired.

- Picture commitments made by a studio can evaporate if there's a regime change before the picture can get a greenlight, and the new regime wants to choose its own slate of releases.
- You can't always count on the people you think you can count on.
- What's "in" today might very well be passé tomorrow.
- Decisions are made by people who don't have crystal balls and can only give it their best guess.
- Promises are often broken, and loyalties can be precarious.
- Nepotism and extreme politics do exist.

So, don't count those chickens quite yet, and understand:

- A deal isn't a deal until you receive a contract and your attorney says it's okay to sign on the dotted line.
- A job isn't a job until you receive a deal memo and that first paycheck.
- Your film isn't going to see the light of day until it's been shot, gone through post and has a distributor.
- An understanding with or promise from another doesn't mean anything unless it's backed up in writing, and even then . . .
- Fame cannot be sustained by one or two successes alone.

Be practical and be careful whom you trust, but don't give up your dreams and don't ever stop trying, because deals do get made, great jobs do come through, screenplays do get sold, other people do come through for you, movies do get made and dreams do come true.

It's Crowded at the Top

> *"Hollywood is a place where a man can get stabbed in the back while climbing a ladder."*—William Faulkner

The climb to the top of the proverbial ladder is different for everyone. Some make it faster than others, and many never make it at all.

Having connections definitely helps; so does a savvy understanding of how the game is played, an I'll-do-whatever-it-takes attitude and a lot of hard work. And sometimes the ability to climb that last rung is merely a result of being in the right place at the right time. There are no set rules that guarantee if you do *this*, you'll achieve *that*. It doesn't work that way.

Think of the ladder shaped like a pyramid. There's a lot more room at the bottom for those just starting out, and it gets narrower as you make your way up, to where the very top portion narrows to a tiny peak—an icy and slippery one at that. So as you can imagine, there's not much room up there, and there's a lot of pushing and shoving and vying for position going on from all those who haven't made it yet. Some drop off along the way (and get out of the business completely) and others choose to settle into other rewarding, albeit less prestigious, positions and give up the climb. Then there's the area reserved for the industry elite such as Steven Spielberg, Tom Hanks, Ron Howard, David Geffen, Tom Cruise, George Lucas, Oprah Winfrey and other A-list power players who are so permanently embedded, they're like the presidents on Mount Rushmore. But their solid presence on the summit leaves even less room for everyone else. It's tough making it up there, and sometimes even tougher being able to stay. Because it's so slippery, weather conditions are constantly changing and there's so much pushing and shoving going on from the lower rungs—it's not uncommon to slide off or get pushed.

There's a tremendous amount of pressure for those who have had some amount of success to hold on to their positions, because circumstances change every day. A film or two that does poorly at the box office can turn a successful producer, director or actor's career in the opposite direction. I know many people who had extremely successful careers producing high-quality movies for television (also called MOWs, or Movies of the Week), but in the past few years, MOWs have become a dying breed. I've also known prosperous individuals whose entire careers have been tied to one producer, one director or one company; and when something happens to sever those ties, the person is left at loose ends. Trends come and go, administrations change, long-running TV series get

canceled, contracts expire, conglomerate mergers create downsizing and age discrimination does exist. Needless to say, "making it," for most of us, is a relative term.

So what happens to those who fall from power? Many brush themselves off and get right back onto the ladder. Some accept lesser positions or move to other aspects of the business. Some give up the industry and take non-industry jobs or start their own businesses. Some move to smaller communities where the cost of living is more reasonable and many of them start or buy businesses. I've known people who start writing or teaching, and many try their hand at independent producing. And there are always those who end up having to sell their homes, cars and toys, because they didn't count on this ever happening to them, and then they waste a lot of time being resentful, blaming others and waiting for the phone to ring. Falling from upon high is only as devastating as you make it, and the best thing you can do is merely get on with your life.

The Land of Big Egos and Bad Tempers

"Ambition is a dream with a V8 engine."—Elvis Presley

I was sitting in my eye doctor's waiting room one day last year and happened to pick up a copy of a *Readers Digest* that was sitting next to me on the table. It was the December 2003 issue and in it was a piece on Julia Roberts. I started reading and then took out a piece of paper and a pen, so I could write this down: in discussing the issue of where she and her husband were living, Miss Roberts said she didn't like living in California because of "the narcissistic, egomaniacal, judgmental, mean-spirited sense of show business." Wow! What an indictment. The sad fact is that Julia Roberts is not alone in feeling this way nor is she totally wrong in her assessment. If you'll remember in an earlier chapter called *The Good, the Bad and the Ugly*, of those I interviewed, several stated that in this business, you'll meet the very best people you'll ever know and also the very worst. Unfortunately, it's the latter who give our industry its bad

reputation and inspire people to make movies like *Swimming With Sharks*.

Work in this business long enough, and you're bound to come across individuals who are any combination of insensitive, nasty, phony, abusive, demeaning, self-serving, intimidating, overly competitive and game playing. I've never known another business where bad behavior is so tolerated and one that's so synonymous with walking into a lion's den. I've seen executives rip phones out of the wall and hurl them across the room, performers act like the brattiest children you could imagine, people who think it's okay to treat other people badly, berating and humiliating them in front of others, and individuals who are thoroughly convinced the entire world revolves around them and their needs.

When up against this, you have four choices: do nothing, quit, change your behavior or change your attitude. Doing nothing isn't your best option, because it could often lead to hurt feelings, stomach aches, frustration, a lack of confidence and anxiety. Quitting is okay, if you've exhausted all other options. As long as you don't make a habit of it, most new employers are fairly understanding (especially when your previous employer has a reputation for being abusive). I worked on a show once where the executive producer was so nasty, after two days I told the other producers I was leaving. I had wanted to do that on a couple of other shows, but never felt I could. Instead, I'd go home miserable every night. This time, I didn't let it get that far. I just politely bowed out. It felt great! Quite a long time ago I was on a film on distant location and was having some trouble with someone on the crew. An older and much wiser production coordinator was doing a show in the same town and staying at the same hotel, and he sat me down one day and said, "Don't ever forget that you have a return plane ticket." You have a choice, too—always. Obviously, if you can change your behavior or attitude, that makes the most sense; because ultimately, your goal is to get the job done, learn and get on with your career. But if an intolerable situation makes that impossible, you do have the option to leave.

Often, the behavior you'll encounter is a result of insecurity, which in this line of work, is not uncommon. It certainly was in the

case of an actress I once worked with on a TV series. Part of an ensemble cast, she was higher maintenance than all the rest of the entire cast put together. It took me a while to figure out that in working with other actors who had much more experience and name value, she was terribly insecure about holding her own. And then there was the day I complained about her once too often, and my friend and boss Phil Wylly just looked at me and said, "Look . . . if it wasn't for her, if it wasn't for *them*, we wouldn't have a job." It was a generic statement about all the high-maintenance people we had to deal with, and I got the message.

I've seen insecurity in producers, directors, other actors, DPs—any number of individuals, many times over. Much is expected of them, they're carrying a lot of weight on their shoulders and a great deal is riding on their ability to produce a quality performance or product that's going to be well received and generate top ratings or big box office numbers. I eventually developed a sense as to when poor conduct is project driven as opposed to, shall we say, strictly ego driven. I was told a long time ago to put myself in their shoes, which I was eventually able to do. And on a smaller scale, I've learned first hand what it's like to have to pull something off I'm not at all confident I can do, even though others are counting on me to make it happen. The anxiety and fear can be intense. Add to that a lack of sleep, and you can see how easily someone's normally pleasant, well-mannered demeanor can fall by the wayside.

Knowing why it's happening doesn't excuse the outbursts, rudeness and temper tantrums, but understanding that it has nothing to do with you, and that you can't take it personally will help you get through it.

When someone pushes your buttons, instead of striking back, let him know you understand, you're on his side and you're there to help. When I see someone I'm working with bouncing off the walls, I can often diffuse the tense situation by walking up to that person and purposefully asking, "What can I do to help you?" You have to put your bruised feelings aside, and instead of walking away from an unpleasant person, direct the offender's attention to the job at hand. Remind him that you're both there for the same purpose, and if you can, try to get him to see another perspective. Let him

know you're there to help, offer solutions, and try to convince him you're on his side—that you're there to support him, to do your job and to be the best (PA/assistant/whatever) he's ever had.

If the other person is not letting you in, tactfully interrupt, non-aggressively. Call him by name, and never strike back using sentences that start with "you," as in, "You're always such a jerk," or "You never listen to what anyone else has to say." Those are attacks, and you'll only make it worse. You want to diffuse the situation, not fuel it. Instead, use sentences that start with "I" (make it about you), like, "I know you're angry, but this is important to me, too" or "I'm having trouble understanding this—let's try to work it out together." Monitor your tone and get your point across without being offensive, or you'll lose him.

Don't confront anyone in public. Find the right time and place. If you think you might lose your temper, excuse yourself, take a short break and pull yourself together. Don't fall apart in front of others. You can command respect without being aggressive, without withdrawing or giving up your ground. Look him in the eye, wait for him to stop and cut to the chase—"The way I see it is . . ." or "I'll be happy to discuss this later when you're calmer." And again, ask what you can do to help, communicate your understanding of the job and offer options to resolve the situation.

I was once hired to work on a show, and when it was over, the producer asked me if I'd like to come work for his company on a permanent basis. This guy was a real screamer. I had seen him fire a succession of people on our show. They dropped faster than ducks in a shooting gallery, and he was definitely someone no one wanted to cross. But strangely enough, there was also something about him I liked. At that point in my career, I was feeling fairly confident, didn't particularly need the job and had nothing to lose, so I told him I would be interested in working for him. But then I calmly added that if he ever screamed at me the way he screamed at other people, I'd walk out and never look back. He said fine, and that was that. I took the job, and he never once screamed at me. I think it's perfectly okay to stand up to someone like that, but be prepared should it not turn out in your favor.

I've worked for some very difficult people, and it always makes the job that much harder. When you're in this type of a situation, though, you're the only one who can decide if it's worth it. Is your need for the paycheck, the credit or the experience more important than what you're having to endure? Sometimes it is. I know many people who just refuse to work for or with the notorious big-ego-bad-temper types, and if you were to ask them why, they'd simply say, "Because life is too short." Others do it willingly because some of the toughest producers and directors also happen to be some of the most brilliant filmmakers. Working with them, they learn a great deal, get to work on some pretty extraordinary projects with some pretty amazing international crews and state-of-the-art equipment, and they've figured out how to let the bad stuff roll off their backs. From personal experience I can tell you that I've done some of my best work and have accomplished more than I ever thought I was capable of when working for people who were overly demanding and wouldn't accept anything less. I couldn't handle that kind of stress on a regular basis, but once in a while, it's all right.

When it comes down to it, not everyone you come across is going to represent the worst aspects of the business. Some fall into a sort of a gray area—not the best and maybe a bit frantic, neurotic or disorganized, but certainly not bad people. And then there are some genuinely decent, honest, caring people out there. When you get to work for the good ones, do the best job you can for them, let them know how much they're appreciated, how much you would like to work with them again—and stay in touch.

Avoid Burning Bridges

"Hollywood is a place where they place you under contract instead of under observation."—Walter Winchell

Continuing on the subject of working with certain individuals you'd rather not be associated with, I'd like to bring up the matter

of burning bridges—or not. This goes beyond leaving a job or distancing yourself when necessary and touches on *how* you would leave or distance yourself.

I once worked for a company where neither of the two top executives could utter one complete sentence without using utterly foul language. Another time, I worked for a production manager who was taking kickbacks. And on yet another show, I worked for someone who was a lecherous alcoholic. And while I don't believe in having to put up with a great deal of abuse, having to do something you find unethical or having to work in an environment that is offensive, burning a bridge behind you is not the optimal way to walk away from situations like these.

You can tell someone off, make a scene, dramatically get your point across, bad-mouth the offenders, cop an attitude, walk out in an indignant huff or any combination of such, but you do this at your own risk. Your initial thought is that you don't care if you ever work with this person (or these people) again, and even though you may be thoroughly in the right, these rash and emotional reactions can have far-reaching consequences.

The person you've just told off may be more than willing to portray an uncomplimentary image of you should a potential future employer call for a reference. Taking that a step further, I once knew a producer who had heard that someone he had recently (and unjustly) fired had just landed a new job; and he called the producer she was about to start working for to strongly suggest he not hire her.

It doesn't matter how right you are and how wrong or disagreeable others may be, powerful people do exist with the ability (and sometimes the inclination) to ruin your reputation and damage your career. On the other hand, some of these same people may also be in a position to help or recommend you at a later time, *if* their benevolence is something you'd even be willing to accept. It could be the frustrating studio exec you're dealing with who has been acting like a complete jerk, but six months down the line, may decide it's the perfect time to greenlight your project.

The longer I'm in the business, the more discerning I've become about choosing my battles, and the more judicious I am about

the way I fight my wars. I'm also not as judgmental as I once was, I spend more time putting myself in the shoes of others and have also seen people change. So while I've burned my share of bridges in the past, I'm now convinced it's much, much wiser to keep as many of them standing as possible.

When working with or for someone I don't like, I tend to finish the project but am conveniently unavailable to work with them again in the future. When I find a work situation too uncomfortable, I will find a plausible reason to leave. I'm not terribly good at keeping my opinion to myself but manage to disagree or get my point across without creating too many waves. It's possible to remain on cordial terms even with people you don't particularly like or respect.

You may find being pleasant to people you don't like is an affront to your integrity (many do), but you'd also be hard pressed to find any other business where the same kind of politics don't exist. There's a big expanse that lies between being overtly friendly and being dismissive, and your safest bet with people who aren't your favorites is to be polite and professional.

It's part of the game. Those who find the people or the work distasteful often opt for another line of work, like a former student of mine who left her job on the big movie because she found the script offensive. She eventually left the business altogether, because this just wasn't a game she wanted to play.

If you should find yourself in a situation in which your integrity is being challenged, then I say go for it and take a stand. But avoid burning bridges if you can, because relationships in this business are like gold; and unless the offense is consequential, no one ego-maniacal jerk or one miserable work experience is worth damaging your career.

There's a Barracuda in My Office—More on Politics

> *"Hollywood's a place where they'll pay you a thousand dollars for a kiss, and fifty cents for your soul."*—Marilyn Monroe

In his book *Reel Power* by Mark Litwak (Silman-James Press), Mark states, "Successful filmmakers are distinguished, not only by a command of their medium but also by their political savvy. Unless a filmmaker is adept at the politics of moviemaking, it's unlikely he will ever get the chance to demonstrate his skill as a moviemaker."

As a rule, when you work as part of a crew, you don't encounter too many heavy-duty political situations. Everyone is hired to do a very specific job, and you don't see many grips or assistant cameramen trying to outsmart each other in a race to take over the script supervisor's job. That doesn't mean politics doesn't exist on shows; it just usually exists within the higher echelons. When you start a production, notice who's got the most power: the director or one of the producers. Who's making the big decisions, to whom do you show deference and of whom are you respectful, even if for no other reason than her position. Each will undoubtedly have his own "people"—loyal individuals they were responsible for bringing onto the show. On *Titanic*, there were several layers of producer- and executive-types and each had his own camp of people. There was so little communication between the groups and so much rivalry, you'd walk into the production office and could cut the air with a knife. It made for a very uncomfortable work environment that was much less efficient than it should have been. Although few get to that point, it does occasionally happen.

It was when I was working in a staff position for a fairly large production entity that I found myself surrounded by more traditional corporate political types. I know this goes on in other businesses every day all over the world, but it doesn't make it any easier. I sat in a meeting once where one individual had surreptitiously gotten information that another department head hadn't been informed of yet and announced it at the meeting to show him up. It's called one-upmanship, and it went on regularly. Then there was something I had never before encountered—a young woman whom I had confronted for being aloof, not sharing information and not being a team player came right out and told me it wasn't personal—she just wanted my job. And I was told that the political atmosphere where I worked wasn't nearly as bad as it was at other companies and studios. While you don't generally find this level of

politics in smaller companies and work environments, you can never totally avoid it, no matter what you're doing or where you're working. When you mix ego and power into any pot, it's bound to boil. And as my friend Mark Hansson advises: "Don't stir the pot . . . and fly low to avoid the radar."

To enhance this chapter, it was important for me to talk to a few top industry professionals I respect for the way they conduct themselves in everyday work environments fraught with politics and to get their thoughts on how they deal with others within this competitive, ego-driven arena.

The first person I spoke to was my long-time friend Ira Shuman (*The Wedding Singer, The Waterboy, Just Married, Cheaper By The Dozen, The Pink Panther*), who's a talented line producer and a great guy. The political attributes I see in Ira start with his affable personality. He's easy to talk to, easy to laugh, is patient, fair, accessible, treats everyone with respect, does what he thinks is right for the entire company as well as the show, and he rarely if ever loses his cool or raises his voice. His philosophy is that you're at work for more hours than you are at home, and you need to be a person, not a machine. And unlike those who separate their personal and professional lives, he prefers to integrate his. He said you have to care about the people you work with, their lives and their feelings. He wears many hats at once, of not only a producer, but also a husband, a father, a friend, a golfer and sometimes even a parent or coach. As easy as Ira is to work with, he holds the people under him accountable, and they know there are consequences for not doing their jobs properly. He sees filmmaking as a team sport, and values supportive and loyal team members. When he's working for someone, his goal is to see that person win and to make the best picture possible. When people are working for him, he expects them to be there to help make him win, to support their teammates and to work to the best of their abilities. He says you can't be a team player and have your own agenda: the team has to come before your personal interests. For those working in a more corporate setting, his advice is pretty much the same—honor your chain of command and make your leader a winner. If that happens, hopefully you'll become a trusted and much relied-on member of

the department. He adds: keep your nose clean, carefully watch what you say, don't deal with others from an emotional level, don't fight the fights you can't win, and should you choose to get into it with someone, carefully ponder the dynamics and consequences before doing so. He says when people around you are playing dirty, you have to honestly ask yourself who you are and exactly how ambitious you are. If this isn't you, nor is it the quality of life you see for yourself, then leave and find a less aggressive arena in which to work. If playing the game to the max and existing in a dog-eat-dog environment is something you're okay with, then jump right in and give it all you've got.

Jonathan Sanger (*Elephant Man, Frances, Vanilla Sky, Suspect Zero, The Producers*) is another producer I greatly admire. His fabulous people skills come out in everything he does and are evident even in the way he answers his phone and expresses pleasure in hearing from the person on the other end of the line. Jonathan has several good tips for dealing with people in this industry, although to him, it's not as a matter of politics, it's just the way he is.

When dealing with his crews, he doesn't talk down to anyone. He came up through the ranks, understands what they're up against and conveys his understanding and respect for them and the work they do. He makes good deals but doesn't go overboard to save a few bucks. He said the crew knows when you're not being fair, and all they'd have to do is slow down for five minutes a day, and you'd lose more than you could have ever saved by shaving a few dollars off of a few salaries. He prides himself on being fair; and as a result, his crews are supportive and loyal, willing to go the extra distance when necessary.

This doesn't mean Jonathan always gets to play the good guy and never has to make hard decisions. He said too many people are afraid of making the wrong choices, so often they do nothing, which is worse. If there's a problem affecting the show, whether it's someone on the crew who isn't doing his job, a conflict of personalities, a petulant actor or a budgetary issue, Jonathan believes you have to act as soon as possible for the good of the entire production. Otherwise you end up diverting too much time and energy monitoring the problem and not enough on everything else

that needs your attention. He said if you're the one in charge, then you should be willing to take responsibility for your decisions, as long as you have justifiable reasons and can defend your choices.

When it comes to dealing with anyone, including top-level professionals and studio executives, he tries to start all new relationships by finding common ground in any situation. He gave the example of walking into someone's office and seeing a photo of the guy playing basketball. "Great" he thinks to himself, "I like basketball," so now he has something to start the conversation with instead of jumping right into business.

As it relates to selling projects, making deals, raising financing or dealing with the studio power structure, he clearly demonstrates to others that he knows what he's doing, and that he takes his responsibilities seriously. When a situation gets too politically sticky, he quickly assesses who's involved and the circumstances. While always up for a good challenge, when faced with too many competing agendas, he says sometimes you just can't be effective enough and it's better to walk away.

When I asked Jonathan how he deals with someone who's being unreasonable or possibly out of control, he said there are no set guidelines on how to handle all situations, that sometimes you just have to improvise. Under these circumstances, however, his best advice is to find a way to comfort this person, calm him down, try to understand where he's coming from and attempt to enlist his logic in finding an amenable conclusion.

Jonathan sees the fact that he likes people as one of his best qualities. He's open and gracious and has the ability to get along with all types of personalities. He does this in great part by creating work environments that are enjoyable, not fearful. And he finds value in everyone he deals with. Feeling his respect, others are more open, they give more and there's less friction. I don't know about you, but this is my ideal universe.

I recently spoke to another friend who's a production executive at a major studio who deals with highly political situations every single day. And while he prefers to remain nameless, he had some pretty insightful advice to share. First of all, he says that you need to treat everyone with respect, no matter their position. Secondly,

know who you're in business with before you get into business with them. For example, when they're dealing with a producer or director who has little regard for budget constraints, they might build safeguards into their contracts, making them responsible for a sizable percentage of the cost overruns. If they know going in someone is high maintenance, they build in back-up plans to cover a range of possible situations. When producers and directors are contemptuous of the studio's involvement or dismissive when it comes to studio guidelines, my friend endeavors to define their common objectives, reminds everyone that they're partners in the process and proposes ways for them to share in the responsibility. He says you can't let your own ego get in the way, because when it comes down to it, it's all about respecting the integrity of the work.

All three of these individuals are people I look up to and try to emulate. They manage to get along with some of the most difficult out there, are adept at diffusing explosive situations and never find it necessary to lead by fear and intimidation. They're the best at what they do, are firm and tough when necessary, able to make hard decisions on a moment's notice, yet all the while managing to retain their integrity and humanity and earning the respect of those who know and work with them. Too bad everyone can't be like this!

But then again, there are people who thrive in a politically charged environment, because they love the sport of it. There's a Paul Mazursky film called *An Unmarried Woman* in which Alan Bates' character says to Jill Clayburgh's character, *"You know, whenever you put 50 artists together in one room, you get a—really pleasant combination of gossip, paranoia, envy, fear, trembling, hatred, lust and pretense. It's, er, wonderful."*

— 17 —

Show Biz Survival Techniques

> *"It took me a long time not to judge myself through someone else's eyes."*
> —Sally Field

A Teflon Coat Comes in All Sizes

Anyone who's been in this business for a while or any "how to make it" book you pick up will tell you that if you're going to work in this industry, you've got to develop a thick skin. Linda Buzzell (author of *How To Make It In Hollywood*) calls it "rhino skin." For the sake of being different, I'll call it a Teflon coat. It's guaranteed to keep anything negative from sticking.

As exciting and fun and rewarding as this line of work can be, none of us is immune to some measure of rejection, disappointment, ill-tempered personalities, sure-thing deals and jobs that fail to materialize or any combination of such. To survive these assaults, you *cannot* take it personally! Ever! It's part of the business, part of the so-called game, plain and simple. It happens every day, and as discouraged as you may feel at times and as much as you'd occasionally prefer to just climb into bed and barricade yourself under the covers for weeks on end, if you let each setback chip away at your spirit and determination, you'll eventually crash and burn. If you can't pick yourself up (in a reasonably short amount of time), dust yourself off and move on to the next possibility, you

might as well go out right now and find yourself a nice, secure nine-to-five job at a bank where you'll always know what to expect. If you're going to stay in the game and stick it out, be sure to get yourself a Teflon coat to help repel any of the bad stuff that comes your way.

Preserving Your Motivation and Confidence

Jackie Jaye-Brandt is a communications specialist, organizational psychotherapist, lecturer and author. I knew her name through the lectures she gives at the Motion Picture Industry Health centers; and a couple of years ago, I asked her to be a guest speaker at a Film Industry Network meeting. At the time, film production in Los Angeles had hit record lows, jobs were scarce, layoffs were rampant and runaway production was taking way too many film jobs out of the country. Many of our members were doing everything they could to find work, but few had much success. Frustration levels were high and bank balances were growing lower by the day. I asked Jackie to talk about how, in light of the current circumstances, people in our industry could retain their confidence, motivation, passion and self-esteem. How were we to stay positive in such a depressed work climate? Her very motivational lecture has continued to stay with me.

Jackie explained that one of the most counter-productive things we can do to ourselves is to think negative thoughts such as, "I bet I'll never get that part." "They'll probably hire someone else for that position." "They'll want someone younger, thinner and prettier." "I don't think I can compete with *him*." "In this competitive market, it's doubtful I'll ever sell my script." "They probably won't like my music." She said when our minds keep going to the same negative thought, a groove forms in our brain just like a scratch in a record, so when you put the record on, the needle just automatically slides to the scratch. These grooves/thoughts become so embedded, they eventually become beliefs. So no longer are they just thoughts, but now they're convictions: "I'll never get that part." "They'll hire someone else." "I can't compete." "I'll never sell my

script." "They won't like my music." These beliefs will gradually turn into feelings, and believing you won't succeed, it stands to reason that your feelings/mood would most likely turn toward some degree of depression, insecurity and disappointment. Jackie then explained that our feelings affect our behavior (makes sense) and our behavior affects the results and outcome of our lives (which makes even more sense). So to reverse this entire counter-productive cycle, start thinking new, positive thoughts and create some new grooves in your brain, ones that will evoke positive beliefs, feelings, behavior and results: "I *will* land a good job." "I *will* sell my script." "I *will* have the career I want." "I *will* be successful."

Jackie shared several valuable mantras with us as well, such as:

- If I don't program life, life will program me.
- I focus on my goals at all times.
- I keep my dream in front of me.
- I cannot afford to be negative.
- I feel great about myself.
- I replace the word "fear" with "excitement."

Getting Past the Disappointment and Depression

No matter how many positive messages you repeat to yourself over and over and over again, sometimes it'll happen anyway—you'll get depressed. You've given it your all (you've worked hard, you deserve it, and this opportunity *should* have been yours), but it just didn't happen. You're terribly disappointed and your spirits have taken a major nosedive. My response to your dilemma would be to offer about five minutes worth of empathy, but then I'd recommend you not spend too much time feeling sorry for yourself. My advice (an utterly conventional, but true platitude) is that it wasn't meant to be, so get on with your life and your career. I know, I know, easy to say, hard to do. I know that! But it's the only way you're ever going to survive on planet Hollywood.

I have found myself profoundly disappointed several times during my career, like when I was up for a fabulous job at HBO that

I wanted very badly, and I came in runner-up. Or when I was up for the job of administrator of the Assistant Directors Training Program, and out of countless numbers of applicants, I was again the runner-up. Or like two years ago, when I joyously landed my first deal as a producer, only to have the deal fall through before the contracts could be drawn up. Or like just recently when a project I'd optioned and had been developing and trying to sell for three years completely fell through. But honestly, would it serve any purpose whatsoever for me to walk around sullen and grumpy for days on end? No! And besides, it would drive everyone around me totally nuts. After a big disappointment, I understand the need to get it out of your system and to mourn the loss, but don't make it into a major full-blown melodrama. Life is too short! I've had my share of successes and also reasons to doubt that some of the lost opportunities would have been right for me anyway, so dwelling on past disappointments is a complete waste of time and energy. Besides, we don't have time machines and can't go back and change anything anyway, so we just have to move forward.

So what to do when you're really down and depressed? Well, many experts will tell you to keep going—keep making those calls, setting up those meetings and sending out those resumes and demo CDs. Keep writing, creating, networking, searching for the next award-winning project, lining up your next client, performing in workshops, planning your next film. Keep thinking positively, and remember that those who never give up are the ones who are most likely to "make it."

Well, I never give up, but I do give myself permission to take a few days off once in a while. I'll do things like go to the beach, spend time with old friends I haven't seen in a long time, work in the garden or on projects around the house. Or sometimes I just lose myself in a novel. My hobby is still photography, so occasionally I'll just take off for a photo shoot. My friend Michael says every once in a while he needs a day at home to watch *Laverne & Shirley* reruns. Returning to my normal routine after a short break, I generally feel recharged, recommitted and ready to jump back into the game.

I also find that being with my show biz friends—people who have been through what I'm experiencing—is extremely therapeu-

tic. They just get it, like no one else does. They're honest but sensitive and not overly judgmental. (If your friends are too judgmental, find yourself some new friends!) So instead of barricading myself under the blankets or bingeing on double fudge brownie ice cream, I'm often making plans with my industry buds who understand how I'm feeling. No matter what's going on at the time with any of us, we have a way of bolstering each other's confidence like no one else can. And whether we get together for coffee and just visit and laugh, go to a movie or end up brainstorming new ideas over dinner, it always helps. That's why they call these people your "support" system.

Another way to pick up your spirits when this business has you down is to stop thinking of yourself and do something for others. Become a mentor to a younger person, help someone else who's looking for a job, volunteer to lecture at a local school or get involved with any charity or worthy cause you believe in. Find something that interests you: work with kids, animals, the environment or slam nails for Habitat for Humanity. Helping others is not only incredibly rewarding, but once you step out of your own little world and focus on the lives of others, you realize just how insignificant your problems really are.

One evening last summer I was driving to USC to teach my class. I had had an absolutely awful day, was late in leaving the house, was stuck in horrendous traffic, was anxious knowing I'd be arriving late and then couldn't find a parking space once I got there. Let's just say I was in a thoroughly rotten mood. But once I walked into class, that nasty mood that had taken all day to incubate just evaporated, because my being there was all about the students, and my personal dramas became totally insignificant. The students were excited, ready to get going and eager to absorb anything new I had to offer them; and all I wanted to do was to make the next three hours as meaningful for them as possible. It absolutely works. Spend time helping others, and your troubles will temporarily disappear . . . poof!

There may be times when no matter how hard you try to convince yourself not to take rejection personally and how intensely you struggle to retain your self-esteem, your confidence will

plummet. There will be times when you absolutely dread having to tell anyone that your deal fell through or you didn't get the job you'd been wanting and talking about for months or that you're *still* not working. But you've got to work past that and get yourself out there, because turning inward and feeling like a loser is only going to intensify and prolong the situation. It's this business—not you! Lose the self-pity routine and remember Jackie Jaye-Brandt's valuable mantras: *I keep my dream in front of me. I cannot afford to be negative. I feel great about myself.* Write these out on index cards and tape them up where you can see them every single day.

Understand that most of us who have been in this business for any length of time have been there and gone through that. It happens. So acknowledge your feelings and get out there.

Walking Around the Brick Wall

Contrary to what I'm telling you *not* to do, I spent several years feeling resentful and carrying a chip on my shoulder because I couldn't get into the DGA and become a union production manager. I had been a production coordinator for ages, having worked side by side with a production manager who not only taught me well but gave me a great deal of responsibility. I had been a staff production executive, supervising production managers on multiple company shows. I had done a couple of small shows as a nonunion production manager. And I had producers who wanted to hire me as their production manager on larger projects, but they couldn't, because I wasn't in the Guild. I had trained the sons of many producers and directors who miraculously found a way to get their kids into the DGA, but I never seemed to have enough hours to qualify. Again, another case of "life isn't fair."

Lamenting my situation over lunch one day with Phil Wylly, the production manager/producer and friend I had worked with for many years, Phil looked me in the eyes and said, "When you're through hitting your head against that brick wall, you can figure out how to pick yourself up and walk around to the other side."

Resentment isn't so easy to lose, but I've got to admit, Phil's advice has served me well. As soon as I let the shoulder chip fall

by the wayside, my career started opening up in directions I had never even thought of before. I think my biggest revelation came when I knew that if I couldn't be successful as a production manager, then I would be successful at something else. And I have been! So if one path isn't working for you and you've reached that brick wall, don't waste too much time banging your head against it and getting all bruised up. Be willing to reinvent yourself. You don't have to get out of the business, just alter your course. Who knows, it could eventually lead you back to where you wanted to be to begin with, or you may decide you prefer being where the new path has taken you.

"Be Bold and Mighty Forces Will Come To Your Aid"

Attributed to the German philosopher, Johann Wolfgang von Goethe (1749–1832), I first heard this quote from Anthony Hopkins, who was appearing in an episode of *Inside The Actors Studio*. He was answering a question from a student in the audience, and he said he keeps this quote in mind when plagued by self doubt or up against a daunting challenge. John Wayne had another good quote with a similar message. He said, "Courage is being scared to death . . . and saddling up anyway." In other words, don't let the fear stop you.

Fear is a natural emotion: fear of failure, of rejection, of what others might think of you, of making a fool of yourself, of making the wrong decision, of overstepping your bounds, of not sounding smart enough, of not being taken seriously, of making calls to individuals you don't know and of meeting new people. It's what keeps most people glued to their predictable little comfort zones and what keeps them from succeeding.

Take a chance! Be bold! And ask yourself, "What's the *worst* that can happen?" It's scary to put yourself out there, but it's not as though you're facing a life or death situation. If it doesn't work the first time out, or the second, you need to keep trying. You'll survive. I promise! And just like the fable of the young woman who had to kiss a whole lot of frogs until one of them turned into her

prince charming—sometimes you have to encounter a lot of "nos" before you get to that all-important "yes." Just shove your insecurities aside, put on your Teflon coat and go for it. Don't let your fear of not succeeding keep you from making it!

Reverting to Plan B

Not everyone in the biz is fortunate enough to be able to climb progressively, one step at a time, up the ladder of success. Some of us find it necessary to take a step or two down, or sideways, before starting back up again. It's rarely preferable that way, but sometimes necessary. If you're flexible, willing to take a lesser position or slightly change directions without resentfully feeling *above it all*, it could prove worthwhile, because you never know what you're going to find or who you're going to encounter once you embark on Plan B.

A question I'm often asked is, "If others see me in a lesser or different position, will they ever think me capable of more or take me seriously?" While some firmly believe one shouldn't go backward, I think it's perfectly acceptable. I've done it myself and have been pleasantly surprised. When you're capable of more, it quickly becomes evident to all around you. And besides, you never stop making contacts, no matter what you're working on or which position you've taken. You wouldn't be the first who has taken a job you're overqualified for because you wanted to keep working, or needed the paycheck or the hours to keep up your health insurance or because you wanted to be involved with a particular project.

As mentioned earlier in Chapter 8, it stands to reason that you need to generate enough income to cover the basics: eating, maintaining a vehicle, health and car insurance, having a phone and paying the rent. So what do you do to earn a living in between shows or while pursuing your dream? Here are some suggestions, including jobs that offer a great deal of flexibility.

- Take on at least one roommate and share expenses.
- Work evenings, so your days are free.

- Become an apartment manager in exchange for free or reduced rent.
- Sign up with a temp agency.
- Work as an extra, or better yet, a stand-in.
- Become a limo driver, delivery or valet parking person.
- Become a house-sitter, pet sitter or dog walker.
- Work with a catering company; or if you're a whiz in the kitchen, find outlets for your culinary delights, like selling specialty desserts to local restaurants.
- If you're good with your hands, build furniture, do carpentry or handyman work.
- Become a companion to an elderly person.
- Think of teaching, tutoring or coaching.
- Work trade shows and conventions.
- Be a headshot photographer.
- Consider working at a health club and/or becoming a trainer.
- Become an event planner.
- Become a personal shopper.
- Get into market research.
- Become a tour guide.
- If you're a computer geek, put an ad in the local paper for your support services. (I can't tell you how many of us need help with our computers!)
- Type and properly format scripts for writers who aren't comfortable writing on a computer.
- For more suggestions and lots of terrific resource tips, go out and buy yourself a book called *Survival Jobs—154 Ways To Make Money While Pursuing Your Dreams* by Deborah Jacobson (Broadway Books).

Don't Fight a Stacked Deck

There's always going to be someone who gets the job you deserved or wanted more; someone who gets a better break; someone who has better connections; someone who's prettier, thinner, taller, younger, more handsome, sexier or more stylish than you; someone who makes more money; someone who has a bigger house or

a faster car; someone who lands the deal that should have been yours or the funding that had been earmarked to finance your picture; someone else who gets the part you were born for, the show you were meant to do, the client who should have been yours; someone who's luckier, smarter, more creative, more talented. It's why you can't compare yourself to anyone else.

Once again, understanding, really *accepting* the fact that, as in life, this business is not fair will save you from an immeasurable amount of frustration and disillusionment. It happens the way it should sometimes, but not always; and there are no real rules. It's always been like this, and it always will be. The deck is stacked. So you can't afford to lose one moment of your valuable time nor expend any amount of negative energy on being jealous, frustrated, resentful or angry, nor can you let it affect your self-esteem. I know this sounds very cliché-ish, but always trying to measure up to someone else's success will only prevent you from being the best *you* you can be.

Concentrate on what you have to offer, on your accomplishments, on your personal style and on what makes *you* special. Don't let anyone else's achievement detract from your dreams or your belief in yourself. If you don't get the job, the part, the client, the deal, the show, the sale you were hoping for, something else will materialize in its place.

Get It in Writing

Protect yourself by making sure all partnerships, deals, options and decisions are backed up in writing, and preferably with the help (or at least the scrutiny) of an entertainment attorney. Most people you're going to be dealing with have the most honorable of intentions—but not all of them. Besides, minds get changed, misunderstandings occur, finances run out and grievances, lawsuits and insurance claims are filed every day.

When you start a new job, make sure you have a deal memo, even if you're working for free. The deal memo should specify your salary (including overtime rates and payment for sixth and seventh days worked); how you will be traveling to location; how

much your per diem will be; if you'll be receiving screen credit, etc. Signed deal memos protect both you and the production company. When you're working for free, are you getting gas money? Will the company supply your lunches? Will you be getting screen credit? To ensure that you receive what's been promised, get a deal memo.

In addition, when you're working a show, cover your ass by:

- Keeping careful inventories and noting when something is lost or damaged.
- Keeping a log detailing dates and incidents when you're experiencing difficulties with another employee.
- Confirming all major decisions and commitments in writing; and if an official agreement or contract is not drawn up, writing a confirming memo detailing the arrangement.
- Having an attorney review all agreements and contracts before you sign them.
- Treating favors just like any other agreement. Favors involving any type of exchange are nice but can also backfire on you. All such agreements should be backed up with a letter in writing stating the exact terms of the exchange and releasing the company from any further obligations.

The "No One's-Ever-Going-To-Hire-Me-Again" Syndrome

For those of us who freelance, we're always relieved when the current project we're on has wrapped, because by then, we're drained physically and emotionally. But once you rest up and catch up on all the personal things you didn't have time to do while on the show, panic generally starts setting in if you don't have another project lined up within a month or two. Or maybe you worked on a show, you know you did a good job, but the producer isn't hiring you back again on his next picture (even though he said he would). Or maybe you've gotten laid off, and you start going on the interview circuit, but nothing seems to click. Or you've had a great interview or reading, and you were sure you had the job or part, but they pick someone else instead. Or someone calls to ask if

you're available (and interested) in working on a particular project, you say "of course," and then you never hear back from that person. Or none of your leads are panning out. It's times like these when you're going to instinctively think, "Oh my God! No one's ever going to hire me again!" It's a *very* common feeling, so universally so that an old friend of my husband Ron's once told him that one of my idols, Henry Fonda, when he wasn't under a studio contract, used to go through this. Can you imagine Henry Fonda thinking that no one would ever cast *him* in another film? I saw an interview with Dustin Hoffman recently, and he confessed to experiencing the same doubts when in between projects.

Some people go into panic mode if they don't have something else lined up before finishing their current job, and others enjoy their time off in between projects and don't really worry about what's next for at least a few months. I don't go into meltdown anymore when I don't know when my next job will turn up, because I've been through this too many times before, and I know that something will eventually turn up. It may be when I'm least expecting it, and sometimes it's just in the nick of time, but something *always* materializes.

So when you're feeling as if you'll never work again, wondering why you're not being rehired or can't find a job—take a step back, take a deep breath and remember Henry Fonda. Everyone goes through this! Insecurity is inherent to the industry, but you can't let it stop you—not for one minute. If you're doing everything you're supposed to be doing, your job will materialize.

It's Not a Business for Sissies

This can be a pretty rough business, and you can't afford to be too delicate or sensitive, nor too easily offended. I believe in political correctness and am fervently against sexual harassment, discrimination and abusive language and behavior, but I know people who take offense at the drop of a hat, and they create almost as many issues as do the true offenders.

This is a huggy-kissy-touchy business. While not always sincere, a hug or a kiss alongside the cheek (or an "air kiss" as they're

sometimes called) is a pretty standard way to say hello or goodbye to your business associates and co-workers. When you've been intensely working together on a project for weeks or months on end, intense bonding often occurs, and with it, a familiarity that breeds hugging, an occasional peck on the cheek and possibly a back rub or two. Obviously, some individuals are more affectionate than others; but in general, this is a business where such behavior is quite the norm. If you're not the touchy-feely type but are approached by someone who is, don't take offense unless the gesture is totally inappropriate. As long as it's just a friendly hug, let the person know it's not something you're comfortable with, but don't make a big deal of it.

When it comes to sexual harassment, if someone politely or playfully comments on how you look or hits on you, thank that person for the compliment (anybody who doesn't appreciate the flattery should lighten up a little), and *nicely* let him or her know you're not interested. If the remarks are offensive or inappropriate, skip the thank you and fast forward to the "I'm (definitely) not interested" part. But don't make a scene or blow it out of proportion. The line is drawn only when someone starts grabbing body parts. And in that situation, reporting the incident to a supervisor is the way to go. For anyone (but especially for women) in this business, you have to know how to take care of yourself, protect yourself and speak up for yourself. And you also can't cry "Wolf!" every time some creepy-looking person leers at you.

I feel similarly about bad language. This is a frenetic and stressful industry, and I hear it all the time; but unless it's brutally offensive, I let it go. It doesn't change who I am or affect my work. In fact, on a rare occasion, I've been known to utter an expletive or two myself (but don't tell my mother).

Should you be bombarded by flying insults, try not to take them personally. They're often hurled about by rude, insensitive, insecure people who make a habit of treating others badly. Just consider the source, and go about your business the best you can. Creating a fuss about it will accomplish absolutely nothing.

I was working on a show once, and our post production supervisor was probably in his 60s at the time. He was a sweet guy,

knew what he was doing and was extremely personable. One day, though, he walked into the production office where I was sitting with two other women (I don't remember what their positions were, but it doesn't matter). Anyway, this guy walks in and says, "So how are you girls doing today?" Well, I thought one of the women was going to take his head off for calling us "girls." She even tried to have him fired. Now, I know it hasn't been the P.C. way to address women for some time, but did his remark really hurt us? When he was younger, it was perfectly acceptable to address women as girls, and he certainly hadn't intended to be insulting. If it was so important to the woman who blew up not to be called a girl, she should have found a nicer way to let this man know.

Something similar happened recently while working with a particular vendor on a show I was on. The sales rep was extremely helpful and accommodating, and he ended most of our conversations with, "Thanks, doll!" It was his way of being friendly, and while not P.C., I'd never say anything to him about it. I could have been rude and told him in no uncertain terms that I wasn't his doll, but that would have been a big waste of time, would have created hard feelings and I would have felt uncomfortable the next time I had to call him to check on an order. It doesn't affect me, insult me, or make me less than who I am, so what's the difference? If anything, it makes me laugh.

Anyone who knows me knows how vehemently opposed I am to discrimination of any kind. I am, however, incredibly disdainful of any individual who falsely cries discrimination when outcomes are not to their liking. If you are truly being discriminated against, you'll find a long line of people standing up with and fighting for your rights. If you falsely accuse someone of discrimination, you'll lose all credibility.

If you should find yourself offended or insulted, consider the source, the circumstances and the business you're in. Keep your Teflon coat securely buttoned, and learn to roll with the punches. If someone is genuinely out of line, speak to that person privately, and let him or her know how you feel; or talk to your supervisor. Don't make a scene. If the situation doesn't change and you find it

intolerable, you may choose to walk away from the situation. But whether you're a man or a woman, if this becomes a recurring problem, you're finding that your feathers are easily ruffled or you're easily offended, then maybe this isn't the business for you.

Humor Is Still the Best Medicine

"You cannot be mad at somebody who makes you laugh—it's as simple as that."—Jay Leno

I know I've mentioned this several times before, but I can't emphasize it enough. A healthy sense of humor will serve you well throughout your entire career. Next to owning a Teflon coat, it's one of the most valuable survival tools you'll ever possess, in this business—or any other.

We work too hard, face way too much competition and far too many challenges not to be able to have fun along the way and to laugh at what we're going through. It's the perfect remedy for lifting your spirits when your confidence is on the decline. It'll help you through the difficult projects and the unemployment in between jobs. It'll ease the frustration and heal the disappointment. It'll supply the boost you so desperately need when working with spoiled, ill-tempered individuals or bring you some relief when working on a God-forsaken, remote location in the middle of nowhere. A sense of humor is also a great gift to offer your friends and co-workers when they need a boost. And as we continue to jump through hoop after sequential hoop, it's comforting to be able to laugh at the absurdities we must endure just to stay in the game.

Humor will create a stronger bond between you and your co-workers, and if you're the one dispensing it, you'll be someone others will naturally be drawn to. Besides, there is nothing like interjecting a bit of fun into a long, hard day to alleviate the stress. When the shows we work on are over, the lasting memories we walk away with are linked to the work itself and to the camaraderie and good times we've shared with our co-workers.

Get Real

> *"When an actor comes to me and wants to discuss his character, I say, 'It's in the script.' If he says, 'But what's my motivation?,' I say, 'Your salary.'"*—Alfred Hitchcock

My friend Andrea has a beautiful daughter named Erin, and when Erin was a little girl, she had aspirations of becoming a movie star. I remember asking her what she wanted to be when she grew up. She had it all figured out. She didn't just say she wanted to be an actress. She wanted to be a *movie star* with one home in Beverly Hills and one home in Paris. Nice dream for a little girl. Fortunately for her, Erin's grown-up ambitions are a bit more pragmatic.

When I start a new class each summer, I ask each of my students what they want to do in this business. Many tell me they want to make movies with moving moral messages, and through this art form, convey stories that will touch the human spirit and shape the consciousness of a generation. Some want to work on projects that will benefit children, others want to make politically charged documentaries and still others want to help bring back the type of classic films that were made in the 30s and 40s. Some want to become movie moguls and there are always one or two who aspire to become household names. All very lofty ambitions, but such dreams must be balanced with a healthy dose of practicality when you're just starting out and have to worry about making the rent each month.

Sure, once you've reached a serious level of success in this industry, you can pretty much write your own ticket and choose (or create) your own projects, but few of us have that luxury. With a modest amount of success, you can afford to be somewhat choosy about which projects you opt to become involved with. But for most of us, the noble cause is in earning a decent living for ourselves and our families. That's why throughout my career, I'll occasionally work on a show I'd rather not list on my resume.

You may choose not to work on something you find morally offensive or turn down a project with someone you find objectionable to work for, but short of that, be practical. Unless you've got people lined up at your door with job offers in hand, take the ones that will pay you fairly, and work with people you won't mind spending a great deal of time with. As your career grows, so will your choices.

The trick is to keep pursuing your dream, but be realistic about it. Dreams do come true, fortunes are made (as are very comfortable livings), success and notoriety are possible and artistic freedom is conceivable. But to improve your chances of surviving the journey, be sure to:

- make a Teflon coat part of your permanent wardrobe,
- make wise choices knowing full well that the business isn't fair,
- find a way to get past the disappointment and depression,
- be willing to alter your course a bit when faced with an immovable brick wall,
- be bold and willing to take risks, but be willing to revert to Plan B when necessary,
- avoid comparing yourself to others,
- get as much in writing as possible,
- hold on to your sense of humor, and
- know that no matter how discouraged you get, it *will* get better if you don't give up.

— 18 —

Advice From the Experts

As previously mentioned (more than once), a significant part of your success in this industry will be directly tied to your attitude, how you treat others and how you conduct yourself at each and every job you'll ever have. So even though my philosophy and advice on attitude, treating others, etc., is peppered throughout this entire book (sorry, you can't get away from it), this particular chapter contains nothing but advice, from me and from other industry professionals. And if you're the type of person who doesn't *have* to learn it all the "hard way," you'll value this wisdom that has already been road-tested by the many others who have walked before you. Take these assertions, insights, beliefs and suggestions to heart, and they will serve you well.

The Word According to Eve

• No matter how insignificant your job or position may seem at the time, think of it this way: the TV or filmmaking process is like assembling a large jigsaw puzzle, where many small little pieces and some larger pieces (each representing a person or element involved in the production) slowly come together to form a complete picture. Each piece, no matter how minuscule, is just as

essential to completing the picture. And once totally assembled, this picture is so rich in detail, it evokes emotion and conveys a story. So no matter what your contribution, the picture can't be completed without you.

- Your job is what you do, not who you are. Don't allow your title to become your sole identity. In other words, whether your title sounds important or not, you, as an individual, are important and have a lot to offer. Take pride in everything you accomplish, everything you are and in all your relationships. Realize that these elements are also part of your identity.
- Along the same lines as "you are not your title": this can be your life's work, but it's not your life. One day work may drastically slow down or disappear all together, and you could be left with nothing. So make time (even if it's limited) for the people you care about and find activities other than work to give your life meaning. It's easy to lose sight of priorities when ambition and titles become too meaningful.
- If you're a person who is truly talented, smart, special and/or important, you don't have to "act" that way. You just are! You show it every day in the way you behave and relate to others.
- Take your responsibility seriously, but don't overestimate, misuse or abuse your authority.
- Be a person who *earns* the respect and loyalty of others and neither expects nor demands it through fear or intimidation.
- Don't be so ambitious you feel it's necessary to take advantage of or snub other people to get where you think you're going. It *will* come back to haunt you.
- Willingly share information, and don't feel threatened. The better your team or department, the better you look and the more you learn. And back up your co-workers, stand up for them and be encouraging (even if it's not reciprocal). If you treat others well, they will usually be there to back you up when you need them.
- Prima donnas don't go over big on teams, so check your ego at the door. In other words, if you've moved beyond being a PA, the call sheets need to be photocopied and you're the only one around, get up and make those copies. If there's no one around

to make coffee and you want a cup, make a pot yourself. Being busy and needing the help is one thing, but don't have other people doing things for you just for the sake of your ego. Don't ever feel you're too important to pitch in and do whatever it takes to get the project completed.

- Stay healthy and don't get so lost in your work that you forget to take care of yourself, both physically and emotionally.
- No one is perfect. Give yourself permission to make mistakes, own up to your mistakes, learn from them and get on with it.
- Don't lie, or it will come back to bite you in the butt.
- Don't be phony, overly nice or solicitous just for the sake of impressing someone or trying to get ahead. Others can see through the insincerity.
- Don't gossip or bad-mouth anyone, because you never know who may be listening or if the person you're talking to may be a friend of the person you're bad-mouthing. It also won't reflect well on you.
- Similarly, there's a saying I've always been rather fond of that goes, "Beware . . . the toes you step on today may be attached to the back side you have to kiss tomorrow."
- Don't compromise your principles and ethics. Stay true to yourself.
- Be willing to give back to those just starting out the way others took time to help you when you first got into the business. Invest yourself in the success of others.
- You don't have to know everything; you just have to know where to find everything you need to know.
- Take the word "no" and any form of negativity out of your vocabulary. Substitute:
 "I don't know" with "I'll find out."
 "It's not my job" with "I'll make sure it's taken care of."
 "That's impossible" with "I'll find a way to make it work."
 "We can't afford it" with "Let me tell you what we can do."
- Pick your battles carefully; know when you can't win and fight hard for those you truly believe in.
- Don't declare an emergency unless there truly is one.
- Stay calm when all around you are bouncing off walls.

- Don't get so wrapped up in small details that you lose sight of the big picture; and don't spend so much time weighing the pros and cons of every issue that you can't make necessary spur-of-the-moment decisions as unexpected circumstances arise. Get too caught up in minutiae, and you'll lose both valuable time and money.
- Warning: You can do all of the above, be great at what you do and be a fair and considerate person, and you may still come across someone who (for some unknown reason) doesn't like you, doesn't want to be a player on your team, isn't going to be cooperative or communicative and/or wouldn't hire you again. This does happen from time to time, and you may never know why. The best thing to do is accept the circumstances, deal with it the best you can, and don't take it personally.
- Realize there are going to be days when you go home at night feeling totally beaten up and stomped on. But be reassured that it does get better.
- Don't ever forget the phrase: It's only a movie!

The Word According to Everyone Else

Just as I did for other parts of the book, I've interviewed many industry professionals from different aspects of the business and varying career levels and asked each of them to offer some words of advice to those just starting out in the business. And whether you're just starting out or are knee-deep in it already, there's something here for all of us to learn, no matter where we stand on the proverbial ladder. Here's what they had to say.

- "This is an awesome way to make a living and worth the fight. Make sure you want it really, really bad. And if you do, stay the course, be patient, humble and unwaveringly hungry."—Shawn Levy, Director.
- "Intelligence, combined with hard work, a willingness to try to accomplish anything and a good-natured *can-do* philosophy will get you further than almost any other quality."—Stephanie Austin, Producer.

- "Love it or leave it! If you're thinking about how much money you can make, or how much time off you can have, or how long the hours are—forget it! If you wouldn't rather be 'on the job' than anywhere else, you probably should be somewhere else."—Phil Wylly, Producer/Production Manager.
- Watch everything, and find a way to learn from everyone. As a wise man once said, 'Even a broken clock is exactly right twice a day.'"—Barry Adelman, Senior Vice President, Creative Affairs/Dick Clark Productions.
- "If you're looking for stability, you're in the wrong business. You've got to know going in where you want to end up, and get on the right career ladder at the start. If not, you'll end up attached to the short-term buck and unable to get back on track."—Mark McNair, Vice President, Production, Intermedia Films.
- "To quote Charles Bukowski, 'What matters most is how you walk through the fire.'"—Eric Mofford, Producer/Director.
- "Surround yourself with people who are positive and inspiring. The best way to attract good people around you is to be a good person."—Morgana Rae, Professional Life Coach/Owner, Charmed Life Coaching.
- "Today, if one insists on being in this industry, one *must* be very determined. Also, one must *never* forget that no matter how high you get up the ladder, we are all incredibly dispensable. For each one of us who is working, there are another thirty standing in line who would be totally willing to do our jobs for less money and less attitude. Stay grateful for any opportunity."—Christine Evey, Commercial Producer
- "You've definitely got to have a lot of patience to make it in this business. But more importantly, you need to be consistent and persistent . . . without being annoying."—Graham Ludlow, Producer.
- "Figure out what it is you want to do, search your soul for the direction that's right for you and don't deviate. Also, understand you're signing up for an entire lifestyle–not just a job." —Mike Papadaki, Vice President, Marketing and Sales—CFI/ Technicolor.

- "You must have a passion for the business; but learn to think before you react, because sometimes passion can lead to volatility. Also, learn *everything* you can about *every* job. Respect for your co-workers and their craft is very important."—Patience Thoreson, Script Supervisor.
- "Work for free for the best people you can connect with."—Robert Bahar, Documentarian.
- "Many are called but few are chosen, so you better have a passion for this business!"—Warren Vanders, Actor/Writer/Director.
- "It's easy to avoid everything and throw yourself into the fracas of film production, but be careful lest you wake up one day to find yourself middle-aged and a stranger to your children and spouse. You don't want your tombstone to read: 'He went into 50% fewer meal penalties!'"—Jerram Swartz, Production Manager/First Assistant Director.
- "Get smart and educated about the industry. I mean the film industry internationally. It's a big world. Don't forget the business part of show business, and don't waste time complaining. Take actions every day. Don't ever expect someone else to do it for you. Be assertive and let everyone know what you're up to. Ask *for* help and ask *to* help. Make requests. Everyone loves to contribute."—Suzanne Lyons, Producer.
- "Read as many scripts as you can get your hands on, and learn what makes a good story. Be prepared to offer your opinion when asked, and always, always, always think before you speak."—Danielle Daly, Assistant to Director John Dahl.
- "First–try to work with people of integrity you admire and respect at the beginning of your career, because that's when you'll be establishing your fundamental working habits. Second—whenever you have a big decision to make, ask three people in a position to know about the issue for advice and an opinion."—Janet Graham-Borba, Vice President of Production, HBO Films.
- "Tackle each job with complete and total commitment, no matter what the job is; and surround yourself with people who compliment your strengths."—Ron Lynch, President, The Culver Studios.

- "Tell anyone and everyone what it is you want to do. Shout it from the rooftops, because inevitably, someone will know someone who is willing to give you a shot."—Vail Romeyn, Production Supervisor/Independent Producer.
- "Be mentally and emotionally ready for the obstacle course that lies ahead."—Jim Byrnes, Writer.
- "Have a positive attitude. People don't enjoy working around people who aren't pleasant and positive. Second, try and have some kind of goal. The goal or goals don't always have to be long-term, but short-term goals in any situation help give meaning and context to whatever job you're doing."—Jay Roewe, Senior Vice President of Production, HBO Films.
- "There are no short cuts—no quick fixes. You have to be in it for the long haul."—Mike Jacobs, Jr., Producer.
- "It's important to acknowledge that there's no one single path to success in this business, but passion and determination are key no matter what you are doing or how long it takes. Learn from every job you have, and try to foster good relationships with those you encounter . . . you never know when you'll need them. Oh—and keep your sense of humor and humanity. Life's too short, and this business is too nuts to forget that."—Lindsay Devlin, Director of Development, Kerner Entertainment.
- "Keep in mind that the PA working for you today could be the producer (director, writer . . .) you want to work for in the future."—Victoria Paul, Production Designer.
- "Don't buy the Mercedes until you've got a year 'in the bank,' and then don't buy it until you can pay *at least* 50% in *cash*!" —John Poer, First Assistant Director.
- "If someone invites you to lunch—go! Make friends on the job, because your friends are your best asset."—Susan Hirshberg, Production Supervisor, Motion Picture Production Department, Disney/Touchstone Pictures.
- "Do your job, and try not to believe your own publicity."—Allen Grossman, Line Producer.
- "Never stop learning and wanting to better yourself."—Chris Zambros, Transportation Captain.

- "Take jobs based on the opportunity they will give you. Don't get hung up about the amount of money or benefits. Take jobs that will add to your resume. Build your resume, and the money will follow. I will still take on work for no pay if it offers me an opportunity to grow."—Keith Raskin, Executive in Charge of Production.
- "Network, take classes, ask questions, work for free and seek out a mentor."—Susan Sullivan, Script Supervisor.
- "Be easy to work with and leave the personal drama at home."—Michael Coscia, Writer.
- "Keep your promises and follow through."—Missy Moyer, UPM/Line Producer.
- "Forward progress is largely dependent on experience and relationships. Practice your craft, exploit your talents and build relationships where it matters."—Steve Molen, Production Executive, DreamWorks SKG.
- "Be positive about what you want to do today, but keep your eyes open to new possibilities; and keep an open mind."—Matt Kutcher, Special Effects Supervisor/Second Unit Director.
- "Stay open to new opportunities. Very few people end up doing what they originally set out to do in Hollywood. The business constantly changes, and you must keep all options open. And always accept a firm offer with a deal memo over a promise of a better project that has not yet been greenlit."—Don Zepfel, Freelance Line Producer.
- "Make sure you have a means of support or enough savings to carry you through the start-up stages (a good couple years) that doesn't drain you or keep you from fully focusing on your career."—Barbara Schwartz, Screenwriter.
- "Persistence (without being annoying), belief in yourself (without cockiness) and a willingness to hang in there when the going gets tough."—Carol Byron, Production Accountant.
- "Cultivate good people skills, adopt a willingness to do whatever it takes, be open to all possibilities, learn as much about the business as you can, be a team player and plan your moves carefully."—Jonathan Sanger, Producer.

- "If you want a career working on set, figure out what career path interests you the most, and then find out how to join the union in that profession. If you get into a union or guild, you will have job and wage protection with medical, health and pension benefits. It's hard work but a good life."—Mark Hansson, DGA First Assistant Director.

- "To make it in the entertainment industry, you must first learn to accept rejection and toughen up your heart. As you gain some perspective, you realize how critical the opposite is: to reject acceptance and to keep your heart open."—Heather Hale, President, Storyworks Entertainment, Inc.

- "Understand the level of sacrifice you're committing to."—Wayne Lamkay, Assistant Production Coordinator.

- "Realize that the people you work with are just as insecure as you are, even if they've been in the business a lot longer." —Richard Wells, First Assistant Director/Director.

- "Passion for persistence will pay off . . . and *never* get discouraged!"—Darren Sugar, Below-the-Line Agent, Prime Talents.

- "Observe, listen and think before proceeding."—Jean-Pierre Avice, Line Producer/Production Manager (France).

- "Start at the bottom, keep your mouth shut and eyes open for the first two years. Volunteer to do everything, especially the airport runs picking up directors, producers, etc. Read the paper every morning, so you have something to talk about on the set. Never talk about politics or religion—sports is good. Never eat on the set until the rest of the crew has eaten. Don't get caught up in the gossip or give out personal information. The first two years it's good to be somewhat mysterious, but also smart and helpful." — Jonathan Singer, Producer.

- "If you have dreams of being the next hot director or producer— be realistic, because the odds are not in your favor. Have a back-up plan and find another area of the business that would make you happy."—Cindy Quan, Production Accountant.

- "Be on time—always!"—Joni Wester, Studio Nurse.

- "Stay with it and take any job offered to you."—Ned Shapiro, Location Manager.

- "Don't get into this business unless you want it more than anything else in your life. It will require 110% of your waking energies to survive—much less succeed. If you are committed to that, then take on the occupational hazard of moving to Los Angeles, because you must be in the center of the cyclone if you wish to weather the storm. From there, perseverance, tenacity, assertiveness, unbounded optimism and bruised knuckles will become your tools. Strive for success, prepare for failure and maintain an undying confidence in yourself and your abilities despite horrific odds."—Louis G. Friedman, Line Producer.
- "Don't be afraid to start at the bottom. The only way to truly learn how to do something is by doing it. Being a PA is the best way to learn how things work, and it gives you a great opportunity to see various aspects of the film world."—Stephen Marinaccio, UPM/Line Producer.
- "Be willing to endure the big egos and the politics. Don't be afraid to mess up, and don't get flustered. Stay calm! Don't care so much about what other people think! Get the training you need, because the more confident you are and in control you act, the more others will trust you, and the less you'll get yelled at." —Michael Brooks, Music Producer and Head of Production for Rafelson Media.
- "Despite your best efforts, things will go awry. The challenge is how fast you can fix it. There will be times when you can't. Get over it. Accept all you meet at face value, and make your own decisions. Don't let others make them for you. Don't lose sight of your dreams, and don't let anyone tell you can't achieve something. You decide."—Dustin Bernard, UPM.
- "Put your ego in your back pocket and sit on it for a while. Be willing to keep your mouth shut, listen, make the coffee and do the runs. The more you can soak up, the more you'll learn. Oh . . . and be willing to work your butt off!"—Cory McCrum-Abdo, Post Production Producer.
- "Do your best and be your best every day and the work will come. Use your time off as a gift to yourself. Be the most interesting and informed person on the set. There's a lot of gab

involved in getting the job and getting called repeatedly. No one wants to spend 16-hour days trapped with a boring, ignorant, boorish crew member. Cultivate *you!*"—Peggy Geary, Script Supervisor.

- "If you still love doing it, even after the fantasy of what you thought show business was—is replaced by the 'reality' of what show business is—if you still 'love it' even after that, then stick with it. Sooner or later, it will love you back."—Matt Zettell, First Assistant Director.
- "Have a willingness to 'do the work' and learn the ropes. Don't expect a lucky break—create one for yourself."—Anne Hopkins, Producer.
- "Go into computer games. That's the future!"—Jack Kindberg, President, Studio Operations & Administration, Sony Pictures Entertainment.

Here are some other words of wisdom worth noting.

- "You can't have any success unless you can accept failure." —George Cukor.
- "There just isn't any pleasing some people. The trick is to stop trying."—Robert Mitchum.
- "Create your own visual style . . . let it be unique for yourself and yet identifiable for others."—Orson Welles.
- "Attempt the impossible in order to improve your work."—Bette Davis.
- "All great work is preparing yourself for the accident to happen."—Sidney Lumet.
- "Stay humble. Always answer your phone—no matter who else is in the car."—Jack Lemmon.
- "I do take my work seriously, and the way to do that is not to take yourself too seriously."—Alan Rickman.
- "Everyone wants to ride with you in the limo, but what you need is someone who will take the bus with you when the limo breaks down."—Oprah Winfrey.
- "Imagination is the highest kite that one can fly."—Lauren Bacall.
- "You're not a star until they can spell your name in Karachi." —Humphrey Bogart.
- "If you want a guarantee—buy a toaster."—Clint Eastwood.

— 19 —

Remembering Why You Got Into This Business to Begin With

"When you have a dream, you've got to grab it and never let go."
—Carol Burnett

When you were a kid, did you ever take the Universal Studios tour, and as the tram was driving up and down the backlot, fantasize about how incredible it would be to work there one day, to actually belong on that lot or another just like it? If you did, you're in good company. And do you remember how alive you felt when you made the decision to go for it and finally started taking steps toward a career in the biz?

Whether it's getting into film school, making your first student film or getting your first job as a PA, there's something magical about this time when your feet rarely touch ground. You're full of passion, excitement, creativity and anticipation. You can't believe you're part of this amazing, exclusive world, even if it's only a tiny part, and you're willing to do *anything* it takes to succeed. It's exhilarating to work with seasoned professionals; to walk onto a real studio or television lot or stage; to walk the halls of famous agencies such as William Morris and CAA; to meet your idols; to learn, to watch and to strive to impress anyone you can. You love reading scripts, going to movies, critiquing movies, talking about

the industry and associating with people in the industry. You've heard the dire warnings about the insecurity, rejection, competition and uncertainty, but your selective form of tunnel vision prevents you from taking any of it too seriously, because it's going to be different for you. What a high! You're starting out on the biggest and most wonderful adventure of your life with the goal that one day, you, too, will be discovering great talent; landing substantial roles; writing scripts that create studio bidding wars; marketing and selling films throughout the world or working on shows that will entertain, influence and touch the minds and hearts of anyone and everyone who turns on a television or walks into a movie theatre. No one can dissuade you from your dream; because you live, eat and breathe it.

Now the trick is to find a way to remember these feelings once reality sets in and the harshness of the business hits you right between the eyes. Having the ability to recall those emotions, revisit the thrill, reminisce about what drew you into this line of work and remember what it is you love about the industry will help you get through the tough times.

Director, writer, producer and Action/Cut Seminar instructor Guy Magar recommends that we put all that passion and excitement and all those memories into a little box and tuck it into our back pocket for safe keeping. Then throughout your career, whenever you're feeling discouraged, frustrated, rejected, beaten down by the politics or competition, you can just take that little box out of your back pocket and open it up, re-releasing all those wonderful emotions and reminding yourself why you got into this business to begin with.

I love the little-box-in-your-back-pocket analogy, but you can also write out your feelings and leave them in your computer, in a journal, in a file, wherever–just as long as they're accessible and easy to get to when you need them. Re-reading your notes after a considerable amount of time has passed is sort of like the thrill one gets when re-reading old love letters and remembering what it felt like when you first fell in love with your spouse or partner after the demands of everyday life have taken their toll on your romance. Here are a few other ways to recapture the magic.

- Collect the shows you work on (or appeared in), watch them from time to time, and remember the good times, the craziness, the locations and the people.
- Save memorabilia from your projects (cast and crew gifts, photos, scripts, etc.).
- Stay in touch with the special people you've met and worked with throughout your career; get together with them from time to time and reminisce.
- Help and mentor others just getting into the biz, and share your experiences with them. Teaching definitely does it for me.

If you're in it for the long haul, you're likely to get involved with projects that will fall through. Then there will be times when you're out of work longer than you'd like to be or you might very well end up working on exceptionally tough projects with people who test your patience beyond all reasonable limits. Whatever it is, there will undoubtedly be times when you'll find yourself disillusioned and questioning what demon ever possessed you to choose this insanity.

I hope you'll always be excited and passionate about your work and that the sense of wonderment never leaves you, but should you ever find yourself up against it and questioning the path you've taken—that's the time to pull the little box out of your pocket. Open it up, take a deep breath and soak up the memories. Or reminisce with people you've worked with, share your experiences with those just starting their careers, watch the shows you've worked on or find the love notes you once wrote to this business and revisit the feelings. Find your own magic elixir that will keep you from crashing and burning and will effectively ward off cynicism, frustration and defeat.

No matter how long your showbiz career lasts, your ability to remember why you chose this profession to begin with should give you the boost you need to keep going and to tackle most of the obstacles in your path.

— 20 —

Eve's Recipe for Success

> *"All our dreams can come true if we have the courage to pursue them."*
> —Walt Disney

- A sincere love of the business.
- One positive attitude.
- One winning personality.
- An array of well-developed people skills.
- One large network, along with a vast collection of solid industry relationships.
- Endless reserves of energy.
- Huge portions of assertiveness and chutzpah.
- A touch of humility.
- Heaps of inspiration and creativity.
- A plethora of determination.
- A willingness to start at the bottom and pay your dues.
- An abundance of hard work mixed together with a "can do" philosophy.
- An impressive knowledge of the business, blended thoroughly with an assortment of well-informed opinions.
- The desire to keep learning and to give more than what's expected.
- The time to have fun and make new friends.
- At least one unique quality that sets you apart from the crowd.

- One foot capable of getting into multiple doors.
- An ability to do well on interviews.
- A workable plan to get you where you want to go.
- The conviction that you're in it for the long haul.
- The patience and tenacity to get there.
- Enough savings or an alternate source of income to get you through the lean times.
- Oodles of confidence, motivation and self-esteem.
- The intuitiveness to anticipate the needs and tastes of others and to remain a step ahead.
- The talent to deliver a great pitch.
- One Teflon coat.
- Ten gallons of shark repellent to ward off all overinflated egos, nasty tempers, annoying back-stabbers and sleazeballs.
- Liberal amounts of schmoozing.
- The time and effort to keep up contacts.
- The support and recommendation of others.
- One sense of humor.
- At least one helpful and inspiring mentor.
- The belief that in spite of all the competition, rejection, insecurity, uncertainty, nepotism and politics—you will work again, sell a project or get a good role.
- One stellar reputation.
- Generous dashes of passion and excitement.
- A huge sense of pride and accomplishment for having made it this far!

Glossary of Terms

> *"Its idea of 'production value' is spending a million dollars dressing up a story that any good writer would throw away. Its vision of the rewarding movie is a vehicle for some glamour-puss with two expressions and eighteen changes of costume, or for some male idol of the muddled millions with a permanent hangover, six worn-out acting tricks, the build of a lifeguard and the mentality of a chicken-strangler."* —Raymond Chandler

Just in case you're not familiar with some of these words and terms, here's some production lingo that might be helpful. (You'll notice that many of these words have been used throughout the book.)

- **24-Frame Playback:** Since videotape runs at 30 frames per second and film runs at 24 frames per second, when you're filming a scene of someone watching TV, the TV footage has to be converted to 24 frames per second so when played back it remains in sync with the camera.
- **Above-the-Line:** Referring to the uppermost categories of a budget that encompass any and all costs relating to the writing, producing, directing and principal cast of a production.
- **Apple Box:** Various sized wooden boxes used to raise the height of an individual or piece of equipment.
- **Base Camp:** The area at or near a shooting location where the company operates out of and where you'll find parked vans,

trucks and trailers containing any combination of equipment, wardrobe, hair, makeup, craft service, cast dressing rooms, school room, producers and the director's trailer. Also, the catering truck and tent, at least one honeywagon and an extras holding area.

- **Below-the-Line:** Referring to the lower portions of a budget that encompass costs relating to the crew, extras, materials, rentals, props, sets, locations, catering, vehicles, office and legal expenses, etc.
- **Best Boy:** There are actually two best boys on a crew: the Best Boy Grip and the Best Boy Electric, and they are the seconds in command to the key grip and gaffer respectively.
- **Box Rental:** A fee paid to a crew member for use of his or her own equipment.
- **Breakdowns:** Schedules of individual elements needed for a show: extras, stand-ins, stunts, effects, second-unit requirements, picture vehicles, make-up/hair, special equipment, etc.
- **Call Sheet:** A game plan for what is to be shot the following day: who is to work, what time and where they're to report and what, if any, are the special requirements needed to complete the day. Included on the bottom of the call sheet is an advance schedule for the next couple of days.
- **Camera Car:** A vehicle outfitted with camera, sound and lighting equipment designed to shoot a moving vehicle. The camera car is often attached to and drives the picture vehicle.
- **Completion Bond:** Insures motion picture financiers against cost overruns in excess of their approved budget and that the film will be delivered in accordance with all specifications contained in the financing and distribution agreements.
- **Contingency:** An amount of money added to a budget (customarily 10% of the total negative cost) to cover unexpected expenses.
- **Continuity Breakdown:** Tracks the sequence (or progression) of events throughout a script.
- **Cover Set:** An interior location scheduled as an alternate shooting site for bad-weather days when exterior shooting is not possible.

- **Coverage:** Shooting a scene from different angles and set-ups.
- **Craft Service:** The area on a set or in a production office where you will find snacks, water, coffee, fruit, sandwiches, etc. It also refers to the food itself as well as the person (or department) supplying and taking care of the food.
- **Dailies:** In the olden days, also known as "rushes," this is footage that has been shot, rushed to the lab to be processed and printed, or if applicable, transferred to videotape for viewing the next day.
- **Day-Out-of-Days:** A chart that denotes workdays, almost always referring to the cast. It's also a handy way to chart schedules for stunt performers, extras, stand-ins, special equipment and anything that might pertain to your show.
- **Deal Memo:** Outlines the terms of one's employment on a specific project.
- **Digitizing:** The loading of material—videotaped footage, sound and music—into a digital editing system.
- **Distant Location:** When a crew shoots in another location away from their home base, necessitating an overnight stay.
- **Drive-On:** Permission left at a studio gate allowing a driver to enter the lot.
- **Drive-To:** A form of mileage reimbursement paid to cast, crew and extras for reporting to a local location. The mileage is determined by calculating the distance from the studio or production office to the location and back and multiplying that distance by a specified amount per mile.
- **Dubbing:** The process of duplicating a videotape, or as a film term, it can also be referred to as "mixing"—the blending of dialogue, music and sound effects.
- **Effects:** *Visual effects* are created when outside elements, such as animation, matte shots and computer-generated images (CGI) are integrated with original photography. The term *visual effect* also refers to the more familiar: reverses, dupes, flops, freeze frames, etc. *Physical effects* refers to the fabrication and development of models (miniatures), prosthetics, mechanically operated vehicles, puppets, robots and creatures and the creation of specialty props. *Special make-up effects*, used in the

preparation of prosthetics, is included in this category as well. *Mechanical effects,* better known as *special effects,* encompasses the recreation of rain, wind and snow, explosions, crashes, bullet hits, etc.

- **End Credits:** Screen credits that appear after a show.
- **Establishing Shot:** A shot that establishes the location or setting of a scene.
- **Exhibit G:** A Screen Actors Guild (SAG) time sheet performers are required to sign off on at the end of every work day.
- **Expendables:** Supplies such as tape, rope, light bulbs and gels that are ordered for use on a show and used up during the course of the show.
- **First Team:** The principal actors required for a scene.
- **Foley:** A method of recording sound effects on a recording stage that involves physical movement recorded in synchronization with the picture (such as footsteps).
- **French Hours:** Union guidelines require a shooting company to break for a sit-down meal every six hours. Should it be inconvenient to stop for a meal break because of rapidly diminishing daylight, oncoming poor weather conditions or a desire to wrap a performer or location by the end of that day—the company *may* continue shooting *if* 51% of the crew agrees to do so. If they do, food is continuously provided, but it's food that can be picked up while working and walking around the set. Once French hours are agreed to, however, the crew can work no more than ten straight hours without a sit-down meal, or the company faces retroactive (massive) meal penalty violations.
- **Gaffer:** The chief lighting technician responsible for lighting a set per instructions from the director of photography. This individual supervises placement of the lights before and during filming and is head of the electrical department.
- **Greenlight:** To give the final "go" and commit the financing necessary to make a film.
- **Green Screen (or Blue Screen):** A visual effects technique where actors are shot in front of a blue or green screen and the colored background is later replaced with another setting, thus transporting the actors to another location.

- **Grip:** One who shapes and shadows lights, rigs, lays and moves dolly track; sets up and alters stands that hold lights, scrims and flags and just basically moves, erects and alters anything essential to the set up of a shot. A key grip is the head of the grip department, a Best Boy grip is his second-in-command and a dolly grip specializes in pulling and pushing the camera dolly.
- **Honeywagon:** A tractor-pulled (long) trailer outfitted with individual dressing rooms ("bangers") and restrooms.
- **Insert:** A close-up shot used to clarify or emphasize an item or action in a scene, sometimes shot on an *insert* stage after principal photography.
- **Lamp Operators:** Electricians who work under the supervision of the gaffer (or chief lighting technician).
- **Leadman (or Leadperson):** The second-in-command to the set decorator.
- **Loanout:** Pertaining to individuals who are incorporated. It's when their corporation "loans out" their services to a production company and their compensation is paid directly to the corporation.
- **Lock Up:** A method of controlling unwanted or extraneous noise and activity immediately before and during the filming of a shot.
- **Looping (or ADR):** The re-recording of production dialogue that has been deemed unusable for any number of reasons (airplane flying overhead during the take, unintelligible dialogue, etc.). The actors repeat the dialogue while watching themselves projected on a screen and listening to the soundtrack on earphones as it was originally recorded on the set. The new dialogue that's being recorded must match the lip movement of the actor on the screen.
- **Main Titles:** The screen credits that appear before a show begins.
- **Martini Shot:** The last shot before wrap.
- **Meal Penalty:** Union guidelines require a shooting company to break for a hot, sit-down meal every six hours. If the meal is not provided, a meal penalty violation (fine) is paid and incrementally increases every half hour until a meal is served. A 12-minute unplanned "grace" period is allowed for production efficiency before a first meal, and a half-hour extension can be used at wrap to complete take(s) in progress at the end of a work day.

- **One-Liner (or One Line Schedule):** A short version of a shooting schedule indicating cast, page count and set description only. It does not reflect the other production and departmental details the full shooting schedule contains.
- **Per Diem:** A daily allowance given to cast and crew members working on a distant location to cover the cost of meals, laundry, etc. Travel and hotel accommodations are generally paid for directly by the production.
- **Picture Car (or Vehicle):** A vehicle that appears onscreen.
- **Photo Double:** An extra performer who is actually photographed as a substitute for another actor, usually in a long or drive-by shot where his or her face can't be clearly seen.
- **Poor Man's Process:** Instead of shooting a vehicle driving down a street/road/highway, this is a "down and dirty" process that creates the illusion that a vehicle is moving when in fact it's sitting on a stage.
- **Principal Photography:** The "shooting" period in which all scripted material covering all speaking parts is filmed.
- **Product Placement:** The props, set dressing, vehicles and wardrobe donated or loaned to a production for on-air usage. It could also be a shot of a recognizable airline logo as a plane takes off or a banner or billboard advertising a brand name product. What manufacturers choose to donate, loan and often pay for the valuable exposure is determined once they (or their representatives) evaluate the script, cast and director of any particular project. Product placement is big business and can be a great way to defray production costs.
- **Production Report:** The official record of what was shot on any given day in terms of scene numbers, set-ups, minutes, film footage and sound rolls; who worked and the hours they worked; the locations shot at; how many meals were served; vehicles and equipment that were used; and the delays, accidents or notable incidents that may have occurred.
- **Prosthetics:** Three-dimensional "appliances" affixed to a body or to alter the performer's appearance. This would include such things as aging skin, scars, burns, mutilations, a sixth finger, a mermaid tail, a full creature or animal suit.

- **Purchase Order:** The most valuable method of tracking and forecasting costs and used whenever possible for purchases, rentals and/or services.
- **Raw Stock:** Unexposed, unprocessed film.
- **Second Team:** The stand-ins (see below).
- **Second Unit:** Scenes shot without principal actors, such as establishing shots, certain stunts, car drive-bys, etc.
- **Scene:** A segment of action that takes place in the same location over the same period of time.
- **Script Coverage:** Script coverage is sort of like a book report. It starts with the particulars: name of the project, writer, date of submission, genre, locale, time period, who it was submitted to and who it's being read by. Under all these details, the "logline" is stated, which is generally a one-sentence description of the screenplay. Following the logline is a one- to two-page summary of the screenplay, highlighting the characters, plot line, etc., and this part is headed "Concept." "Comments" comes next, and this encompasses the reader's personal opinion about the script. This could run anywhere from one paragraph to a full page. Lastly, the reader rates the concept, plot structure, characterizations, dialogue, resolution and commercial viability. The ratings run from "poor" to "fair" to "good" to "excellent."
- **Shooting Schedule:** A detailed schedule reflecting the scenes, actors, stand-ins, extras, number of pages, locations, special props, vehicles, wardrobe, equipment, animals, etc. to be shot each day.
- **Short Ends:** Lengths of unexposed film left over after the exposed section has been cut off. Short ends can be loaded and used for short shots and inserts. Leftovers at the end of a shoot are generally sold and occasionally donated to students and low-budget filmmakers.
- **Sides:** Reduced-size script pages that contain the scenes to be shot that day.
- **Skins:** A list of extras to work that day issued by the extras agency. Another definition is a piece or length of material containing an advertisement or logo that's affixed to a car or truck that's photographed in a shot. Skins are often used on local fire engines, police cars and ambulances.

- **Sound Effects:** The adding, replacing or enhancing of sounds of any kind that are not recorded during production or were recorded but deemed unusable. Sound effects can include anything from the sound of a kiss to that of a major explosion.
- **Spec Script:** Short for speculative, it's a screenplay you are *not* being paid to write but rather one you're writing with the hope of selling.
- **Spotting session:** A screening of a picture at which the composer discusses the placement of music cues with the producer, director, editor and post production supervisor.
- **Stand-in:** An extra used as a substitute for another actor (for the purpose of focusing shots, setting lights, etc.) who is not actually photographed.
- **Station 12:** A SAG procedure to ensure that the actors cast to work on a show are in good standing with the Guild prior to reporting for work.
- **Swing Gang:** Also known as *set dressers*, they dress and strike the set and work under the supervision of the set decorator and lead person.
- **Taft/Hartley:** A federal law that allows a nonmember of a union or guild to work on a union show for 30 days. At the end of that period, he or she *must* join the union to continue working on that particular show or for another signatory company.
- **Take:** A single, continuous shot.
- **Telecine:** The process of, or place where, film is transferred to videotape.
- **Timing:** A process in which the color and density of the picture are balanced from one scene to another throughout the picture. It's done at the lab with the lab's color timer, the editor and occasionally, the director of photography.
- **Turnaround:** Regulated by a union or guild, it's the minimum rest period allowed from the time of dismissal one day until call time the next day. It also pertains to the time off from dismissal at the end of a week until call time on the first day of the following work week. A *forced call* is when a production decides to bring a cast or crew member back to work before their required turnaround.

- **Video Village:** An area on or next to a set where the director, DP, producers (or in the case of commercials, clients and agency reps) can view all on-camera activities from video monitors.
- **Wrap:** To finish up, to complete as in "wrapping" the day or the shoot. To say you've wrapped implies that principal photography has been completed. Wrap party or wrap gift would be something held/given at the completion of a show.

Here are some initials for you.

- **AD:** Assistant director.
- **ADR:** Automatic dialogue replacement.
- **APOC:** Assistant production office coordinator.
- **CGI:** Computer-generated image.
- **CU:** Close-up (and ECU is extreme close-up).
- **DAT:** Digital audio tape.
- **DGA:** Directors Guild of America.
- **DI:** Digital intermediate—going from (shooting on) film to (post production on) digital back to (releasing on) film.
- **DP:** Director of photography.
- **DV:** Digital video.
- **E&O:** Errors and omissions insurance.
- **EPK:** Electronic press kit.
- **EXT:** Exterior.
- **HD:** High definition.
- **IA or IATSE:** International Alliance of Theatrical Stage Employees (union).
- **INT:** Interior.
- **L&D:** Loss and damage.
- **M&E:** Music and effects track.
- **MOS:** Without sound.
- **NG:** No good.
- **ND:** Nondescript.
- **OS:** Off stage.
- **OT:** Overtime.
- **PO:** Purchase order.
- **PGA:** Producers Guild of America.

- **POC:** Production office coordinator.
- **SAG:** Screen Actors Guild.
- **UPM:** Unit production manager.
- **WGA:** Writers Guild of America.

Index

Television series
 working on, 55–56
Temp agencies and assignments
 advantages of, 131
 in back-up plan B, 131–132
 common sense and, 133–134
 future possibilities through,
 131–132
 general letter of reference
 through, 134
 partial list of, 134–135
 skills needed for, 132–133
Thank-you note
 for meeting, 201
Third area
 work on, 291–292
Third Area Qualification List,
 291, 292
Time management
 personal time in, 114–115
 prioritizing in, 114, 115
 scheduling in, 112
Tinseltown, moving to, 121–124
Trade papers, 245
Travel
 freelance work and, 47
 home base and, 124
 opportunities for, 21, 22

U
Unions and guilds, 50–52
 keeping current and, 246

 membership requirement for,
 52
Unit Production Manager
 responsibilities of, 76–77
 skills of, 77
Unit publicity
 abilities needed for, 86
 description of, 85–86
 entry into, 86
 pros and cons of, 86–87

V
Vacations
 scheduling, 24
Vision statement, 115–116
Volunteering, 323
 on the job, 217
 in network building, 232–233

W
Website, 155–156, 158
Work hours, 26
Working for free, 342
 advantages of, 126–127
 as script writer, 127
Writer
 career path for, 108
Writers Guild of America (WGA),
 50, 52
 story registration with, 262
Writing
 for new media, 104